THE
OPTICKAL
ILLUSION

THE
OPTICKAL
ILLUSION

A NOVEL

RACHEL HALLIBURTON

OVERLOOK DUCKWORTH
New York • London

First published in hardcover in the United States and the United Kingdom in 2018
by Overlook Duckworth, Peter Mayer Publishers, Inc.

NEW YORK
141 Wooster Street
New York, NY 10012
www.overlookpress.com
For bulk and special sales please contact sales@overlookny.com,
or write to us at the above address.

LONDON
30 Calvin Street, London E1 6NW
T: 020 7490 7300
E: info@duckworth-publishers.co.uk
www.ducknet.co.uk
For bulk and special sales please contact sales@duckworth-publishers.co.uk,
or write to us at the above address.

Cataloguing-in-Publication Data is available from the Library of Congress
A catalogue record for this book is available from the British Library

ISBN: 978-1-4683-1629-2 (US)
ISBN: 978-0-7156-5197-1 (UK)

Manufactured in the United States of America

2 4 6 8 10 9 7 5 3 1

To my husband Bill and son Fergus.
And to Lily.

'We are never further from our wishes than when we fancy we possess the object of them.'

—JOHANN WOLFGANG VON GOETHE
Maxims and Reflections, 1819

London, January 1797

Benjamin West thought back grimly on the events of the last year. Forced himself once more to remember that initial meeting.

The Provises had seemed curious from the start. There was something disconcerting about the two of them, as if they had been belched up fully formed from the earth seconds before appearing on his doorstep. The man was sallow-skinned, mud-eyed. A creature of perverse moods and humours. The girl, by contrast, had a fresh and pleasant demeanour. Lit by her curiosity, her pale blue eyes swept boldly around the room, even as she described to West the purpose of their visit.

They were father and daughter, they said. The father was a courtier at St James's Palace who worked in the Chapel Royal. The daughter had ambitions to be – and here West still felt a jab in the stomach for reasons he couldn't understand – the daughter had ambitions to be an artist.

What had he failed to comprehend? He had intended to deal with them honourably, but now everyone in London was saying he had not. It was as if somebody had dropped a small amount of ivory black paint into yellow orpiment on a palette – the more he prodded and stirred the memory, the murkier it became.

They had come to him for advice. They wanted to talk to Benjamin West as the preeminent artist of his time. He laughed contemptuously. Traveller, innovator, and great friend of King

George III despite the undoubted disadvantage – since 1776 – of being an American.

His heart started to beat slightly faster. In these times the world seemed permanently to be shifting. Each day was a walk onto thin ice – you never knew whether the next step would leave you upright or plunge you into oblivion. When he had arrived in London, thirty-four years ago, he'd had no intention of staying. Yet somehow his centre of gravity had shifted. Now the city was his home. But for how much longer now that all in London were calling him a scoundrel?

Like a greyhound slinking to its bone, West's mind returned again to the meeting. It had taken place just over a year ago in December, at his house on Newman Street. The couple had entered the very drawing room where West sat now. The father, Thomas Provis, had sidled up to the sofa clutching a sheaf of papers, while the daughter, Ann Jemima, almost danced into the centre. Both looked as if they had found their natural positions in the room, she the source of light and he some insignificant little planet orbiting around her.

'I am filled with gratitude that you set aside this time to see us,' she declared. Her long thin fingers clasped and unclasped themselves. As she began her account of why they had come to visit him, he had been captivated by the excitement in her eyes, the confidence of her voice. But now the recollection of the father's lingering silence made more of an impression on West's mind. Was he being judged even then? Had Mr Provis perceived something about his own character that even he hadn't realised? Some duplicity he hadn't fathomed?

'The father and daughter have a manuscript.'

Another painter had told him about them. Richard Cosway – a renowned philanderer – had been giving art lessons to Ann Jemima Provis, and was eloquent about her charms. Even before he met her West could see in Cosway's eyes, in the suggestive movement of the tongue across cracked lips as he talked, that she was just the kind of young lady who appealed. He had not, therefore, taken it very seriously when Cosway told him she had made an important discovery.

The manuscript had been left to her father, Thomas Provis. In it, apparently, was a secret that had obsessed every single artist of note over the last half century. They were willing to hand it over for a considerable sum of money.

'It is a technique for painting like Titian,' Cosway said. His eyes held West's for a second. Scepticism glimmered in the air between them, and they both laughed. 'I agree, it is most unlikely that a low-ranking courtier like Provis has come into possession of any such document,' he continued. 'But it would mean much to Miss Provis if she had the chance to explain it. She is a most insistent young lady, and I have told her that you, as President of the Royal Academy, would be in the ultimate position to judge the manuscript's authenticity.'

'How did they come into possession of it?'

'I believe they found it in papers that Mr Provis inherited.'

'Why was the secret not discovered till now?'

'I think Miss Provis would explain it better than myself. The story is somewhat convoluted.' Cosway coughed drily. 'An expert such as yourself will find it easier to separate the vinegar from the wine than I have.'

The flattery was clumsy. But that did not mean West was immune to it. In this city every other scoundrel had a miracle. Yet with a flourish of the quill and a splash of ink, he made an appointment to see them the following Tuesday. What the couple claimed to possess was no doubt as dubious as most of these schemes. But there was no reason not to hear them out for a few moments – entertain himself with their theories about something that had taunted him for much of his life.

If they were obvious charlatans, he would escort them politely to the door. And in the unlikely event that they had discovered something of value, he would give them some money in return for their presenting it to the Royal Academy. Of one thing he was sure: whatever they were claiming about their manuscript, they would not be in a position to understand it fully. Thirty-seven years after first coming to Europe, West had made sure that no one in London had an understanding of Titian that was superior to his own. If their

game was one of deception, he would see through it in a second. If they were honest people then he would be in a position to help them greatly.

And so the meeting had taken place. Now, more than a year later, he found himself threatened with ruin.

He gazed out of the window at the darkening winter sky, lost in thoughts from which he emerged discomfited some moments later.

'Was it myself I misunderstood, or the Provises?' he whispered. Then he shook his head angrily. 'A crime has been committed. And I am the one who stands accused.'

Scandal was the meat of this city's conversation – whether it was good quality beef or maggot-riddled mutton it was consumed daily and regurgitated as eagerly in St James's Palace as in the lowest taverns. Till now he had avoided being butchered for London's entertainment. How West acted in the next few days, he realised, would make the difference between whether his reputation was merely put on the grill, or stuck through with a spit before being ripped apart so savagely that he would never be able to live here again.

America, 1757

*'To live is not to breathe but to act. It is to make use of
our organs, our senses, our faculties, of all the parts of
ourselves that give us the sentiment of our existence.'*

Jean-Jacques Rousseau,
Émile, or On Education, 1762

Forty years before the scandal that threatens to consume him,
Benjamin West is on a riverbank in Pennsylvania covered in mud.
He will never forget the smell of it, the feel of it. Rocks and minerals
pulverised by time, swirled into sludge by the same forces that will
eventually grind everything down.

Benjamin and his elder brother William are following a Mohawk
tribesman. The tribesman, Running Wolf, has promised to impart
to them secret knowledge that Benjamin wants, and his brother
thinks he is mad to want.

As Benjamin West makes his way along a steep bank he slips. A
world flies up around him; his elbow, then the rest of his body, hits
the ground, and seconds later he is looking at the sky.

'Tarnation!' he bellows.

The mud is spattered across his stockings and breeches, and he
can feel it starting to seep under his jacket. He slides towards the

water. He grabs at a root, winces at the raw pain of it against his hand. Below the river roars and shimmers. With a jolt his body stops.

'Benjamin!'

His brother's face – upside down – hovers above him. He can see the raw lines of shock upon it. His eyes are darting back and forth, making the calculation: can he descend the bank without slipping himself and dragging them both towards the river?

Benjamin looks downwards. He can see a rock jutting out, and lunges towards it with his right foot. Once he has confirmed the rock will take his weight, he swings his whole body round so he is facing the bank, and starts to attempt the climb back to the path.

'Curses!' he cries as he slips again, but this time Running Wolf is reaching down. Benjamin stretches his hand up with his fingers extended, 'as if he were Michelangelo's God, and I were Adam', he will joke later. The tribesman's hand goes past his and grabs onto his wrist, there is a sense of a great upward force, and then he is on the path. William regards him with a mixture of relief and disbelief.

'You look like a man born out of mud,' he declares.

'I came here to discover about mud,' Benjamin replies. 'I feel no shame that I have covered myself in it.'

Around them nature's canvas dances and shifts: ruby-throated hummingbirds, yellow-bellied sapsuckers, ox-eye sunflowers, the white and crystal fury of the river.

'Come further upstream,' says Running Wolf. 'The river is slower there. You can wash the mud off...'

'... and then you can mix it with bear's entrails and paint it on again...' says William.

The tribesman's eyes flicker towards Benjamin, who smiles and shakes his head.

'My brother shares not my passion for art.'

'It is fine enough when it sits quietly on a canvas,' replies William.

'He understands not that I want to talk to people for whom paint is a part of life and death, of war and celebration.'

'You will do anything to gain an advantage over other artists.' William's eyes spark. 'If you had to go to Hades and back to get a colour that no one had used, I'd wager you would do it.'

A large clot of mud falls off Benjamin West's cheek as he considers a reply. The two brothers stare at each other. Two men standing either side of an obsession – Benjamin's eyes ablaze, William's eyes shiny with mockery. They hear the same words, yet the words stir emotions in each man that the other cannot comprehend.

'It is bear's grease, not bear's entrails,' Benjamin eventually says more seriously.

'I see not a great difference. The bear still dies.'

'Mr William,' says Running Wolf. 'Let us go. Your brother needs to wash. There will be someone who can teach you to fish with a spear.'

A look of sly amusement crosses Benjamin's face.

'Is not his tongue sharp enough?'

'I speak thus because I love you, brother.'

Benjamin reaches out with a muddy hand and grabs William's till it too is encased in dirt. He looks into his eyes. 'Then taunt me no longer.'

A truce is established with a look, and the three men walk on together. The morning sun has returned after two days of rain – dragonflies dance, and a bald eagle soars overhead. That day William catches six fish, and Benjamin learns secrets that will stay with him for the rest of his life. But right now all is the rushing river, the heat of the sun, the whirr of insect wings and the different rhythms of birds, the shivers in the grass, the darting of lizards, and the thick, clinging mud.

Voyage to the Old World, 1760

At the age of twenty-one, Benjamin West is on a sugar-merchant's ship heading for Italy. There will be a point in his life when he will ask himself if this is where it all started to go wrong. But as he embarks all he can sense is the swirl of sea against the prow and a silver sun breaking through early morning cloud. His old life is packed up in a trunk and the possibilities of the new one hang in the briny air.

A wealthy patron has recognised his talent and has offered to send him five thousand miles away and three hundred years back in time. Titian, Raphael and Da Vinci are some of the artists West shall study – he shall also witness the dissection of human corpses, and sketch according to the Golden Ratio.

His excitement at what is to come sustains him through a voyage that proves tedious apart from an incident in the third week when a pig escapes and causes uproar below decks. On a morning raw with the sound of seagull cries, a sixteen-year-old boy goes to dispatch the animal for that evening's dinner. But whether it is the gleam of the knife, or the look in the boy's eye, the pig scents oblivion and decides it does not want to meet it. One flash of steel, and the swine turns battering ram. The boy runs to hide, while the animal pants and squeals between the galley and the storeroom.

West is one of the men who helps to catch it. It is a moment of strange joy amid the tedium. On the night of the pig's attempted escape, he sits in his cabin and draws the incident in his journal. Working with black chalk held in a porte-crayon, he takes much time over the pig's fleshy snout and the contours of a belly that seems continental in size compared to the stumpy promontories of its legs. He does eight or nine sketches of the men trying to catch the animal, observing how the different angles of the bodies affect the sense of speed and chaos within the picture. 'If it is done the right way, a picture can contain past, present and future,' he murmurs. He stares at his final image, then, dissatisfied, rips out the page and screws it up.

He goes to lie on the uncomfortable narrow bunk that has been warden to his nights since the ship set sail from Philadelphia. As he struggles to fall asleep, his memories of the furore merge with the commotion that arose when, two months beforehand, he announced to his family at dinner that he would make this trip to Europe. He remembers his brother, sees again the outrage on his face. When he eventually spoke, his words were full of contempt.

'It is ambition that drives you from us. Our grandfather risked everything to come from England with William Penn. Why can

you not honour him by building your life here and supporting our parents?'

'It is not ambition,' he chided him. Though in truth he could not say what the excitement was that gripped him. The taste of unknown cities, untried ideas, the sense that the future had become a cliff edge from which he might either soar or plunge.

His mother watched them keenly.

'Benjamin is doing exactly what his grandfather would have wished him to do,' she declared.

He understood her too well not to recognise that she was upset, but knew also that she would be mortified if he stayed behind for her. William raised the level of attack.

'There is a chip of ice in your heart. I have witnessed it all too often. Most of the time you are an honourable man, but whenever you get the chance to advance yourself, you will do whatever is needed, no matter who suffers.'

There were tears in his eyes that he blinked away quickly. Benjamin realised that in his anger he too was trying to conceal a fear of losing him. He reached out a hand. But his brother backed away, glaring.

He felt the tears in his own eyes.

'When have I made others suffer?'

'What of your fiancée, Elizabeth, right now? You were to be married this summer. What is she going to say?'

Benjamin took a deep breath.

'I would not be who I am if I did not take this opportunity. I hope and pray that she will be content to await my return.'

He groped to say something more. Of the struggle he felt it had been to become a painter. Of how he was no natural scholar, so every fact and technique he had mastered was a triumph of stubbornness. Of how the words jumbled in his head when he read books, so he had learnt to make a virtue out of learning through experiment and conversation, doggedly taking apart each idea he was told and building it up again until it finally made sense. Of his instinct that this journey would teach him a hundred times more than black marks on a page. Yet he saw the expression on

his brother's face, and realised that rather than explain this, it was wiser to say nothing.

'So she believes you will return?' William said finally. It was as much a question as a challenge.

'I am going to Europe.' He attempted weakly to make a joke: 'I will not fall off the edge of the world. I will be back by the end of the year.'

William shook his head.

'You may tell yourself that is true. But I will certainly not waste my time by believing it.'

He stalked out of the room and into the night.

Italy

When the ship eventually docks in Pisa, the land appears to rock beneath Benjamin West for two days. His sense of elated terror is added to by the fact that in 1760 he is the only American that most Italians have met. He realises quickly that many who encounter him judge him as a curiosity. He squirms under their scrutiny like a clam prised open by a bear.

Before arriving in Italy, he has imagined it as a world of fantasy. A mountain range of domed cathedrals; ancient libraries filled with papery whispers; metallic choruses of bells and alleyways dirty with history. His head has been filled with myths of babies suckled by wolves; with glittering treasures stored by the Medicis; with a land lofty with pagan gods and bombastic with popery.

But reality comes with a twist. Within a few days he begins to realise that he is engaged in a fight he had not anticipated. He has English grandparents, so considers himself to have an affinity with Europe. Yet the Italians he meets view it differently. Quickly he sees that many of them are not just ignorant of his own culture, they are contemptuous of it. He discovers this with most embarrassment on the afternoon that a cardinal takes him on a tour of the Vatican with a group. The cardinal's holiness has a stench of condescension – he

quips loudly on meeting West that he is disappointed to realise he is not a Native American.

West starts to talk about the summers he has spent hunting and shooting with tribesmen, about the painting techniques he has learnt on the riverbank. But with a swift turn of the head, the cardinal indicates he is not interested in a reply of any kind. West feels cowed until, towards the end, they come to the seven-foot-high statue of the *Apollo Belvedere*. Turning to the group, the cardinal describes it in pinched, saintly tones as the greatest classical statue in existence, the embodiment of physical perfection, one of Italy's greatest treasures. His words drift in the arid air. West stops listening to him – stares at the statue to see what his instincts tell him. And suddenly he feels as if he is back in Pennsylvania again. He sees that it has been sculpted to look as if it has just fired an arrow, sees the tension of the muscles, the tilt backwards of the body, the strange sense of blood flowing vigorously beneath the stony flesh. Filled with pride, he declares, 'Now this is worthy of comparison with a Mohawk Warrior.'

But he has miscalculated. The laughter and gasps rise around him. He looks at the cassocks, breeches and waistcoats, the cerebral expressions, the bodies corseted by decorum. He sees how he has been judged vulgar for associating the naked statue with a living breathing man. He feels angry embarrassment that what he has intended to be a compliment has been seen by everyone else as an unacceptable mockery of a classical ideal.

As the outrage increases, West realises that just as he must learn to understand the Europeans' continent, he must battle to make them understand his. Here in the Vatican art suddenly seems to be about ghosts fermented in wine and trapped in stone, the voices of a thousand dead men, dust and superiority. He vows to master every technique he can, while never forgetting the mountains, forests and endless skies of the landscape that has made him. In Florence he perfects chiaroscuro and gazes endlessly at green-faced Madonnas, in Ravenna he stares at mosaics that shimmer like fish caught by the morning sunlight. In the cutthroat salons of Europe's intellectuals he gradually starts to gain acceptance.

His letters home show none of the problems he encounters. They mark the triumphant progress of a young American abroad. He never mentions the frequent bouts of illness that hint at his unhappy state of mind, even when he is laid low for months in Florence. He does not talk of the times that he wishes he were just a canvas on a wall, the times that a snide remark makes him wish to punch someone, the times that he aches to smell Pennsylvanian air again. At this point it is only the pressure of paying his patron in new artworks that stops him from returning home before the end of the first summer.

And then the tide turns. He cannot say exactly how and when that is. There is no steady progression – just advances and retreats, shimmers and surges. Small epiphanies, such as the evening where he arrives in Venice. A sense of fantasy about what he observes, as if it is all a figment of a sea-god's imagination. Something dirty about the beauty – the history of each palazzo imbued with bloodshed, licentiousness, poisoned rivalries and corruption. He sees Titian's *Assumption of the Virgin Mary* – a painting that once reinvented composition and colour, and it turns him inside out. The clashes of reds and golds, Mary smaller than the apostles and yet more vivid, a sense of swaying and light. In Florence, Massaccio's *Expulsion from the Garden of Eden* will also give him a sense of broken rules and liberation. Bodies hunched with despair that somehow speak of a new world. A sense of eloquence that he cannot precisely describe. Yet he tries to reproduce it again and again in shabby notebooks.

Brushstroke by brushstroke, Europe starts to change him. He discovers like minds, wins accolades, starts to walk taller and prouder. The months abroad turn to years. Each time he puts a date on a letter that he writes home, he realises his brother is winning their argument, but he is starting to enjoy the new rhythm of his life, the continuing sense of fresh perceptions, the belief that he is gaining hard-won respect. As the commissions flood in, any sense of guilt is drowned out by the louder noise of opportunity. In the salons he is known as 'The American' – where once the description was a form of disdain, now it is a warm acknowledgement. He thinks he has won a victory. Yet he does not recognise how the word 'American' is like

a hinge from which attitudes will swing back and forth throughout his life. Right now it is a term of acceptance, but in the more distant future it will adapt equally easily to tones of hostility, fear, and even mockery once again as the world around him changes.

It is on an early evening in October 1762, when the stones of Rome seem saturated in gold, that he decides he should delay his return to the country he professes to love no longer. He sits and writes letters to both his family and fiancée that he will be back in the spring. But for reasons he cannot entirely understand the pieces of paper are still sitting on his desk a week later when a letter arrives from his patron. He breaks the seal while eating bread and partridge at breakfast. In it is an invitation to London. It is the work of a moment for him to accept it.

Britain

A set of two pictures. In the first, it is 1763. The sky is grey and hurls down raindrops like mockery. West is not sure yet what attracts people to this city. The Thames and its ferment of corpses and excrement seems no substitute for either pure blue Pennsylvanian lakes or the warm Mediterranean. He has little conception that he will spend the rest of his life here. What he does know is that though he has travelled more extensively than many who are twice his age, he still feels less educated and articulate than the wits and fops who see themselves as the city's predators.

All these details lie outside the frame. Inside it is the self-portrait West creates that year. Some might call the image a lie, others a paradox. Still others might call it a declaration of intent. There is no sign in this picture of how disconcerted he feels. He sports a grey powdered wig with panache, while his black hat is tilted at a jaunty angle. He has the full-blooded complexion of one who is in good health, while his long straight nose lends him an air of distinction. One half of his face is in shadow, so that just one dark eye stares at us as if to challenge us. With his left hand he clasps an easel. In

this moment, the portrait of the artist is more substantial than the man it represents.

Soon, however, the image and reality will conflate. The arc of ambition that William has noted is carrying West upwards, and wealthy patrons and acclaim are waiting in the wings. In London, the teeming city – with its vagabonds and tradesmen, exiles and patriots, dukes and beggars, opportunists and innocents waiting to be corrupted – he will be one of the survivors. Within a month he will write to his mother that he has an introduction to the King.

And then there will be one political revolution. And after that a second. All certainties will rise up into the air like ashes from a fire. The young man's portrait is replaced by that of a fifty-eight-year-old. A man both augmented and weighed down by his experiences, the pink bloom in the cheeks replaced by vascular red threads, the eyes corrupted by uncertainty. A man whose upright shoulders show he is well acquainted with the taste of success yet whose bitter set of the chin demonstrates he is not a little marked by the scourges of envy. A man who has learnt that all that was once unpredictable is now even more unpredictable, for whom the edict that the only true wisdom is in knowing one knows nothing rings darkly true.

A man for whom, right now, the Provises are just shadows in a world of shadows. All he knows is that they exist, and that finally the laws of chance have seen fit to cross their path with his. They are somewhere out there amid the passing carriages and the clatter of horse-hooves, their voices just more sounds amid the beggars' cries, paupers' wails, whorehouse groans, and tattle of aristocrats. London is the teeming city, filled with all manner of humankind. What do they really have to offer in this, the world's largest city, so many bodies pressing themselves together in the dirty streets seeking the hope that somehow they cannot find in the green fields beyond?

CHAPTER TWO

St James's Palace, residence of King George III, London, 1795

'*Gall Stone is found in the gall of oxen. It is of different forms, sometimes round, at others oval. Ground very fine upon Porphyry; it produces a beautiful golden Yellow. It can be used for Oil Painting, though rarely: it is chiefly used for Miniature and Drawings in Watercolours.*'

Constant de Massoul,
A Treatise on the Art of Painting and the Composition of Colours, 1797

Mrs Tullett, seamstress to the Queen, has arrived at the living quarters of Mr Provis – verger to the Chapel Royal – to help prepare his daughter for their visit to Mr West. Yet the matter in hand is never her favoured topic of conversation, and for an hour now she has been railing about the catastrophic state of the world around them.

'Until the last moment the King had not the slightest idea of the danger she posed.' Her eyes grow large. A drab woman with a rasping voice, she is a scavenger for misfortune. As she talks, fat fingers shuttle back and forth in the air, between those fingers a

silver needle glints. In the other hand a delicate headdress starts to take shape.

'He was getting out of his carriage to greet the crowds,' she continues, 'as he had hundreds of times before…'

The needle pauses. The Provises exchange glances.

'A woman came up to him who had the appearance of a domestic servant. She was holding a sheet of paper out to him, which he thought was a petition of some kind. So of course he took it. But underneath it was a knife…'

The girl, Ann Jemima, stares questioningly at the man who nods affirmation. Mrs Tullett's voice becomes cold, admonitory.

'She could have killed him there and then. But she didn't. The blade was too cheap, it left no mark, and King George walked away saying he felt sorry for her…'

Mr Provis reaches over to the tray on the table between them, and takes the lid off the engraved silver pot sitting on it. The smell of coffee punches into the air. He looks at Ann Jemima sitting demurely. Senses her scepticism as the story becomes ever more sensational, sees her eyes flash with amusement at Mrs Tullett's more ghoulish flourishes. Later they will mock the old crone's predilection for disaster. 'She was hatched from the egg of a carrion crow,' Ann Jemima has often declared. But for now they flatter her with compliments that will turn to dust once the door has closed behind her.

It is Ann Jemima who has decided that Mrs Tullett should be invited over from the Queen's residence at Buckingham House to help her dress for the visit to Mr West. Though Mrs Tullett is now a needlewoman in the Queen's Wardrobe, she has worked her way up from scullery maid, and has known the comings and goings of the palace for almost thirty-five years. She is bulky with regrets. The weather system of her moods goes from stormy to overcast, the sun rarely glimpsed.

She talks often about how she started at the court in the same week that the then young and naïve Queen Charlotte arrived from north Germany. She has a memory of creeping into the back of the Drawing Room where celebrations were being held following the wedding service. Of seeing the lights blaze like constellations,

hearing the symphony of clinking glasses, velvet chatter and song. Amid the finery it was a shock to realise that the royal bride was as dark and ugly as she herself – and yet could be the source of so much admiration.

Today the three of them are sitting in Provis's own much more humble drawing room. As Groom of the Vestry at the Chapel Royal, he lives in a small apartment on Green Cloth Court at St James's Palace. Of the seven courtyards around which St James's is built, Green Cloth Court is one of the largest. Yet Provis's own residence is modest in scale – 'Put a microscope on it,' he tends to joke, 'and you may see a residence fit for a flea.'

The microscope would also reveal his living quarters as a retreat filled with curiosities. It startles all who enter it for the first time. The ivory sphinx that guards the mantelpiece, the framed copies of Hogarth's *Mariage A-la-mode* that hang above it. The Venetian skeleton key that dangles from a cord by the window. The Indian white jade cup with a goat-shaped handle. All bear testimony to a passion for the esoteric and exotic that would seem more fitting for a man with five times his income. Yet he has not come by any of his possessions through dishonest means, but – as he often reminds people – through a talent for seeing treasure where others see only dung. More than one market-stall holder has yielded an object up to him for a ha'penny that would be fit for any stately home after a bit of polish and loving care.

He places the lid back on the silver coffee pot and pours them each a cup. 'The woman's name was Margaret Nicholson. She was trying to attack him with a dessert knife I believe...' he says dourly. 'She was aiming for his heart, but only managed a swipe at his waistcoat. She'd have had as much luck trying to assassinate him with a teaspoon...'

Ann Jemima can suppress her laughter no more. Mrs Tullett darts her a resentful glance. The girl swiftly recovers herself.

'Mrs Tullett is right – it could have been most grave.' She takes a deep breath, and is demure again. 'How could a madwoman approach the King so closely? She could have done the deed if she'd had the right weapon.'

'That's what everyone was saying at the court.' Mrs Tullett noisily sucks the end of a piece of cotton before threading it through the needle again. 'But the King refused to take it as a warning. He continues to go out into the crowds at every opportunity, saying he does not fear malefactors.'

'And by and large he has been proved right,' says Provis briskly.

'Until five weeks ago,' declares Mrs Tullett.

They are all quiet for a moment. Provis's fingers drum a dirge on the table, while Mrs Tullett leans over to reach the sugar tongs.

'In this more recent attempt the King was truly in danger,' Ann Jemima declares, fixing her gaze on Mrs Tullett.

'Indeed he was,' replies the needlewoman. 'Imagine what it felt like for him. Sitting in the carriage, surrounded by the angry crowds. Stones smashing against the sides, faces leering and shouting at him. Lord Onslow of the Bedchamber said they thought the stone that came through the window was a bullet at first, it came so fast. It was a miracle it missed the King.' She purses her lips. 'He did not act scared at all – but he has said more than once since that he thinks he may well be the last King of England.'

Provis takes a long sip from his cup. 'We beheaded our King more than a hundred years ago,' he replies. 'And what did we get in return for it? Oliver Cromwell, who shut down our inns and theatres, and whipped boys for playing football on a Sunday. In France it has been yet worse. They sent their King to the guillotine but two years ago. It all started with jubilations, but then the radicals brought in the Reign of Terror. Tens of thousands beheaded on the streets in the name of liberty.' His lip curls. 'Now France is at war with half of Europe including ourselves. I think it will be a while before the English truly have the appetite to kill another monarch.'

'Maybe you are right,' says Mrs Tullett, 'but I think the King should be worried. People are hungry, Mr Provis. I've got cousins who can't afford bread, and we all know people who are suffering from the bad harvests this year. What more will they endure before he is punished for it?'

She stares hard at Mr Provis and he stares impassively back, the two of them like prophets at a poker game where only the future has

the winning hand. What they, like everyone at the court, can sense is how, even though the King has not been physically hurt, rivers of unease have been sent running throughout the entire country. It is yet another reminder of how thin the line is between monarchy and anarchy. Yet another reminder that what seems to be the political status quo is just another ship on a storm-tossed sea.

In the city coffee houses Provis has heard both sides of the argument. The pro-revolutionaries regurgitating *Rights of Man*, the anti-revolutionaries spewing back Mr Burke's *Reflections on the Revolution in France*. Though he normally speaks in support of the King, he can be a chameleon when it comes to expressing his political views. London is filled with people with concealed agendas, and he knows that in these turbulent times a pragmatist is more likely to survive than an idealist. Here at St James's Palace no one, of course, confesses to reading anything other than Burke. But Provis is a man whose ambiguous approach to life makes it easier to know other people's secrets – and these he collects as assiduously as the possessions in his apartment.

'The time approaches, Mrs Tullett. Have you almost finished?'

It is half an hour later. Mrs Tullett's needle continues to fly back and forth, Provis is reading *The London Chronicle*, and Ann Jemima is sketching deftly in a vellum-bound note pad. Now she shows her drawing to Mrs Tullett. The seamstress sucks in her cheeks before allowing a shocked laugh to escape her.

'I had no conception of what you were doing.' She takes the pad and studies it closely. 'You have made a fair attempt at my likeness, there's no denying it.'

Provis stands up and walks across the room. He looks down at the pad to see how in a few swift pencil strokes, Ann Jemima has brought all Mrs Tullett's quivering discontents to life. The sag of disappointment in the chin, the suspicion scored into the crow's feet around the eyes, the disapproval ironed stiffly into the forehead are all there. At the same time he can see how the girl has calculated

enough flattery to make the picture acceptable to her subject. The coarse wires of Mrs Tullett's hair now whisper more sleekly around her face, so it has a softer aspect, while an unaccustomed smile tarries on the pinched lips.

Your problem, child, is that you see too clearly, Provis thinks, but he does not say this out loud. Instead he declares drily, 'You must be sure this does not fall into the hands of our debauched Prince of Wales. He will be banging on Mrs Tullett's door nightly to gain admission.'

Mrs Tullett's laugh gives the impression of something broken inside.

'I pride myself that I am one of the few who has not caught his eye. Ugliness has its own rewards.'

'I do not think...' begins Ann Jemima.

'No,' cuts in Mrs Tullett. 'I am not such a gorgon here.' She gazes at the picture again, her breathing slow and calm. 'There is a kind of sorcery to your talent, young lady. I am not sure I altogether trust it.'

The brief silence shivers around them. When Ann Jemima looks at Provis, he indicates she should put the drawing pad away. On her face he reads puzzled mutiny before she finally acquiesces.

Mrs Tullett sits back and displays the almost finished headdress. 'You must try this on now, Ann Jemima, if you are to be ready in time.' She shoots a baleful glance at Provis. 'Mr Provis, you are still most secretive with me. Will you at least tell me which of your associates found you this manuscript you are taking to Mr West?'

'What mean you by associates, Mrs Tullett?' he responds quietly.

'Do not be coy.' The resentment in her voice is thinly disguised. Until three years ago she was his chief confidante. When Provis started working at the palace, it was known his wife was dead. Ann Jemima had been living in the country with her grandmother, but after she too died the girl arrived in London, and everything changed between Mrs Tullett and Mr Provis. 'Many have profited from the black market in art since the turbulence started in France. Your great friend Mr Darton is one of them, and you are another.

You think me blind and stupid, but that small bronze bull that fetched you a pretty penny did not arrive in this country through honest means.' She stabs a needle into the pincushion next to her. 'Nor did that pornographic etching of a woman by a stove, which you seemed to set such store by.'

Provis refuses to be hooked by her accusations.

'That was a Rembrandt.' He frowns. 'It was not for titillation. I sold it not through the black market but through Skinner's auction house, and received £59 for my pains. Its new owner values it highly, and keeps it well. As for how I acquired it, when the original owner is dead, and the etching in danger of being stolen or burned by vandals, I see not what the dishonesty is in receiving a painting to find it a safe home.'

She is undeterred.

'And this manuscript you are going to take to Mr West?'

'It comes not from any of my associates, as you choose to call them,' he replies with barely disguised vexation. 'This is a piece of inheritance. It came to me through my grandfather. I have possessed it a while, but did not till recently realise its value.'

'How to paint like Ti-ti-ern.' The second 't' is hard, the 'a' half swallowed, but her tone carries an implicit mockery of any who might dare to correct her. 'I have not your understanding of art, Mr Provis. But I did not believe great artists took their inspiration from written instruction.'

'I must confess I did not understand the manuscript's full significance at first,' he replies. 'It was Ann Jemima who had the wit to awaken me to it.'

Mrs Tullett's scepticism hangs heavily in the air.

'Oil paintings are built up in layers. Like humans, they owe more to what lies below the surface than what is visible to the eye.' Provis's stare goads the seamstress for a moment. 'Any accomplished painter must understand the alchemy of the paints and materials they use.'

His left hand frets at a button on his jacket. Swiftly he darts a sideways glance at Ann Jemima, almost, Mrs Tullett thinks with outrage, as if for approval. Mr Provis who has never once sought anyone's approval in the two decades she has known him, a man

who till now has operated entirely according to his own rhythms and humour.

'It is science, not alchemy,' the girl rebukes him.

'That is enough, Ann Jemima.' Mrs Tullett's voice snaps at the air. 'You know to talk in such a way is not ladylike.'

A look she cannot read enters Ann Jemima's eyes.

'Have you ever seen a man light a glass of brandy using an electric spark from his finger?'

'I do not believe such a feat is possible.'

'It is a trick performed the length and breadth of Europe these days,' Provis interrupts. 'It is a popular entertainment for those who consider themselves devotees of science.'

Mrs Tullett is about to respond, then thinks better of it.

'The painting teacher my grandmother hired showed me the trick,' says the girl. 'He could see I was bored with painting flowers…'

'And that's where the trouble started…'

'Science and art are not as separate as you might think.' She comes closer to Mrs Tullett, looking directly at her so she must look back. 'Once he'd lit the brandy he made me study the flame. Made me observe how the colour shifts all the time. You hold one image in your eye of what it is, but really it is several images – the reds, oranges, yellows and blues subtly change their position every second.'

'I am surprised your grandmother retained this painting tutor when he asked you to indulge in such fancies.'

'A flame takes this principle to the extreme.' Ann Jemima ignores her. 'But then he made me notice how the colour shifts in every-thing. If you watch a tree dancing in the sunlight, or a man walking down the street, you see that while the essential colours remain the same, light and shade play with each other to create different versions of that colour.'

'I do not understand what bearing this has on the document you want to sell.'

The girl takes a deep breath.

'Colour is not simple. People have spent centuries working out its secrets. Just making paint is an art. My teacher told me of crushed berries used to create certain reds, of metallic ores,

insect eggs, tree resins, crushed lichens, semi-precious stones, powdered woods.'

Mrs Tullett's lips twitch. A sly humour comes into the girl's eye.

'He told me of a paint that comes from crushing Egyptian mummies. It is often used by painters to create flesh tones.' Various emotions cross Mrs Tullett's face, but she still will not commit herself to a comment.

'There is also a rare pigment that is taken from the gallstone of an ox. Only a few private slaughterhouses supply it. When ground it produces a wonderful dark yellow.'

As Provis swings round to observe more closely how Mrs Tullett is reacting, he thinks of other sketches Ann Jemima has made of the seamstress that she will never see. In one she rises, with crow's wings, so that her shadow is scored against the sun, in another she is a vampire, sucking the happiness from a young married couple. Now he sees that vampiric glint enter her eye.

'Crushed Egyptian mummies, and ox's gallstones? And you call it science? A century ago, a young lady might have been burned at the stake as a witch for talking of such things.'

'Maybe so.' The girl looks swiftly towards Provis. 'But no painter could put brush to canvas without such practices. The best colour-men vie to produce their paints from the rarest sources. And great artists will willingly pay the price for their expertise.'

She takes Mrs Tullett's hands. The seamstress is startled but does not resist.

'When I saw the manuscript that we had inherited, I realised quickly that it was extraordinary. It contains knowledge of the science of colour that many thought had been lost to history.'

Mr Provis clears his throat. 'In all my dealings in art, I have never encountered this before. But it turns out there is a whole literature on how to combine colour to achieve the most powerful effect.' A satirical edge enters his voice. 'It promises miracles – though it does not always deliver them. There is the Roman technique for those who want to paint like Caravaggio, the early Flemish technique for those seeking to copy Van Eyck.'

The girl laughs. 'You were my greatest doubter,' she declares. 'Yet

now you are convinced.' She holds his gaze for a moment. As he nods, Mrs Tullett imagines puppet strings. 'Amid all the manuscripts that have been published,' says the girl, 'no one claims to know the precise details of the paints that Titian used, or how he used them. It is a kind of Holy Grail for today's painters.'

Her eyes blaze as she looks back to Mrs Tullett. Her face in repose is not remarkable – the skin sallow, the eyes small, the nose an upturned bird's beak. Yet now she is engaged in what she is talking about, the pale blue eyes take on a hypnotic quality – glinting like small seas in the early morning sun.

'If the manuscript is genuine, it provides a key to understanding a genius who many believe has not been surpassed to this day.'

'If the manuscript is genuine. How can you prove it is not mere forgery?'

Mrs Tullett relinquishes the girl's hands and steps back.

'I was not altogether certain – my judgement is of course not enough.'

The force of Mrs Tullett's contempt is entirely destroyed by the humble answer.

'But I have shown the manuscript to Mr Cosway,' continues Ann Jemima.

'That man is a scoundrel! I would not trust his judgement on anything.'

'Yet he is a painter of note, and he has judged that it is authentic. It is he who has urged me to show it to Mr West.'

'Whatever his motivations,' mutters Mrs Tullett.

She asks no further questions, but gestures to the girl that she should sit down at a small table on which a mirror is placed. Swiftly she deploys a regiment of hairpins, and alongside them the three ostrich feathers that will complete the headdress.

'If you truly do intend to proceed with this venture,' she says flatly, 'then we should finish dressing you now.'

The girl acquiesces. As an act of decorum Provis removes himself to his room to continue reading *The London Chronicle* while the fitting is completed.

It is a full fifteen minutes before he is summoned back into the

drawing room. 'There we are,' Mrs Tullett says as she stands back. 'Now make sure you don't catch the feathers in a chandelier.'

When he had left the two women, the two ostrich feathers already in the girl's hair were leaning over to the left as if swooning from opium. But now he has returned, he sees that the addition of the third has introduced a symmetry that for reasons he can't understand has reinvented both Ann Jemima's face and her silhouette.

'She is…' he laughs uncomfortably as the word escapes him, 'perfect.'

At the pronouncement of his verdict, Ann Jemima gets up from the table and parades in front of him triumphantly. Her high-waisted dress, in the latest fashion, swoops down over a slim figure. Indian-woven flowers climb with abandon across the muslin, while a demure pale green caraco jacket completes the ensemble. From beneath the dress, matching green kid shoes put the finishing touches to this portrait of a lady.

He, she can now see with some satisfaction, is bemused by what he sees before him. Unable to express sarcasm – the emotion with which he is most at ease – it is as though he's struggling to learn a new language to express his thoughts. When he opens his mouth next, the words are incoherent – and with a clearing of the throat he stops himself and begins again. 'I am proud to call you…' he pauses, 'my daughter.'

Mrs Tullett's scepticism briefly deserts her.

'I do not wonder that Mr Provis is proud. In truth you could have any man you want. You are quite the picture, my girl. You should marry a duke and be done with your talk of painters and gallstones.' She walks up to her and carefully adjusts a hairpin, with the precision of a sculptor putting the finishing touch to a statue. She stands back again. 'Or if you must frequent with artists, you could present yourself as a model. Look at Emma Hamilton.'

'What of her?' Ann Jemima replies.

'She started out as a maid. Then she realised she could make more money by taking her clothes off. She ended up marrying an aristocrat more than forty years her senior. Now she is the toast of Europe. I believe she understands what true cleverness is.'

Something flares in the girl's eyes, but she chooses not to respond. Instead she makes an almost imperceptible nod to Mr Provis, who disappears quickly from the room and returns with a red morocco leather briefcase. No word needs to be said for Mrs Tullett to know that it is in this that the manuscript is contained.

She picks up the remaining hairpins.

'Let us hope Mr West will prove more perspicacious than I about your discovery.'

She takes pleasure in delivering this in mordant tones – as she speaks, the pins clatter loudly into the small tin box she has brought with her. 'Maybe he will give you a couple of pounds for your troubles. It will reflect badly on him if he ridicules you to your faces.'

Provis eyes her caustically. 'In truth if he offers us no more than a couple of pounds, we will see that as ridicule,' he declares. 'We are going to ask him for five hundred.'

The seamstress's eyes become millstones.

'Five hundred pounds?' She looks towards Ann Jemima. 'Five hundred pounds?' Her voice soars into a shriek. There is a flurry in the courtyard outside, and a sense of eyes at the window. Provis swiftly moves to close the shutters.

'Surely you jest,' she says more quietly, looking furtively from one face to another.

The pair of them are silent.

Her voice trembles. 'Enough to rent a good house in London for ten years – enough to feed a family for twenty. Who in their right mind is going to pay you that amount,' she gestures to the manuscript, 'for this, no matter what is written in it?'

Provis puts on his overcoat. 'As we explained to you, this is no less than the secret technique of a genius, an extraordinary piece of scholarship,' he says calmly.

'I know little of such things, but I did not think you could pay for genius itself,' Mrs Tullett retorts.

'Genius is a more earthly quality than most will admit,' he replies. 'There are many who have not been granted the divine gift who will go to considerable lengths to be described thus.'

Mrs Tullett's mouth opens, but it cannot give birth to the angry

half-formed thoughts in her head. As Provis makes to open the door Ann Jemima goes and gets her cape. The older woman swiftly gathers her own paraphernalia together, starting to jabber under her breath. Then they are out in the cruel, cold air, making their way to where a carriage awaits Provis and Ann Jemima at the guards' entrance to the palace.

The low sun of the winter afternoon turns father and daughter into black silhouettes as they climb into the landau that will take them to Benjamin West's. For a second, it looks as if the ostrich feathers are about to fall out of place, but then Ann Jemima puts her hand to her head and the operation of entering the carriage is performed without mishap. Briefly Mr Provis looks back in Mrs Tullett's direction, yet the light means it is impossible for her to read his expression. She shakes her head as the carriage starts off, and the click of horses' hooves marks their progression inexorably into the distance.

The environs of Somerset House, December 1796

'The moon's an arrant thief,
and her pale fire she snatches from the sun.'

William Shakespeare,
Timon of Athens, Act 4, Scene 3

The full moon hangs fat-bellied over the city. In its light the new Somerset House looks like some great piece of confectionery designed by Newton. White, edibly beautiful, a miracle of geometry. Shadows so sharp you could cut yourself on them. Columns, domes, porticoes and unblinking windows standing sentry to the night.

'You are invited for a demonstration by Benjamin West,' the invitation reads. 'The gentlemen of the Academy are asked to assemble for a Discourse on the Rainbow at eight o'clock, followed by dinner at nine o'clock.'

The Somerset House clock has just struck seven. West has let himself into the great Council Room one full hour before the other painters are due to arrive. He opens the door to find it still in darkness. From an adjoining kitchen there is the clatter of knives, forks and plates being prepared for the night's great battle of the dinner table. He walks to one of the windows. As he opens the shutter,

the moonlight filters into the room, white lines scoring themselves against the black. Chairs set out for the Academy meeting fill the place with a sense of expectation.

He thinks of the figures who shortly will fill those chairs. Ghosts of his mind that soon will become flesh, in all its squabbling, vitriolic imperfection. It shocks him to acknowledge how few of his fellow artists he truly likes. He recalls with exhaustion the arguments and debates that began before this society was even founded, just five years after he first arrived in London.

The Academy was to herald a revolution – before the word became politically explosive. It would be a place of experiment, of instruction, of the introduction of new and exciting names to a public ever more voracious for novelty and acquisition. West remembers how he daily petitioned the King to agree to provide both funds and his royal approval for this society.

'The art we worship is too often by dead people, and confined to aristocrats' drawing rooms,' he had declared when he went to see him at Hampton Court. The King was sitting in the formal gardens beneath a chilly spring sky. Servants were serving coffee accompanied by plain bread and cold meat, in accordance with the King's frugal tastes. To his surprise, the King invited him to sit down. Most of their meetings to date had been conducted with West standing.

'We need to follow Hogarth's example,' West continued, encouraged by this gesture of friendliness, 'and put paintings by living artists in buildings where the great public can see them.'

He remembers how the King's fleshy lips had twitched, how a light of amused curiosity had crossed the bulbous eyes.

'Unwashed or washed?'

'Your Majesty, I do not quite comprehend.'

He felt not the twitch of anxiety that he would have these days – the King's bouts of madness had yet to commence.

'You wish that any individual should be able to attend an exhibition – be they unwashed or washed, a barrow-boy or a baron?'

'I wish yet more than this – I wish that any individual should be able to paint for an exhibition. You are a great patron of artistic

talent, Your Majesty. You will know as well as any connoisseur that art finds its disciples in all types of soil. Da Vinci was the bastard child of a peasant girl and a notary. Rembrandt was a miller's son. I want Britain to create an academy that will allow men from any background to achieve excellence. Whoever joins it, no matter what their origins, can receive the tutoring and training that will allow them to become great.'

A sharp breeze picked up, but George showed no discomfort. As West took a sip of the bitter coffee, he reflected with surprise on the King's growing warmth towards him. Both had been born in the same year, both – though neither knew it – were destined to die in the same year. As they approached the age of thirty, each was distinguished by a certain social awkwardness. Yet though only one was king, both had the arrogance to believe that the world around them could be moulded like clay into a shape that would be equally pleasing to both creator and beholder.

'You make a different case for an Academy from other artists.' The King took a large bite from a hunk of bread, and sat quietly for a moment as he chewed. 'Some,' he continued, 'like Joshua Reynolds, talk of improving painters' status in England. Others talk of rivalling the French and Italians with new standards of excellence. You talk of equality.'

West stared down to the Thames. He became aware of a long boat, a clamour of voices, bright colours, and sudden silence as the passengers realised whom they were passing. What perverse logic is urging me to talk to you of such things? he thought.

Out loud he said, 'I come from a young country where it is important that each man can make of himself what he wants.'

'In England that makes you a radical.'

'In America it does not,' West replied quietly.

The King studied him.

'You know I would have to make Joshua Reynolds president, and not you,' he eventually said. 'I find the man hard to tolerate – he talks to me as if I were a stupid child. Yet Reynolds is your senior if not your better. He suffers not from the need to be original – his portraits are modelled on those of other artists, and it is known

throughout London that assistants paint the clothes. But he can quote Plato while holding a paintbrush. And thus he is seen as a genius.'

West dipped his head, and smiled.

'I had no expectation of being President. I know that I suffer too much from the vice of originality.'

'You are also a foreigner and an outsider.'

'Just like your grandfather, Your Majesty.'

The bulbous eyes glimmered.

'The art world is as closely ranked as any of the tribes I have encountered in America,' West continued. 'I recognise that though I have been here some years, many believe I am not fully initiated. I am not fool enough to wrestle with their ambition.'

In the dark, almost thirty years later, his eyes are torn towards the giant plaster cast of Laocoön that looms at the back of the room. Its whiteness is just discernible in the dark, yet West has sketched it so often that he can see its details as clearly as if it were daylight. A man in agony wrestles for eternity in the grip of serpents, his face turned to the sky, his muscular body contorted with pain. One son is on either side of him, both trapped in the serpents' coils.

'I lied then – I was always fool enough,' he whispers. 'And now I have been made President, I have discovered my foolishness.' He thinks of how the King's attitude to him has changed since that time. Following American Independence the rare and remarkable intimacy between them has died. Now that George is marked by madness and political failure, West never knows in what mood he will be on those rare occasions when he receives him.

In the room next door there is a sound of crashing and shouting. A servant rushes into the darkened room where West is sitting, only to exclaim loudly as he lights the first oil lamp and sees the President sitting there.

'My apologies,' says West quietly.

'Shall I put out the light?' The servant has thin anxious lips and darting eyes – as he starts backwards, his face is all consternation.

West laughs wryly, and stands up. 'Please do not worry – you can continue. I am expecting the first arrival imminently.'

The servant falters. 'And are the instructions right? That you want the lights to be on till all the artists arrive, and then you wish them to be extinguished?'

'That is right.'

There is a sense of words being swallowed. But the servant does not see fit to offer more questions, nor West to answer them. The young man continues to make his agitated progress round the room, lifting the cylindrical glass covers to light the lamps. Slowly the room is shown in its entirety. Laocoön's full agony is revealed behind dining tables that are arranged in a horseshoe shape. West observes afresh how he has grasped one of the snakes that is trying to kill him, hopelessly fighting back against his fate.

He looks back out of the window. 'At least there are no clouds tonight. The experiment should work well.' He picks up a leather case, walks and places it on a desk with a tabletop easel. Then he lifts the lid and surveys the three-sided piece of glass contained within it. Cautiously he takes it out and holds it up towards the window. As he gazes at it he becomes deaf to the noises around him – the continued clatter of cutlery, the metallic slap of lids on pans, and the light thud of the servant's footsteps that eventually retreat to leave him alone again.

Henry Fuseli – one of the artists due to attend West's talk – walks to the window of a private dining room in a City tavern and looks up to the sky. The moon filters through his distinctive white hair, which surges from his scalp like thistle seed. He turns his gaze down to Fleet Street, to the revellers descending from carriages and lone walkers stumbling through the cobbles. Any shreds of sound from outside are eclipsed by the drunken roar coming from within the tavern itself.

'There will be an army of mad people out tonight,' he declares in a strong Swiss-German accent. 'This is the kind of moon that conjures up werewolves, and sets old crones singing to their gin bottles.'

He turns to regard his companion, Joseph Johnson, who sits staring at his wine goblet as if he is haunted by it.

'London feels perpetually in the grip of the moon these days,' Johnson replies. He looks towards Fuseli. 'But I do not fear were-wolves. I reserve my worries for the men who work for Mr Pitt.'

'You tease me for my fascination with the irrational.'

A brief smile flits across Johnson's lips.

'You are a rationalist fascinated with the dark creatures of our minds. No painter has ever before tried to capture this aspect of who we are. So I salute you for your spirit of experiment.' He pauses. 'But if you'll forgive me, right now our Prime Minister seems more sinister.'

Fuseli's eyes catch light, his laugh has a dangerous edge to it.

'I despise the man as you do, but we are not going to say farewell to him any time soon. His victory in this year's election has left the opposition with no more power than a mewling pup.'

'Yet Pitt still fears the people.'

'The people are fickle. That is a huge part of their power. With subversives like yourself on the loose, who knows what may happen?'

'Please do not tease me.'

Fuseli surveys the face regimented with straight lines – as if to denote the measured aspect of Johnson's personality – the hollows in the cheeks, the long thin nose.

'Chide me not, Joseph. I remember all too well what it is like to be persecuted.'

Johnson's gaze relents. 'I know you do.'

'I am not so brave as you. I simply accused a corrupt Swiss magis-trate – you and the writers you publish accuse whole governments.'

'Yet for your accusations you were forced to flee your country.'

Fuseli looks at him searchingly.

'Some might say that was a fortunate outcome.'

Swiftly he walks across the room and kisses Johnson full on the mouth. For a moment Johnson responds passionately. Then he pushes him violently away.

'You cannot do that here.' His eyes blaze savagely, as he steps backwards. His goblet falls over, and wine eddies its way onto the

floor covered with sawdust. 'Pitt has reasons enough for arresting me,' he says, swiftly righting the goblet. 'Do you desire to send me to the gallows, man?'

His head flicks anxiously towards the door of the private dining room, as if suddenly expecting to see accusers standing there. But there is no one, nor is there any foot on the stair. He breathes more slowly.

'I will always…' His eyes say the rest. 'But we agreed…' He grits his teeth. 'We agreed that we would imperil ourselves no longer. Besides, you are married…'

Fuseli starts to whistle.

'Let us have a little more wine.'

Before Johnson can stop him he walks out of the room and hollers down the stairs. As the footsteps come running, he turns in the doorway and regards his companion.

'You know I would never put you in danger.'

Johnson is silent.

A boy with an impudent, slightly dirty face stands at the door.

'A flagon of Chateaubriand, if you will.'

The boy disappears. Fuseli walks back towards Johnson, who flinches. Fuseli holds up his hand in acquiescence, and takes his seat at the other side of the table.

'I must depart before too long.' Fuseli drains his glass. 'I promised Mr West I would arrive at the Academy early. He wishes to consult me in private about whether he should buy a document that has been brought to him by a young female artist. Her father works at St James's Palace.'

Johnson takes a deep breath as he regards him warily.

'He trusts you greatly, does he not?'

'In matters of the intellect, I am both trustworthy and discreet.'

The room is taut with Johnson's unspoken response.

'I am also more sceptical on such matters than many of those who surround him. I believe he wants to consult me because he knows I shall advise him not to buy the document,' Fuseli continues. 'It appears to promise miracles. I have seen many similar works, and I wouldn't give a farthing for any of them.'

Johnson taps his fingers impatiently.

'Henry, how many of the artists at the Academy are like us?'

'In what sense?' The question is meant to provoke.

'I mean politically,' Johnson replies with irritation.

'There are artists of all political persuasions, though most are fonder of our Leader of the Opposition, Charles Fox, than Mr Pitt.'

Johnson nods as if some theory has been confirmed.

'It is one of the great contradictions of the Academy,' continues Fuseli. 'Without the King's funding and benevolence, many of us would struggle to hold body and soul together. The revolution in France excited us. But you will find few of us arguing for regicide, including myself.'

They stare at each other for a moment. The door opens to the dining room again, and the boy walks in briskly to place the flagon on the table. Fuseli pays him, before filling both goblets to the brim.

'Let us drink these in one. Invoke the spirit of Epicurus,' he declares.

'If we invoke the spirit of Epicurus, we believe that tomorrow we die,' responds Johnson drily.

'A coward dies a thousand deaths...'

'Yet neither of us is a coward.'

Fuseli walks to the window.

'Let us simply drink and be merry.' But his voice is low and serious. He turns. 'Then walk with me to the Academy. Let us teach bravery and truth to the werewolves.'

He raises his goblet and downs it. Johnson hesitates.

'I will walk with you briefly.' He pushes his goblet aside untouched and stands up.

'Please?' Fuseli stares at the goblet. Reluctantly Johnson picks it up. He holds it out. 'To the downfall of Pitt.'

Fuseli nods.

'That is as good a toast as any.'

A sound of singing and stamping rises up from the room below them. As Johnson drinks, the empty flagon shakes on the table.

• • •

John Opie stares down at the Thames and shivers. He can hear his father's voice in his head. 'You'll end up on the gallows.' Blue eyes raw with rage, mouth trembling. 'An artist is of no use to anyone.'

Of all the perversions that a Cornish carpenter's son could have manifested, an inclination towards art was the worst. It went hand in hand with idleness, the most despicable of the deadly sins. Now imagining his father's face, John can see the large nose, the acute hollows in the cheeks, the eyebrows thick with disapproval. The hair on his head long gone, as if burnt off by his perpetual industry. 'Your journey to London will take you straight to hell,' he had shouted. Opie thought he had proved him wrong, but the most recent year of his life has killed this conviction.

Down below him the river Thames laps black against its banks, the path of moonlight like a slash of white paint on its surface. Shoals of secrets swimming below. Shudders of forgotten suicides; connivings of thieves; ecstatic ululations of forbidden lovers. His imagination flies ahead of him into the darkness, down towards the Pool of London. Now it is full of ships whose stillness makes them phantoms, but in the day their comings and goings trace the precarious lines of George III's empire.

Not for the first time he curses the day that Dr Pindar arrived in his village. Opie had been just fifteen. Pindar was a corpulent man with a ruddy demeanour and a nose that shone perpetually as if it had been greased. Through brown teeth he barked stories about Michelangelo, Durer, and Giorgione. At first the people of Trevellas laughed at him, but then he became better known for his power to hypnotise a room with his tales and observations. Only the very perceptive could see how the ugliness masked a grotesque vanity, how the flamboyantly displayed knowledge was a shoddy patchwork of fiction and fact.

Yet Pindar's years of posturing had offered him at least one glimmer of perception. After seeing Opie's paintings at a patient's house in Trevellas, he was persuaded that the boy's talents were wasted in a small village. First he offered the boy tuition, then he

offered him a new life. Five years later, as Opie's father issued his damnations, the pair set off to London to launch the boy as 'The Cornish Wonder.'

'I was nothing more than a pawn in his game,' Opie thinks wretchedly. He had suspected this to be the case from the start. But the lure of London made him ignore his worries, and once they arrived he had quickly found himself surrounded by admirers. Sir Joshua Reynolds himself had hailed him as the new Caravaggio. Soon Pindar had organised an introduction to the King. As a child Opie had demonstrated a remarkable intellect, mastering Euclid by twelve and quoting Newton on Natural Philosophy by the age of fourteen. But Pindar was far too cunning to let this detract from his protégé's allure. He spread the rumour that Opie had never read a book or had a painting lesson in his life, that he was talent rough-hewn from Cornish stone. The device worked perfectly.

Soon Opie's rooms at Orange Court were filled with every specimen of love token that the city had to offer. Miniature portraits, ribbons, scent bottles – a shameless treasury of engraved coins. Opie quickly discovered how an arch smile could lead to a flash of nipple, how a chaste whisper could precede a full seduction. London had always danced in his mind as a place of opportunity, yet he had never imagined such an orgy of flesh. He did not suffer from physical vanity – did not comprehend how with his dark hair, long patrician nose and the somewhat insolent set of his mouth, he would have had female disciples if he had possessed but half his talent. Nor did he understand that wielding axes and hauling around large pieces of wood in his father's workshop had given him an enviable physique. 'Able to snap some of the fops of London in half with a mere glance,' whispered one virgin as she thrust her hand inside his breeches.

Pindar kept reminding him that the more that duchesses and their daughters exposed their flesh in his studios, the more the commissions he needed to survive in London were assured. This was all the inducement that Opie needed. He was haunted by his father's scorn. The chief vow that he had made to himself when he left home was that he would not satisfy his family by ending up in a debtors' jail. On the days when self-disgust mocked him, when

his mind numbly counted his seductions in the way that a Catholic monk might count his rosary beads, he still gave thanks that at least, so far, he had escaped the gutter.

Yet life continued like a cartwheel rattling down a slope, faster and faster, the debris flying everywhere. Some kind of collision seemed inevitable, and it had come a week ago when he returned early to his apartment. Foxes screamed in the alleyway as he approached. The noise jarred and shredded at his thoughts, so it was only when he was on the point of entering that he realised the front door had been left ajar.

Fear tightened the back of his neck. As he entered warily, expecting burglars, a scuffling surged out of the dark. Opie realised he had no weapon with which to take them on. His hands were shaking, but he quickly gained enough composure to dart outside and seize a loose rock from the road, large enough to inflict damage in a fight. It weighed cold and heavy against his fingers – with the other hand he reached to take the lamp hanging on a hook next to the apartment entrance.

He entered again. The noise was coming from his studio – a realisation that further spiked his rage. His lamp cast a queasy yellow light as he went to open the door. He readied himself for the fight, and raised the stone. But then the images started to crash against his mind like a flock of birds trapped in a small room. The curve of a woman's naked breast, a pair of walnut buttocks, flapping sheets, sheer locks of blond hair, hands in the air, faces leached of expression. And all the while sounds of shouting that he initially thought were coming from his mouth, but seemed to be coming more loudly from the other side of the room.

As he fought to make sense of the confusion, time froze, then shattered. The buttocks, he realised with a lurch of disgust, were Pindar's. An entirely separate body, now hastily being wrapped in a sheet, was that of a much feted society beauty. She was trying not to look at Opie, but her eyes juddered towards him as if drawn by a magnet. As they looked at each other Opie felt the sour tang of disbelief.

Whenever he thought of the expression on her face in the days

47

immediately afterwards, he would not be able to rid himself of the image of Pindar's obscene anatomy. The grotesque swell of the belly, the forest of hair erupting from ruddy flesh, the Priapic tilt of the large dripping cock. And the woman, that woman whose guilty gaze fixed him to the spot. Opie had spent weeks tracing her lustrous curves and the pearly white hue of her skin both on canvas and in his mind.

Her name was Elizabeth Delfton, and her father was the richest man in Lincolnshire. He had commissioned Opie to do a portrait celebrating her modest and virginal qualities. It had taken him a fortnight to persuade her that as well as the clothed version for her father, he might also paint her naked. The sense of victory when she agreed was one of the sweetest he had ever tasted, and that same evening he had confided to Pindar that he was in love.

But now love lay ripped and ruined across his apartment. His great friend and confidante was his chief betrayer, and his lover's virtue worth no more than a counterfeit guinea. The unwelcome truth tore through his mind like a hurricane. His lamp dropped to the floor and they were in darkness again. By the time he had lit it again, Pindar and Miss Delfton had disappeared.

He is brought back to the present by a drunk lurching towards him – the pale face leers and gurns before retreating into the senseless night. Opie looks down into the dark waters of the Thames again. His shivering is becoming uncontrollable – the wind seems to pierce his skin, and runs malignantly through every bone in his body. He cannot delay for much longer his entry into human society this evening. Wrapping his cape around him, he turns his back on the river, and walks across the terrace towards the Royal Academy.

The Royal Academy, December 1796

'Even Light it self, which everything displays,
Shone undiscover'd, till his brighter Mind
Untwisted all the shining Robe of Day;
And from the whitening, undistinguish'd Blaze,
Collecting every Ray into his Kind,
To the charm'd Eye educ'd the gorgeous Train
Of Parent-Colours. First the flaming Red
Sprung vivid forth; the tawny Orange next;
And then delicious Yellow; by whose Side
Fell the kind Beams of all-refreshing Green.
Then the pure Blue that swells autumnal Skies
Aetherial play'd; and then of sadder Hue
Emerg'd the deepen'd Indico, as when
The heavy-skirted Evening droops with Frost.
While the last Gleanings of refracted Light
Dy'd in the fainting Violet away.'

James Thomson,
'A Poem Sacred to the Memory of Isaac Newton', 1727

It takes just a couple of minutes for Opie to walk across Somerset House courtyard and arrive at the entrance hall of the Academy. Inside, oil-lamps give the busts of Newton and Michelangelo the

human glow he feels he lacks. As he walks up the geometric stair-case, he smiles briefly as he remembers a ripped sketch for a cartoon being passed round a couple of nights ago in a coffee house. In it society ladies tumbled down the staircase, bottoms exposed and petticoats flying, as old men squinted lecherously at the view.

As he reaches the first floor, a footman greets him and removes his cape before opening the door to the great Council Room. The action makes him feel strangely naked. He fights the urge to turn and run back down the stairs. In front of him extends the horse-shoe table around which twenty artists from the Royal Academy are seated. All are engaged in private conversation, yet suddenly he feels under scrutiny.

'My dear Opie – what ails you!' cries a voice. Opie looks with irrit-ation to see the artist Joseph Farington. Farington's curiosity crawls over other humans like a colony of ants, he reflects. Sometimes it feels harmless, at others as if it is whittling the flesh from your bones.

He takes a deep breath.

'My patron is trying to ruin me,' he replies, as he walks over and sinks into the chair next to Farington. 'He is a phallus on legs, an obscene Priapus, a swollen cock of the farmyard.'

'A Madeira for Mr Opie, please.' Farington beckons to a foot-man holding a tray of glasses. He turns back to Opie. 'It sounds as if matters have become quite unpleasant.'

Beneath his carefully tended crop of white hair, Farington's ruddy visage burns – it would be wrong to say with pleasure. But his expression suggests he is less distressed than his words imply. His domed, white forehead takes on an almost celestial glow, while thick dark eyebrows sit like leeches above his darting eyes.

'What crime has he committed now?'

Opie laughs blackly.

'What he has done cannot be repeated in polite company. I dream of ridding myself of him,' here he takes a sip of Madeira before starting to laugh almost uncontrollably, and Farington looks with concern at those sitting around them.

Opie contains himself. 'I thought I had met the woman I was going to marry.' He realises he is almost spitting the words out. 'Yet

Pindar has bedded her. I cannot work with him, yet he tells me I will be nothing if I do not work with him. I am in purgatory.'

He becomes aware of the long-limbed presence of Robert Smirke. As ever, he is sitting – hand resting on his cane – at Farington's side. Smirke's gravitas and sedately curled hair give him the aura of the kind of Caesar who would neither commit incest with his sister nor fiddle while Rome burned.

'I am most sorry to be apprised of your news,' he says drily. 'I knew your patron was troublesome, but I had not appreciated to what degree. What is the woman's name?'

'Elizabeth Delfton,' Opie replies shortly. 'I have been painting her these three months past.'

Smirke's eyes meet briefly with Farington's.

'Will your patron truly ruin you if you take recourse?'

'Pindar writes doggerel that he describes as satire. You and Mr Smirke are too sophisticated to be among his readers. But there are hundreds – some might say thousands – who think him amusing. If he writes an insulting verse in the morning, it can be distributed by pamphlet so that half of London is reading it by the afternoon. As long as he salts it with enough wit, no one is concerned with discerning fantasy from fact.'

Farington shakes his head. 'I have not read Mr Pindar, but I have read some of the attacks on him by rivals.'

Opie looks at him darkly.

'Pindar is hated,' he replies, 'yet it is all fuel to the fire of his self-importance. Nothing can shame him as long as he is shaming others.'

Smirke is quiet for a moment.

'I saw you coming across the courtyard from the Thames,' he says eventually. 'I trust you were not thinking of jumping into it.'

Farington shakes his head violently, as if he hopes through this action to dismiss the words his friend has just said. But though his tone is light Smirke's gaze in Opie's direction is steady. Opie frowns.

'Be not mistaken. I have no intention of committing suicide…' he begins.

'No, no, no, I am sure that is not what Mr Smirke meant,' interjects Farington.

Opie looks at Smirke, who maintains his gaze.

'I am pleased.' Smirke's tone slices the air uncomfortably. 'Mr Pindar may be making your life wretched, but there are many who prize your existence over his. It would not be worth ending your life because your pride has received a bruising.'

Opie thinks back to the black waters of the river. He shudders as he imagines their cold embrace.

'That was not my intention,' he declares with more rage than he has intended. Seeing the alarm in Farington's eyes, he softens his tone. 'Maybe it is my patron who should be plunged into the Thames – then the trouble would be at an end for all of us.'

Finally Smirke smiles. He gets up, puts a hand on Opie's shoulder, then turns to a group of men behind them. Opie becomes more conscious of the dip and rise of other voices in the room – a great smudge of sound as the artists of the Academy wait for the evening's lecture to start. He looks around. Many of the men here have sweated their way up from humble beginnings. One the son of a bankrupt, another a political exile, another with an innkeeper for a father. All have achieved their fame after long, lonely hours in the studio. All know what it is to rise in the early hours of freezing winter mornings to paint with numb fingers, or to ignore the call of the outdoors when the sun is dancing outside the window. All know what it is like, despite those efforts, to be devoured and spat out by the London critics. A litany of solitude, self-doubt, and ridicule – that, to him, is the lot of the striving artist. And now they have achieved success, each would fight to the death to be considered infinitely better than anyone else in the room.

We proclaim that we are a fellowship, yet we are in eternal combat, he thinks, staring at the two men sat across the table from him. Together the pair look like an illustration of youth and age. The former, Richard Westall, is sketched in ink and blood with curly black hair and a sensuous red mouth. The latter, John Rigaud, is a more solid proposition, his tombstone slab of forehead overhung by the tendrils of a powdered wig.

A clinking on a glass at the top of the table silences the room. Benjamin West stands up. 'Now we are all here,' he declares,

looking round at the gathering of artists, 'shall we commence the demonstration?'

As Opie stares at West, he is aware that the latter's face is starting to disappear. In response to the President of the Academy's words, footmen have started to extinguish the oil lamps. Swiftly Opie moves up to West's end of the room as the shutters are secured over the windows.

'What have we here?' he exclaims to Farington, who has followed him. 'A séance for my reputation?'

'No, he intends to murder us all,' murmurs Westall, who has come round to their side of the table. 'It's the only way he has a hope of winning the greatest acclaim at next year's exhibition.'

Laughter in the encroaching darkness. Opie takes another sip of his Madeira. Now he cannot see it, he feels more clearly the amber colour of the drink as it runs down his throat.

'I will not keep you in the dark much longer, gentlemen,' comes West's voice.

A few guffaws, though he can sense the masks of contempt on the other men's faces. Even those who respect West cannot pretend he is a good public speaker. The jokes tend to be leaden, the delivery stumbling. Yet the darkness has a stilling effect, and the mixture of condescension and forced amusement is steadily being replaced by an air of expectation.

After a few moments one of the shutters is opened and replaced with a board with a hole in it. A thin shaft of moonlight pierces the darkness next to where West is standing.

'We have all studied Newton's *Opticks*,' comes his voice. 'We bow to his genius in proving that white light is composed of different colours. I have been thinking recently about what the structure we see in the arrangement of these colours teaches us as artists.'

He is just visible behind the shaft of moonlight. Now he takes the large prism from the leather case in front of him on the table, and holds it so that the rays of the moon shine through it.

A murmur goes up. The artists are able to observe a small rainbow gleaming in the dark. Its colours are not as bright as those

that Opie has seen in more common demonstrations of prismatic colour involving the sun. There is something simultaneously more concentrated and more ghostly about them. All sense of ridicule has now completely vanished. The entire company – the speaker included – seem hypnotised by what they see before them.

'As we know, the refracted light is strongest at the top of a rainbow. Here it shines out in red, orange, yellow,' continues West. 'As the angle of light diverges more from that of the original beam, so the shades become more muted – we pass to green, violet, and blue. I have been thinking about how we can reflect this in the practice of history painting.' He picks up the glass of water next to him, and takes a sip. 'We structure our paintings through chiaroscuro,' he continues, 'through the contrast of light and shade. By studying the rainbow we can enhance this structure through colour. Those aspects of the picture we wish to make most prominent – those onto which, in a sense, we want to shine the most direct light, we can tint with the primary shades of the rainbow: red, yellow, orange. Those aspects which are less significant we can pick out in greens, violets, and blues, which complement the brighter shades without detracting from them.'

He pauses for a moment, allowing them to take in his words.

'Rubens in particular is a master of this,' he continues. 'He uses it to show what is significant and what is not, making it the rule that governs all his great historical paintings. I want you to hold the image of the rainbow in your minds before we move to the next part of my demonstration.'

Two argand oil lamps are lit. Under the influence of their glare, the moonbeam and with it the rainbow disappears. Between the lamps stand a covered picture. As one attendant removes the prism, another removes the cloth, to reveal Rubens's *Flight Into Egypt*.

There are a few gasps. 'Good god, this is very interesting,' comes Farington's voice.

Opie merely stares.

'I hope you can see now, gentlemen, why I chose to give you this demonstration by moonlight rather than during the light of day,' says West.

His voice carries on, but for Opie there is no more need for words. He has always loved this picture for its sense of stealth and mystery, the muscled angels in the dark bringing a sense of the danger of divinity. Now he looks at it to see how the different levels of emotion bleed into the colours. On the canvas the moon appears as a crescent, twice – once in a limpid grey-blue sky, once reflected in the water below it. To its left the huddled trees create a looming black mass that provided the backdrop to Mary and Jesus on a donkey, accompanied by Joseph on one side, and the angels on the other. What is extraordinary, following West's demonstration, is how clear the use of prismatic colours is in shaping the way the Holy Family is presented. Science and emotion are balanced perfectly. Mary – as always the emotional focus of the picture – wears a dress of deep brilliant red. Her face, and that of the infant who she holds closely to her breast, are painted in a golden yellow light, so luminous that they outshine the moon, while Joseph, his face turned away from the onlooker, is clad in a rich tawny orange. The strongest colours of the rainbow having been used to establish the heart of the painting's story, Rubens has made his modulations in pale blues – for the Virgin's headdress – and muted browns, for the downward bent head of the donkey. The rest is in blackness.

West seems to be speaking more fluently than usual this evening, and his enthusiasm has spread like a contagion through the room. As the lights are lit again and he concludes, 'I would like to invite your comments,' there is an eruption of sound.

'Mr West, Mr West,' calls one voice particularly loudly.

Mr West turns towards his speaker with a smile, but when he sees who he is, he looks as repelled as if he were being addressed by a pile of dog excrement. There stands James Barry, an Irish painter with a face soured by perpetual discontent – the man who is by far the most prominent of his critics.

'Mr West, this is indeed an interesting theory, and you have presented it well. But why do we let ourselves be seduced by colour over and over again? For all your claims tonight about its contribution to structure, it is like the paint on a harlot's face – it draws us in, without giving us any sense of the body beneath it.'

A few of the men in the room laugh, but the comment is greeted by the majority with a roar. Opie takes a deep breath.

'Maybe Mr Barry has more experience with harlots than the rest of us,' he declares equally loudly.

He well knows the statement to be untrue, but he speaks with the intention to maim, and he succeeds – a little too well.

'That is not what your patron claims,' shouts Barry back across the table.

Opie's intention to maim shifts to the desire to mortally wound. 'Let me finish, Mr Barry, you trade too greatly on what you mistakenly apprehend to be an easy target.'

Around them the whole room goes quiet. Opie feels a strange sense of calm descending. Despite his early signs of genius, he has not had the elite schooling of many around him. But years of associating with educated fools has shown him the advantage of simply speaking his mind.

'Just because colour delights doesn't mean that it deceives. Different colours can stir us in different ways – and I will concede to you, Mr Barry, that certain shades, like red and gold, are more seductive than others. But in the hands of painters of true talent – like the Venetians, like Rubens – they are not strumpets' tools, but a device for unlocking our hearts. Mr West's demonstration is one way of trying to understand why these colours strike us at such a profound level, and a demonstration of how they contribute to a painting's structure. Of course you can only perceive this if you have the sensibility to do so. If that sensibility has been blunted by greater knowledge of the whorehouse than of love, then there is no hope for you.'

A loud clinking of glasses round the table and guttural laughter indicates that his point has hit home. Barry seizes his own glass as if he is about to use it as a weapon, but after a few glowering moments decides to hurl the drink down his own throat, before getting up and leaving.

• • •

'The love of the strumpet as opposed to true love?' declares Richard Westall. His wiry frame slips unceremoniously into the seat next to Opie at the meal after the discussion. 'What flatulent nonsense is this?'

Around them servants have set the table with plates of roast beef, fine green beans, and crystal glasses glinting with different hues of alcohol. Opie laughs.

'I concede the merits of true love can be praised too greatly. It has certainly caused me nothing but pain recently.'

'Our debates on colour always provoke strong passions, but this has proved by far the most animated,' says Smirke, lowering himself elegantly into the seat on the other side of Opie. The silver greyhound's head of his cane gleams in the candlelight as he leans it against the table. 'I was convinced Barry was going to strike you.'

'Indeed, it could have been the first time that blood was shed at an Academy meeting,' says Farington, making up their four. 'I thought both you and Mr West spoke rather well tonight.' He pulls in his chair and spears a bean with his fork.

'There will be other opportunities for bloodshed soon, I am sure,' declares Westall, raising his glass. A muscle flickered in Farington's cheek, while Smirke coughs quietly.

Opie looks at all three of them quickly.

'I comprehend not your meaning, gentlemen,' he declares.

'I shall state it plainly then,' says Westall.

Smirke flips open the top of his cane and takes a pinch of snuff.

'Barry may be Mr West's most crude opponent,' Westall continues, 'but he is not the only one. I believe it is time for us to rid ourselves of Benjamin West as our president.'

Farington shakes his head and raps his hand on the table. Westall waves his finger. 'Mr Farington, you know I speak truth; do not try to rebuke me. The first president of this Academy was Sir Joshua Reynolds. Though he has been dead these past four years, most believe there to be more talent in his decomposing cock than there is in West's entire body.'

Farington's anger sucks his cheeks in – he looks like a pig's bladder that has suddenly been deprived of air. In some triumph, Westall

beckons to the footman to renew Opie's glass, while he swigs from a flask he has brought with him.

'Mr Westall – your disregard for Mr West has long been noted,' Mr Farington finally says.

'Oh, come, come.' Westall's eyes flare. 'I am far from alone in my doubts. He is ambitious and vain, yet to my mind has not the ability to justify either attitude. There are several men in this room who think they would make a better President, and we all know it. Including yourself, Mr Farington. Do I speak truth, or do I not?'

He takes another swig from his flask. Opie suddenly realises that it contains laudanum. Though Westall appears drunk, his pupils are constricted, while the expression on his face suggests the swerves and loops of a faintly disorientated mind. Yet his sharpness has not deserted him. As Farington fights to assume the right expression before making his reply, Opie can see the vulturish ambition flare in his eyes.

'Surely it is for our King to make such a decision,' he eventually says.

'However long he may last,' retorts Westall. 'It must be of great comfort to Mr West that his patron is a madman who pisses blue urine.'

For a second the older man's glance whispers towards the laudanum flask before looking back to Opie, who nods in answer to the silent question.

'The King does not favour West as much as he did,' says Smirke quietly. 'They say the Queen is mortified that West, because of their friendship, has witnessed him during his worst bouts of madness. She has urged the King to keep him at a distance. Have you not noticed how rarely West is invited to St James's Palace these days?'

Suddenly Opie feels weary. The endless suck and surge of the Academy's power games give him little pleasure. Whoever emerges triumphant only seems to do so for a few months before being sucked back down into a whirlpool of envy.

He regards Westall and Smirke impatiently. 'I must confess it concerns me little whether or not Mr West keeps his position as President,' he declares. 'With power comes responsibility, and with

responsibility comes less time to paint. He has travelled and read as much as most men might do in three lifetimes. I do not begrudge him this presidency if he is foolish enough to want it.'

'He may have read three times as much as most men, yet somehow he has learnt a fraction of what he is supposed to,' says Smirke drily.

'I am relieved I am not subject to such scrutiny.' Opie's smile is flinty. 'He has made at least one significant innovation in art, and that is more than most round this table can say.'

'But this Academy was founded to promote excellence,' retorts Smirke. A pause follows his statement. 'What we achieve is down to individual merit,' he continues. 'Yet I believe it does not help our younger artists when they look for guidance and inspiration and see a President who, if not the Joker in the pack, is certainly not the Ace.'

Opie stares at him. 'I refuse to participate in making West a scapegoat.'

'Gentlemen, gentlemen.' Farington's eyes blaze.

Opie takes a deep breath.

'Forgive me.' He rises. 'I know all too well what it is like to have your name destroyed for no good reason. I take no pleasure in inflicting the same torture on another man.'

He turns to leave, and Smirke jumps up.

'You have scarcely touched your food, Mr Opie.' His tone is apologetic. 'Please stay – there are more entertaining topics with which we could divert you.'

'I have little doubt of that, Mr Smirke.' Opie bows. Believe me, I have already been amply diverted. I was invited earlier today to a session of poker on Fleet Street. I was not going to attend, but I prefer playing cards to playing with men's reputations. I thank you,' he concludes wryly, 'for your most stimulating company.'

He dips his head and hurries towards the ante-chamber. As he looks round, he realises Farington is following him.

'Please, Mr Farington, there is nothing you can say that will detain me,' he declares.

'That was not my intent. I commend you for refusing to denounce Mr West without evidence.'

Opie pauses wearily. He is all too used to Farington appearing to express one point of view while seeking to put forward another.

'Westall is hysterical,' the older man continues. 'Yet there are more serious matters at hand here. West has made several mistakes over the last year in the administration of Academy matters. I believe it will take just one more transgression on his part for his resignation to be unavoidable.'

'Well let us hope he does not make that transgression.'

'Mr Opie,' Farington's voice takes on an urgent note. 'We must be practical. Who will you support to be President if...'

'No, Mr Farington. I will have no more of this. Forgive me, I must be gone.'

He continues rapidly to where a footman is waiting with his cape. As he puts it on, it strikes him that while earlier this evening it has felt like a dead weight on his shoulders, now it feels weightless, as if rendered so by his relief at escaping the Academy's cloying intrigues. His feet whir down the spiral staircase before walking him out into the Aldwych. There two link-boys who carry lamps for night-revellers – deprived of their livelihood that night by the brightness of the moon – are fighting and scrapping while five other boys cheer them on.

He watches for a moment, then, whistling, throws them a handful of pennies, enjoying their look of confusion as the dull metal clatters on the stones around them. The fight stops, one of the boys flings himself to his knees to see what has caused the noise, and then the cry of astonishment sheers into the air. Opie laughs to himself as the seven boys become one animal, a scramble of limbs on the ground frantically foraging for the money. For a brief moment one of the boys detaches himself from the frenzy and yells towards Opie. But before he can engage him further, Opie turns briskly on his heel and sets off through the moon-quietened streets in the direction of St Paul's Churchyard.

A walk through St James's Park, December 1796

'[She] has a most remarkable, and for a woman unheard-of, talent; one must see and value what she does and not what she leaves undone. There is much to learn from her, particularly as to work, for what she affects is really marvellous.'

Johann Wolfgang von Goethe,
on the Georgian artist Angelica Kauffman

Ann Jemima steps hurriedly into Green Cloth Court from Mr Provis's apartment and surveys her surroundings with impatience. She feels around her the clack and flurry of the palace as it stirs into action for the day: heels ticking across stone courtyards, bellowed orders coming from windows. When she first arrived, she often sensed that just stepping outside the front door was to become part of some elaborate board game where she did not yet know the rules. Beneath the palace refinement it felt as if the court insiders were observing her, waiting for her to make a false move that would let them dissect her with silver knives and distribute her in the streets around St James's.

In those days she would often wake in the morning feeling as if she were inhabiting someone else's body entirely. The sounds around

her, the way the furniture was arranged in her room, the angle at which the light filtered through the window – all seemed different from the way they should be. She would close her eyes again, waiting to hear the shriek of swallows that had once nested above her bedroom, and the music of voices that were long gone. She would hope that when she opened her eyes once more the walls would be cream-coloured and not deep green, and that the old oak dressing table that had belonged both to her grandmother and her mother would be standing there.

The coach that had brought her to live in London had felt as if it was abducting her from her childhood. The raw joy of extreme youth – running through frost-spiked fields, stealing seedcake from the baker, paddling in streams on mornings ablaze with light and birdsong – that had all been brushed away forever. Even before she had arrived in this city, she had perceived that the journey from girlhood to womanhood was as much about forgetting as about learning. Forgetting about running wild and free, forgetting about saying what you felt. Gradually putting the body in a cage, and training the mind so that it appeared to walk the pathways of conformity.

Then the chasm opened up beneath her. Smallpox killed first her grandmother, and then – it seemed – everyone else that she loved. She will never forget the January day three years ago when even the extreme cold could not numb her pain. An archway formed by yew trees to one side, rows of tombs huddled like grey beggars on another. Two gashes in the ground, and the coffin bearers, eyes fixed and expressionless as if they themselves were walking corpses. She wanted to smash open the coffins and haul the dead back into the living world. Wanted to shout that this was not real – how could a person 'be' one moment and 'not be' the next? Wanted to rage at the skies for their injustice. But instead she watched the coffins being dropped into frozen ground, dimly heard the choked condolences echoing in her disbelieving ears.

The coach that abducted her from her childhood could never outpace those memories. They clung like cobwebs to the wheels before rampaging through the windows and weaving themselves tightly around her heart. In those brief moments after waking in

London, her desolation would be all encompassing. She would feel as if the air were being sucked out of the room, and the sound of a bird's wings beating against glass would fill her head. Gasping, she would open her eyes, drinking in the morning light like air as she fiercely chastised herself, banishing her tears as she addressed the new day.

Those who watched her at court would never have guessed at the raw wounds of her grief. To most, it appeared to take surprisingly little time for Thomas Provis's estranged daughter to be at ease at the palace. Swiftly she absorbed the court's secret codes and languages. Learnt the titles in all their strange variety – the Gentlemen Ushers, the Embellishers, the Keeper of the Lions, Black Rod. Through Mrs Tullett, she has also mastered the court's darker knowledge – the women, of both high and low rank, who have had abortions, the equerries who are concealing symptoms of syphilis, the footman with a predilection for choirboys. She has grown to understand how the court's grand ceremonies are not so much a proclamation of greatness as a gilded screen for all of humanity's imperfections.

She sees all this around her, yet at the same time looks beyond it. Today, now she has shaken off the unhappiness of the morning, her preoccupation is with what awaits her outside the palace. She is dressed distinctively in a crumpled silk cape the colour of burnt umber – from the matching embroidered bag that she carries a cluster of paintbrushes can be seen to protrude. Her step conveys her impatience and purpose. As she approaches the palace side-entrance where the sentry stands on duty in his box, she speeds up like a prisoner kept for months in a cell who has just seen a first glimpse of daylight.

'Miss Provis!'

Her instinct at first is to ignore the voice. Her pace wavers slightly, as if she has stumbled on a small object, but then she continues without looking back.

'Miss Provis!' the voice repeats.

She stops, vexed, and turns around. There stands Josiah Darton, Mr Provis's closest friend and a Gentleman of the Choir. The Irishman is some twenty years younger than the verger, but they

share the same eye for unusual artefacts. He comes two or three times a month to their apartment bearing offerings that he often delivers, as Mrs Tullett has noted, with some improbable narrative. The Chinese porcelain horseman that he has won in a game of cards. The Venetian mirror with Murano glass – a gift from a dying duke in Marseille. He is also widely rumoured around the court to be a spy. Provis will never be drawn on this, except to mutter that Darton seems to be as well acquainted with drinking songs celebrating revolutionary France as he is with the sung liturgy for Sunday morning.

As Darton looks at her, his eyes glint amber – the lines around them show that he has in general been more entertained than disappointed by the world. Yet though he affects a wry amusement, she feels the familiar stab of fear when she sees him. Among the sycophants, power-mongers and social peacocks at the court, he is the individual whose motives she feels least able to divine.

'Why, Mr Darton,' she declares coolly.

As he walks towards her, her attention is caught by the scar on his left cheek.

'It has been several weeks since we last spoke.' He bows.

'It has indeed been an unusually long time since my father and I have seen you at the palace,' she replies acerbically. 'What has changed to bring about this happy circumstance? The direction of the wind?'

She studies him sharply as she talks.

'You jest, but you are closer to the truth than you surmise,' he responds. 'I have been in France this past month. I would have returned to London earlier had it not been for inclement weather on the Channel.'

'Another of your trips to the continent. What business took you away this time?'

She finds her eyes drawn again to the scar on his face. For a reason she cannot divine, she suddenly imagines him standing over a corpse.

'I was singing at the new Conservatory in Paris,' he replies.

'Mrs Tullett says you sang for Robespierre a month before he was executed,' she says, raising her voice slightly.

He looks swiftly around them.

'When Mrs Tullett declares a thing once, it is a rumour, ten repetitions later it is a fact, and a hundred times later it might determine your fate,' he hisses. 'Do you think I would have any standing here at the court if I had ever sung for the chief architect of the Terror?'

She stares for a moment, lightly amused at his consternation. Tries to gauge the tone of his voice, the look in his eye.

'It is well known that you have a taste for danger.'

'Not enough to risk my head as well as my reputation. Besides, I have learnt to avoid idealists whenever possible. They hang people's corpses on their virtue, and expect the world to applaud them for it.'

The clock at the palace entrance chimes the quarter hour. Ann Jemima turns.

'Forgive me, Mr Darton, I have a pressing engagement.'

'It is you who must forgive me, Miss Provis,' he replies. Yet there is no request for forgiveness in his voice – it is like a thin skein of cotton round her throat, both insubstantial and difficult to ignore. She turns back exasperated.

'I wish not to delay you. I simply wanted a quick word with you concerning your father…'

'I have not the time now.' She takes a deep breath. 'I am going to see Benjamin West.'

He frowns.

'He is painting your portrait?'

'He is not,' she replies scornfully.

His eyes fall to the brushes protruding from her bag.

'He is giving you instruction in painting?'

'You seem amused by this, Mr Darton.'

'I am not at all. Anyone who has been to your father's apartment has seen that you have formidable abilities… at least some of them in art.'

'What then would you say if I were to tell you that it is I who am giving the instruction.'

She delivers this last statement with the defiance of a poker player placing a winning hand on the table. As she has surmised, he knows not whether to respond with flat disbelief or astonishment.

'You are aware that in the eyes of the King that means that you yourself are consorting with revolutionaries?' he declares softly.

So you decide to play for time while you figure it out, she thinks.

Out loud she says, 'Mr Darton, you are too fond of conspiracy. In what sense might the President of the Royal Academy be a revolutionary?'

A look of unbridled amusement crosses his face.

'I am surprised I need to explain it. Many Americans feel an affinity with the French Revolution, for somewhat obvious reasons. Now that we are at war with France, West's loyalties are – at the very least – questionable.'

'Your logic is incomplete.'

His eyes dance as he steps closer to her. She can smell the scent of shaving soap and expensive snuff.

'He has received sympathisers to the French Revolution at his house on many occasions. Not least Thomas Paine. He was close to his countryman Benjamin Franklin, who acted as a diplomat, but was considered as dangerous to our country as he was eccentric. West also once sheltered a young American painter who was arrested for treason.' Ann Jemima shakes her head. 'He may seem to be a friend,' Darton continues, 'but surely that only places him in a better position to betray our monarch. I would watch your association.'

His eyes fix her, and she feels trapped for a moment. Angrily she steps back.

'You play this game simply to disconcert me. What you say is no more than conjecture.'

But her voice has not the certainty of her words. He stares at her for a moment, before nodding approvingly.

'You have spirit and intelligence. Does this allow you to see, now, how any of us can fall under suspicion?'

She feels her breath coming more rapidly, and tries to conceal it.

He tilts his head to one side.

'Let me paint you the other picture,' he continues. 'Though many Americans support the French, many have been alarmed by the radical turn of the revolution. Last year they signed a treaty that means they are better off getting fat on British money than in shedding British blood.' He smiles darkly. 'The King, of course, still sees America as his Achilles' heel. But for now his suspicions of Americans have receded.'

'That still does not remove West from the dock you have constructed.'

'In terms of Thomas Paine, West also entertained his sworn enemy Edmund Burke. He considers himself, with misplaced vanity, to be a man of ideas. So he wants to meet such individuals, but it does not mean he is in bed with them.'

'And the young American?'

'The King saw fit to release him from gaol and he returned to America, where he is now a respected painter.'

'So in that light Benjamin West is no traitor.'

'I am merely showing you how from one side the facts seem to damn him, while from another he is perfectly innocent. We are living in times where reality swings back and forth like a hanged man from a gibbet. At a certain point, any of us may be condemned.'

She is silent for a moment.

'I am glad I do not inhabit your mind, Mr Darton. There are such horrors in there that it would stop me from sleeping, and without sleep,' she pauses, 'who knows what nonsense I might talk?'

His eyes flare. She dips her head and turns to continue walking.

'Are you intending your route to take you through St James's Park?' he asks loudly as she moves away.

'Indeed I am.'

'Then please allow me to accompany you. You are not in the country any more. You must be aware that few ladies who venture there alone emerge with their virtue intact.'

He means to provoke me to outrage at every turn, Ann Jemima thinks.

'You yourself are aware that that depends on the time of day a lady ventures forth.' Her tone is contemptuous. 'A carriage awaits

me on the other side. I have walked there before on my own, and I can hold my head up as high now as I did when I made my first excursion. I cannot account for the other women with whom you associate.'

The sentry at the gate is racked by a coughing fit. From outside, they can hear an oyster-seller calling in the street.

'I see you have lost none of your pointed wit during my absence,' he declares, ignoring her pique as he follows her. 'Tell me, do you upbraid other acquaintances of your father in this fashion? You are noted at the court for your independent spirit. Yet it seems – though maybe I flatter myself – you save your sharper spears and arrows for when we talk.'

'Pray do not flatter yourself, Mr Darton. You receive no special treatment at my hands.'

'Then I am not alone in feeling myself as full of holes as a Saint Sebastian whenever I depart your company?'

'Mr Darton, you are too kind to us both. I can neither imagine that my wit devastates you as greatly as you say, nor that you could on any level compare yourself to a saint.'

She has goaded him to laughter – it flickers in the air before quickly disappearing.

'I have been trying to find your father as a matter of some urgency, Miss Provis. But he has proved most elusive of late.'

'We have both been much occupied in negotiating the price of a manuscript we are selling to Mr West.'

'The manuscript that your father inherited?'

'He has talked to you of it?' She cannot stop the chagrin creeping into her voice. 'It seems there is little that is not shared between you and my father.'

'In truth I was confused by his account of how he received it. Why did he first see it only two years ago? His uncle died twenty years before that.'

'It was not his uncle,' she corrects him. 'It was his grandfather.'

'My apologies, I misremember, but my point still holds true. His grandfather worked in the Navy, did he not?'

'He worked for the East India Company. He was sent to Venice

to import dyes, but then he encountered a man called Signor Barri, who told him about something rather more interesting.'

A cold breeze starts to pick up. She draws her cloak more closely around her.

'I never cease to be amazed at the ability of dead people to surprise us,' he replies quietly. 'We talk about the silence of the grave, but in my experience the dead are more generous with their secrets than the living.'

For a moment he sees a look of horror on her face. Before he can comment on it, she collects herself.

'Your father said it was connected to the secrets of the colourmen who supplied the painters of the Renaissance.'

She smiles fleetingly. 'In Venice, colour was almost seen as a currency, it was so valuable. Those who betrayed the secrets of the colour shops could go to prison.' She bites her lip. 'Some of those secrets were formulas related to specific painters. At some point those relating to Titian were lost.'

'Surely it is impossible that knowledge like that is truly lost.'

'That was Signor Barri's opinion. He and my great-grandfather set out to trace those who could help them put the formula together again. It became a kind of mission for them. They visited private libraries, tracked down anyone who could provide even a small fragment of knowledge. Everything they discovered my great-grandfather wrote down in a document that he brought back with him to England.'

They are at the edge of the park. Despite the cold of the December day, the fashionable are promenading up and down its canal while the destitute linger at the sides. Ann Jemima sees a dead-eyed duchess in purple propped up by a man with a rash who is at least two decades her younger, while a beggar reaches his hand out to a gentleman and is kicked back towards the undergrowth. A young girl in rags clutches a babe in her arms and shivers as it howls. It is nine o'clock in the morning, and currently there are more waterfowl than debauchees in the bushes. Yet everyone in London knows that the pimps, adulterers and libertines will fully stake out their territory as dusk falls.

'You still have not explained to me why the manuscript was not discovered till two years ago,' says Darton.

She glances momentarily at the canal before continuing.

'You say, Mr Darton, that the dead are generous with their secrets. But my great grandmother had never learnt to read, so the papers were no more use to her than kindling for fire. She kept them locked in a chest and no one else ever sought to look at them. When my grandmother died two years ago, I was handed them along with other family papers before I moved to London.'

He reflects for a moment.

'It would have taken more than mere reading to comprehend them. Your scholarship is quite considerable when one takes into account...'

'... that I am a woman?'

'I was going to say that you were raised in Somerset.'

She laughs.

'London does not have claim to all the wit in the country. The Lunar Society has some of the finest minds in all of England, yet most of its members live close to Birmingham.'

'Which is also far from Somerset.'

She does not respond.

'Miss Provis, permit me an impertinent question. Your own paintings are – in all seriousness – most accomplished.' She is silent. 'If this discovery is so extraordinary, why do you yourself not use the method so you can exhibit your works to the acclaim of all London?'

'Your sense of humour is most low, Mr Darton. Do you think London is ready to acknowledge the female Titian?' Her eyes gleam. 'Dr Johnson has been cold in his grave for just over a decade, and he said that for a woman to preach was like a dog walking on its hind legs. If I myself tried to demonstrate this method, I anticipate the comparisons would be yet ruder.'

'There have been female painters at the Academy.'

'I can think of two. Both forced to marry men much older than them to have money to live on. Each then told she should not paint so much if she wanted to be a respectable wife.'

'Yet the critics see no difference in their art.' She looks at him

in surprise. 'They savage the women every bit as mercilessly as they do the men.'

'So in that sense we are all rendered equal.' Her laugh is filled with self-mockery. 'In any case my talents are modest. This kind of method – for all the knowledge it contains – is of no use if it is not interpreted by a painter of the highest ability. You are a man of the world, Mr Darton. Surely you can see why Benjamin West's demonstrations of the method will be seen as more valuable than my own.'

He is about to reply, but a cry goes up from further down the path. A small boy, feral in rags, hurtles past with two men in pursuit. Darton and Ann Jemima watch for a moment as they disappear across the park in the direction of Queen Charlotte's residence.

'So Benjamin West will receive acclaim, he will pay you a large sum of money, and then you will not be forced to marry a man three times your age.' She does not reply. 'Is that what is at stake for you?' His voice is suddenly much quieter.

'I simply want my father to receive the money he deserves for his inheritance.' She will not look at him.

'Has Mr West indicated that he will pay the money?'

'He does not possess the manuscript yet,' she declares.

'How then, is he testing the method?'

Now she meets his eye.

'I shall reveal its most important elements in three or four demonstrations. Just enough to let him know what he could achieve if he studied it all.'

'Is he paying you for these demonstrations?'

Briefly she looks disconsolate. Then, collecting herself, she looks fiercely at Darton. 'He will make the payment. Whether or not the gossips term him a traitor, Mr West is without doubt a gentleman. Believe me, I have no doubt that he sees enough value in what I have shown him so far.'

There is shouting in the distance as the men finally catch up with the boy. Match-thin limbs flail in the air as one man holds him up while the other extracts a wallet from inside the boy's threadbare coat.

Darton looks towards them briefly – then nods and turns back to her.

'I congratulate you on your determination, Miss Provis. I have always considered you to be a young woman of ambition.'

'Do not seek to disarm me with compliments. I know you are simply seeking to be diverted by my delusions.'

'You know I would never accuse a young lady like yourself of suffering from delusions.'

'Never directly, indeed not. But Mr Darton, I have seen you flatter half a dozen individuals in as many minutes. To suggest that you think equally highly of all of them suggests both a lack of judgement on your part and an appalling gullibility on theirs.'

There is a shadow of amusement on his face as his eyes narrow.

'Was it your conception or your father's to take the method to Mr West?'

'I have had help – but the idea was mine.'

He nods as if a theory has been confirmed.

'You have proved a most interesting addition to your father's household. You would not believe how many of us at the court are waiting to see where your ambitions take you next.'

Anger suddenly runs red through her cheeks. She looks over to where a coachman is raising his hand to attract her attention. Then she looks back to Darton.

'What are you insinuating?'

'Nothing to cause you to take offence. I am one of your greatest admirers. Though I sense that you are a woman with a secret, and I would give much to know it.'

'Do you have so little regard for me that your main fascination is with what you do not know about me, Mr Darton?' Her eyes spark. 'If you were not such a slave to conspiracy, who knows what satisfaction you might derive from the real world?'

He dips his head as if in acknowledgement of the jibe.

'What would you fight to save, Miss Provis?'

'Why do you wish to know?'

'I am asking you what is most important to you in life. In France I have talked to people who have fought to change their society. Liberty, equality, fraternity – these ideals should thrill the heart, yet they are all broken by the very people who say

they champion them. Your father and I have often disagreed on political matters. He believes I am too wedded to ideas rather than reality. But now I wish him to advise me on – shall I say – a matter of conscience.'

She contemplates him as if calculating whether he is worthy of a response.

'I do not believe you to have a conscience, Mr Darton,' she finally replies. 'I suspect you want my answer only to taunt me about it. I value liberty, but it is worthless unless it comes with dignity. It is very little to ask – yet too often it can be ripped away from us. Without it we are nothing. I would fight for dignity beyond anything else.'

Darton is silent.

Finally he nods gravely.

'I do not know who would try to rob you of your dignity, Miss Provis. But they would find you a daunting opponent.' He bows low. 'Let me tell you that each time I see you, my respect for you grows. I will relieve you of my company here. Please convey my regards to your father, and tell him I intend to call on him in the next couple of days.'

Mr West writes home

'If you need to learn how this goose quill should be cut, get a good, firm quill, and take it, upside down, straight across the two fingers of your left hand; and get a very nice sharp penknife, and make a horizontal cut one finger along the quill; and cut it by drawing the knife towards you, taking care that the cut runs even and through the middle of the quill. And then put the knife back on one of the edges of this quill, say on the left side, and pare it, and taper it toward the point.'

Cennino Cennini,
The Craftsman's Handbook, c. 1400

Benjamin West sits in his study. It is late afternoon, and time is starting to bleed and blur with the onset of evening. He has tried to start the letter several times now. He takes up the crow's quill and begins again.

'December 22, 1796 *Newman Street, London*
 'William, my dearest brother,'

He sits back and sighs. 'I am not certain even of this, my old friend and sparring partner. I have not seen you for almost forty years.' He remembers their farewell at the docks when his ship departed for

Europe. How after all the arguments, William had finally agreed he would take the coach and horse with him early that morning. The smell of brine, the clatter of chains and shouting. How they had stared at each other briefly before hugging fiercely, sensing the uncertainty in the air all around them.

He frowns, and starts to write once more.

'I have had much on my mind reecently, and feel the want of a dear Friend like yourself to talk with. The Atlantick has never felt so wide as it has in reecent weeks, nor indeed has London ever felt so small. I have been here some thirty-three years now, yet on some days I feel more of a Stranger than I did when I first struck these shores.'

For a moment he imagines the world and its oceans spreading around him – the rivers, mountains, great plains and deserts. He thinks of himself as a small dot within that world, and of the political events that are changing it daily. As Britain huddles on the map, to one side the young General Napoleon is leading the French army across Italy and central Europe, surprising the world with victory after victory. To the other side, America has just elected its second president, John Adams. Yet for one of West's nieces, all these events have been eclipsed by the arrival of an elephant in New York. 'Such a strange and wond'rous beast you have never seen, dear Uncle,' she has written. 'So ugly in each individual detail – the tiny eyes, the discolour'd teeth, the grey pallor of the wrinkly skin, the absurd little tail. Yet in sum so dignified.'

Such is life, West thinks to himself. In so many details, so filled with ugly absurdity. Yet in sum, if not always dignified, certainly a thing to be marvelled at.

'These days even I find it hard to credit,' he writes, 'how bold I was in courting Outrage. I remember that you yourself, with that characteristick Skeptycism that I have come to value so dearly throughout my life, expressed Amazement when I wrote to you that I had enter'd a dispute with both

Sir Joshua Reynolds and the King. I was thirty-two, so not a young man – yet still I was fill'd with the spirit of vigorously Questioning all that I set out to do.'

His education in Europe has not improved his ability to spell. He suspects now that it is one of the causes of his stubbornness – the memories of his schoolmaster hitting him on the knuckles and berating his stupidity still linger. Fear of the scorn he will court through his mistakes is a demon he must wrestle every time he writes.

'That argument prov'd one of my defyning moments,' he continues. 'I desired to paint the great Battel of the Plains of Abraham that the British fought in North America in 1759. It was a battel that seem'd to change everything in Britain's favour.' A smile flickers on his lips. 'No one knew then that we were living in a century of political Earthquakes. Certainly no-one in London could imagyne that in fewer than twenty years America would declare independence.'

He shakes his head, lost in thought for a moment.

'The convention was that historic figures in paintings wore togas. But this made no sense to me. I believed the time was ripe for change. "No", said I. "They shall wear what they did on the battlefield. When the Romans had their Empyre, they did not even know that North America existed. If Julius Caesar could not have imagined it on a map, why should I paint the men who fought there in togas?" No-one could give me a sensible answer. So I created the first historical painting without Classical attire. From what some persons said, I was about to walk into the jaws of Hell.'

Sir Joshua Reynolds looms before him. He remembers how the great man had summoned him to his house. When West had entered his study, there had been a sense of winter in the air. He had never seen Reynolds so severe. After he had offered his counsel and saw

West was still not to be diverted from his course, he had entirely lost his composure. As West had retreated, he had shouted that his reputation as a painter would be destroyed forever by this venture.

Dazed by Reynolds's anger, West had taken his leave and wandered to Lincoln's Inn Fields to contemplate his future. As he had sat on a bench, a thin, insidious rain had started to fall, stinging his eyes and quickly starting to run down the back of his neck. A homeless man had approached him – the skin on his face raw, almost as if it had been flayed by hunger and exposure to the cold and damp. West had given him a guinea. As he had watched him disappearing, he had made a bargain with himself that if the experiment did not work, he would sell everything he had in England, and set sail for America within the month.

'I suspected my subject would otherwise be Pleesing to the King,' he recalls now. 'The Death of General Wolfe, after all, shewed a British General dying gloriously after Victory against the French. I constructed my picture so that Wolfe – tho' in contemperory dress – evoked the dying Christ when held by the Vergin Mary. He was surrounded by the doctor who essayed to save him and other heroic commanders from the Campaign. I made certain that my English friends could not forget, either, the bravery of the Mohawk tribesmen. I painted the indiginous warrior prominently in the fore- ground to the left. You alone will have noted his resemb- lance to Running Wolf who took us out fishing those many years past.

'Some critics were outrageous enough to write that my painting did not shew the truth in any event. They said that since General Wolfe died in the heat of battel, it is impossible that all the Personnages in my painting would have been present. To which I replied that there is a purer truth than that which can be observed through the eye alone. It is the truth one has when one is in possession of all the Facts, a truth that thru echo and implication tells a story in full.'

He remembers the elemental force of London's outrage, how fighting against the scandal had felt for a short while like being a piece of straw tossed in a hurricane. Everywhere he had turned he had been buffeted by disapproval. He had proclaimed he found the sensation invigorating, even as he had been filled with alarm. But he had never confessed to his brother – or indeed himself – till now, how terrified he had been.

'Today,' he continues, 'that picture is seen as my Greatest triumph. After chiding me for it, the King realised that the many among the publick loved it. In the end he himself ordered a copy. Some would say I chang'd all of history painting through what I did. No artist paints historical figures in togas these days. Even you, who have so often rebuk'd me, were forc'd to conced that because of my daring I changed the course of art.

'Yet it has been a long while since I achieved a great success. Now, it feels that even when I Adheer to the rules, I am chastised. The King – and maybe this is a symptom of his Madness – has threatened these last two years not to attend the Royal Academy Exhibition. He believes I am secretly Sympathetick to the French Revolution, and reminds me bitterly of past conversations we have had about equality. Yet I am no traitor. I recognise there is a Delikate line I must tread as a guest of the King, and tread it I do.'

He dips his quill in the ink.

'There is but one happy Aspect of my life right now,' he continues, 'though I comprehend not precisely what it portends. A young girl, one Ann Jemima, and her father, Thomas Provis, came to me a year ago offering a Manuscript that appears to shew the technique of painting like Titian. I was highly Sceptical when they first appeared. But I think I am able to create an effect through using it that is simultaneously subtil and vibrant. The girl herself has responded well to some of the

insights I myself have given her on Titian. She is but young, just seventeen years of age, yet it is worth remembering that when one of our youngest members, Joseph Turner, entered the Academy he himself was no more than fifteen years. What is in little doubt is that she is socially more agreeable than Mr Turner, who when I was with him last was spitting on the canvas – whether for social or artistic Effect I am at a loss to say.

'There is only one curious aspect of our encounters. When she is not in my presence – and I have met her five or six times now – I have no precise recollection of what her Face is like. I can tell you that it is a pleasant enough Face, and the eyes have a blue Aspect, but were you to ask me to sketch it, I could not. Maybe this is an Instance of old age advancing on me. It is of little matter, but it is not a Problem that has afflicted me in the past.'

He frowns, and stares out of the window as if hoping, if not to find the answer to the question he has raised, at least to be distracted from something that is starting to discomfit him. The sky's blue is lit up by angry streaks of pink, carriages clatter back and forth below.

'Please let me know,' he eventually writes, 'whenever you first have the Opertunity – your opinions on these matters, and anything else that Strikes you to be of importance. I hope you will always know how Important your Opinion is to me, even tho' I have so often ignored it. Forgive me. The older I get, the more I admire your frankness. I wait to hear from you with impatience, and hope this will find you and your Family in health as through mercy mine are.
Your brother,
Benjamin'

He signs the letter with a frown, and makes to put the crow's quill back in the small copper oval holder that also contains the

inkwell. But he miscalculates the force with which this should be done, and the entire holder tumbles to the floor. For a moment he watches the inky puddle disperse into tiny black rivers across the floorboards. The sky outside grows still darker and the pink streaks disappear, yet it is a while before he can stir himself to remedy the situation.

Dealing with Mr Cosway

'Although from habit, acquired in our earliest infancy, we suppose Colour to exist in Bodies, nevertheless it is evident, and generally acknowledged, that the word Colour *denotes no property of Bodies, but simply a modification of our mind, and only marks the particular sensation, which is the consequence of the shock produced in our sight, by such and such luminous corpuscles.'*

Constant de Massoul,
A Treatise on the Art of Painting and the Composition of Colours, 1797

I t takes some time for Provis to suspect the one eventuality that had not occurred to him before he and Ann Jemima approached West. He has anticipated ridicule, humiliation, and even outright denunciation. In rarer moments he has anticipated success. What he has not anticipated is that West might have a hidden agenda. Yet after a few months, this seems the only plausible explanation for what is going on.

Provis's long experience of doing deals means he has a nose for the right way to set things up before, as he and Darton describe it, going into battle. Normally he himself is well acquainted with the person to whom he is trying to sell – he knows their predilections and perversions, senses as he talks to them what might tilt them one way or another. This has, he believes, put him in exactly the right

place for advising Ann Jemima on the best way to try and sell the document. Yet in this situation he has needed to rely not just on Ann Jemima's perceptions, but on the perceptions of the man who has introduced her to West. Richard Cosway – even the sound of the name makes the bile surge in his throat. 'But now,' he whispers to himself, 'I must treat him as a brother till this whole wretched business is over.'

Cosway, a society portraitist, resembles a diseased fox with his fading red hair and jagged teeth. Rheumy eyes glisten malignantly, while the mouth is rigid with spite and regret. Once the face is animated it becomes more acceptable – an easy, caressing voice lends it a charm that has helped it gain admission to the drawing rooms of Queen Charlotte among others. Yet it is in repose that the face reveals most, and it is in this state that Cosway's exhausted cynicism is on full display.

Provis still does not know how Cosway discovered what made him walk away from his family in Somerset almost two decades ago. He had decided to amputate his past as if it were a gangrenous limb. Against the roar and chatter of London life, personal details were a luxury in which he could choose not to indulge. He knew some speculated that he had committed some kind of crime – he had overheard the whispers among those who worked with him. Yet in the absence of evidence or any direct accusation, more people indulged him by assuming he was concealing his past because of some personal tragedy. It was known his wife was dead, and that Ann Jemima had been raised by her grandmother. But that was all that was certain. There was something about the man that meant nobody dared to ask him about it outright. Yet Cosway knew. And though he was silent on the matter now, there was an unspoken understanding in all their dealings that if the information ever became valuable enough to him he would have no compunction in sharing it.

Shortly after Ann Jemima had arrived to live with Mr Provis two years beforehand, the portraitist had called at their apartment. From the start there was something precarious about his politeness, as if it were crafted from eggshells. Something is about to break, thought Provis to himself, and I cannot tell what.

'I have been hearing most favourable reports of Ann Jemima in recent months,' he began. 'It seems she has changed quite considerably since you sent her to school in Highgate. She has transformed from a petulant brat into a young lady.'

He did not look directly at Provis, but walked up to the ivory sphinx on the mantelpiece and lifted it to examine it.

'She is faring better than any of us had dared to hope,' replied Provis, watching Cosway distrustfully as he made his way over to the window with the sphinx to hold it closer to the light. 'The palace can be an invidious environment for those who are not used to it. But since she came to live here she has adapted admirably.'

Cosway turned round. 'Is this Assyrian?'

'No, it is Ancient Greek. As you will see it is female. The Assyrian variety is normally male.'

'The detail of the nemes is exquisite.'

He ran a dry finger across the headdress. Provis felt the loathing surge.

'May I ask what the purpose is of your visit, Mr Cosway?'

Slowly and deliberately Cosway placed the sphinx back on the mantelpiece.

'I would like to do you a good turn, Mr Provis,' he said, turning.

What bait do you lay for me? thought Provis.

Out loud he said, 'I'm sure that is not necessary, Mr Cosway.'

'You took quite a risk at my behest.'

'We have often found ourselves in a good position to help each other.' He tried to mask the resentment in his voice. 'I did what I thought I should do – no more, no less.'

'Even so I should like to help you further.'

Cosway came closer – Provis could see the red veins in his eyes.

'Most young ladies who fare well in polite society possess a skill,' he declared. 'They play the piano or learn embroidery. Such attributes can make them highly marriageable, as long as they are not vulgar enough to excel at what they do.'

I must wait, reflected Provis grimly. Soon the mechanism of the trap will be revealed.

He nodded his head, acknowledging the sour wisdom of Cosway's comment.

'Does Ann Jemima remain interested in painting?'

'I would say it is more like an obsession.'

'I would like to offer her tuition.'

And now he plays his hand, thought Provis.

'That is most kind of you, but I must refuse your offer,' he replied shortly. 'She was taught by a man called Septimus Green when she lived in the country. Now she is happy to instruct herself from books…'

'Play not the over-protective father,' interrupted Cosway, coldly amused. 'Who was this drawing master? Some desiccated old bore who helped her trace the reproductive organs of honeysuckle?'

An unspoken reply curdled in Provis's stomach.

'As you know, I have some standing as a teacher,' Cosway continued. 'I would not charge you for the first lessons. Though I know you are a proud man, Mr Provis. If you were happy with her progress, and wished to pay for her to continue I would not turn you down. The debt collectors have proved most cantankerous of late.'

There was a fleck of spit on his lip. Sensing it, he moved his hand up uneasily to wipe it away. His learning and sophistication are like gossamer round a rat's corpse, thought Provis. They cannot disguise the rank odour of self-disgust that lies beneath them.

Cosway's eyes darkened for a moment as he saw Provis hesitate again. 'Do not be afraid. You should be well aware you have nothing to concern you regarding my conduct. I know my wife was my painting pupil…'

'Your former wife.'

'Quite.'

'I hear,' Provis cleared his throat, 'that she has acquired quite a reputation on the Continent.'

If Cosway's laugh had been cracked open, there would have been dust in it.

'I have been taunted for the fact I did not want her to be an artist at all. You know as well as I do how the desire to paint seriously can taint a woman's sexual reputation.'

'In truth I had not considered that.'

'Now she is a most successful artist. In France especially she has many admirers. It has been a harsh lesson. I have realised, too late, that my attempts to constrain Maria's talent bred a resentment from which our marriage never truly recovered.'

Suddenly an expression of such desolation came over his face, that for a moment it felt like an intrusion for Provis even to look at him. It was there just briefly, then he reasserted himself.

'Do not misread me. I am not in accord with scribblers like Mary Wollstonecraft who say that all women must be educated. On most women – and indeed on certain men – education is as wasted as an opium enema on a dog. Yet Maria has taught me that if a young woman has ability, and a certain determination, then that ability should be cultivated. It is partly my desire to atone for my treatment of my wife that leads me to offer these lessons to Ann Jemima.'

Again it was as if the mask had fallen from his face. Provis looked directly at him this time, trying to read him. Is it possible that his offer is prompted by genuine concerns, he asked himself. Even a man as repugnant as Cosway is occasionally capable of heartfelt sentiment. Yet quickly suspicion reasserted itself in the shadows of his mind. This man has deceived and deceived again, he reminded himself. He looked down at Cosway's fingers, which twitched uneasily, often a telltale sign of mendacity in his experience. After all, he thought wryly, how often does the deceiver play penitence as his first card?

'Your have parted company with your wife.' He cleared his throat, hoping at least briefly to divert Cosway from his original intent. 'In that were your worst fears not confirmed?'

A spasm of disgust crossed Cosway's face.

'It was not painting that corrupted her. You are mistaken if you think my Maria proved to be a harlot. I realised with some distress that since birth she had been something far more dangerous for our marriage.' He paused for a moment. 'She was a romantic.'

Provis looked down.

'One of the world's most influential men pursued her,' Cosway continued, 'a far better man than I. I expected daily to discover them

in bed together. Yet to my surprise, and, I must concede, mistaken satisfaction, she resisted his physical advances.'

'Why was your satisfaction mistaken? Surely this was a considerable compliment.'

That dust dry laugh came again.

'So I thought. Until I realised where the real seduction had occurred.'

'I comprehend not.'

'While she was with me he never tasted her body.' Cosway pronounced the words lingeringly. 'But he had seduced her mind and her heart. From that moment, though physically she was mine, she only ever truly belonged to him. I believe I took the only honourable course possible. It was I, not she, who suggested that we separate.'

Once the portraitist had left the apartment his presence lingered like the stench of damp on an early October evening. Raindrops spat against the window, swelling and splitting on the dirty glass. Provis had felt sickened by the proposal, but was sickened still more by the thought of how he would raise it with Ann Jemima. Each chime of the quarter hour on the clock before she returned to the apartment seemed to jeer at his nerves. When she finally did return, singing lightly to herself as she entered, it was only with some effort that he could even mention that Cosway had visited. She had come in from a small dinner in Mrs Tullett's rooms. The sounds of the evening were written on her face – in her half smile, he could hear the lively chatter, from her flushed cheeks, the clink of glasses.

'What scandal did Mrs Tullett serve up tonight?' He feigned levity, but could feel the limp and judder of his words.

She could hear his unease straight away, and looked at him with sharp puzzlement.

'She declares that another lady-in-waiting is with child,' she replied studying Provis's face, 'and once more, that the baby is not her husband's'.

He turned away to evade her scrutiny, and went to stoke the fire.

'Tell me not. It is the Prince of Wales who is at fault.'

'For once the fault is not his.' She disappeared for a moment to hang up her cape and bonnet. 'According to Mrs Tullett it is the

bishop who preached at Michaelmas,' she continued coming back into the room. 'I find it difficult to credit – the mother is both fair and witty, and her husband almost limpet-like in his devotions. Jealousy begot this rumour.'

Provis wanted to speak, but the words huddled at the back of this throat. She glanced at him keenly again. When he remained silent, her eyes roved restlessly around the room. She seized a small calfskin-bound book from the table in front of the fire and started to flick through it. He took it upon himself to walk over to her with a small glass of fortified wine. As she reached to accept it, he looked down at the page in front of her and saw a deft pen and ink drawing of what he assumed was some mythical creature.

'What strange being is this?' he croaked.

She regarded him for a moment – he could see she was considering whether to deliver a serious or teasing response.

'It is the anatomy of a louse,' she finally replied. Seeing him confounded, she laughed. 'It is no one at the Palace.'

A half-thought flickered in his mind of members of the court as parasites in silks, scuttering across the dung heap of London.

Out loud he said, 'It is from Hooke's *Micrographia*?'

She nodded approvingly, both pleased and surprised he had caught the reference. She handed him the book from which she had made the copy. Provis looked at it, frowning and squinting. 'I know of it,' he said. 'It was popular in Charles II's reign.'

'Can you imagine what it was like when Robert Hooke looked through a microscope for a first time? He saw a whole new world. Poppy seeds like boulders with hexagons, lice like soldiers in armour.' She darted him a swift glance.

He peered more closely. 'I have seen framed illustrations on market stalls. I believe also there is a copy of this in the King's Library. I trust this is not the same volume.'

'I sketched the louse this morning,' she said, ignoring his question. 'Yesterday I drew a mite from the same collection. I first saw it when I was a young girl. I thought it the most magical book ever published.'

'This is not from the King's Library, is it?' he repeated.

Again she ignored him.

'It puts a glass where we see nothing and reveals a whole teeming life.' She looked up. 'Hooke would stop at nothing. He wrote how he had let a louse suck from his hand to see how the blood travelled through it. He also froze his urine to examine how the crystals formed.' Her eyes were ablaze.

'You did not repeat this to your elders and betters?'

'I did not need to. Sadly a visiting aunt noted my application to the book. When she read it and realised it contained such indelicate details, it was confiscated.'

'You will replace it in the library?'

She reached out to take it back from him.

'Please let me keep it for just a few more days.' There was a whisper of apology in her voice. 'I will replace it unharmed.'

Provis took a deep breath.

'I believe you would try to persuade an executioner to stay his axe. If it is not gone in a week, I will replace it myself.'

They were both silent for a moment.

'You are unusually severe tonight,' she eventually replied. 'What is it that truly troubles you?'

He took a deep breath and told her of Cosway's visit. At first she simply looked surprised, but when she heard the proposal, she gripped his hands so tightly he felt as if the blood had stopped flowing in them. Then she started to walk up and down the room.

'Do you think he means to hold you to account?'

'I know not. I believe I have done nothing wrong.'

'No, indeed. You are not at fault in the slightest. The honour and kindness in what you have done…' She paused for a moment, her eyes glistening. 'No,' she continued. 'Even a man with a perverse disposition such as Cosway cannot feel the urge to do you harm.'

Yet even as she reassured him, he could see she had started trembling. She has grown in assurance so greatly since she arrived, he thought to himself. But now it is as if the void has opened up beneath her once more.

He cleared his throat. 'Cosway is one of those who enjoys causing discomfort in others largely because it distracts him from his own unhappiness.'

She nodded vehemently.

'Yes, you are right. It is a strange game, but is probably harmless.' She was silent for a moment. 'Harmless so long as we play it in the right way.'

As the words left her mouth, it was if she became colder, harder.

'We must seem to appease him, at least to begin with. Let me take the lessons, and we will see if we can turn this situation to our advantage.'

'What if he demands a payment that goes beyond money?'

She looked at him impatiently. 'Send Mrs Tullett with me as a chaperone; she is well acquainted with his housekeeper.'

'You believe Mrs Tullett will act as chaperone?' His voice is incredulous. 'Will she stay her tongue?'

Ann Jemima put her hands to her head as if to contain the thoughts swarming within it.

'I believe, because of her loyalty to you, she will.'

He looked at her sharply.

'If Mr Cosway chooses to dance with other people's concealed skeletons,' she continued more calmly, 'then we shall at least know that Mrs Tullett has danced with some of his. He shall fear her, both as a witness of the past and of the present.'

'More than we fear him?'

The pain that crossed her face was so great that he wanted to reach out to her, but he knew better than to act on this impulse.

'It is more dangerous not to play the game than to play it,' she whispered.

The first few months of lessons passed without mishap. Provis's wariness became sapped by the routine. He remarked to himself too how Ann Jemima seemed to become more at ease as time went by. He had never been quite sure what to do about her obsession with drawing and painting. For the first time he confessed to himself that in those early days something about it had frightened him. There had been a painting that she had completed in one of her early

lessons of a sunset over a field. He had seen the dance of reds and yellows, observed that the sun was bleeding into a landscape that was not merely lit, but transfigured by what was taking place with the onset of dusk. He had noted the rapt look on her face when she was waiting for his response. So he had croaked that it was good even as he reflected that it was no more use for a woman to have this ability than it was for her to have seven toes on one foot.

It was of some comfort to him to realise that Cosway was equally disconcerted by her talent. The painter's sarcasm did not have its usual easy lilt when Provis called to hand over his first payment for the lessons.

'She has learnt something from her country drawing master, Septimus Green, even if his tastes seem a little eclectic,' he remarked.

'You will take a guinea for three months of lessons?'

'You are most generous.'

'She is not more able than your wife?'

Provis's laugh died on his lips as he saw Cosway could not meet his eye.

'She is but seventeen. She has a raw talent that could, or could not, advance her quite far in painters' circles should she be foolish enough to want to spend much time in such pursuits. Her amateurish interest in science is somewhat fashionable now in the arts. A book called *Newtonianism for Ladies* by an Italian, Signor Algarotti, discusses light and colour and is popular in salons on the Continent. If you are happy to pay me, I can acquire one for you.'

The verger felt a sense of something crumbling around him. He wondered whether his emotions were akin to those felt by contemporaries of Galileo when they first discerned that the earth might revolve around the sun, rather than vice versa.

'I... I have spent much time in auction houses, a–as you are aware.' He knew not how to express himself. 'In the last few years especially I have seen many pieces of art that have come from France, and beyond. But they are not... but they are not...'

'By women.'

Provis looked at Cosway almost pleadingly. 'To my mind there is nothing wrong with a woman painting well.'

'You are an unconventional man, Mr Provis. That is one of your greater attributes.'

'It is empirical evidence rather than any other measure that makes me consider it an unwise future. If women were meant to paint,' his hands flailed in the air, 'surely they would have painted great works for centuries.'

Cosway got out his wallet and opened it. In response to his gesture Provis handed over the guinea.

'My former wife,' the portraitist replied, 'was somewhat tedious on this matter, as you can imagine. There have been female painters since the Renaissance, and even before – we just do not hear of them very much, if at all.' He sighed, as if disdainful even of the effort of repeating her. 'She talked much of Fede Galizia, a Milanese painter from the early seventeenth century. She was the daughter of an artist, and was herself acknowledged as an artist of some talent by the age of twelve. Towards the end of her life, her preferred theme was Judith cutting off the head of her lover Holofernes.'

'She talked to you of this...' Provis began, and then stopped himself.

'... at the point when our marriage was clearly coming to an end. Yes indeed. One needed little imagination to understand her fondness for Galizia's work at that point.'

He looked penetratingly at Provis, who forebore to meet his eye. 'She also talked of Sofonisba Anguissola,' Cosway continued, 'who was born in Italy and later worked as a court painter for Philip II of Spain. One of her more charming images was of her sisters playing chess. She must have been reasonably formidable, at the very least as an individual – Philip II also employed Titian.'

'These are remarkable instances. Why then...?'

'Are they not as well known? I certainly found it best as a man not to speculate – at least not in front of my wife.'

Provis frowned at him.

'Philip was the son of an Emperor. If he was enough of a connoisseur to employ Titian, then surely he would not have indulged a woman painter out of charity.'

'That was certainly Maria's interpretation.'

They stared at each other for a moment.

'Mr Provis, if you are minded to bear with Ann Jemima on this – and I can see you may be – then you can do no harm. She is the kind of young lady who, if opposed, will only become more determined. Marriage and children will distract her before too long, God willing. In the meanwhile, shall we see where this journey takes us?'

The twist to Cosway's bargain happened, in the manner that such things do, once Provis's guard was dropped entirely. One afternoon Ann Jemima arrived home from her lesson late. When Provis asked her how she had fared that day, her response was clipped and irritated, while the air around her shimmered with unease. His suspicion made him suddenly feel ill. He observed the hunch in her shoulders that had not been there, noted the drawn pinched look in her face. Any phrases that came into his mind to ask her what had happened felt too dangerous to deploy. He burned with quiet anger, but did not want to scare her into silence. Later that night, over dinner, she suddenly declared with some disbelief that Cosway had promised she would become a better artist if she inserted her hand into his breeches. When she spoke the words out loud Provis could feel his fury as if it had been stamped on him by a branding iron.

'What did you reply to the scoundrel?' he asked her.

'I told him I had no desire for white paint at that moment,' she declared angrily. As her eyes flashed he could see the tears in them. 'In truth he did nothing. He spent the whole lesson looking goats and monkeys at me, but he never tried to touch me.'

'What of Mrs Tullett?'

'She has not accompanied me in the last month.'

Disbelief blotched red up his neck.

'You have not had a chaperone?'

'We agreed...' She took a deep breath, as she fought back the tears. 'We agreed that since he was behaving himself,' she looked at Provis angrily, 'that I would attend the lessons on condition that his housekeeper was in the house.' Distractedly she wove her napkin in

and out of her fingers. 'I thought that would be safeguard enough. And for three weeks it was. I thought there was a truce between us. But now it seems it is over.'

He paced up and down.

'I should go round and beat the bastard. You must cease the lessons straight away.'

She cast the napkin to the floor.

'I cannot. Oh – you must credit me when I say I would if it were remotely possible.'

He looked at her in horror, saw the mixture of anguish and defiance in her eyes, sensed the taut anxiety in her voice.

'What can you possibly mean, my girl?'

She looked away.

'I thought there could be no harm in it.'

'In what?' he asked increasingly alarmed.

'The manuscript.'

'The manuscript?' he repeated. Later he would be aware that this was the moment when the trap started to close in earnest, but right now he just looked at her, dumbfounded.

'I have asked Mr Cosway to approach the President of the Royal Academy. I wanted him to find out if he will buy it from us.' She could not look at him. 'You and I talked much about the best way to achieve the highest price possible for it. You yourself said in the auction houses most buyers would not comprehend its value. And you were right. It was then that the idea came to me. I thought that no one in London would either desire or be in a position to pay more money than Mr West.'

It took him a while to absorb what she had said. As he did, he shook his head repeatedly.

'The President of the Royal Academy?' he whispered with incredulity. 'You wish him to scrutinise this manuscript?' He held his hand to his forehead for a moment. 'Does Cosway understand its origins.'

'He does.'

She stared at him for a moment, and he stared back.

'I cannot believe what I am hearing,' he whispered.

'The techniques in the manuscript work. Cosway himself is convinced from what I have demonstrated to him. This is the surest way of proving their worth.'

She stepped closer to him and he stepped back.

'I have gone out of my way to support you in your ambitions to be a painter, my girl. That has proved precarious enough. Are you confident Mr West will recognise its value? That he will not ridicule us to the King and lose me my position here?'

'There is no one better to scrutinise it. Cosway himself believes that Mr West would be delighted to preside over such a discovery.'

'Cosway, Cosway, Cosway.' His hands clenched and unclenched. 'Ann Jemima, you have known from the start that I want us to have as little to do with Cosway as is humanly possible.' His voice rose with anger. 'Yet at every turn I find myself shackled to him as if in Newgate gaol. What has possessed you to ask him to make this approach?'

She did not answer.

'It is ambitious in the extreme. If he succeeds it means we will be even further beholden to him. And if we fail…' He shook his head. 'Now as you have seen this afternoon he is already trying to exact his price.'

Still there was no response.

'You think you are cunning enough to deal with anyone,' he said more loudly. 'Yet you are too young to appreciate the extent of the world's wickedness.'

'You cannot get rid of Cosway as it is.' Her eyes were mutinous. 'I hoped you would commend my audacity.'

'If you were a young man I would give you a beating,' he said as his rage increased, 'and that would be the long and short of it. This is a truly regretful situation.'

She looked as stung as if he had truly struck her. Suddenly she started shouting.

'Speak not to me in this manner. It is you who do not understand the way of the world.'

He was about to reply, but stifled his words – he did not trust himself to speak further. 'You yourself spelt it out. Only a painter

at the Academy would truly want a manuscript of this kind,' she continued. 'You have told me often enough that you can only make a good deal if you understand the desires of the person to whom you are selling.'

'I was going to sell it myself.'

'Yet the seller must understand its worth, and I still think you do not appreciate what we have. You would have received a paltry sum that would have changed nothing.'

'Ann Jemima – sometimes this is about worrying what you might lose, as well as what you might gain.'

She looked at him angrily.

'What price are you thinking of asking?'

'You told me that a Titian itself can sell for anything between £60 and £900. I thought we could begin modestly and ask for £300.' His face darkened. 'The President is in a position to pay that. But as you well know, Mr West will only give us his attention if we are recommended by somebody he knows.'

Mr Provis remained quiet, recognising that her fury was as much at herself as it was at him. She has crept out on the ledge, he thought, and realises there is further to fall than even she has anticipated.

'As for Mr Cosway,' she said, regaining some calm as she perceived that now he was heeding her, 'he is – in essence – a coward. A spent old ram who revels in the wretched games he plays. As long as I have a chaperone, I have more power over him than he does over me.'

'That is one risk you have already miscalculated,' he growled.

She shook her head.

'I cannot undo what I have done. If he is piqued by what we do now, then he can stop any chance of our getting the recommendation of the President.'

He regarded her quietly.

'Which is most likely? That Cosway genuinely believes that West will perceive the value of the manuscript? Or that he wants you beholden to him during the time that it will take him to investigate this remote possibility?'

'I do not believe the possibility is so remote. Once Mr West purchases the secret, we will have more than enough money to make Mr Cosway go away, and give ourselves a new life.'

He sighed and turned away.

'I thought you had the wit to understand this. Never trust a seducer.' He clenched his hands. 'And never trust a blackmailer.'

'Then help me.' He could hear the tears in her voice, but refused to look at her. 'We have nothing to lose.'

The thought that 'In time, we may have even less,' whipped across his mind, but then he turned round and saw her face and realised the best course was to say nothing.

Mr West's betrayal, January 1797

'[We] often take the shadow of things for the substance, small appearances for good similitudes, similitudes for definitions; and even many of those, which we think, to be the most solid definitions, are rather expressions of our own misguided apprehensions then of the true nature of the things themselves.'

Robert Hooke,
Preface to *Micrographia*, 1665

As the midnight chimes ushered 1797 into its hurried yet unremarkable birth, Provis found himself thinking of what Ann Jemima had observed about Robert Hooke. 'She said that when he looked through his microscope,' he recalled, '"he saw a whole new world". We are surrounded by unseen forces – a drop of pond water can teem with life, while an insect can rival a great monster from mythology. All we need is the right instrument to see them. Oh that such an instrument were invented for human thought!'

If such an instrument had been developed, he continued to think, what would have been observed just over a year ago when he and Ann Jemima had visited Benjamin West? He recalled, as he had so often, that when they had eventually walked in to the

President's drawing room, the American had looked at them with little enthusiasm. Yet what began as disdainful curiosity on West's part seemed to change as Ann Jemima talked about the manuscript.

'Titian loved the messiness of paint,' he suddenly said. 'He did not confine himself to brushes, sometimes he smeared the pigments on the canvas with his fingers, endlessly shifting and changing the image.'

He leant forward and played his fingers on the table.

'Many people were of the opinion that he wasn't a very good draughtsman. He did not create many sketches.' He paused. 'But texture. Colour. His mastery of these commanded the attention of the most powerful men in Europe.'

Provis cleared his throat. 'A mixed blessing, I am sure.'

'Indeed,' West replied. The two men exchanged quick glances. 'To engage with the characters of the wealthy and powerful is an art in itself. But Titian was adept at it. Emperor Charles V, then the most powerful man in the world, was his patron.' West glanced sharply at Ann Jemima. 'On one of his visits to Titian's studio, the painter dropped his paintbrush. Such clumsiness in front of the Emperor would have been an embarrassment for anyone else. But the story goes that the Emperor got down on his knees and picked it up for him.'

He motioned to Provis to bring the manuscript to the table. Provis felt a sudden tightness in his stomach as he watched the American read. In the corner, a mahogany grandfather clock ticked away the seconds of his nervousness.

'So, according to this theory, there are three key points,' West declared finally, standing back. 'The first is the exclusive use of linseed oil to mix the paints? No walnut or poppyseed oil?'

'Only the best quality of linseed oil,' Ann Jemima replied. 'It was favoured by Titian.'

West nodded. Turned the wedding ring back and forth on his finger as he pondered.

'The second is the preparation of the canvas. First you size it with a mixture of rabbit skin glue and Spanish Brown pigment.'

'That is right,' Ann Jemima replied.

'Once that has dried for three days, you smooth the canvas with a pumice stone. Then you mix the colour of burnt umber with linseed oil and apply it on top.'

She nodded.

'Obviously the tone and absorbency is crucial,' she replied. 'If the canvas is not correctly prepared then you have little hope of achieving the richness of colour you are seeking when you paint on top of it.'

He nodded impatiently at this latter point. Quickly she caught his meaning.

'Mr West, elements of the method may sound like no more than common sense. But when you combine them, they promise something no artist has achieved for centuries.'

Provis looked at West again. He saw the amused flicker on his face as he registered the boldness of her assertion, combined with a deepening interest.

'And the third point is the use of this Titian blue to establish the form of the painting and emphasise the shadows,' he continued.

He paused, scrutinising her again. Provis watched anxiously for any glimmer of sexual predatoriness, but could find none. Felt the scratch of relief in his throat that West was not like Cosway, at the same time as his mind told him he was disappointed. The manuscript had enough merit to sell itself, of that he was starting genuinely to be convinced. But he also knew it to be the way of the world that if West felt even an element of desire for Ann Jemima the deal was as good as signed.

Out of the corner of his eye he suddenly thought he saw two other people in the room, and quickly turned his head. He discerned, with a smile of relief, that it was the reflections of Ann Jemima and West in the large mirror above the fireplace. He realised, as the beating of his heart slowed, that they were still talking about the technical aspects of the method.

'You say that to create Titian blue you combine ivory black pigment with Prussian blue and Indigo?' Benjamin West was saying. 'This does hold fascinating possibilities. He is a master of all colours, but to my mind no other artist has managed to work with blue as

powerfully as Titian.' He looked at Ann Jemima. 'Where I come from in Pennsylvania there are lakes that on sunny days seem to embody the most intense shades of blue that nature has to offer. Yet they are as nothing next to Titian's *Bacchus and Ariadne*. The blue of the sky alone in that picture seems to contain several other colours, and yet it is the purest blue you have ever seen. He uses the most costly lapis lazuli as his dominant shade. As well as hypnotising the eye…' he paused, 'it displays the considerable wealth of the man who commissioned it. But it is through the sense of shifting colour, in the blue shadows on Ariadne's dress, in the mountains behind Bacchus, in the modulations of the clouds that the painting truly comes alive.'

'Mr Cosway showed me a copy of the painting,' Ann Jemima replied. 'He was not as eloquent as you on why it beguiles so much. It felt to me as if I needed new eyes to appreciate it.' Provis could sense her mind racing for more terms with which to flatter him – she knew that at this moment West was most susceptible to her persuasions. 'And ears too, for it resonates like a note played on a 'cello. I could have sat in front of the painting for ever.'

Provis coughed with embarrassment. She has gone too far now, he thought to himself. Only a mad person would talk about hearing a colour. But while her head flicked round nervously at the sound of his coughing, to his surprise, West was nodding approvingly.

'You are right, sometimes one sense does not seem enough to appreciate a painting. Many of the Venetian artists were also musicians, and debated how colour, like music, could influence mood.' The gleam in his eyes was that of a teacher who had suddenly realised his pupil to be more precocious than he suspected. 'I very much appreciate your bringing this to me, this has been a most informative session, most…' he paused, as if weighing up the words in his head, 'valuable. I know you said I cannot keep the manuscript, but can we meet again to talk about this. Believe me when I say I am not casting any aspersions on you, but the crucial issue for me at this point is to prove that this discovery is authentic. Certain experiments need to be performed based on what I have learned today. Will you be kind enough to grant me a few weeks before I come back to you with my answer?'

• • •

Provis did not admit to himself straight away that the visit had gone better than he had anticipated. He was too distracted by his concerns about Cosway's role in the success. Though once we receive the money… he thought to himself. Then he shook his head in disbelief? £500?

He had been as surprised as anyone else to find himself standing in West's drawing room. His initial instinct had been to write to the American and distance himself from Ann Jemima's approach. To ask indulgence for her over-eagerness, and say that these were worthless family papers that should probably have been buried along with his grandfather. To suggest that they should be returned, with nothing more being said of the matter. Yet the more he reflected, the more he realised that no good could come of such a gesture.

Instead, his keen perception of human nature had led Provis to resolve on another course: to avert disaster by becoming Ann Jemima's greatest ally. He would develop an expertise in this strange subject, would learn to see and appreciate the document in the way she saw it. He had shared Mrs Tullett's astonishment at the sum on which Ann Jemima had finally decided. Yet he had resolved it was part of his pact with Ann Jemima that they should charge it as an appropriate amount. 'If we receive that money…' He shook his head again. 'No, the old seamstress was right, though I will never confess it to her.'

Now that the visit had gone well, each day of waiting for West's response chiselled away at Provis as if it were a knife. It was two weeks before that first Christmas that he finally arrived on their doorstep.

Sleet whistled in the door as they let him in. Yet already Provis noted that where at his house he was friendly but removed, now he forbore to show his teeth when he smiled. West asked if he and Ann Jemima could spend a few hours together while she took a prepared canvas and demonstrated the technique in the way that she understood it. He revealed he had spent much time reflecting

on what she had told him, but was not quite sure he had grasped the essence of it.

Yet still he did not offer payment. Provis's mind was thrown into turmoil. 'What is his motivation?' he asked himself, 'what is his intent'? Yet even viewed through the eyes of suspicion, West's visit to their tiny apartment seemed to bode well. Provis marvelled at how Ann Jemima talked to West like an equal, and at how charmed once more the President of the Royal Academy seemed to be by her cleverness. Observing the progress of their friendship, Provis suddenly realised that it might be reasonable to expect at least two or three hundred pounds. He informed Mrs Tullett with uncharacteristic optimism that he expected an agreement to be struck by the end of January at the latest.

But it was not.

Weeks and yet more months progressed, and still no money came. The bare, shivering arms of the trees along the canal in St James's Park became covered with spring blossom, which in its turn yielded to a triumphant ensemble of summer foliage. As the sun climbed ever higher in the sky, Provis began to develop aches and pains accompanied by an increasing rigidity in the jaw. West had made his interest clear. What, now, was the delay?

'Let us go and see Mr Cosway,' Ann Jemima had said. 'He will have a strategy.'

Provis's hatred consumed him like molten lead.

'You know Mr Cosway has done enough. You know that he is more likely to cause problems than solve them,' he said.

'As long as you are with me, there will be no problem,' she had replied crisply. 'West has clearly shown his interest. We have every right to expect the money. There is something beyond our comprehension that is causing a delay. Mr Cosway will be able to explain it.'

Provis's hostility increased as he realised during their visit that Cosway could hardly be bothered to look at him. His eyes either locked with Ann Jemima's as she talked, or lazily roved up and down her figure as Provis put forward his concerns. 'If Mr West is taking a while to make any payment, I would not concern yourselves,' he said. 'He is highly occupied. Not only must he oversee the Royal

Academy, he is also in negotiations to buy paintings that have been smuggled out of France. I know, Mr Provis, that you as a connoisseur are well acquainted with the extensive market for art that has sprung up in England since the French Revolution. Some of it reputable, some of it not.' He sniffed. 'It is astounding quite how many London residents are happy to display stolen artefacts in their reception rooms as trophies that have been saved from the mob.'

Finally he looked directly at Provis – Provis stared directly back.

'A particularly interesting collection arrived a few years ago on these shores,' Cosway continued. 'It is no exaggeration to say it contains some of the most important works in the world. Titian's *Diana and Callisto*, Tintoretto's *Deposition of Christ*, a Raphael Madonna.' He rubbed dry fingers together – with a flinch of disgust, Provis saw flakes of skin falling to the floor. 'Negotiations to buy these works are of course above board if complex,' he declared. 'Benjamin West has made various attempts to secure them for the nation, but there are other powerful buyers who are interested, and he faces a difficult task. In truth, you should take heart from the fact he has shown enough interest in the method to make time to come back to your apartment to talk further. In my opinion that shows he has a strong intent to give you the money.'

'The deal is still alive,' Provis announced to Mrs Tullett. Outside the palace, summer leaves danced in the sun. Yet autumn would steep the leaves in red and orange hues before West finally became more overt about his interest.

'He has asked me to go to his house to create a new painting with him,' Ann Jemima declared that October. Suppressed excitement in her voice like packed gunpowder.

Surprise took Provis's own voice away – he stood there shaking his head.

'He wants us to paint Venus and Cupid,' she continued. 'The President of the Royal Academy wishes to create a painting with me so that I can demonstrate afresh those aspects of the method we have chosen to reveal to him. He is becoming obsessed.' She laughed. 'It was you who said that anyone selling to connoisseurs thrives on their obsession. You see, I truly have taken your lessons

to heart. Now we see that our buyer is truly captivated, there is no limit to the deal we can drive. Our faith in this manuscript has proved justified.' Her voice became quieter and more intense. 'The knowledge it contains is every bit as valuable as we suspected it to be.'

By this point Provis had allowed himself to think that maybe they might receive £400 for the method. Yet October gave way to November, which in turn abdicated – along with its cold wet nights – for the snowy reign of December. West had still not paid a guinea, and now even Ann Jemima's optimism was dissipating. After her encounter with Darton, she had become especially struck by the way the President of the Academy slipped like an eel in lard away from the question of what he should pay them. 'He says he must perform yet more experiments,' she declared with impatience when she returned home to Provis after her third visit. 'Sometimes he claims he is not satisfied with the colour of the canvas, sometimes he is not convinced that the glazing technique is truly that of Titian.' She threw her hands up in the air. 'It is most vexing. Whenever I refer to the matter of what we should be paid, he either changes the subject entirely, or looks at me in a way that implies I am being vulgar. When all the while it is he who is being vulgar by assuming he can take the manuscript for nothing.'

Provis nodded angrily at her final words, but though they contained the ring of truth, still he did not believe them. One evening, as Ann Jemima and Provis played cards in front of the fire, a knock came at the door. There, to their surprise, was a man dressed as if he intended not merely to survive the winter cold, but to do battle with it. His figure was shrouded in a cape, his head was covered with a beaver hat, and a scarf was wrapped so tightly around his face it seemed to mummify it.

The layers were finally removed to reveal the person of Mr Cosway. Provis felt the usual hatred. Yet on this occasion it was accompanied by mild excitement. He knew the artist could only be coming here at this time of night to reveal something of importance.

'What do you know, what have you heard?' he asked. All Cosway could do in response was shake his head.

'Bring me brandy,' he begged, as he stood, teeth chattering. Then, as he was rushed to the chair closest to the fire, he added 'Pour some for yourselves as well. I bring very grave tidings.'

They all stood round him frowning as he took his first sip of the drink. At this encounter, Provis noted, Cosway chose to look at all of them equally rather than just at Ann Jemima. Tonight he was not in the mood for flirtation.

'What have you discovered?' said Ann Jemima after a few seconds.

The pallor of her face, the terrible flatness of her voice.

'I have advised you wrongly,' Cosway replied. 'It seems that Mr West has been playing games with you all this while.'

'What kind of games?' asked Provis uncomfortably.

Cosway took a deep breath.

'He has taken a friend of mine into confidence at the Royal Academy, and has shown him the painting he has recently done with Ann Jemima.' He paused. 'When my friend told me of this, I of course talked of you, but he was not aware who you were. I am sorry to say this, Miss Provis. But Mr West is claiming that he painted it alone.'

For a second it felt to Provis as if everyone in the room has stopped breathing.

'*The Venus and Cupid?*' Ann Jemima finally asked. 'You are sure?'

He nodded gravely. 'The very same.'

Her face was stupefied. 'On his own? How does that profit him? Why can he not acknowledge my...'

She shook her head, unable to say anything further.

'And is he talking about the technique used to create the picture?' asked Provis gruffly.

'He is not merely talking about the technique,' replied Cosway. He looked directly at Ann Jemima. 'In an unguarded moment he has said it completely reinvents the way we look at colour.' She gasped. 'He is not ready yet to share it with other members of the Academy, he claims. But there is no doubt that he intends to use it to prepare all his pictures for next year's Royal Academy Exhibition.'

'Then he is convinced...' Again Ann Jemima's words trailed off. She swallowed. 'And yet he mentioned nothing of me,' she turned to Provis, 'or Mr Provis?'

'My informant told me that when he asked him where he had got the technique from, he was most evasive. If you were being charitable, it means he does not want the other artist to track down its source quite yet. But the time that has elapsed since he last saw you,' he nods towards Ann Jemima, 'and his assertion that no one helped him with the very painting you both prepared together. These things are of concern in terms of his intention to make a payment.'

Ann Jemima was about to speak, when a low growl came from Provis's direction, and her open mouth, instead of releasing words, emitted a shriek.

'This is an outrage,' he roared. 'All the time we have taken...'

In the blurred room in front of him, his daughter's white face came into focus.

'He has betrayed me! Has betrayed us!' Her eyes as agitated as lightning-lit seas, the tears plummeting down her cheeks.

She ran over to Provis, and he put his arms around her.

'He has no intention of giving us any money. This is theft. He is telling lies, lies to everybody to take all the credit himself.'

The heat was building in Provis's head. This news both mocked and justified all the pain of the last year.

He looked over to Cosway. The artist was leaning over from his chair to pick up the brandy glass he had dropped in shock at Provis's roar. 'You have known Benjamin West longer than we,' Provis said. 'Were you aware of this dishonesty in his nature?'

'I feel I owe you my apologies,' replied Cosway. He looked with concern at Ann Jemima who was now standing back and wiping her eyes angrily. 'In truth, I have never known him dishonest before. It was my folly to make excuses for him where he deserved none. If I had not, you would have been on the trail sooner.'

'Can the situation not be remedied?' Ann Jemima asked.

Provis glared into the fire.

'There is, indeed, a happy element to this in that he is telling a confidante that he believes the method is extraordinary,' Cosway

replied. Both he and Provis stared at Ann Jemima intently for a moment. 'Almost as extraordinary as the woman who brought it to him...' Cosway continued softly.

'... But that means that there is at least one witness to the fact that he owes us money,' interrupted Ann Jemima, unwilling to take the flattery.

Provis glowered. 'Surely we can challenge him?'

'Indeed, he has had no one challenge him yet,' Ann Jemima replied. She turned to Cosway. 'What if we threaten to bring embarrassment upon him if he does not give us the payment? Might that change his attitude towards what he owes us?'

The small spark of cheer that she had tried to ignite was snuffed out at the tone of Cosway's voice. 'It would be a dangerous strategy, and one I would not advise,' he replied sombrely. Provis walked over and poured him some more brandy. 'I will do what I can to help you. But remember this in all your actions. Despite the disagreements between them in recent years, Benjamin West remains close to the King. He has decided – as we hoped – that this is a most important discovery, but at the same time he has decided that he has the prestige to preside over it and you have not.'

'In my eyes that is straightforward theft,' muttered Provis.

'Theft, yes, but it is not straightforward – and Mr West is clever enough to play that to his advantage. We cannot understand at this stage what subtleties he has used to justify this action to himself, or to others. If someone should tell the King that you are expressing displeasure, and persuade him your accusations are unfair on any level,' he continued, 'it will take but a second for the King to choose between you and West.'

'But there are witnesses,' Ann Jemima replied. People like you. Surely if you say what you know, West will have to confess.'

Richard Cosway paused. 'I wish it were so. But go about this the wrong way, and it will rebound badly. After all, West has his entire reputation to lose if your story is proved to be true. Yet he has calculated that he poses an even greater threat to you, and indeed to anyone who supports you.'

'In what way?' Ann Jemima asked.

'I have no desire to be saying this,' Cosway replied. 'At the moment you have a roof over your heads and a salary on which to live. A thousand people would fight for the same life as you have. Believe me, I wish you well in this. You are good people, and if you play this properly, you may well have something to gain. But be mindful,' he continued, gesturing around him, 'you also have much to lose. More than you have lost already.'

Joseph Johnson
delivers a warning

*'I do not wish them [women] to have power over men;
but over themselves.'*

Mary Wollstonecraft,
A Vindication of the Rights of Woman, **1792**

London sleeps. Yet though the jabber of voices is stilled, and the dark dissolves the distinction between one house and another, there's still a sense of the constant ferment that makes a city. Hundreds of thousands lie in their beds, but their ideas, dreams and motivations swirl and mutate in the encompassing blackness, colliding blearily as they head towards the light. Some of these ideas will burst the moment day breaks, others will go on – for better or worse – to subtly alter the chemical composition of the city.

While the residents of King George's court anxiously survey the shifting scents and tastes of the social brew that surrounds them, two miles away the publishers of St Paul's Churchyard see it as their job to keep it constantly simmering. These are the men who decide daily which writers will stir the city to argument, and which will entertain it. One of these publishers is Joseph Johnson, who on this cold night – not for the first time in recent months – finds

himself unable to sleep. He is more haunted than ever by the fears he expressed to Fuseli at their meeting in the tavern. Noises from the pavement outside have broken his dreams and he has woken with a start, worried that finally Pitt's spies have configured a motive for arresting him.

He still carries scars from being in the witness box for the treason trials three years ago. More than thirty men had been arrested – many in the middle of the night – on suspicion of conspiring against King and government. It was the latest of William Pitt's bids to paralyse the political groups agitating for change. For Johnson, it was the first time he had felt that danger was just a breath away – slinking beneath his every waking thought, holding him rigid as he slept. The government had passed a measure saying that anyone they chose to arrest could be held for months first in the Tower of London and then in Newgate Prison without being charged. None of them knew if they would ever be released. Many of his friends had spent months in the dark, clad in irons and subject to the kicks and jeers of prison guards. All faced the prospect – if they went on to be convicted – of being hanged, drawn and quartered.

'Pitt the scrawny wants the radical movement for breakfast, yet we shall give him nothing but stomach pains,' Johnson's nephew had declared angrily. Of the three men who were eventually charged with high treason, two were regular guests at his house. Though Johnson was only asked to appear as a witness, he can still remember the cold fear that surged through his heart when he received the summons. In court, as the barrister prowled before him, the two things foremost in his mind were his desperation not to betray his friends and his determination not to lose his business. He had never met the lawyer, but he felt the force of his loathing for the man sting the air as he gave his answers. As it was, his appearance proved a masterpiece of evasiveness. Afterwards a friend of his had overheard the lawyer in a tavern cursing that Johnson must be the only man who could run a successful publishing house and yet know less about it than a penguin from the Sandwich Islands.

The scuffling in the alley outside grows louder. Despite his fears he looks out of the window. Below a stray dog wrestles haplessly with a pile of rubbish – as he holds his oil lamp out of the window he can see the tension in its spine as it pulls till it finally extracts a rabbit carcass. He grips the windowsill tight for a moment, then laughs wearily to himself and returns to bed. Around him the darkness feels hard, unyielding. He feels its mockery as in vain he closes his eyes, bidding the onset of sleep. St Paul's cathedral clock tolls every quarter hour like a hammer on his brain. At five thirty in the morning, finally he rises, deciding he will do some work before he makes the visit that has been preoccupying him for days.

The shadows loom and recede as he goes downstairs and places his oil lamp on the desk. Before him is the latest edition of *The Monthly Magazine*, and an article on the philosopher from Konigsberg, Immanuel Kant, that he must edit by the end of the week. He begins with enthusiasm, but though he has no recollection of falling asleep, at one moment St Paul's is chiming a quarter to seven, the next it is nine thirty. His vertebrae have the stiff slightly aggrieved feel that results from spending time vertical that could have been spent horizontal. Beside him is a cup of tea whose temperature indicates it was brought to his desk some time ago.

He stirs himself and goes to the window. People are moving along the streets warily, as if caught under the gaze of a large unforgiving eye, sceptically scrutinising their fragile hopes for the days ahead. He calls out a ragged thank you for the tea to his housekeeper, before informing her that he is now ready for breakfast. Then he goes back upstairs to dress himself.

An hour later he finally emerges from the front door of his business, clasping a large book. The Hackney coach drivers waiting in the Churchyard are shouting obscenities back and forth to each other, while their mangy horses chafe at lice and drink from the gutter. A driver leaps down from his seat and holds the door open. Johnson can smell the mustiness of his cloak as he climbs into the carriage.

The book is so weighty he tilts heavily to one side as he gets in, but just when it seems inevitable he will fall he lands the tome on the seat and with a grimace settles himself next to it.

As the horse passes the cathedral, he reflects, not for the first time, on the irony that a Dissenting man such as he – dedicated to scepticism and rationality – should work so close to a building representing the monarchy and faith. Rather like a disease, he reflects, institutionalised religion comes with its own set of symptoms, whether it's the crow-black flocks of clergy hurrying up and down the cathedral's main steps, or the lost souls in the Churchyard seeking anything from soup to spiritual redemption. Some are more notable than others. A pock-marked man now trudging to the top of Ludgate Hill is possessed by the belief that he is the Virgin Mary. His ragged blue headdress and halo are worn above traditional gentleman's garb. Johnson knows him to visit the area regularly. Unlike the masqueraders who throng to balls in their costumes at Christmas time, there is no self-consciousness about his attire. Sometimes he sits and wails on the cathedral steps. But more often he interrupts the course of passers by, admonishing them for their sins till they either push him aside or give him a penny to buy pie and ale.

Now the horse picks up its pace as it heads out of the City and towards the village of Islington. From the dark huddled houses along the route he can see faces peering out from windows that are often dirty and broken. Many of his friends flock to Islington for the weekend, but in truth Johnson thinks the pleasures of the village overrated. He appreciates the fresh milk and cheese that come from its dairy farms, but he doesn't understand the desire of so many educated Londoners to go, as he says, 'to make communion with its cows'. His own destination is a house just short of the village, at a residential street close to the Euston Road. It is the point where the city starts to flirt with the countryside – allowing patches of open land to appear as cautiously as if the natural state of the world were urban, and these flashes of frozen grass and trees the first signs of a revolution that might eventually overcome the stone and brick.

'You are in danger of dying from the weight of that book,' the woman says as she opens the door to him. 'Put it down and take

your coat off.' Her voice is low and severe, but her eyes burn lightly with amusement. 'Though it would be a fitting epitaph for a bookseller – crushed under the weight of his latest talent,' she continues. 'I hope the writer is a good one.'

Johnson deposits the book with relief on the table in the hall and darts her a glance. He takes in the pensive, slightly flushed face, the soft brown wispy hair, the dark, stern eyes.

'It is the book you have been asking for recently?' he says.

'The anti-slavery work? Stedman's expedition to Surinam?'

He dips his head. 'Illustrated by your old collaborator William Blake.'

Swiftly she opens the book's cover and turns to the first illustration. 'It is more than a year since I saw Blake last. How is he?'

'Still mad as a glow-worm,' declares Johnson with a quick smile. 'Yet he has done fine work here. What he has done is quite different from his more hallucinatory works. His images are most simple yet they provoke to the extreme. When you study them, they show quite clearly the humanity of the black man and the inhumanity of the white.'

She frowns as she flicks through the book.

'Yet they are very clean images, considering what they depict. Whippings, hanging…' She peers closer, then looks up in horror at Johnson, 'by the ribs, all manner of other torture.'

'It is the most powerful book for the abolitionist movement I have seen.'

'It would be more powerful yet if Blake had been allowed to illustrate it in his own style.'

'Mary Wollstonecraft, you were never a woman to accept compromise.' The amusement in his eyes has a sheen of exasperation. 'I think it is a tonic for Will Wilberforce. Many do not want to abolish the slave trade because they still make a huge profit from it. This book means they cannot hide from the consequences any longer.'

The woman regards him for a moment, then leads him through to her dark green parlour. It is a small room, rendered yet smaller by the precarious architecture of piled up books interspersed with the

corpses of toy soldiers. A fire spits sparks up into the chimney. On either side of it are two elegantly-carved India-back chairs, while in the middle of the room is a drop-leaf table, slightly past its prime. She indicates to Johnson to sit to the right of the fireplace, while she takes the chair on the left.

As he sits he looks at her searchingly.

'We have a long history of being direct with each other, Mary.'

She raises her chin slightly. 'This sounds most serious, Mr Johnson. What is your accusation?'

'It is rather,' he clears his throat, 'delicate. If you'll permit me, I have been so proud of being your publisher…'

'…you are more than my publisher, and you know that. You are my dearest friend. You have saved me from destitution. You have seen me through both tears and laughter…'

'Yes – you have always been one of my more tempestuous writers.' His smile at this point has an edge of weariness. 'To be the friend of the writer of *A Vindication of the Rights of Woman* may yet prove my greatest achievement,' he continues. 'So I trust my question will not offend you.'

'You are scaring me. The more you compliment me, the more I worry what you are about to say. Please state your question without any further delay.'

He takes a deep breath.

'Is all well with you and Mr Godwin?'

Now it is her turn to look at him searchingly.

'It has only been a few months, I concede, but so far very it is very good indeed. After our unpromising start it still feels like something of a miracle.'

'It was a terrible start…'

'And the fault was very much yours.'

Unwillingly he laughs.

'It seemed an excellent idea to invite you both to dinner to meet Thomas Paine. I did not foresee that every time Paine tried to express an opinion…'

'… I would have more to say on the subject than he did,' she retorts.

'I thought Godwin would never forgive you. I half expected him to detonate that night. Afterwards he said you were the most loathsome woman he had ever encountered.'

Her smile is triumphant.

'This morning he came over from his house as he does every day now, and we drank coffee together. He is happy that his book is selling well, but, as you know, Mr Godwin is never truly happy until he perceives some complication. Today he fretted that he was one of the few not to be censored by William Pitt.'

'Because of his novel?'

'No, no, his work on political justice. I spent much time soothing him, assuring him that if I were Prime Minister I would have no hesitation in throwing him in prison for sedition. So as you can see, the flame of our love still burns strong.'

He laughs with relief at the acerbic glance with which she delivers this. 'I am pleased indeed to hear that. Though censorship is no matter for jokes…'

'I am sorry, Joseph. Sometimes we need to find cracks in the darkness.' She looks at him suspiciously. 'Why do you ask about Mr Godwin and myself? He has not been seen in the company of another lover, has he?'

'No, no, no. It is not the company Mr Godwin keeps.'

'Then what?'

'There are certain rumours reaching me about a male visitor you have been entertaining recently.'

There is a sudden half-light in her eyes that he cannot quite understand – both teasing and suspicious.

'I can't imagine what you are talking about. What might the name of this visitor be?'

'John Opie.'

She stifles a laugh. Turns her head to look at the dart of orange and red in the flames, as if it is from there she will draw her response.

'John Opie is a very good friend, but nothing more,' she says. 'We have known each other for years. He is painting my portrait and will be here later this morning for the latest session.' Her voice

swoops low with amusement. 'Did you truly think I had taken him as a lover?'

Johnson regards her quietly without answering.

'When he visits, we talk about painting, philosophy, and the women with whom he is in love, who do not include myself. We are more like brother and sister.'

'Well that certainly accounts for how often he is seen coming to your house.' He smiles, feels the knots releasing at the back of his neck. 'You are absolutely sure you are not brother and sister in the sense of Jupiter and Juno?'

'No, no, you are wicked. Not in that sense at all. It is still Mr Godwin who resides highest in my affections. He and Opie are extremely good friends, which, as you know, would be impossible if there were any hint of interest on Opie's part. Mr Godwin may be famed as an anarchist philosopher, but he is most territorial.'

They stare at each other for a moment.

'That is reassuring to hear. Very good to hear.'

'I appreciate your frankness, Joseph. I must confess you are not the first to accuse me thus. Why were you so concerned?'

He takes a deep breath.

'What happens to you in matters of the heart is of course your own business. But I must confess mixed reports had reached me of Opie before now, and I was a little concerned when I thought he might be your latest suitor. He has a reputation for displaying poor judgement in personal matters.'

'And I was the latest example of that?'

His eyes, dark as flint, spark their denial.

'You know that was not my allegation.'

She looks into the fire again and surveys the flames sharply.

'I will concede that Mr Opie can on occasion be naïve,' she says. 'He was in love with one of his sitters, a young woman called Elizabeth Delfton. I met her once at his apartments – I would say that many see her as a considerable society beauty, not least Elizabeth herself.' They exchange wry glances. 'He wanted to marry her – but was worried that her wealthy parents would not be impressed by the advances of a painting teacher.'

Johnson nods. 'So things go in conventional circles.'

'So he tried to set up a go-between to assure them of his respectability. At one point he asked me if I would perform the task. I took a certain amusement from asking him what would outrage them the most. The fact that my husband deserted me a year ago, the fact that shortly after I tried to kill myself, or the fact that I am vulgar enough to champion the rights of women.' Her laughter is metallic, defiant. 'Poor Opie was lost for words. I thanked him for asking me, but pointed out that the devil would scarcely horrify them more.'

Johnson looks stricken. The memories from a year ago are locked into his body now, they lurch grey and confused in his stomach, and suddenly bring unexpected tears to his eyes. 'Mary, I am glad you can make light of it,' he says, recovering himself. In his mind again the knocking on his door in the small hours of the morning, the breathless messenger outside. 'I am still consumed by fury when I think how we almost lost you. Your last husband was a liar and a scoundrel – he was not worthy of you intellectually, or as a human being. I cannot bear the thought of you throwing yourself into the Thames, the thought…'

He leaves the words unspoken, clenching and unclenching his fists. A maid appears at the door.

'Would you like some coffee?'

Her question drops like a pin into the brief silence.

'Marguerite,' says Johnson quickly rising. He looks across to Mary, and rebukes himself that she looks crushed. He walks over and touches her lightly on the shoulder before going over and embracing Marguerite.

'It has been too long since we have seen you, Mr Johnson,' Marguerite declares, returning his embrace. She steps back and looks at Mary. The glance that is returned to her is not the kind that goes between employer and employee, but a glance of acknowledged solidarity. Johnson reflects how the maid has supported Mary through marriage and pregnancy in France, through the bitter return to England, and after her suicide attempt the year before.

'I would very much appreciate a coffee,' he declares, trying to ease the atmosphere. He looks to Mary, who nods briskly.

'Would you like anything to eat, Joseph?'

Johnson inhales sharply as he considers. Finally he shakes his head.

'It is very kind of you. I will not be here long today, so I think I must say no.'

He comes and sits down again. His face is pinched and drawn.

'To return to a happier subject,' he says quietly, 'we have established that Opie is not your suitor and Godwin still is. That means we can talk about Opie with perfect freedom. Mary, he has some most alarming connections.'

He becomes aware he is starting to shake.

'Joseph, are you quite well?'

He pinches the top of his nose.

'Forgive me. I am making you wretched.' He pauses, and she watches him warily.

'There is much talk that the French are joining forces with Irish Republicans to invade England.'

He can see she is astonished.

'I feel I should be pleased at this news, yet I know not what to think.'

He nods his agreement.

'Nor indeed do I. But I know and have had dealings with some of the Irish Republicans who are planning it – and the authorities are aware of my connections.'

She leans forward and frowns.

'I did not sleep much last night,' he continues. 'William Pitt has made me feel I am not safe even with my own thoughts. There are times when this whole country feels like a prison.'

'I should not have joked about censorship...'

He holds his hand out.

'No, no. You are one of the bravest of my writers – we must be able to make light of this if we are to survive it. Though there have been times in recent months where I have found myself

tempted by thoughts of emigrating to America again.'

She watches him for a moment.

'I can understand your sentiments, yet you would be wretched there. You are needed in London, you are a part of it.'

He composes himself with a thin smile.

'I understand that Opie had a patron, Peter Pindar…'

'A most sinister man,' interrupts Mary. 'He is one of those who preys on the young. In Cornwall he realised that Opie had the kind of talent he would never have. He was utterly unscrupulous in creating a rift between him and his family. Then he introduced him to London. Opie at first was too young to see the monster he was. But when he did he was horrified. In December,' her voice goes quiet, 'Pindar seduced Miss Delfton.'

Johnson frowns. 'I know not what to say.'

'Opie has written to her, but she has not replied. As you can imagine, now Opie does everything he can to keep Pindar at a distance.'

Johnson dips his head as if to duck the flurry of her outrage.

I know that Pindar has made a name for himself by writing satires,' he says. 'You say he and Opie are estranged?'

She nods. 'But he has written many vulgar poems about the painters he sees as Opie's competitors. I was looking at some of his doggerel. He makes a number of attacks on Benjamin West – describes his paintings as no better than floor cloths. It is cheap stuff, yet to my surprise he has become somewhat influential.'

Johnson sits back in his chair. He constructs a bridge with his fingers, over which he looks at Mary.

'So I too have little regard for the man. Even so, I was shocked to hear of a highly sinister trick Opie and a friend of his played on Pindar.'

'A sinister trick?' She darts him an incredulous glance. 'Mr Opie?'

'Oh yes.' His voice drops. 'It deals in the all too serious matters which we have just discussed.'

He takes a deep breath. Smiles at her, but the warmth of the smile does not reach his eyes.

'Pindar has recently decided to make his satire political. He has

penned some rather pathetic lampoons of the King. It is clear to anyone with a splinter of discernment that he is a Narcissus more than he is a humourist.'

'You mean that he champions Republicanism in order to attract attention to himself?'

'Quite. I do not truly believe that he has any serious dispute with the monarchy.'

'That is a rather dangerous game to play.'

'I agree entirely. So, it would seem, does Opie. Earlier this year Pindar began to attend meetings for radicals. He was noticed because, as you know, Pitt has ordered his spies to infiltrate radical gatherings. Friends of mine made it their business to find out more about him. Yet those who talked to him largely concluded him to be a trivial man, and that he was attending these gatherings to find more readers to sell to.' He puts his hand to his forehead. 'He disappeared last month.' He can hear the flatness in his voice. 'Nobody knew what had happened. That was the point at which I found out that John Opie and a friend of his had decided he needed to be taught a lesson.'

Mary is very quiet now.

'Opie's friend is a certain Josiah Darton. An interesting man, Mr Darton – like you he has travelled to revolutionary France. He consorts with radicals, including our Leader of the Opposition, Charles Fox. Yet he also sings in the choir at the Chapel Royal in St James's Palace.'

'So is he for the monarchy…'

'… or against it? A couple of months ago I would have said against. But for obvious reasons it suits Mr Darton that nobody is quite sure. Since his last visit to France he has been observed on at least one occasion coming out of Mr Pitt's residence.'

Johnson starts to shake again.

'Opie asked Darton to go and position himself across the road from Pindar's house dressed in a greatcoat and slouched hat,' he continues. 'It was a piece of amateur theatre, somewhat pathetic.'

Mary tips her head to one side.

'Opie then went and knocked on Pindar's door. He informed him

the man across the road was one of Pitt's spies and had a warrant for his arrest. Pindar was terrified. Scared for his life – with Opie's help – he climbed out of the back window. From there he fled to Windsor. He remained in hiding till yesterday when he returned to London, and I became aware of the whole story.'

Mary studies Johnson's face for a long while before responding.

'I am most disappointed in Opie. It is a cruel joke – especially viewed by one such as you, who is pushed almost to madness by this threat,' she eventually says. She gets up and walks to the window. 'It would have been unforgivable indeed,' she takes a deep breath, 'had it involved any other individual.' She collects herself and advances her next words carefully, like weights on a pair of scales. 'But Pindar has been a parasite on his life for years. There were times when we talked of him when Opie was racked by tears, so furious about what he'd done that I was worried he was going to go off and murder him. He is still too ashamed to go and see his father. Can you understand how deeply this has wounded him? I think it says much about his good nature that Pindar hasn't been found in an alley with his throat cut.'

Johnson's nod is slow and conciliatory.

'It would make me happy not to condemn him. The art world is a crocodile pit full of opportunists, and from what you say Pindar deserves all that he suffers.' He stands up and joins her at the window.

'Yet even if Opie's intentions are ultimately good, do we know precisely what Darton is up to?'

He looks at her intently. 'In this city most of our friends are being watched. The fact that Darton and Opie are friends, and Opie – I presume – spends many hours in conversation with you while he is painting your portrait…'

She puts her hand to her mouth.

'Opie would not inform against us.'

'But he is, as you have said, a little naïve.' He takes a deep breath. 'And with the threat of invasion looming, Pitt's spies will use the slightest excuse to round up anyone who attracts their attention. Has Opie ever talked to you on such matters?'

She shakes her head.

'Then let it remain that way,' he continues. 'I am uncertain who Darton spies for, as I have said. But as long as there is any doubt, please can I enjoin you to be careful in what you say? Could you also refrain from corresponding on paper with Mr Opie?'

She is reflective. Walks over to the window, and briefly splays her hand against it.

'What kind of world do we live in, Joseph? The most harmless of connections can suddenly seem treacherous.'

'I know.' His tone is conciliatory. 'Perhaps I am being over-cautious. Perhaps I need to discover how to laugh again. But Pitt is merciless. And I would prefer to stay outside prison for a while longer.'

A discreet chink of coffee cups announces that Marguerite has arrived back in the room. Just behind her toddles a small girl in a light blue gown, with dark eyes and fierce black curls. She lurches uncertainly towards Mary, who swoops her up and kisses her before she reaches the fireplace.

Johnson turns too. The darkness on his face lifts.

'Her character is just like yours,' he declares, as the child lets out an elemental howl and demands to be put down. 'Extremely independent. And thank the Lord, she looks nothing like her father.'

Mary puts the child down for a moment and watches with interest as she lunges towards one of the soldiers. Then she walks over to the table and pours a cup of coffee for herself and Johnson.

'Is it possible to trust anyone in London these days?'

'I trust you,' replies Johnson taking a sip from his cup. 'But that is about the extent of it. And now, much though I would like to spend more time here, I must go.' He takes a further, longer sip. 'My other reason for coming here was to come to ask you to dinner a fortnight hence. Could you pass on my invitation to Mr Godwin?'

'You must not invite us as a couple.' Her voice rings out in mock rebuke. 'We are lovers, but we are not like two dogs chained together

in Hogarth's *Mariage A-la-mode*. You can invite us separately, and we shall decide individually whether or not to attend.'

Johnson nods. 'Of course – I should not have expected either of you to stick with convention. I congratulate you heartily, Mary. It seems that in Godwin you have met your match on every level.' He tilts the final dregs of coffee down his throat. 'Now remember what I have said. Stray not into politics when you talk with Opie.' He puts the cup down and solemnly takes Mary's hand. 'All of our futures may depend on it.'

CHAPTER TEN

Ann Jemima's flight

'Take some soot and grind it with urine, upon a shell, until it is perfectly refined; then put it into a glass vessel, that has a large mouth, filled with clear water; stir the mixture with a wooden spatula, and let it settle for about half an hour; the coarsest part will fall to the bottom; the liquor is then carefully poured into another vessel; the sediment is the most inferior Bister and is thrown away. The same operation must be repeated with that which remains in the second vessel; it is then emptied into a third, and after letting it remain for three or four days, you procure the finest Bister.'*

Constant de Massoul,
A Treatise on the Art of Painting and the Composition of Colours, 1797

Ann Jemima is walking, stumbling, trying to hold her chin firm, intent on not losing her composure. Hobnailed boots of self-reproach stamp through her mind, but she cannot dwell on such thoughts for long, she must keep her head up, up, look at the buildings around her, chart her route across London before she is stopped. Her chance to leave the palace came at seven thirty this morning after Provis left to prepare the chapel for the eight o'clock

* A dark paint used for the mixing of earthy colours.

communion. The lock clacked shut behind him, and she slipped into a grey cape, making a ghost's escape ten minutes later. She is furious at West's deception, smarts with the humiliation of it. Cosway's words reverberate. 'Go about this the wrong way, and it will rebound badly.'

The best I can do is be gone, she thinks with fury.

Her anger blows her up to Piccadilly, past the Bath Hotel and Fortnum and Mason's, past the silent booksellers and after-the-night-before taverns, to Piccadilly Circus. She has never walked this far outside the palace without an escort, she knows already that to be on the streets alone raises questions about her virtue, her social status, her marriageability. All around her the polished windows stare. Yet the recklessness of what she is doing helps to lift her spirits, and on she blows, through the gardens of Leicester Square with the statue of George I rising up in the centre, through Charing Cross, and on to Covent Garden. There the prostitutes linger in doorways, singing raucous songs and calling out to passers by. Their painted faces like masks, their thoughts part of London's great untold story. Ann Jemima looks towards them, pulls the hood of her grey cape over her head and continues.

She has put on kid-leather half boots in preparation for her long walk, but already the leather is splattered with dirt and beginning to tear. She frets that her entire wardrobe has been designed as if by captors who anticipated that one day she was going to make this escape – her skirts and petticoats hinder her speed and two or three more miles will destroy her boots. She does not dare to hail a Hackney carriage – it will provoke too many questions, and will also create a witness to her flight. Instead she threads her way up the alleyways and to Holborn. In her head, past, present and future collide.

She had thought she was getting the sense of West. He had seemed different – because he was an American he seemed like an outsider, just as being a woman made her an outsider. Somehow this connected them, though if asked how neither of them would have been able to articulate it. Where Cosway patronised and played sexual games, West had revealed himself as his antithesis.

He was socially awkward at first, which had made him seem cold and uncomfortable inside his own body, almost as if nature had bestowed on him a physique too large for his confidence. But in subsequent encounters he became generous, unpredatory, effusive about both the mistakes and discoveries that had made him who he was. When he flattered about her painting it did not put her on her guard, 'fool that I was,' she whispers angrily to herself.

She had prided herself that she was playing the game skilfully. Even though she trusted West, she had been assiduous in calculating exactly how much of the method she should let him see to whet his appetite, without letting him walk away with it for no money. Each time he had returned for a further demonstration it had seemed to vindicate her approach, at the same time as it trumped Mrs Tullett's doubts and eroded any lingering scepticism on the part of Provis. She saw the way she started to change in each individual's eyes. After surviving the fire of cynicism from all sides, she had risen like a phoenix as a force to be reckoned with. The worst that had been predicted – that her interpretation was wrong, and that West would ridicule her and Provis to the King – had not happened. At the same time as Provis had started worrying about their debt to Cosway, she had become euphoric about her daring.

And now it was all proved to be for nothing. Since she had discovered West's deception, she realised she had convinced him of the method's value precisely at the point at which she had most feared he was going to walk away from their negotiations. The image she had taken away in her mind of that meeting had to be revisited and reinterpreted. Something subtle had changed in his behaviour on the last afternoon when they had worked on the Venus and Cupid. But when she was in the room she had seen it as the birth of scepticism rather than of conviction.

The theme for the painting was of a mother comforting her son who had been stung by a bee. When Ann Jemima realised this, she felt a spasm of grief for a mother she could hardly remember, yet she did not talk of this to the President. No pictures in her mind, just a twisting inside, and a sense of a fury she could not articulate. As ever she concealed this by playing the role she knew was expected

of her. Calculated that by doing so, she and West might finally reach an agreement by the end of that day.

Late autumn sun streamed through the window of the studio as they worked together on the painting. After lunch West was suddenly called away unexpectedly for an hour. Engrossed in what they were doing, Ann Jemima had taken it upon herself to fill in the details of Cupid's face, and the white silk of his mother's dress on which his hand rested. In the glazing and layering of paint she applied all that she had learned of the way Titian captured light. And as she stood back she saw how what she had done brought to life not simply a mother and child, but the sense of an infant thriving on the love it received. In the flush of the child's face she could see how it had been upset and now was calmed, how its hand had rested on its mother not just as a sense of comfort but as a life source. Upset, for reasons she couldn't understand, she started to shake. Then, to her shock, she realised that West had re-entered the room, and quickly recomposed herself.

Her concern that she might have betrayed any kind of emotion to the American was quickly supplanted by her alarm at the way he seemed to react. When he saw the painting, he stopped dead. She suddenly feared he was angry – pushing her own emotions to the side, she apologised for having done so much while he was out of the room. He shook his head and walked closer to the painting. 'Is this from the part of the method you have not allowed me to see?' he asked. She was silent, not knowing exactly how to answer. 'Or is it what you have deduced from what I have taught you?' he continued.

She found some words, unable herself truly to understand. 'It was from the method,' she replied firmly, 'though…' she continued as she saw the expression hardening in his eyes, '… you have taught me much. But it was the method that allowed me to do this.'

He turned to scrutinise the painting again. She saw a sense of shock in his bearing, a return of the unease she had noted when they had first met. She feared she had overstepped the mark, that somehow she had broken some unspoken contract between them.

'The method,' he repeated. 'That it lets you – if you'll excuse me, my dear – that it lets you create this…'

His voice went quiet.

'Have I done something wrong?' she asked.

She looked towards the dark eyes stricken with doubt.

'In truth, my dear, I cannot understand what you have done.' He could not stop looking at the painting. And at that point, she thought with fear, he has turned against me. She could feel it as surely as if he had declared his hostility out loud, but she could not understand it. She thought back with anxiety on what she had said to him before he had left the room. She wondered if some careless word had pricked him, some thoughtless observation had put him on his guard. Then she looked towards the painting again.

There is something wrong with it that I cannot see, she thought in faint desperation. He was happy to have me here and now he is not. Please God, tell me not that we have gone through so much to reach this stage, and now it is I who have ruined it.

She could not say anything more to him beyond the polite formalities as she was ushered out to a carriage. Even as he smiled and bade her farewell, it was as if a wall had sprung up between them. How often had she chastised herself since then? How often had she wondered what naïve mistake she had made, what unspoken code she had violated. Yet after Cosway's visit she could see that the change in his attitude represented something that even she could never have dared imagine. 'His loss of composure was because it was I and not he who created the full Titian effect,' she whispers to herself. 'When he said, "That it lets you create this..." it was not an expression of disdain, it was an expression of wonder.'

In the Sub-Dean's vestry at the Chapel Royal, Provis has no conception that Ann Jemima has fled. Round and round he paces, muttering in the incense-silenced air. Eventually, to calm himself, he sits down, picks up a communion chalice, and starts to polish it.

Clicking heels on the chapel's marble floor interrupt his solitude.

'Provis?' The Serjeant of the Vestry, Joseph Roe, is in the doorway.

Small dark eyes blaze with the intensity of fire in a pale elongated face. 'I need you to come and assist me with trimming the candles.'

Provis opens a drawer in the cupboard next to him, removes a white linen cloth, and starts to fold it in preparation for laying it over the chalice.

'If you will forgive me, Mr Roe, I desire to remain alone right now.'

He refuses to meet his eye.

'Mr Provis,' Roe spits out in a whisper. 'I know you believe you have been wronged, but that is no reason to be insolent with all around you.'

'There have been many nights that I have not slept this year because I thought Benjamin West might be laughing at us.' He looks at Roe through reddened eyes. 'Now I discover I was right – but it is not because he attaches no value to the manuscript. It is because he attaches no value to myself and my daughter.'

Roe sits down at the table to their right, and raps on it to indicate that Provis should sit on the other side.

'I am concerned, Provis. Have you considered how serious the accusation is that you are making?'

'This is the gamble he has taken. He knows that all will ask why a man as important as he would want to swindle people as lowly as we are. He knows that they will speculate that the money we were asking was too much, that the method was of little importance,' he declares. It occurs to Provis as he speaks that his outrage is bestowing a lethal confidence – now he has no doubts at all about the sum they should receive. 'Yet he would have no trouble paying us. Each time I have been to his house I have noticed something of value.' His anger wrenches at him. 'In his hallway he has a mirror with a frame carved by Grinling Gibbons. In his dining room he has a seventeenth-century Flemish tapestry that covers more than half one wall. To my mind he could sell just one small painting in his drawing room and have enough to pay us three times over. Why would he deny us £500?'

Roe's eyes narrow.

'I am sure there is some reasonable explanation. You should calm down before doing anything, Mr Provis, your frame of mind helps no one, least of all yourself.'

'You are sceptical, I see.' Provis speaks more calmly now. 'Well, so be it. But what is important here is that Mr West is not. Can you not see how West's dishonesty is also a vouch of faith in what we have revealed to him? I fail to comprehend how the situation can be read otherwise.'

Roe is silent for a moment. 'What does your daughter say?'

Provis takes a deep breath. 'She was calling out in her sleep in the night, and she would not eat this morning. I pray that West's insult is not compounded by her becoming ill.'

'She is a most admirable young lady.'

'Yet she has had to combat so much. Some will condemn her for being too ambitious. If that is enough to acquit West, then this is a world without justice.'

'But this is a world with justice.'

Provis regards his employer with withering irritation, marvels again at his unquestioning belief that his God is just, and that the English monarch is the prime instrument of God's rule on earth.

'Well in that case,' he replies with barely disguised irony, 'I shall simply wait till all is resolved favourably.'

'The King and Pitt are with us for communion this morning.' The Serjeant of the Vestry rises. 'We shall talk on this later.'

A chorus of croaks and jeers distracts Ann Jemima from her thoughts. The bell tolls in a small church to her left – ahead of her a crowd is gathering. Horses trip and stumble as they pull the carts of revellers down uneven streets. When she looks up at the windows, men, women and children are pressed against them. Despite the early hour and coldness of the morning, people are standing outside taverns drinking.

'What is happening?' she asks an old man with hollow cheeks and disappointment scarred beneath his eyes. He surveys the passers by over his tankard. 'What is the celebration?'

'Execution,' he replies shortly.

'An execution?' she repeats with shock.

'We have not had one like it at Newgate for a while,' he replies. 'Five 'angings including a woman.'

'What is their crime?'

'They counterfeited coins. For men the punishment's always been 'anging, but the woman is lucky.'

She looks at him, incredulous.

'Lucky?'

'Six years ago they would've burnt 'er at the stake.' He surveys her impassively. 'Women counterfeiters was punished more 'arshly – the crime was considered a greater perversion of their nature. But some bleeding 'earts got the law changed. As I said, she is lucky she is just being 'anged.'

His mouth opens to become a cave stinking of beer. She takes her leave swiftly and walks on. All around she sees the faces darkened with anticipation, smells the hunger for death, hears the ribald denunciations. She imagines the condemned men and the woman in their cells. Wonders if they are terrified or defiant, resigned to their fate or raging against its injustice.

She moves further down the street. In the distance she can see where the gibbets have been set up. She walks over to a boy who is selling pamphlets.

'Tale of Eleanor 'arris and 'er gang,' the boy intones, dull-eyed, holding out one of them. 'Cost you a farthin'.'

'Is she the woman being executed?'

'The very one.'

'How did she commit her forgery?'

'She did what many have done before 'er. Clipped the edges off coins, and melted the metal for counterfeit moulds.'

'And for this people must die...'

'She and 'er 'usband and 'is friends. Yes they must die. Can't show disrespect to the King's image in these times and get away with it.'

Ann Jemima looks around her again. 'Move along, missy,' shouts an old man. Now she feels herself being shifted along the ground – all around her she can see open mouths, raised hands, hears the shouting get ever louder. She cannot quite comprehend the surge of energy around her, the vibration of sound that invades her body and skull. She wants to scream for it all to stop, to call out that it is a madness. Every atom in her body is driving her to flee from here, and yet at the same time she feels that she must stay, be one person in the crowd who is not jeering, screeching, vomiting contempt.

She realises there is a low wall to her right, and with a little effort climbs up onto it. A cart is rattling from the other direction down the street. As it passes her she sees it is carrying three women in rags smiling happily with children – the youngest seems little more than six. She looks beyond them and sees that in the distance animal carcasses are being loaded onto carts before setting off towards Smithfield. All around her, the crowd swirls and eddies – the surging waves of excitement, the rhythmic pulse of baying sound. Kisses are blown back and forth, the voices of hawkers tout food and pamphlets, stray dogs bark from surrounding alleyways.

And in the middle of this all, five gibbets standing in a row. Death among the living, silence amid the noise. The sun catches the gibbets, paints their loops in shadow on the ground. In the prison cells, the condemned are waiting.

As the Serjeant of the Vestry is taking his leave, the door gapes open again. There stands Darton, his eyes swiftly reading the situation.

'I see we are in serious debate, gentlemen,' Darton says. 'Shall I return at a later point?'

'We talk of West,' says Provis grimly.

Darton studies him for a moment.

'Mrs Tullett told me. I was sorry to hear it. From what Ann Jemima said to me when we last met, the signs were hopeful.'

Roe indicates that he should step to one side, so he can leave the vestry.

'I must prepare the altar for today's service,' he says. 'I hope to see you in the chapel shortly, Mr Provis.'

At his departure, the atmosphere in the vestry changes – as if molecules have arranged themselves in orderly lines on his entry, and with the force of his exit have been sent rolling around like billiard balls. Darton shifts his frame to the seat opposite Provis. He looks hard at the face that even in good humour seems blighted by misfortune: shadows like bruises under the eyes, the misshapen nose, the heavy mouth. 'What do you intend to do to take revenge?' he asks quietly.

'I have not calculated it in detail, but revenge I will take.'

'Will you have him attacked?' Darton looks around him quickly. 'I could arrange it.'

Provis grimaces. 'I intend something slightly more subtle.' He stares. 'Something that will leave its stamp on his reputation for a long time.'

Darton is quiet for a moment.

'Provis, if you'll forgive me, I have come here to see you on another matter. You seem to have been avoiding me of late.'

The verger's eyes flicker.

'I have many troubles in my life right now. You will forgive me if having a friend who I know to be sympathetic to France feels a little burdensome. More than a few people have told me that you have been looking for me. If you want some information that might help your cause, I am not your man.'

He stares at him. Darton shakes his head and quickly goes to the door and opens it. Satisfied that no one is standing outside, he returns swiftly.

'You should not be worried. My visit to France was not altogether what I expected,' he replies in a low voice.

'I take it you were not just singing.'

'No indeed.' The smile is almost indiscernible. 'I was sent to meet an Irishman – a man called Wolfe Tone. A prominent and passionate Republican.' He sits down again. 'I thought the man was a genius – but he has a plan that is entirely reckless. He is conspiring with the French to send a fleet across the Channel, first to liberate Catholic

Ireland, and then bring fear and terror to the English mainland. He has neither sufficient forces nor the organisation to do it. I predict it will be a disaster.'

Provis clears his throat.

'Your friend, the leader of the opposition, must be delighted with your conclusions.'

'My friendship with Mr Fox has not been so warm since my return. We have not been able to see eye-to-eye on this matter in the slightest. I have sympathy with Mr Tone on the injustices he feels Ireland has suffered. But he believes the French are happy to serve him, when it is clear all he is doing is serving them.' He sighs. 'I have seen enough now to realise that England should not have its own Terror. As a result it is Mr Pitt who is currently most happy to receive me.'

Provis stares for a moment with incredulity.

'After all these years? Are my ears deceiving me?'

Darton swallows.

'They are not.'

Provis recovers himself.

'You were ever the pragmatist, Mr Darton. Does he pay better too?'

'I suspected it might be in your character to condemn me, even if you agree with my position. Well hear me, Provis, I have seen far too many senseless deaths now to want to help someone who will only cause more. We have watched wave after wave of leaders in Revolutionary France turn on each other in hatred. Even now we cannot tell who will lead the country a year from hence, and what the consequences will be for the countries they have invaded. I know you are of the same mind. I hoped you might be happy to hear what I said.'

His anger is making him breathe fast. He pauses for breath.

'You believe this invasion of Ireland to be imminent?' Provis asks quietly.

'A message was brought to me in the middle of last night saying that it could happen within days.'

'Does the King know?'

'He has been apprised.'

'Why do you seek me out on this?'

'Having this change of heart has not been an easy matter. I wanted to seek the counsel of the most discreet individual I know. You have always challenged my political views in the past, but you are no one's man, nor will you ever be.'

'Maybe you give me too much credit.'

'I think I know of what I speak.'

Provis is about to reply when the door opens again at speed. This time it reveals Mrs Tullett. The two men catch each other's eye in alarm.

'How long have you been wai—' Darton begins, but she has no time for his words.

'Mr Provis, you must come right away! Oh God help us, you must come now.'

'What has happened?' he says.

'Ann Jemima,' she says. 'She has fled.'

She starts weeping loudly, and the Serjeant of the Vestry comes running.

'What is the commotion? The King and Mr Pitt will be here any moment.'

'My daughter...' gasps Provis. Without speaking further he pushes past Mrs Tullett and Mr Roe, and leaves the chapel at a run.

Ann Jemima stays till the condemned men and the woman appear in two separate carts. The men travel together, and the woman on her own. Two of the men are drunk – one shouts and leers at the crowd, though she cannot make out what he is saying. The second sways and lurches, while the two other men sit, grim and insensible.

When the cart with the woman rolls past, Ann Jemima sees that she is small, neat and dressed in a white tunic. Her lips are pinched, her shoulders hunched, her eyes burn with quiet anguish. She does not look at the crowd. The louder the noise, the more she seems to retreat into herself.

As she watches the carts progressing towards the scaffold, Ann Jemima realises that she cannot stay and watch the cleaving of soul from body, of life from flesh. She steps down from the wall and starts to fight her way out of the crowd – through the men shouting bawdily at the prisoners, and the children throwing food. The wall of bodies seems to go on forever – a maze of inhumanity, a labyrinth of cheap hate. Some people push back as she tries to pass, others shout angrily, others are insensible to any external force as they stare towards the prisoners being led out of the cart and up to make their confessions. Then, suddenly, Ann Jemima does not have to fight any more. There are still people around, and the noise continues to pursue her, but she feels as if she can breathe and move freely as she makes her way up towards Cheapside.

Where am I fleeing to?

The question patters across her mind with increasing urgency. No relatives left in the country, no world for her outside London. She thinks of crowded stagecoaches, of roads snaking in the darkness to villages with no names and faceless inhabitants. She tries to imagine herself as a governess teaching whey-faced children, or as a companion to a silhouette constrained by corsets and privilege.

As she hurries on she stumbles into a flock of pigeons pecking at a hunk of mouldy bread. They sheer up into the air. For a moment, all she is aware of is wings and dust. As the shock agitates her mind, she is propelled back into a small dark room where the twenty-year-old painting master hired by her grandmother is showing her the first picture she has ever seen to depict a scientific experiment.

It is this work that more than any other has made her want to paint. It's a painting by a man called Joseph Wright of Derby, 'the greatest artist to bring together science and art'. In her memory she can hear her painting-master's words, the sound of a voice that once meant much to her. For a moment she can see his face, the thin elegant nose, the eyes furious with curiosity, the dark hair that one day she suddenly wanted to touch. The sense of impatience that animated his whole body when he was gripped by an idea. The laughter lines that transformed his face when she said something clever, the distracted air when she did not. Septimus Green. He

could not see that when she went to his lessons, this skinny irrever-ent fourteen-year-old found a light there that was otherwise absent in her dark and tedious world. He had agreed to teach her simply in return for money to buy equipment for his scientific experiments. When he had seen how well she could draw, he had told her that one day she might become an excellent scientist's assistant. Told her about Madame Lavoisier – wife to one of the greatest scient-ists in the world – about her skill in drawing scientific equipment and translating ideas that made their experiments among the most exciting in Europe.

When Septimus shows her the picture by Joseph Wright, she feels as if she is inside and outside it at the same time – that she is the observer and the observed. She is watching a group huddled round a table – through the window a full moon can be glimpsed through the clouds, but it is candlelight that paints their faces and emotions. There are two young girls in the group – one of them cannot bear to look up at what is taking place, but there is one, about nine years of age, who stares with a mixture of curiosity and sorrow that breaks her heart. In all there are ten people in the room, one man deep in thought, one young boy operating some kind of device, one man comforting the older girl, and the others either looking on in fascination or engaged in conversation.

In the centre is a man who looks like a long-haired prophet, haunted by what he sees in the future. He is a scientist whose hand hovers over a large glass bulb – inside that bulb is a white bird, its chest resting on the bottom, just one wing held out, trapped and unable to fly. The device operated by the boy is slowly sucking the air out of the bulb. Normally the bird would be acting wildly, but the experiment is depriving it of enough air to do so, instead it is docile – and that docility is a prelude to death. The man in the centre is trying to sustain the right amount of air in the bulb to keep it between docility and extinction. But he does not know if his calculation is right, and some in the picture are not upset by this. If the bird's life is sacrificed, then some level of knowledge will have been achieved, and that alone will have made the experiment worth it.

And then she is in the picture. At first she is the girl looking up, she cannot stop looking, she wants to see all that is wrong and right. She craves knowledge about how air sustains life, and she is curious to see if this creature will live or die. She watches the bird, which was terrified and beating against the glass just moments earlier. She cannot understand why it is so still.

When Septimus asks her if she likes the work, she wants to tell her him that when she is not allowed to draw and read what she wants, she too feels deprived of air. That when Hooke's *Micrographia* was confiscated, and she was instructed to read a book for *The Improvement of Young Persons* instead, her desire was to smash a window. She wants to say that the precious hour with him each week is like the breath of life in a suffocating existence. But she does not say any of this. She thinks she might say it to him in a couple of years when she is older. But then a week after smallpox takes her grandmother away, he too is dead of the same cause.

Where am I fleeing to?

Her mind casts around wildly. There is another memory – it comes to her as a voice first, it is the voice of a girl the same age as she is, she can hear the friendliness in its rhythm, its easy lilt. They are talking easily in a large drawing room, she is confiding in her about what she has loved and what she has lost. This girl is the first ally she has known since coming to London, it is in her parents' house that Ann Jemima stays before she arrives at St James's Palace. She remembers helpless laughter and shared secrets, fleet-footed chatter and carefree afternoons. In this friendship she finds a kind of home, a sense of complicity that allows the wretched hours and days to speed away before she is united with Provis.

But I cannot return.

There are different emotions concerning other people in this house. She knows she is but a short distance from where it is now and her mind begins to weigh up the memories, frantically balancing her happier recollections against the swirl of confusion that followed. Her feet carry her on, up Cheapside, past the Bank of England, and up to Bishopsgate, till she reaches the alleyways

that span out like arteries around the market. Above her patches of deepening blue sky are fringed by clouds gleaming gold in the sun. She thinks of Mrs Tullett talking about the houses for harlots in this area, about the women smuggled into the Palace for the pleasure of the Prince of Wales and other dignitaries at the Court. There are agencies for domestic work around here too, should she decide her only course is to become a scullery or laundry maid.

Where am I fleeing to?

For a moment her mind goes back to the condemned men and woman, the different expressions on their faces as they rattled past in their carts. She imagines each one, framed by an unforgiving sky, taking those last few steps towards nothingness. Their deaths seem both unbearably close, and yet a hundred miles away. As the chaotic thoughts loop and swirl around her head, Ann Jemima is suddenly aware of her own frail physicality, of the veins pulsing blood beneath her skin, of the lungs taking in air and turning it into life. For the people she has seen earlier that day, all of this is has stopped. She sees their heads placed in the nooses. A sob surges in her throat, as she thinks of them dropping towards the ground while the crowd shouts in ecstasy. For what seems an eternity, the bodies judder, till finally they stop moving.

Next to this my problems are as nothing.

The thoughts continue to loop and swirl, but her feet are taking her directly to the house in Spitalfields. And now she sees it. Her heart starts to beat faster. For some reason it is a shock to see it still standing there. She looks at the street name, recognises the blue door, sees once more the distinctive doorknocker in the shape of a man's head wreathed with laurels.

'I have no choice,' she whispers to herself. Behind that door so many memories that she has banished for years. 'It is my only chance for now.' She takes a deep breath and approaches it unhappily. Gathers her cloak around her. When she raises the knocker and drops it for the first time, there is no answer. The blue painted wood seems to mock her. She raises the knocker higher so it hammers louder. She stands back and sees curtains moving, glimmers of lamplight.

And then the door opens. The young woman behind the servant who opens it has high colour in her cheeks and dark hair. She wears an elegant long green dress, accompanied by cream gloves. She looks imperiously at Ann Jemima without seeming to recognise her. Then she takes a second glance and frowns in disbelief. 'You!' she exclaims. Ann Jemima is about to reply when footsteps approach her quickly from behind. A hand suddenly seizes her arm, forcing her to walk further down the street.

She shrieks, and turns in outrage to find herself staring into Darton's face.

'Miss Provis,' he says. 'Your father is looking for you.'

'How did you find me?' she gasps, looking back. The woman has stepped out of the house to see what is happening, but when she observes Darton she quickly retreats and re-emerges with an older woman who looks shocked, before ushering her back inside again.

'You had no right to find me,' shouts Ann Jemima. 'I knew what I had to do. Mr Provis is suffering because of everything I have done. The best thing was for me to be gone.'

She looks wildly back to the house again, but the door is now closed though she can see a curtain moving on the first floor.

He waits for a moment till she is calm again.

'You must come back and hold West to account,' he says. 'You owe it to your father to do so.'

'I will not come home. It is too great a risk,' she hisses.

'I have never seen your father so upset,' he says, grasping her arm still more tightly.

'I persuaded him to approach West. I have caused him nothing but trouble. I must be gone from his life, from everybody's lives.'

He relaxes his grip on her arm, and stands back.

'You will cause him yet more by running away.'

'I do not think you understand.'

'What do I not understand?'

She studies his face for a moment. Her own expression is filled with a mixture of defiance and terror, he has a sense that she is not sure what she is about to say or what effect it will have on him when she says it.

'It is your duty to help Mr Provis take revenge.'

He gestures solemnly behind her.

It is at this point that she sees the waiting carriage, and Mr Provis waiting within it.

CHAPTER ELEVEN

Three artists and a bottle of gin

'LAKE'

'Lake, of which the true origin was for a long time unknown, is certainly a species of Wax, either found in its natural state upon flowers or trees, or wrought by a sort of Flying Ant, common in many provinces of the East Indies, as Pegu, Siam, Bengal, and Malabar. The cells of this Wax contain small bodies, more or less swelled, which in all probability, are the eggs of these Ants—they are of a fine Red, more or less deep. When bruised, they are reduced to a powder as beautiful as Cochineal. By putting these small bodies in water, they will swell in the same manner as Cochineal, will tint it of a colour equally beautiful, and in appearance will be almost the same. These small bodies are the colouring part of Lake; for, if entirely divested, or in a small proportion, the colour-would be extremely faint.'

Constant de Massoul,
A Treatise on the Art of Painting and the Composition of Colours, 1797

The first impressions of the day are like a rake scratching across Richard Westall's brain. The artist has drunk two bottles of claret and half a bottle of brandy the night before, and he lies groaning

for a while beneath his bedcovers. When he finally rises up from his bed he descends to his studio in his nightshirt and walks over to a standing cupboard from which he removes a large bottle. There is only a small amount of laudanum left in it, but it is enough to ease the pain in his head and allow him to consider what to do next. His eyes rove around the relics of his most recent month's work: a huddle of half-completed canvases, two skeletal easels, and a vast pile of rags smeared with oil paint.

Over the last year he has made £400 from his paintings – more than any other artist at the Academy. A mythical landscape alone has fetched him £105 at the Coxe, Burrell and Foster auction house, while a small study of a peasant boy has fetched him £84 at Christies. He enjoys the wealth and acclaim more than he admits, though he is increasingly sick to the soul at creating the kind of work that will sit prettily in patrons' drawing rooms. He has a talent for Cupids and pale-skinned beauties that fills him with a mild self-loathing, and as long as it keeps him wealthy he suspects he will not have the courage to relinquish it.

He picks up a bladder of yellow orpiment and punctures it. Briefly he catches the faint odour of arsenic – a garlicky smell, which he knows will become a stench if the orpiment is heated. He is about to squeeze the paint onto his palette when he hesitates and instead squirts it directly onto a landscape he has been working on. Half-formed recollections from the night before intrude on his mind. But he pushes them to one side, focusing on what is on the canvas before him. Without bothering to pick up a brush, he agitates the yellow orpiment with his fingers to create sunlight. The action becomes hypnotic, and he squirts more paint so that the golden pigment dazzles its way across the canvas. Yet when he stands back it does not look like sun. 'In truth,' he curses to himself with a wince of self-disgust, 'it as if a horse has farted mustard.' He seizes the canvas from its easel, staggering slightly with the unwieldiness of it before he casts it to the floor. Then he stamps his foot through it and throws the debris into a small room next to his studio.

He experiences some pain when he returns to his bedroom to put his breeches on. The model he has been painting as a demure

Venus for one of his patrons comes from a high-class brothel in Pall Mall, and last night she revealed herself to have a talent for birching. He had never been whipped before, and at the first shock of the wood against his buttocks felt it to be profoundly unerotic. But after a few more strokes, as his buttocks began to throb, he felt he was getting an erection and cried out for her to whip him harder. The sex that followed was frenzied – he has memories at one point of his head hitting the bedstead, another of smashing up against his mahogany wardrobe before taking her from behind. He raises his nightshirt. A large bruise is starting to bloom to the left of his ribs. 'In truth, I cannot remember how she administered this one,' he mutters.

Since neither his mind nor his body seem fit to do work involving concentration, he decides he will not stay at home that morning, but will visit the shop of local colourman, Constant de Massoul. Though painters' supply shops flourish all around St Martin's Lane, Covent Garden, and Newman Street, Monsieur de Massoul's shop is considered one of the best. The Frenchman himself – an exiled royalist – is considered as peregrine as the wares he peddles. With his darting grey-blue eyes and rasping voice, he delivers lengthy and often dubious accounts of the origins of his paints. He spits when he is talking enthusiastically, which is often. Customers have learnt to keep themselves at a distance if a new colour is in store.

His shop has a distinctive smell – of linseed oil and sawdust. The paints are sold both as powders and ready mixed in pigs' bladders. The bladders must be handled carefully in order to avoid leakage. It is not unknown for an entire bladder to burst, sometimes on the journey between the colour shop and home.

It comes as little surprise to Westall to find two other painters from the Academy at Monsieur de Massoul's shop – Robert Smirke and Thomas Stothard. The beginning of the New Year has brought a surge of business as the looming annual exhibition at the Academy creates an intensified demand for materials. In contrast to the small societies for exhibiting in the past, the Academy's greatest success has been to elevate the viewing of contemporary art to a scale and prestige never witnessed before. There is talk that a National Gallery

might be established too – for some years Benjamin West has been involved in negotiations on this very matter. But in this time of war, dinner party orators tend to believe that the money involved would be better devoted to the Navy.

At Monsieur de Massoul's shop the profit on the rabbit-skin glue used for preparing canvases is considerable this time of year, as indeed it is on lead white paint. There are rare brushes of badger, squirrel and sable hair on offer, alongside the more common hog's bristle brushes. Among his most professional customers, the weave and fibre type of canvases is discussed obsessively. Flax and hemp are the most common materials used, while artists can spend many tedious hours debating whether plain, twill or herringbone weave will benefit them the most.

Westall does not need to talk to Smirke and Stothard for long to perceive that they – while not intoxicated as he is – are in that state of mind preceding creativity where any distraction is most welcome. So he suggests they go to his studio where they begin drinking gin and water at eleven o'clock and continue until lunchtime. His disaffection with the world persists. So he decides with a streak of sadism to propose a game in which he presents the gin and water in identical bottles. Then he instructs his companions to choose which liquid will fill a fifth of their glass and which four-fifths simply by pointing from a distance.

Two hours later Smirke remains the most dignified of the three as he walks with exaggerated slowness up and down the room. Even so Westall can see the mottling of red veins in his cheeks, the slightly uncontrolled sway as he marks his step with his cane. Stothard – a large red-haired man with a flickering cold-blooded gaze – has become drunk much more quickly and is collapsed on a chair. It is as if his body contains half the bones it did when he arrived.

'Urine?' he declares loudly. 'You say urine?'

'That is correct,' replies Westall. 'I thought I would attempt a study of Mount Vesuvius…' he suppresses a belch, 'so I bought some Indian yellow to pick out the reflection of erupting lava.'

'A fine pigment,' replies Smirke. 'If strong smelling.'

'That is right, sir. You have hit the mark. All paints have their own

odour, but this is a stench that turns the stomach when you first open the jar. I asked Monsieur de Massoul if he could account for why it is so rank. And he replied that is because of the urine used to make it.'

'Urine,' repeats Stothard loudly once more.

'This particular urine comes from Indian cows fed only on mango leaves and water. It is collected in a bucket and the liquid is reduced over a fire. What remains is filtered through a cloth, and the sediment is then rolled into balls.'

Smirke regards him sceptically.

'No cow could survive solely on a diet of mango leaves,' he replies briskly. He has a cadaverous slimness that exaggerates his current lack of balance – warily he lowers himself into place in a nearby chair and leans his cane against it. 'That is surely a myth.'

'I do not dispute Monsieur de Massoul's tedious talent for ornamentation,' retorts Westall. 'Yet the story is true. Many of our paints have either absurd or dangerous histories. Verdigris also uses urine, does it not?'

'But not from cows fed only on mango leaves,' says Smirke. 'And I think you'll find that creating verdigris by using urine to start a reaction with copper is increasingly rare these days. Most colourmen find vinegar more effective.'

Westall gets up and does a turn round the room. He looks through the window as if wishing by the force of his gaze to transport himself elsewhere. Smirke eyes him indulgently as he does so. In temperament the men are as different as earth and air. But in speed of wit they are similar, and it is this that allows them to tolerate each other. Smirke knows that Westall had lost his mother and seen his father go bankrupt by the time he reached seven. It is a conversation the two men would never have had between themselves, but there have been enough whispers at the Academy for Smirke to become acquainted with the wretched details of the situation. He appreciates that Westall's response to life's mocking cruelty has been to mock life in return. Though his own life seems marked by precision and order, he has sympathy for those who choose a more rebellious course.

'Mr Smirke,' Westall declares as he turns back from the window.

'Let me refresh myself with a glass of water, and see if I can think of an example that might kill your scepticism.'

He walks over to the bottle that Smirke knows from his observations to contain alcohol and pours it into his glass, filling it to the brim. Then he tips it down his gullet till none is left. Smirke raises his eyebrows, while taking a sip of his own drink.

'Pray do not over-exert yourself, Mr Westall,' he says. 'I am in agreement with you – the history of paints is knotted up with some of humanity's lowest moments as well as its greatest.'

'And its cruellest,' Stothard interrupts dourly. 'For yellow we take piss from undernourished cows. For cochineal we roast insects. Then we mix these colours and put them together in the bladders of English pigs.' He tilts his empty glass back and forth in his hands. 'As artists we strive to represent beauty. But we cannot do it, it seems, without inflicting a wide range of tortures on every other species.'

His belch is thunderous. Westall, who has at first stared at him as if he were a madman, now starts to laugh till tears torrent down his cheeks. Stothard allows a small gratified smile to invade his flushed face.

'Would you like to take another drink?' Westall asks. He takes hold of the tray with the two bottles on it, they sway like two passengers on a ship at sea.

'Pour me a drink from one or the other – I am happy to take the gamble as to whether it will make me more inebriated or less,' said Stothard.

'I will have none,' replies Smirke in answer to the raised bottles. 'I must depart soon, for I am taking lunch with my son today and I wish to be sitting upright for the occasion.'

Westall bends over to put the tray on the table next to Stothard, and yelps with pain.

Smirke looks at him alarmed.

'Dear Westall, what ails you?'

Westall starts shaking his head. He puts the tray down, then stands up straight and starts to finger the area on his left ribs. 'It was not the girl,' he says to himself in a tone of wonder as he traces the area of his bruise. 'No, it was not the girl. It was the visitor.'

'Mr Westall, I believe you are delirious.'

Smirke says sharply.

'No, no, I am not,' declares Westall. 'I had a visitation last night. It pertained,' he checks himself, 'yes, that is right. It pertained to something concerning Benjamin West.'

Smirke sits forward.

'Are you quite sure, Mr Westall?'

Westall falls into the nearest chair. He picks up a glass from the floor and starts distractedly to flick his finger against it.

'The man was most peculiar. Even though it was cold he was perspiring. Yes, he looked quite desperate. He had hammered on my door for ten minutes before I answered it. He put me in mind of a man who no longer cared what life did to him, or he to it. He said he wanted to seek my assistance.'

Smirke is quiet for a moment.

'Was he a beggar?' he eventually asks.

'No – he appeared peculiar as a specimen of the human race, but he was perfectly well-dressed.'

'Did he stink?' says Stothard.

'No, Mr Stothard – he emitted no noxious fumes. He was clearly well acquainted with both soap and hot water.'

'So what did he desire from you?' This from Smirke.

Westall is suddenly serious.

'He said he wanted to report a theft.'

He rubs his eyes.

'What kind of theft?'

'He said that...' Westall frowns, 'he said that £600 had been stolen from him.'

Smirke leans forward.

'Why was he reporting this to you?' he asks quietly.

'Because he said the person who had stolen the money from him was Benjamin West.' Suddenly Westall feels a little more sober. 'He told me he knew I was one of the few people at the Academy who saw Mr West for what he really was. So he wanted me to assist him in seeking justice.'

Both Smirke and Stothard are silent.

'Although, as you know, I am always interested to hear any tales

that show Mr West in a bad light, my first interpretation of the situation was that he was mad. I asked him where he came from, and he said he was the Groom of the Vestry at the Chapel Royal. A Mr Provis. Now this is the most curious aspect of his story.' Westall's eyes flare. 'He said he had supplied West with a method for Venetian Renaissance painting. He first took it to Cosway, who valued it at a considerable sum. So it was agreed it would be brought to West so that he could share it with the other members of the Academy.'

'Did you credit him?'

Smirke's question raps out into the air.

'At that point I could see no reason to doubt him. However, I had company,' Westall colours slightly and is silent.

'So you did not let him in,' replies Smirke acerbically.

'No I did not. I told him I was most interested in his story, but bade him return tomorrow.'

'In other words, today.'

'Indeed. When I said this, suddenly he took on an air of menace. He said it was more than a year since he first divulged details of the method to West, after inheriting it from his grandfather. Since West is using the method but has not handed any money over, he has, in effect, stolen Mr Provis's inheritance. He said he was fed up with fine words and promises from artists. Grabbed me by the arm and eyed me like a mad dog. He said that if I wanted to do justice for an honest working man, I had to help him get the money.'

Smirke's expression subtly hardens. 'And your response?'

'I told him I would see him on the morrow. Then he punched me in the ribs.'

'He attacked you?'

'Yes,' says Westall, feeling the bruise again. 'I could have punched him back at any point. Yet there was some kind of physical trans-formation as his fist made contact with my skin – his complexion became scarlet and I feared he was about to have an apoplectic fit, so I restrained myself. The last thing I desired was a corpse lying in my front hall.'

Smirke slowly raises himself from his chair.

'Mr Provis sounds like a dubious character. Or do you think it is desperation that has made him so?'

Westall does not reply.

'He is saying Mr West is a thief and a liar,' Smirke continues. 'These are serious accusations indeed. Are you going to approach Mr West about this visitation?'

'What precisely should I say?' Westall straightens his back defensively. 'So much of this apparent crime depends on whether or not this method is valuable. Often I find they are not. Those that claim to be are like potions that translate lead to gold, turn strumpets to virgins, and grant eternal life. Maybe West simply decided it wasn't worth the money.'

Smirke flips open the silver greyhound's head at the top of his cane and takes a pinch of snuff.

'It is all very well to be sceptical, my dear Westall. But while some of these methods are absurd, others have merit. Is it not the eternal strangeness of our profession that all we do is scratch lines and apply paint to canvas, yet at some point these lines and colours start to live and breathe? Some of this is to do with inspiration, but it is partly through the careful study of techniques involved. It is with this latter, and highly important, aspect of art that these methods concern themselves.'

Westall holds up his glass, and peers at Smirke through it. 'Why, you have become quite rhapsodic, Mr Smirke. I think it would benefit you to take gin for breakfast daily – it greatly improves your conversation.'

Smirke ignores him.

'If what Mr Provis claims is true, West is guilty of immense wrongdoing. As well as deceiving the members of the Royal Academy, he is defrauding the man who introduced him to the method.'

'If what Mr Provis says is true,' repeats Westall pointedly.

'Indeed.'

Westall takes a deep breath. 'But I found myself unable to be entirely sympathetic to our Groom of the Vestry. His air of desperation made me wonder if the story is exactly as he has told it.

I am the last man on earth to give credit to Benjamin West, but perhaps Mr Provis has proved unreasonable in his negotiations. If he turned to violence with me so quickly, who knows what threats he has issued against Mr West?'

Smirke narrows his eyes, as if hoping by this device to clarify the situation being described.

'We can take it that Mr Provis is not lying about his own connection with the manuscript? Why would he be privy to such an extraordinary piece of scholarship?'

'If he inherited the manuscript, that is a creditable enough reason,' says Westall. 'That is the most straightforward aspect of his story.'

Smirke rubs his chin. 'It is worrying for West that a member of the Royal Household feels able to make any allegation against him. Five years ago he was there almost daily. Was not West, in fact, the first person outside the royal household to see the signs that King George was mad?'

Westall nods. 'It was after he had painted a landscape with a lion in it for Queen Charlotte. I'm sure the lion was no good – West has little talent for painting animals.' A muscle moves in Smirke's right cheek, but he forebears to smile. 'So I cannot say whether it was a moment of madness, or a rare moment of sanity when the King kept on insisting the lion was a dog,' Westall continues. 'West kept his counsel. But then the King took a paintbrush and swept a great line through it. Replaced it with some monstrous apparition that he swore was much better.'

'West made no comment at all?'

'He was dealing with the King – his great patron. I'm sure, being West, he said the only thing he could say – that it was clearly an improvement. If the King had stuck the paintbrush up his arse and told him to wag it like the tail of a dog, I have little doubt he would have done that too.'

Smirke tuts, but this time a small laugh escapes him.

'To return to Provis, I think we should commence by talking to West,' continues Westall. 'If the man is telling the truth, then maybe West will demonstrate some shame. In that case Provis

should be paid the money to redeem his inheritance, and we can raise the question directly of his sharing the method with the rest of the Academy. If the man is lying, then there are plenty of ways for us to deal with him.'

'Is West necessarily the right individual to approach first?' asks Smirke. 'Is there some more disinterested party who could verify the story either way?'

Westall's eyes are opaque for a moment.

'What you say, Mr Smirke, contains a great deal of sense, as ever. I shall make some enquiries at the Palace about this man first. Find out the whispers on Mr Provis's reputation. That way we shall find it easier to know how we must proceed.'

The plot for revenge

'The facultie of Painters, sayth Plato, knoweth no end in painting, but findeth still something to change or to adde; and it is altogether impossible that beautie and similitude should receive such an absolute consummation, as not to admit any further encrease. Thus doe they decline the supposed toilesomnesse of this Art before the least experiment; and they will not resolve to doe any thing, because they doe forsooth despaire to doe all. Neither is there any possibilitie to cure this overthwart humor of theirs, unlesse they doe first learne out of Vegetius, that all kind of worke seemeth to be hard before we doe try it. They must secondly, consider what a vehement efficacy there is in mans wit; wheresoever you doe bend your wit, sayth Salust, it will prevaile.'

Franciscus Junius,
The Paintings of the Ancients, 1638

Yet Provis was spared immediate embarrassment. The next day, the French launched their first attempt to invade Britain by heading for Ireland, just as Darton had predicted. As news of the attempted invasion sped inland, fear flowed through London streets as if brought there directly by the winter seas. The threat of war had loomed for so long without any attack that a haze of denial had started to prevail.

Now, however, pamphlets and newspaper articles about Irish treachery and the perils of French rule filled the coffee houses and taverns like petrels fleeing a storm.

'Those who calculate most freely, state the Directory's navy to consist of 17 ships of the line, 13 frigates, 15 other vessels and 15,000 effective men,' reported *The Times*. 'It is led by General Lazare Hoche, a most fearsome commander who did suppress the royalists in the West of France. He has joined forces with Theobald Wolfe Tone, founder of the Society of United Irishmen, and an ardent Republican. These madmen cry that they wish to threaten our Monarch and strike terror into these shores. Yet their insolent invective is as naught in the face of His Majesty's great Navy.'

As Joseph Johnson had fearfully anticipated, William Pitt's response was to step up his attack on potential enemies within England itself. Each day seemed to bring news of another prominent radical thrown into Newgate Prison, held up as a public example by the Prime Minister for potential links with the French. To Provis's shock, one of the radicals sent to Newgate was a server who had worked at the Chapel Royal, a man whom he had liked and respected. He did not know to what degree Darton might have been connected with the arrest – it was another murky event in an increasingly murky world. Though at least Ann Jemima had returned. 'Bodily at least,' he whispered to himself. 'Where her heart and mind are is a mystery.'

His mood was so bleak that he hardly felt any of the relief that swept across the country when the announcement came, several days later, that the invasion had failed. Britain – it transpired – had been saved, not by its great Navy, but by the weather.

'Britain has prevailed,' thundered *The Times*. 'General Lazare Hoche's fleet did encounter such turbulent conditions first in the Channel and then the Atlantic that it was torn apart before it could dock in Bantry Bay. Captain Sir Edward Pellew of the HMS Amazon states that 12 ships have been captured or wrecked and thousands of men either taken prisoner or drowned. The leaders of this sorry expedition were blown so far off course that they were entirely separated from their men.'

The earlier fear quickly translated into a grim hilarity. Britain exhaled, and the French and Irish were transformed from bogey-men to clowns. Trying desperately to provoke some reaction from Ann Jemima, Provis showed her the Gillray cartoon in which the satirist depicted the failed 'French Armada' being blown around on the waves by English Tories. Normally she would have devoured the humour with sharp eyes, would have laughed at the picture of William Pitt, cheeks fat with contempt, venting foul air through pursed lips at the leader of the opposition stuck as a figurehead on a French boat. But now she sat and stared at it, listless, unmoving.

He could not quite bring himself to tell her that he had punched Westall as a result of his visit. Like Ann Jemima he had been in anguish at his powerlessness, miserable that whatever he tried he could not remedy the situation. Before departing for Westall's house he had sampled a glass of a drink called absinthe, brought to him as a gift from France by Darton. Had it been this, or his anger that had made everything in the streets seem more vivid as he had set out into the night? The catfight that had suddenly hissed and arched its way across his path. The laughing crone with her bottle of gin, her ravaged features given a strange beauty by the chestnut seller's fire. The treachery of icy puddles that kept betraying his balance as he lurched nearer and nearer to his destination.

He had not told Ann Jemima he was going to see the artist at all. She had told him that she was not ready to plan revenge, that the one truth was that West was powerful and they were not, and that she was not going to cause any further trouble. Yet the madness had seized him, and he would not let it go. He had hoped he was going to be able to recount his visit as a triumph. He had imagined serving up Westall's outrage to her like the head of John the Baptist. But Westall's wild and dishevelled state on opening his door had caught him off guard, not least because it seemed to mirror how he felt inside. Once he had recovered from his shock, he had started to feel anger that the artist was not inviting him in, felt the insidious December breeze whistling down his collar and through his clothes. A further humiliation after months of humiliation by West. The suspicion that he was not being taken seriously increased when

Westall had suggested he return the next day. When he lunged out with his fist, his intention had been to wind the artist, but Westall had tilted to the left so his impact was on the ribcage. For a moment the two men had surveyed each other, horrified, before Provis turned and fled into the dark.

Ann Jemima had not looked at him as he came back into their apartment. One of the most wretched aspects of her return had been her decision to take up embroidery, something he had once encouraged her to do, but which she had rejected so she could study painting. Now simply seeing her with her basket of threads made him despair. He wanted to rip the infernal thing out of her hands and set fire to it. As if infected by his sentiments, she pricked her finger with the needle at the moment he looked over towards her. She yelped angrily as the blood started to flow from it, then looked down as it flowed onto the embroidery, blotting gorily on the stitchwork.

'Ann Jemima – I have a confession to make to you,' he began falteringly. Slowly he started to relate the events of the evening, hoping his account might stir some sympathy, but it did not. Instead she suddenly became furious. As he flinched beneath the weight of her rebukes, he chided himself that he should have expected little else, whatever the outcome. Since the events following West's betrayal, it had been as if she had been made out of some different, more brittle element. She did not laugh these days, it was as if it might shatter her.

He tried to explain how, through painstaking enquiries, he had concluded that since Westall was one of West's most notorious detractors at the Royal Academy, he would be the best person to approach. He told her he had calculated that if he were going to start rumours against West here was the place to begin. But her ridicule increased the further he progressed with his account. 'You went to him as a complete stranger,' she said. 'Cosway has warned us about addressing this the wrong way. Why would Richard Westall heed what you have to say?'

'He loathes West,' he replied. He knew now he did not have the courage to tell her that he had punched Westall. 'I hoped he would leap to do justice to our cause.'

'Did he invite you in?'

'No, he was… no, he was…'

His mouth went dry. She will disown me forever if she knows I have committed this assault, he thought.

'Of course he did not,' she spat out, misunderstanding his consternation. 'Do you really think the artists at the Royal Academy give a fig for doing justice for strangers? You speak as if they were some ancient order of knights. Some strange old man approaching them and telling them their President has failed to honour us sounds like insanity at best, and at worst blackmail.' She paused, breathing heavily. 'You may be ingenious when it comes to engaging with people at the court, but you are like a man lost at sea with these artists. You must be more judicious if you wish to enjoin their support.'

'You know not of what you speak,' he had wanted to shout. But he had not – it was not his way. I cannot influence her any more, he thought. I have used all that I know to try to help her, and yet it has not been enough to stop us both from being trampled. He kept the thought to himself, like the Spartan boy he had once read about who had concealed a fox he had stolen under his cloak, refusing to admit his theft even as the fox devoured him. Like the Spartan boy he could feel something eating into him, sometimes making him want to cry out with pain, but no one could have told this from his face, grim with concentration as he continued the day-to-day routine of work at the Chapel Royal.

Her attitude had changed suddenly a fortnight later. It would have been indiscernible to anyone not closely acquainted with her – it was connected to a rhythm of movement, a jutting slightly higher of the chin, the cautious gleam in her eyes as she and Provis dined together. She had not talked much, but she had been cordial to him as he had imparted court gossip, even laughed on a couple of occasions. The laugh was a ghost of what it had been, but still it made him glad to hear it. He had not asked what had occasioned the shift in her humour – merely rejoiced that it had happened at

Rachel Halliburton

all. Then, just before she retired to bed, she had announced, 'I have
devised a plan. We will talk of it at tomorrow morning after you
have prepared the chapel for morning prayer – somewhere away
from the palace.'

His first thought was, she is going to run away again. She is
preparing the ground to deceive me, and when I go to meet her she
will be gone. Yet now he had learned how she could be absent even
when she was sitting in the same apartment as him, could look at
him directly without seeing or hearing anything that he said. So he
had decided it would be wisest to stay his concerns and wait for her
to reveal what she wanted him to do. She had told him they would
meet in St James's Park. It was known to only a few members of
the court that there was a secret tunnel below Green Cloth Court
that led out to the park at one end and the former site of Whitehall
Palace at the other. The tunnel had been created by a Jesuit priest
fleeing persecution, and led to a network of others snaking beneath
the West End of the city. Once he had finished his duties in the
chapel, Thomas Provis was to head out as if he was returning to his
apartment. Then, just before he reached his front door, he would
dart down through the secret entrance.

Now here he was in the park. It had snowed overnight, which
gave the landscape around him a deceptive air of virginity. Dawn
trailed white skeletal fingers over a sky bruised black and blue by
the receding night. All around him trees held their branches up in
surrender to the unforgiving cold. As he walked he could see his
breath creating small warm clouds in the air. He wanted to reach
out and reclaim them, because he felt that with each hot breath, he
himself was becoming icier.

Momentarily he wondered if a contemptuous God was looking
down on him. He imagined himself from that God's-eye view – his
lamp turning him into a small firefly as he made his jerky progress
against the dark landscape. Only months beforehand St James's Park
had been the focus of all Britain as the place where the rioters had
attacked King George. But at seven thirty in the morning all the
park's memories of assassination attempts, society preenings and
debauchery were invisible.

He felt anonymous. Such anonymity made him feel comfortable, relieved. He felt himself breathing more calmly than he had since the whole wretched business had started. Somewhere, he hoped, out here in the dark was Ann Jemima, waiting, ready – he thought with pained curiosity – to confide in him again. But his heart began to beat faster as he realised he could see her nowhere. He started to spin round with his lamp held aloft.

A branch snapped, and a duck's quack echoed through the frozen air. Provis turned and saw the other lamp through the branches of a tree on the other side of the canal. Silently he walked across the bridge. He hardly dared to believe, now, that it was Ann Jemima waiting for him. She was wearing her grey cloak – for the first time in weeks it did not seem to shroud her. She said nothing – simply came and took his hand before leading him further away from the palace.

'This is better,' she said to him when they finally stopped. 'I couldn't abide being in that apartment any longer. The air stank with our disappointment, it was choking both of us, I did not know how much longer we would be able to bear each other.' She paused. 'The cold air out here helps me to think more clearly, more cleanly.'

'Less cruelly?' he joked wretchedly.

'I regret profoundly that I have been unable to stop myself being so unkind with you these past two weeks.' Her own voice faltered. 'I did not want to come back – it made me feel trapped, humiliated. Yet even as I was so harsh with you, I was asking myself why…'

'You had to show your anger to somebody. West would not oblige us with his presence, so you directed it at myself.'

'Yes, yes…' She was silent for a moment, biting her lip in embarrassed acknowledgement. 'After you went to Mr Westall, I decided I should write to Mr Cosway again.' Here her eyes refused to meet his. 'He wrote back, and was most supportive.' Now she looked up. 'He is more sympathetic to the idea that we should pursue West than he was on his last visit. His insights have given me the perfect idea for what we can do to make West give us the money.'

Another game, thought Provis sourly. But he kept his counsel.

'What do you think each artist at the Academy cherishes more than anything else?' she continued.

'Each artist?' he echoed stupidly.

'I am not talking in terms of possession. I am talking about the quality that makes them who they are.'

He remained silent, unable to see where she was leading.

'I am not talking about their honour, or the honour of the Academy.'

Finally he understood.

'It will probably vary from man to man,' he answered slowly. 'But if you are talking about the way they see themselves as artists, then it will be their talent they value more than anything else.'

'Not just their talent,' she concurred, 'but the way that talent is perceived.'

He laughed low.

'Then we are talking of one of the deadly sins, pride.'

'Pride or vanity. It matters not what name you give to it. But yes, I believe that is what is most important to them.'

A fox ran out in front of them with a struggling duck in its mouth. It looked at them, startled, before leaping onto the frozen canal and disappearing into the undergrowth beyond.

'No one will be interested that Benjamin West has wronged two strangers,' she continued. 'As you have seen, if we present our case to them straightforwardly with ourselves as victims we have no hope. If however, we present it to them as a crime against themselves...'

'A crime again themselves?'

'Yes,' she replied triumphantly.

He stopped. 'In what way?'

He looked at her face as she prepared to respond. He saw the renewed self-assurance. The glint in her eye had a knowing, Machiavellian edge to it. She had become a mature woman rather than a disappointed girl.

'West has been cunning, and we must be cunning too,' she declared. 'He only became interested in deceiving us once he realised the manuscript had true worth. Up till that point he viewed us as eccentric individuals...'

'He saw me as an eccentric,' he corrected her. 'He had more regard for you.'

'No.' Her voice was cold. 'No, I have come to realise this. He did not have regard for me. He had interest in me in as far as I could provide him with details that aided his ambitions. I failed to see that, and that made me weak.'

The last word cracked out as if on the tail of a whip. She paused for a moment as if needing to collect herself.

'His belief that he can use the manuscript to produce the best pictures for this year's Academy exhibition is a strong advantage.'

'Indeed.'

'We can inform the other artists of the Academy in all good faith that he is using the method in the hope that all of them will trail behind him.'

He was starting to understand.

'In other words we tell them that West is trying to cheat them.'

'Precisely,' she said. 'On top of this we raise the price of the manuscript to reflect its worth.'

Here, he felt, he was ahead of her.

'I had conceived a plan along those lines already,' he replied. 'When I approached Westall I said it was worth £600.'

'That is not sufficient.'

Again her tone was sharp.

'Then how much are you thinking of asking for it?' he replied.

'One thousand pounds.'

'One thousand pounds?'

She laughed his incredulity.

'You do understand how important the Academy's annual exhibition is?' she continued. 'You do understand how much it matters that West is using the method to prepare all of the pictures he submits to it? It takes just one patron to favour an artist to increase the money he can command for a painting ten times over.'

He was silent for a moment. Then he too started to laugh, feeling the stiffness in his jaw at the unaccustomed movement.

'We must be bold,' she continued, taking his laughter as a sign of approval. 'We have been too cautious, too deferential. So on top of this we approach not just one or two artists, but ten, fifteen, however many it takes to sway opinion against West. Through his

greed, West sought to disinherit us. Let us use the ambition of others to take our revenge.'

He was starting to lose all sensation in his hands, so he held his left one up to the lamp. He looked as his fingers glowed red, the light illuminating the blood in them.

'When do we commence?' he asked.

'We leave our appointment cards today,' she said shortly. 'Tomorrow night there is a meeting at the Royal Academy – and we want the rumours to be starting to spread then.'

'Excellent, my girl. You have, as ever, worked hard – this is an admirable scheme.'

'Westall's response to your approach,' she continued, starting to enjoy herself, 'need not be of concern to us.'

He was about to answer, but decided not to blacken her optimism.

'He is often inebriated,' she continued, 'and is not viewed seriously by the other artists.'

'That is most interesting to hear,' he replied, his heart lifting slightly.

'You should not have expended your efforts on him to begin with,' she continued. 'The most important individual for us to seek out is Joseph Farington. He is a diarist as well as an artist, so he sees it as his personal duty to be aware of everything that is taking place in Academy circles. Not merely so that he can write about it, but so that he can talk about it.'

'In short, he is a prattler.'

'Precisely. Yet unlike Westall, people tend to credit what he says.'

Provis looked around him as he absorbed what Ann Jemima had just said. He felt, in more senses than one, the darkness lifting. He turned round to see that, just above the Queen's house, there was still a crescent moon, while over towards St James's Palace, a silvery sun was starting to make its presence felt.

'I should have known you would not let us endure defeat on this,' he said. 'My visit to Westall made me despair…'

'Yet your problem was that you did it in anger.'

She looked directly at him, and he frowned. Had she guessed – had she somehow heard?

'We cannot allow ourselves to be ruled by our emotions any more on this,' she declared firmly. 'We must do this calmly, rationally. Use the surgical knife rather than the dagger.'

Two somnolent geese started honking.

'I have never felt so betrayed as I have since that moment when Cosway told us what he had discovered,' she continued. 'But I allowed myself to become as vulnerable as a small animal – all I could feel was pain. Now I have collected myself. I am no longer the naïve young girl who went to Benjamin West's, believing he would honour his side of the agreement.'

'You never were naïve, Ann Jemima.'

She flinched slightly as he said this, and he frowned.

'I genuinely believed him to be a good man. I genuinely believed…' her words trailed off. Fell to the ground softly as snow-flakes. 'Well that was then,' she said reasserting herself. 'Now we have a plan. Are you prepared for this? Prepared even though, as Cosway says, it is a risk?'

'I was prepared before now,' he replied. 'But then I lost heart. Yet it is better for me to proceed now, than not to.'

Again the memory of the punch ricocheted across his mind. He briefly closed his eyes, as if, ineffectively, trying to rid himself of the image.

'Let us return to the Palace,' he said finally. 'We must act swiftly. I will leave the first calling cards this morning, and we shall start making our visits this afternoon.'

A thin ray of winter sun fell across her face. Now that the dark had receded he could see her as if she was painted in new colours. The blue-grey of her cloak brought out the pale blue of her eyes, while her skin had a peculiarly translucent quality as a result of her breathing the cold winter air.

'It felt like the world had stopped turning,' he said as he looked at her. She tilted her face to one side.

'Well, now it is turning again,' she replied crisply.

A dispute with Mrs Tullett

'Ultramarine blue is a colour illustrious, beautiful, and most perfect, beyond all other colours; one could not say anything about it, or do anything with it, that its quality would not still surpass. [...] Know that making it is an occupation for pretty girls rather than for men; for they are always at home, and reliable, and they have more dainty hands. Just beware of old women.'

Cennino Cennini,
***The Craftsman's Handbook,* c. 1400**

It is of some relief to Ann Jemima that when they return to the apartment, the Serjeant of the Vestry is standing outside with a restive air that demands Mr Provis's instant return to his duties at the chapel. Thomas Hadwick has sent word that he is in bed with a fever, and extra help is needed to prepare for lunchtime communion. As a result, Ann Jemima is able to walk through the front door alone. For a moment she feels Provis's presence in the small drawing room more forcefully than when he physically occupies it. She surveys, as she has so many times, the cartoons he has had framed, the carefully arranged antiques, the stack of *London Chronicles* next to the fireplace. Her hand raises itself, unbidden, to her forehead. She lets it stay there as she breathes slowly and considers their conversation. Then, hurriedly, she takes off her cape, hangs it on

the coat stand in the small hallway next to the drawing room, and runs to her bedroom.

She is back in a matter of moments. In her hands she holds a dark oak letter-writing box. She places it on the table and opens it, pulling out the drawers to get a piece of foolscap paper, a goose quill, and a small bottle of iron gall ink. After sharpening the quill deftly with a penknife she begins to write.

'St James's Palace *5 January 1797*
 'Dear Mr Cosway,
 'Though the burden of what I wish to say weighs heavy on my heart, I believe it will take but a few lines to convey my Intent. I would like you to release Mr Provis – and by implication myself – from the Hold you believe you have over him.'

She is breathing fast as she writes the words, and realises she is holding back tears. She takes a deep breath, composes herself and continues.

 'Forgive me if there is a degree of Presumption on my part. But much damage has been done thusfar – and yet more may ensue if the Misunderstanding is allowed to continue. Scandal is a voracious beast. It seizes on what it does not know, and creates an Entertainment for the world that belittles all who take part in it. Yet in truth Mr Provis has no case to answer. He is an honourable man. Three years ago you believed you had little Stake in what became of him. Circumstances have conspired to make you change that view.'

She looks to her right, to catch a glimpse of a small mirror hanging on the wall. For a second she frowns, as if not recognising the person she sees there.

 'In truth, whenever we embark upon any course of Action,' she continues, 'it is impossible to say what we will beget. Bad origins may produce good Outcomes, and good origins bad

ones. Nothing has proved that more than our dealings with Mr West. After a period of doubt, thanks in no small part to your advice, I believe that his Deceitfulness may be turned to good for all of us.

'Beyond our expectations he has stepped into a trap that he has designed himself. It is for us to ensure that he is caught. As you yourself have pointed out this will require much Daring. Yet you said this to me knowing that I would eventually take the challenge. It did, after all, take much daring to approach him in the first place.'

There is a noise outside the apartment as if someone is about to enter. She looks at the letter in front of her fearfully and her hand hovers towards the lid of the writing box, ready to shut it. But no one comes in. After waiting a minute to ensure she is alone, she resumes her writing.

'I wish you not to be under any Misapprehension. There is of course an extent to which we will always be indebted to you. You could have shunned and ridiculed us when West started to deny our part in his Discovery. As we have discovered in these last weeks, the relationship between the perception of power and the perception of truth is most intimate. Among the people who are of any account in this Situation you have power where we have none. Yet you have – quite remarkably – chosen to champion our discovery.'

She frowns and stares towards the fire. 'And I do not trust you in the slightest,' she whispers. 'Please, God, I have found your price.' She dips her quill in the ink once more.

'I therefore propose that if we succeed in selling the method – with your backing – we will give you precisely half the money. I trust that you will accept it as a sign of our Gratitude.' She takes a deep breath. 'I also trust that you will accept it as a Sign that our debts to you are discharged, and Mr Provis

and myself can go about our lives without a whisper of what has happened in the past, for which, after all, not one of us is guilty.'

She sits back again. As she does so, the rattle of a key is heard in the lock of the door and Mrs Tullett enters. Ann Jemima quickly closes the lid of her writing box. After a swift suspicious glance, Mrs Tullett walks towards her.

'What are you doing, my girl?' she says quietly. 'What are you attempting to conceal?'

For a second Ann Jemima regards her.

'I am concealing nothing, Mrs Tullett.'

'Then open the lid of that box.'

'It is a foolish letter that would not interest you.'

'We have all been foolish in our time.'

Doom starts to make its familiar imprint on Mrs Tullett's voice. Her eyes narrow as she returns Ann Jemima's gaze.

'Yet when you are foolish, Miss Provis, it is not only you but everyone around you who must suffer.'

As she awaits Ann Jemima's response, she seems to swell with her rage. A clump of fat fingers twitches, disaffected, against her skirt.

'I do not comprehend your meaning,' the girl replies with restraint. 'To my knowledge I have made no one suffer. I tried to go away, and was brought back. I have no desire ever to see or talk of Mr West again.'

Quiet disbelief crosses Mrs Tullett's face.

'You do not stop suffering by disappearing. You did not see Mr Provis when he thought you had gone. He was like a bear that wanted to chew off its own head.'

Ann Jemima frowns.

'I was wrong and I panicked. But then I returned.'

'Yes, you were made to return.'

The seamstress glowers.

'Most girls would be happy simply for the privilege of living at the court,' she declares. 'Yet even that has not proved good enough for you. Mr Provis may have brought you back, but he is

the laughing stock of all who survey him. You have changed him into a different person.'

An unruly lock of hair snakes across her forehead – in irritation she pushes it back.

'You talk riddles, Mrs Tullett. Whatever my transgressions, I have not turned Mr Provis into another person.' Ann Jemima shifts uneasily.

Mrs Tullett's voice becomes low and contemptuous.

'A servant came to the Palace kitchens this morning, making enquiries about Mr Provis hitting a man. He was sent by a Mr Westall – an artist – who said Mr Provis punched him in the ribs when he went to talk to him about the manuscript. I never thought such a day would come.' Mrs Tullett thwacks her hand on the table, glowering at Ann Jemima as if daring her to contradict her. 'If it had happened a year ago, I would not have believed the story for a moment. Yet as I said, Mr Provis has changed. And it appears that he is in danger of losing everything, including his good name.'

Ann Jemima's eyes flare at the sound of Westall's name, and become yet wider when she hears about the attack. She stands up and walks away from Mrs Tullett. She puts her fingertips together, as if calculating how best to frame her reply.

'Mr Provis is not a violent man.' But though her voice is cool Mrs Tullett can see the fear racing through her eyes as she looks back at her.'

'No, indeed.'

'Do we know if anyone else saw this happen, or do we just have Mr Westall's word for it?'

'It was just Mr Westall's word till his servant came to the Palace – but now it is going round all the courtyards.'

'Do you really believe he did it?' Now the fear enters her voice.

'Yes, I do.'

'He cannot have, he must not have…' It is as if she is talking to herself. 'If he has, he has jeopardised everything before we have started.'

Mrs Tullett shakes her head.

'No, it is not he, young lady, who has jeopardised everything. It is you and always was you.'

'I never told him to strike a man.' Ann Jemima's tone suddenly becomes sharp with outrage. 'It is he who has pushed for revenge on this – till now I have urged caution.'

'No, you never told him to strike a man. But when you ran away you made him discover he would fight to the death to protect you.'

'I never asked for that…' Ann Jemima shakes her head.

'It is what any father would do.' Mrs Tullett glowers again. 'Why would Mr Provis be any different?'

They are both silent for a moment.

'I have said it before, and I'll say it again,' declares Mrs Tullett eventually. 'A little learning is a dangerous thing, especially in a woman. You should never even have approached West with that manuscript. It has released forces you cannot control that will ruin your reputation and Mr Provis's. If you are not careful, you will not even have marriage to save you.'

At this last jibe, all Ann Jemima's restraint falls away. She looks at Mrs Tullett, sees the years of disillusion in the lines beneath her eyes, the snipped creases of endless dissatisfaction around the mouth.

'How you revel in the role of the doubter,' she explodes. 'You have never wished for anything other than my humiliation from the start of this. And you say that marriage could save me…'

She shakes her head. She feels she is shouting into a dark wood.

'I remember shortly after I came here, a story that you yourself recounted to me,' she continues more quietly. 'You told me of the small boy who came to the court to play the piano for King George and Queen Charlotte. He was eight, his genius was renowned across Europe, and he was able to play the piano better than an individual three or four times his age.'

Why talk you of Mozart?' replies Mrs Tullett warily.

'Because of what took place after the concert he gave. I have never been able to forget what you said to me. You told me that when all had gone, you were helping to make ready the drawing room for the morrow. You had been called away for a few minutes, but as you returned you heard the most beautiful playing.' Her voice

trembles. 'You crept in, expecting to see the young Wolfgang. But it was not him. It was his sister – as you have said many times – every bit as brilliant as he.' She starts to feel the white heat of her anger. 'Yet we rarely hear of her. Why not?' She looks at Mrs Tullett. Now it is the seamstress who has nothing to say. 'Because as the time approached for her to be married, the family knew there was more to be gained from cherishing the talent of the boy,' she continues.

Mrs Tullett will not be wooed.

'Maybe she was simply not as good as I remember.'

Ann Jemima shook her head. 'I have talked to others who were there. They recount the story the same way that you do.'

She can see on Mrs Tullett's face a form of stupefaction. There is a kind of recognition in her eyes, but her mouth is locked shut against conceding any kind of agreement. The seamstress may be wedded to her predictions of an overturning of the world order, yet there are certainties that even she cannot bear to question. The light of recognition disappears, and the eyes glaze with outrage.

'Why should it be so upsetting for the world to know that genius does not only wear breeches?' Ann Jemima continues, with a quick laugh. 'Blood flows through every human's veins in the same way, we all have the same senses, the same eyes to observe, the same ears to listen. Why should any human – no matter what their sex – cause outrage by asking to be free to practise what they can do best?' She steps closer to Mrs Tullett. 'Talent is so often seen as something divine. The men we admire have all been kissed with a rare ability. Blessed with something that cannot be taught. There is a whole mythology to it. And maybe that's right. Maybe there's something about it we can never understand.' Ann Jemima takes a deep breath. 'But can you in truth tell me that at some point it is not to do with being encouraged, being recognised, being believed in? Being given an education that lets air into your mind rather than stifling it?'

Mrs Tullett's pupils dart back and forth as she considers her answer.

'There are all kinds of unfairness in life.'

'Indeed there are.' Ann Jemima finds her voice is trembling. 'Men must fight battles too. Misery, hypocrisy, fear of poverty and

shame, illness and death – we must all combat these, it is our lot as humans. Yet there is a kind of conspiracy of silence which refuses to acknowledge that women can do this outside the parlour. Why?'

'Sometimes we need encouragement, sometimes we need discouragement,' Mrs Tullett replies darkly. 'Can you not remember – it is but a year ago that your obsession almost killed you?'

'What do you mean?'

'You were so stubborn, so single-minded when you were studying theories and working on your paintings, it was as if you had been gripped by a madness. Some of us were worried it was going to finish you off.'

Now she has hit her mark. Ann Jemima frowns.

'Finish me off? In truth, all I had was a temperature.'

'Ann Jemima – it was I Mr Provis came to when he needed to send for a doctor. You were in bed with a high fever. He wept when he talked to me. He believed you were going to die.'

'I had simply found myself unable to sleep for a week…'

'Because you were reading your books till all hours of the night. I came with the doctor, I saw you myself. You were delirious. Kept on crying out all kinds of nonsense. At one point you were so delirious you even told the doctor Mr Provis wasn't your father.' She fixes Ann Jemima with her gaze, and the girl's hand flies to her mouth. 'The doctor treated you with leeches. Your ravings increased, and then you went to sleep. It was two days till you were able even to rise from your bed.'

Her eye catches *The Craftsman's Handbook*, which lies on the table next to Ann Jemima's writing box. She picks it up and walks towards the fireplace. 'I think you should burn your books. All they represent is misery for you and Mr Provis.'

Ann Jemima watches her as if in a trance for a moment, and then cries out, 'No!'

Mrs Tullett turns back to her.

'Do not burn the book,' declares Ann Jemima. The iron has returned to her voice.

'Your books made you ill,' Mrs Tullett continues. 'Will you desist from this for Mr Provis's sake?'

Ann Jemima draws herself up to her full height. She sees the old woman making her calculations. She realises she is building a pyre of books in her head, and on top of it Mrs Tullett. She takes a deep breath to quell her anger.

'Mr Provis wishes to take revenge and I am going to help him.' Ann Jemima walks forward and extends her hand. 'You must trust me in this. We are in too far.'

Mrs Tullett's cheeks mottle with disbelief. Ann Jemima realises she is exhausted by her rage.

'In truth I do not believe any more I can trust you in anything,' the older woman declares finally. 'Why will you not stop now before you ruin him?'

'Mrs Tullett – if I make this succeed then Mr Provis will be the first to profit from it. He will be a rich man. That alone will make people condemn him less harshly.'

The seamstress takes the still extended hand, all the while shaking her head. 'You are a clever girl. And you are battling dark forces, that I will concede. None of this is just. But you have set the stakes very high. This matter has already slipped beyond your control – and may do so even further.'

Her hand tightens on Ann Jemima's and she glares.

'You have changed so much since you fled. It is as if you lived a whole life in that one day before you returned,' she pauses, 'and yet still you are no wiser.'

Finally she relinquishes her hand.

Ann Jemima breathes deeply for a moment. 'I give you my word I will prove you wrong,' she eventually says. She walks away from the seamstress and stares out of the window. Mrs Tullett waits for a moment. Sighing loudly, she picks up the book and – after a quick glance towards the fire – walks out of the apartment carrying it.

Persuading the artists of the Royal Academy

'Our mind, sayth Strabo, maketh up the conceivable or intelligible things out of the sensible: for as our senses doe certifie us of the figure, colour, bignesse, smell, softnesse, and taste of an apple; so doth our mind out of these things bring together the true apprehension of an apple: so falleth it likewise out with great figures, that our sense seeth the parts of them, but our mind putteth the whole figure out of those visible parts together.'

Franciscus Junius,
The Painting of the Ancients, 1638

When Provis wakes the morning after his meeting in the park with Ann Jemima, he realises he is both exhilarated and terrified. According to her analysis of the situation, the artists of the Royal Academy are now placed before them like pieces on a chessboard – each with a trait that will allow him to be manipulated in a certain direction. Reality will of course, he knows, show the moves of the game to be not so straightforward. The divisions between the squares will become muddy, pieces will move in a way

that has not been anticipated, and the winner of the game will be ever harder to predict.

It occurs to him that in playing others for their vanity, he perhaps has his own vanity to assuage. Till now he has been the great connoisseur, the great negotiator of deals. When Ann Jemima first came to live with him, she would sit and ask him about the paintings and different objects in his apartment, and he would recount to her the way he had acquired these and sold others like a hunter boasting of his greatest expeditions. But he has never done anything that requires the daring she has needed to put the manuscript in front of West. Now that it is generally agreed that West values the method, he has realised with a shock that Ann Jemima has perceived an opportunity that he, with his age and experience, would have missed. One of his motives in pushing for revenge is a sudden desire for her to acknowledge him as her equal in daring.

The calling cards have been delivered, and the first move in the game decided. An artist called John Rigaud has replied that he will receive them. Rigaud has painted for royalty across Europe. When they walk into his drawing room on Jermyn Street at eleven o'clock that morning, Provis recognises that the wallpaper – which he perceives as unbearably fussy – has been created by the same Frenchman whose designs were once sought out by Marie Antoinette. If this were not automatically a sign of Rigaud's self-regard, the resonance of his voice and the spread of his girth are. A black embroidered jacket struggles to contain him. His lips bulge prominently, like a breed of mollusc. There is a slight sheen of sweat on his waxy brow.

Yet any temptation to regard the man satirically is quickly removed by the realisation that he is not going to be easy to convince. His glares are dyspeptic, and his voice whittled down by scepticism. Provis goes from forced calm to feeling the beating of his heart intensify till he is like a tin box in a hailstorm, battered from inside and out by his fear. He sees that Ann Jemima is slightly unnerved too, but it is at this point that he recognises the strength of the confidence she has been given by her anger with West. Coolly and repeatedly she asks the artist why West has not fully shared the results of his experiments with the Academy. Finally Provis

realises Rigaud is unable to deliver an answer that interprets events in West's favour.

At the point of acknowledgement, Rigaud looks almost in pain. Though his frame is large and crude, his body is prey to every twitch of his thoughts, thinks Provis, as the artist's right knee agitates itself back and forth.

'It is a most shocking situation,' he declares. 'Miss Provis, I remember very well when I met you at Mr Cosway's house and we discussed the method. I urged you strongly to take it to Mr West, with the view that, should he find merit in it, he would share it with the entire Academy.'

He rises with a wince from his chair, and starts to pace back and forth.

'I have thought often of our conversation since.'

He stares at Provis and Ann Jemima, who are sitting in arm-chairs opposite him. Beneath his powdered wig, the sheen on his forehead intensifies.

'I would have liked to have experimented with the Venetian Secret myself,' he continues. 'But it seemed only right and just to hand it over to Mr West, since it required someone with not just integrity but the right level of prestige.' He blows his cheeks in and out. Provis watches him with loathing even as he draws uneasy comfort from his words.

He remembers well Ann Jemima's dismay at Rigaud's initial disinterest. She had been convinced that he had urged her to talk to West because he had not the inclination to deal with the method himself. Yet Provis has noted often at King George's court that when the powerful decide to transform opinion the first sign is their rewriting of their own memories. In this way they can appear to be the prophets of change – wise seers rather than the fools they have been, stumbling around in the dark.

'I was most grateful for your encouragement at the time,' declares Ann Jemima.

Provis directs his smile towards the floor. Yet Rigaud nods as if she has answered correctly.

'Of course I have a certain standing in courts across the world,'

he continues, 'especially that of King Gustavus IV of Sweden.' His mottled eyes intensify their expression. The feeling that pervades the room is his desire for their subservience. He craves it as other men crave a drink, reflects Provis, and accordingly dips his head. The muscles relax around Rigaud's eyes. 'In some ways,' he continues, 'you could say that my extensive experience abroad combined with my Italian heritage would have made me a better candidate for testing the merits of a method that came from Venice.'

'That was very much what I myself had hoped for,' said Ann Jemima. 'I was, I confess, slightly surprised when you urged me to go to Mr West.' She makes a sly glance here towards Provis. 'Mr Cosway had told me there was no one at the Academy with greater authority than yourself on the Italians…'

Oh, beautifully played, my girl. With an effort Provis stops himself from saying the words out loud. Instead he declares, 'You can see clearly the effect of Titian on your painting of Samson and Delilah. The flesh in it is exquisite.'

Rigaud looks stunned.

'You are a connoisseur?'

'A mere amateur,' Provis demures. 'Never more humble than when in the presence of someone who creates themselves.'

The flattery is too thick, he chides himself. He worries for a second that the scepticism in Rigaud's eyes has returned. But he realises that the expression is one of reappraisal.

'Of course you are a connoisseur,' the artist declares. 'If your grandfather was clever enough to identify this secret, why would his grandson not be equally clever? Was he alive when you were a boy?'

Provis clears his throat.

'He died before I was born. But my mother talked a lot of her father. The tales of his adventures when he was working for the East India Company made a great impression on me as a young boy.'

Ann Jemima looks at him. She is concentrating sharply on what he says, and he is surprised by the growing warmth of expression in her eyes.

'What twist of fate took him to Venice?' Rigaud asks.

'He was sent there around seventy years ago. Up till then his trade had taken him to India and Bengal as an importer of Indian fabric. That was the cause of his interest in colours and dyes – for which, of course, Venice was a great centre.'

'It was a great centre for many things. Was he there at the same time as Casanova?'

Provis frowns.

'I believe he was,' he replies after a moment, 'yet Casanova would have been but a babe in arms at the time – he was not, so to speak, Casanova.'

Rigaud is quiet for a moment – he has the wariness of a man who is aware that a shard of wit has been deployed but is not quite sure when it is going to hit. Finally he nods.

'Now, I hear, he works as a librarian for Count Waldstein,' he declares. 'I met him many years ago in Paris. He tried to persuade our circle of his skills as an alchemist. None of us believed him, but his charm was such that we were more than happy to indulge him for an evening.'

Though he, I suspect, struggled to tolerate you beyond an hour, thinks Provis. They are silent for a moment, as if their conversation is a clockwork toy that has finally lost momentum.

'In terms of my great-grandfather's diary,' says Ann Jemima, interrupting the silence, 'do the artists of the Academy challenge West to reveal the elements of the method to them in a demonstration? Or do we demonstrate the secrets of the manuscript ourselves before the Academy Annual Exhibition?'

'West has not the manuscript?'

'No,' says Ann Jemima firmly. 'He has seen it, and I have performed several demonstrations of the techniques contained within it. But currently it is in my possession.'

'I see.'

His eyes glisten, and the mollusc lips twitch.

It is fascinating how greed can show itself in such a subtle realignment of a man's face, thinks Provis.

Ann Jemima leans forward slightly.

'I am most gratified that you understand the full seriousness of

this situation.' She smiles demurely. 'It is particularly important to me that this method is practised by artists of great accomplishment.'

Provis nods. 'It is not like one of these manuscripts one hears about offering a formula through which the foolish may find wealth quickly,' he concurs. 'There is no claim that any man in the street could pick it up and produce a Venus of Urbino.'

He looks over to Ann Jemima, as if for approval. Yet she is staring at Rigaud whose responding laugh sounds like the scraping of a rusty bowl.

'The beautiful Venus of Urbino,' he says. 'Now that is a painting where I have often admired the flesh tones. Titian was the first artist to use living women for his nudes, and you can certainly tell the difference…' He collects himself, realising his indelicacy. 'Forgive me.' He looks at Ann Jemima shamefaced, a dark red suffuses his neck and ears. 'What you say has the ring of truth. The fact that this is only suitable for the eyes of experts I think is key to asserting the verity of the method.'

Ann Jemima stands up and extends her long slim hand towards him. He engulfs it in his grasp. 'Mr Rigaud,' she says crisply, 'I applaud your acute perception of the matter. My father and I thought a lot about whom the best individual would be to approach. For wisdom and understanding of greatness it seemed that…' she pauses for a moment, distracted by the violence of his nods, 'seemed that you would be the obvious individual.'

'I thank you for recognising that,' he replies. 'I will talk to my fellow artists this evening on the matter. It will be a travesty if West alone profits from it.'

Their second visit is to Opie. From the start it has a different tenor. As their large-wheeled phaeton pulls up in front of Opie's house on Berners' St, the front door opens with alacrity. A footman ushers them upstairs and into a pale green double drawing room. As the artist comes forward to greet them, Provis notes with interest that though he – like Rigaud – is clearly sceptical at this stage of their visit, it is not

in his nature to patronise. On the contrary he is both direct and open. Provis realises there is a faint trace of the West Country in his accent.

While Provis is impressed by his directness, Ann Jemima is less so. How can he have such a reputation as a ladies' man? she thinks to herself. His skin is sallow, and his face is almost ugly. There is nothing of the flirt in his manner either. To her he seems both exhausted and mildly impatient – the shadows under his eyes are so dark it looks as if he has received them in a brawl.

The drawing room in which they meet him demonstrates – to her imagination – the same combination of aspiration and exhaustion. Spectacular glass chandeliers hang from the ceiling, but almost as spectacular is the spider's web that trails from one chandelier to the right hand corner of the room closest to the street. One of the two carved mahogany sofas with embroidered cushions has prominent splashes of red wine on it, while the exquisite walnut side tables are all adorned by dust. The overwhelming impression is of a place that has been loved but now is not. Ghosts of forgotten laughs and half-remembered conversations hang in the air.

She realises that Opie has caught the slight expression of shock on her face. Hastily she attempts to explain herself in a way that will disperse any awkwardness.

'I was thinking about the great individuals who you must have received here,' she says. 'They tell me that you have painted Samuel Johnson and Edmund Burke.'

A half smile creeps onto Opie's face. She can see he has under-stood precisely the cause of her expression, but will not make her feel uncomfortable by pressing her on it.

'I found Samuel Johnson more melancholic than I anticipated,' he replies gently. 'His intellect was in no doubt – he cross-examined me brilliantly on Euclid at one point, and the absurdity of fashions in men's breeches at another. Yet for many hours of our sittings he would sit staring ahead muttering vehemently to himself. He told me that he feared the loneliness of night more than anything on this earth.'

She is quiet for a moment. 'What of Burke?'

'He was eloquent, charming and infuriating. Most passionate when he talked about the damage the British Empire is reeking in

India. He enjoys hearing himself speak, but if I were as articulate as he, I would no doubt be equally self-indulgent.'

He holds out his hand as an invitation for Ann Jemima to sit down. She tries not to scrutinise the wine stains on the sofa too carefully as she takes her place at the other end from Provis. Opie himself perches on a stool. As he folds his hands in front of him, she sees the streak of livid yellow paint on the left one, and the flecks of red and blue beneath the fingernails of the right.

'We are sorry even to have to raise this matter…' she begins.

'Well quite,' he says. 'I have to say I am deeply surprised by Mr West's behaviour. It does not seem in character. He has – like all of us – many faults. But untrustworthiness has never seemed to be one of them.'

She nods.

'I would have agreed with you, till recently.'

Hearing the deadness of her voice, Provis looks at her sharply. The easy charm that he has noticed her display so often is absent now. She is struggling to understand him, he realises. She does not know how to play this move right yet.

'Mr Cosway came to see me yesterday, and after his visit I took it upon myself to go and see Mr West. What was curious was the fact that in some senses he was very open. He invited me to see some of the paintings he had done using the method.'

'Did you explain to him why you wanted to see those paintings?' Provis interrupts.

Opie contemplates him for a moment.

'I do not enjoy subterfuge. But Mr Cosway told me it was imperative that I said nothing about you or your daughter.'

His eye moves to Ann Jemima.

'Did he say he did the paintings on his own?' she asks, looking quickly at Provis.

Her voice is still stilted.

'He did,' Opie replies shortly. 'So I am not clear which ones he has painted and which you yourself assisted with.'

There is an awkward silence. As Provis notes, with some amazement, Ann Jemima struggling for her next words, suddenly

Opie realises her consternation and smiles sympathetically. The change in his face is extraordinary. It is as if an ache has suddenly been relieved. The shadows under the eyes are less severe, the creases round the mouth speak no longer of suffering. He can see from Ann Jemima's expression that she would still not judge him attractive. But he sees her starting to respond to the man as a whole rather than the imperfections of his surroundings. Provis himself is struck by the dignity of the way he moves, the resonance of his voice. He answers to no one but himself, he thinks, and yet somehow survives in the top rungs of London society. A rare animal indeed.

'I must be honest with you, I am not personally inclined to using special methods,' he continues. 'When people ask me what I use to paint, my response tends to be my imagination.' He smiles again. 'West had done a version of the Crucifixion using the method, which I must confess did not impress me much.' He looks directly at Provis as he says this, and Provis nods acknowledgement of the criticism. 'But the Cupid Stung By A Bee…'

'That is the one with which I assisted.'

Now Ann Jemima seems flustered, emotional.

'That is yours?'

'I assisted with it,' she repeats precisely.

He pauses.

'Which parts?' Provis can hear in his voice he is testing her.

'Cupid's face. The details on Venus's scarf…'

He frowns and stands up.

'West has painted this subject before, but frankly I thought what he did was terrible. You could be forgiven for thinking he had never seen a mother with a young child.' As he speaks more eloquently, Provis notices his West Country accent becoming stronger. 'This time there was a greater directness of emotion in it, an altogether better use of colour…'

He stares at her as if he is seeing her afresh.

Now she looks down while he scrutinises her.

'Has Mr West offered you no other opportunities to display your own work? I really did think what I saw there was extraordinary.'

He can see a mixture of emotions on her face that he cannot

quite understand. A look of incredulity combined with surprised pleasure. Then she asserts herself.

'It is the Venetian method that makes the painting what it is,' she says briskly.

Provis, recognising the slight tone of grievance in her voice, concurs.

'Ann Jemima could not herself believe how much the method had improved her painting,' he says loudly. 'It was one of the reasons we decided to take it to West.'

She swivels her head round quickly, and her eyes glint. Quickly she nods, and turns back to Opie.

He is silent for a moment and goes and sits back down on his stool. He looks at both of them hard. Provis is not sure what calculation is going on in his mind.

'I think it is important to make sure there is no misunderstanding. This should be put openly to West. I fear he faces opprobrium from all sides, and I will not be party to an unnecessary accusation.'

Ann Jemima's words from St James's Park resonate in Provis's head. He leans forward.

'We have no desire to cause trouble for the sake of it,' he says. 'All we wish is to be paid in full for the method. It is most difficult to support a young lady on a modest verger's salary.'

At first Opie seems to look straight through him. Then the artist's eyes become luminous with agreement.

'Of course the money is important. I hear that you hail from Somerset. Not so far from my part of the world. Though I can only hear it slightly in your accent.'

He looks at Ann Jemima, who seems a little taken aback by his assertion.

'My grandmother was very keen for me to speak like a London lady. She always imagined that some day I would go and join my father.'

He shakes his head. 'Those of us who grow up in the country must learn the hard way that the city is a beast. No matter how well prepared we may be, it will devour you if you give it even half a chance.'

'It is a treacherous bear pit indeed,' says Ann Jemima. Finally

Provis sees her eyes light up, and in Opie's returning gaze he is glad to note a steadily increasing warmth.

'Never more so than in circles where men are supposed to be most refined,' he replies.

The balance has tipped, thinks Provis. Out loud he says, 'We are most grateful that you have received us, Mr Opie.' He rises, and walks over to shake his hand. 'We will consult with Mr Cosway on your most wise counsel.'

The final visit of the week is to Joseph Farington. They set out to see him as London is receiving its second covering of snow in seven days. The first fall has not enjoyed its triumph for long over the city's dirt. Within a day or so, melted slush has gurgled grey and brown through the gutters, waiting for this new onslaught from the sky to fill the winter streets with light once more.

'I believe I start to understand how an actress feels at a playhouse,' Ann Jemima declares to Provis, as they climb into the covered landau carriage that will take them to Farington's house. 'We have told our story so many times these past few days, it feels as if it were a script – though the audience members grow ever more unpredictable.'

'Then you are an actress playing a lawyer,' he replies. 'You have built the case against Benjamin West with ingenuity – now every man of them is ready to convict him.'

She flushes, and laughs.

'I have often heard you condemn lawyers as liars.'

'That is not necessarily to condemn them – there is a great art to lying well.'

Her eyes glint.

'So it is by that measure you acknowledge me to be an artist.'

'You know that not to be true.'

He is suddenly serious. Unwilling to acknowledge his change in tone, she looks out of the window.

'What a vast and strange menagerie of men the Academy contains,' she declares.

'Indeed. I would scarce credit that that oaf Stothard was an artist, had I not seen his work. He fell in love with you at once.'

'John Hoppner was charming even though he seemed unwell,' she retorts, ignoring Provis's jibe. 'They say he is the illegitimate son of George III, but I find it hard to credit – he is far more prepossessing than the Prince of Wales.'

Provis guffaws.

'And all of them, apart from Opie, would walk over broken glass in order to see details of the method.' He reflects for a moment. 'Has it not struck you that the greater the artist's greed is to see the manuscript, the more openly he expresses his concern for our wellbeing.'

'Well, if you are to gain something from someone, you are always happier to see them well,' she replies drily.

'Unless you are West.'

'Indeed.' She adjusts the scarlet shawl she is wearing. 'Now let us concentrate. This visit is one of our most important. If Mr Farington decides that he wants to take up our cause, then the other artists will look to him to organise what must be done and how we shall be paid.'

On this occasion, it seems as if the decision has been made before Ann Jemima and Provis have arrived. The moment they enter his house on Charlotte Street, he ushers them with alacrity into his drawing room. I feel like a tree, and he the beaver stripping the bark from it, thinks Provis as Farington surveys them. Ann Jemima also feels the intensity of his scrutiny, yet she cannot altogether discern the nature of it. He is the most courteous man I have met, she thinks as he greets them, yet I have never seen courtesy carry such menace.

'I am delighted at last to meet the famous Provises,' he says as they sit down. 'I have had many reports of the beauty of the daughter and the…' he hesitates for a moment, 'impressive gravitas of the father.'

It is as if the unexpected compliment has gone the wrong way down Provis's throat – for a few moments the room is discomfited as he is seized by a fit of choking.

'My poor Provis, this has been a trying period for you,' Farington

says, frowning, 'I want to do everything to remedy the injustices you have suffered. Pray, what can I offer you first? Tea? A little sherry?'

'I am happy to take tea,' replies Ann Jemima.

'I will avail myself of some sherry,' says Provis, recovering.

'Of course you will, my good man.' Farington comes over and pats him on the shoulder. His touch is light as gossamer – in it Provis thinks he can detect a slight distaste, even as Farington mutters, 'It is an outrage what you have both endured, a veritable outrage.'

The verger stares around him in a faint daze at the duck-egg blue walls, the large giltwood mirror above the fireplace, and the cream sofa, which rests on six carved mahogany lion's paws. The paws the only reference to the fact there might be a more feral world than that contained within these civilised walls. On the mantelpiece resides a small and tasteful bust of Apollo.

'I think necessity demands that we plan in detail the way in which the truth of the matter can be revealed to all parties,' declares Farington neatly. 'I do not wish to chastise you for naïvety, but one of the reasons that Mr West has been able to take advantage of you in this brazen manner is that no written agreement was made before you began to demonstrate the method to him.'

Ann Jemima looks quickly to Provis.

'We were naïve not to request written agreement,' she replies looking back to Farington. 'But in truth we did not anticipate that the President of the Royal Academy would stoop to an act of such monstrous cynicism.'

'Till now we were not acquainted with the more insidious ways of the art world,' concurs Provis.

'No indeed. I profoundly regret that you have encountered such practices at the highest levels of our institution.'

'We look to you for guidance in how best to proceed.'

Provis can hear from Ann Jemima's voice that she is trying to suppress her excitement that Farington is so clearly wedded to their cause without the need for her persuasion.

The artist nods.

'A legal document needs to be created, so there is no further danger of misunderstanding.'

There is a knock at the front door. He raises one finger in the air, as if testing the direction of the wind.

'If I am right, the person at the door this moment is my esteemed friend Robert Smirke.' He waits calmly to hear the sound of the voices in the hall, and nods with satisfaction as Smirke's voice is heard just before he appears in the drawing room. 'In terms of organisation of Academy meetings and elections, Smirke is absolutely instrumental. If you want to get anything done, he is your man.'

The smart tap of Smirke's cane can be heard just outside the door now. As he enters and sits down, a maid comes in with a trolley. Like everything else in the house, the Nankeen tea set upon it conveys a world tamed to be both ordered and picturesque – cups with fiercely pruned trees next to still ponds accompany a teapot decorated with pagodas and ornamental bridges. While the tea is poured and handed around, and Provis is administered with sherry, Smirke sets out his strategy.

'Mr Farington and I have had some extended discussions on this. We can quite see why you are at the end of your tether. The incident with Westall was unfortunate.'

Here he glances quickly at Provis.

A chill wind suddenly assails Provis's growing confidence. It is the first time in the week that the matter has been mentioned, and even he has started to wonder whether what took place was no more than a bad dream.

'I was m-most remiss,' he begins to stutter, looking down into his sherry.

But Smirke, he realises with some wonder, is not interested in his explanation.

'In the light of what we have subsequently discovered, it is understandable. Obviously if such an incident were to occur again, we should be forced to reconsider our connection with you.'

Provis chokes back his words, and nods promptly.

'We would like to propose what we believe to be the fairest way forward for everyone.'

Provis looks quickly at Ann Jemima. She is studiedly refusing to

look at him, so he decides that it is for him to move the conversation on as swiftly as possible.

'Fairness is what has been missing from this process up till now,' he says loudly, after clearing his throat. 'Both for myself and my daughter, and for you, the gentleman artists of the Academy. We are most eager to hear your proposal.'

'Very well then,' replies Smirke. He takes out a small notebook, which he consults briefly. 'To commence, we must prove beyond a doubt that West's prevarications are unjustified. He has not been fair to you, but we must be fair to him.'

'Yet we have been fair to him, Mr Smirke,' says Ann Jemima. Her tone is sweet even as her eyes gleam coldly. 'We have spent more than a year awaiting his response. In recent months he has rebutted our attempts to talk to him on at least three occasions.'

'No, no,' Smirke laughs. 'We are aware you have exhausted that route. No, Miss Provis, what we are suggesting is that you yourself provide proof of the effectiveness of this method by performing a demonstration in front of the artists of the Academy.'

She looks quickly at Provis. Fear and delight fight on her face.

'Forgive me, Mr Smirke, I mistook your meaning. You wish me to paint in front of...' Her words trail off.

'All the artists of the Academy, bar Mr West. Yes, that is precisely what we desire. Would you be willing?'

Her glance flies to Provis once more. Of course I would be delighted,' she replies, turning back to Smirke.

She is scared, Provis thinks to himself. But she will rise to this challenge, as she has before. 'No one has studied the method more intently than my daughter,' he says. 'This would be a wonderful opportunity – for her as well as for you.' He sits further forward on his seat.

'That is most pleasing to hear,' declares Farington. 'However, the agreement which Mr Smirke and I propose must be drawn up before this demonstration. It is agreed, is it not, that the value of the secret will be reduced if too many people know of it.'

'That is certainly what Mr West believes,' declares Provis lugubriously.

To his surprise, his joke provokes loud laughter from Farington and Smirke.

'And so,' continues Smirke, looking questioningly at Farington, who nods, 'we need to set up a form of legal contract. The artists who come to the demonstration must sign a document in which they swear secrecy on the nature of what is revealed, and agree to contribute to a sum of money for the Provises.'

Provis sips his sherry.

'That is most generous of you.' The responding silence indicates that a more complex response is demanded of him at this point, so he contemplates his glass for a moment. 'If you do not mind my asking, the sum we demand is considerable, as indeed it should be. Would the artists pay myself and my daughter gradually in the form of an annuity, or just as one lump sum?'

Farington nods briskly at his point, and looks over to Smirke.

'That is something to be debated,' responds Smirke. 'But you are right to raise this concern. We shall make sure the document is not undervalued, should the demonstration go well.'

'Where would you like the demonstration to take place?' asks Ann Jemima. 'And upon what date?'

'Now you have agreed to perform it,' replies Farington, 'we must move forward swiftly. It is clear that many more members of the Academy need to be present for us to agree the form of contract. So I would like to suggest that we meet at Wright's Coffee House tomorrow night.'

The look of excitement vanishes from Ann Jemima's face.

'At Wright's Coffee House?' she asks.

'Yes,' Farington dips his head.

'But that means I cannot attend.'

'Yes, it is unfortunate that ladies cannot visit coffee houses,' says Farington, holding her gaze steadily. 'But it is the only aspect of this process in which you will not be directly involved.' He is smiling at her benignly. She is aware of a huge anger surging up inside her, but she realises that she must suppress it if she is going to keep him as an ally. 'Your father will be there, and it is without question that he will be acting in your best interests,' he continues.

'We need somewhere that is large enough to accommodate all the artists who must know of this. My own humble house can hold but ten in the drawing room or dining room with any comfort. And we cannot meet at the Academy, because I fear – without wanting to be disloyal to Mr West – that we must engage in a little subterfuge in order to deduce the precise nature of his subterfuge.'

Ann Jemima looks rapidly at Mr Provis. Smirke, discerning her agitation, coughs.

'Mr Farington, Miss Provis is looking alarmed and with reason. We have not heard yet from Mr Provis whether he can attend. Far too much has already taken place behind their backs. Until he says yes, nothing is confirmed.'

Farington puts his hands together and rests his chin on them.

'I must apologise. Mr Provis – can you attend?'

Provis looks over at Ann Jemima. 'Do you trust me, my dear?'

She holds his gaze for long enough for them to sense the entire room going quiet around them.

'Of course I do,' she says in measured tones. 'What girl wouldn't trust her father?'

'A thorny topic,' says Smirke. The laughter round the room is fractured, uncomfortable. Provis continues to stare at Ann Jemima.

'My girl, you have worked harder for this than anyone,' he says. 'I am not happy to come to this meeting alone,' he says turning back to Farington and Smirke, 'unless you agree that the legal document must be signed by my daughter as well as myself.'

She feels Farington's stare on her again – coldly approving, intrigued.

'Your daughter will be involved with every aspect of this,' he says, as he continues to look directly at her. 'I myself will take a detailed account of what is agreed, so she can read it. Do not worry, Miss Provis. None of us underestimates you, or your importance in this.'

A silence falls across the room for a moment. Ann Jemima sits there, absorbing what Farington has said. After a few seconds she seems to come to a resolution. Tightly, she smiles and says, 'You are a true gentleman, Mr Farington.' Farington walks over to her and kisses her right hand. Then he turns, shifting his attention to Smirke.

'It is agreed, then, we shall set things in motion. Mr Smirke and I will call this evening on as many of the artists of the Academy as we can. Tomorrow we shall convene at the coffee house. And once Miss Provis has seen and approved the results of that discussion, we shall go to a lawyer.'

'It is agreed,' says Provis loudly. Smirke murmurs 'agreed' in chorus with him.

'Then I think we should fill our glasses and raise a toast,' declares Farington. 'This is an important moment in the history of our Academy. Till this point, I fear we were doomed to be judged harshly by posterity for our handling of the Venetian Secret. Hopefully the crisis has been averted.'

Benjamin West and the art of self-deception

'Take your linseed oil, and during the summer put it into a
bronze or copper pan, or a basin, and keep it in the sun when
August comes. If you keep it there until it is reduced to a half,
this will be most perfect for painting.'

Cennino Cennini,
The Craftsman's Handbook, c. 1400

How does a man lie to himself? With ease. The architecture of
self-deception is powerful because it is intrinsic to the architecture
of the self. When Benjamin West considers the bricks and mortar of
who he is, he sees the young man covered in mud in Pennsylvania,
he sees the adventurer travelling across Europe in search of new
styles of art, he sees the man who defied all of London by changing
history painting forever. Reality has added failure, compromise
and self-doubt to who he is, and there are many days when this is
all he can see. Yet the fierce belief that he can transcend his fellow
artists remains.

Is he a thief? Not within the architecture of self-deception.
When the Provises came to him, after all, they came to him because
they needed West's interpretation of their manuscript. It was he

who brought the insights that were needed. He who had the knowledge that drew them to his door. He who had travelled the world to understand precisely the light, the landscape and the painting traditions that had inspired the manuscript. All they had done was inherit some papers. Their luck, in essence, was an accident of history.

He would never voice such sentiments out loud. Perhaps if he did, he would engage more fully with the problem that while he has provided the insights into the manuscript, Ann Jemima appears to have produced the greater work from it. In the rare moments that he does think of this, he tells himself that either she has benefited from what he has taught her, or she has experienced some happy accident aided by an aspect of the method he has not yet seen. Whichever of these is the truth, he will not hand over any payment until he has worked out how much is down to his contribution, how much to her ability, and how much to these unknown parts of the method. Apart from anything else, once he has handed over the payment, it is his duty to share the method with the other artists. And this, for reasons he will not even contemplate, he is not prepared to do at this stage.

The whole imprecise nature of creativity is a considerable aid to his self-deception. In a letter he has written to his brother, William, he has expressed it thus:

'I am now convinc'd that what the girl understands of her Manuscript is not enough to yield up the secrets of Titian. She has not traveled as much as I, nor indeed has she read as much as I. Yet in the many visits she has made to my house, I have managed to provyde some Illuminasion that has enabled her to produce a powerful Effekt. I truly believe it could have as dramatick a Result on our understanding of colour as the publication of Newton's Opticks almost a century ago.'

He does not think for a moment of William's assertion of how his ambition blinds him to the needs of others. In his studio, as

he attempts to recreate the effect on his own, it is instead Titian who dominates his imagination. When he thinks of the artist these days, it is the older Titian who appears before him, the long white beard softening the harsh-lined, watchful face, the trademark black skullcap perched above faintly reddened eyes, worldly and yet unworldly. Like Benjamin West he is working for royalty, but where George III is doomed to be remembered for losing America and his sanity, Titian's emperor – Charles V – is the most powerful man in Renaissance Europe.

It is a challenge for Titian to paint this emperor. Charles's lantern jaw is so pronounced, he cannot close his mouth properly, while his feet are in eternal agony because of his gout. By the time the artist goes to stay with Charles at Augsburg, the emperor is not in a fit physical state even to sit on a horse, and has to be carried into battle in a litter. Yet there he is, in one of Titian's portraits, moun-ted proudly on his black steed, the jutting lantern jaw transformed into a sign of determination and bravery rather than deformity. A different reality has been created through visual echoes – Charles has become a Roman emperor rising stoically into battle, or Dürer's courageous warrior in his *Knight, Death and the Devil*, surrounded by evil but riding unflinchingly forward.

Like West, Charles wishes to see an image of himself that changes and enhances the truth, and has give strict instructions for this commission. Both the men's delusions are connected to power and vanity – but where West's deceit thrives on omitting details (which will prove his downfall), Charles's is about transcending them (which has proved his triumph). As Titian seeks to celebrate Charles's victory at the Battle of Muhlberg, he engages with the emperor so that he becomes philosopher-king as much as warrior. He is dressed for battle, yet the mood is meditative: he rides out onto a calm sylvan landscape with the sky flaming behind him – a bringer of stability as well as war.

Reflecting on his own less happy relationship with King George, West wonders whether Titian's relationship with Charles was always conducted at the exalted level recorded in the history books. Whether Charles ever really did stoop to pick up that paintbrush

for Titian in his studio. And if so, what it was like to be the artist staring at the top of the imperial head as it tilted downwards, to hear the grunt of pain as the gouty knees were bent. When Charles sat for Titian, did they talk, or did Titian – as he was renowned to do – go into a trance while he was painting, deaf to any complaints of boredom or physical discomfort that Charles might have made? And when they did converse, what were their discussions about? Charles's wars against the Ottomans? The annulment of the marriage of his aunt, Catherine of Aragon? Or was the conversation more mundane? Their children perhaps, or the latest remedy for an aching tibia?

Muttering to himself, West goes over to the large table at the end of his studio. He tips Prussian blue powder onto his palette. Gently he drips the linseed oil onto it from the cap of a bottle and swirls the powder and oil together with a palette knife. He takes some of the ivory black shade and stirs it into the blue. Looks at his palette with pleasure as the colour becomes more complex. Once he has achieved the right thickness, he takes a small scoop of paint – the size of an almond – and places it in the middle of the palette. Then he takes his muller and starts to grind, wielding the heavy weight so that it blends the colours with the oil.

Yet again he feels the stirring of excitement. He reflects on how that first return visit to the Provises was almost unintentional. Another part of his justification for not paying them yet was that he had initially found the techniques they had given him from the method unsatisfactory, and was on the point of abandoning it. What, then, was it that had hauled his feet to their doorstep? Battling against the sleet and his own disbelief.

'I think I wanted it to be true for the girl,' he had told his twenty-one-year-old son, Raphael. 'She was so passionate about it, so... convinced. Her enthusiasm reminded me of myself when I was younger. I felt I would be letting her down if I didn't give her at least one more chance of explaining it to me.'

His son had delivered him a cynical glance as he stirred his bowl of chocolate. The smell of cocoa and aniseed drifted across the table. But Thomas Provis had been right, there was no sexual flicker there.

The seduction, at that stage, was just as West described it – the resurrection of his younger self through Ann Jemima's enthusiasm, in which he hoped to be the ultimate beneficiary.

Was it this sense of new optimism, or some attribute of the method that led to the next stage? After that visit he had created a painting of the Crucifixion that he had suddenly realised was closer to Titian than anything he had done before. Again he drew on his obsession with the different ways of creating colour ever since he was a boy. How to make the silk on a lady's dress shimmer so you could almost hear the rustle as she walked into the room. How to evoke the tone of flesh so you could sense the blood flowing beneath it. He thought back again to Running Wolf teaching him how to create different pigments by mixing riverbank clay with bear grease. This time he remembered the pungent scent of the grease and laughed wryly – when he had first smelled it he had wanted to be sick.

As the year went on, he started to become more obsessed than he would admit with what other revelations the manuscript might contain.

'Can you truly comprehend the mind of another artist through a formula he has used?' his son Raphael had asked him. 'Thoughts do not translate perfectly from one person to another. The music of Beethoven is as close to an artistic formula as any I have ever encountered – yet when some play it is brilliant, and when others do they sound as if they have souls of tin and fingers of lead.'

West felt his heart quickening.

'Indeed, my boy. That is my view entirely. Only truly great artists can interpret other great artists.'

'So the value of the method becomes greater according to the aptitude of the artist using it. From you they are asking £500. For a lesser artist like myself, it may be only worth half as much. Maybe it is I who should put in the bid.'

West laughed.

'You tease me, my son.'

'Yet I am serious too. When are you going to decide on the payment? You have seen the Provises many times now. Surely you believe they deserve some form of recompense.'

He smiled tightly.

'We are potentially at a great moment in history. There are more important things to be considered than the vulgar issue of money?'

'When will you talk to them?'

West was quiet.

'When I have decided what they deserve,' he eventually said.

In his studio later that day he finds himself thinking back to January 1793, when news has reached England that King Louis XVI has just been executed. As the political tremors spread through France and across the rest of Europe, West is summoned to see King George III. He is concerned that the purpose of the summons is for him to be cross-examined once more as a potential revolutionary. But it turns out that the King wishes to interrogate him about something rather different – the Orléans art collection that has been smuggled into England.

'It is the greatest art collection in the world.' At this meeting, the King has insisted that West stands. They are at St James's Palace, and Queen Charlotte is also in attendance, watching West with hostility.

'Indeed. I know how keen Your Majesty is to acquire it,' West replies.

'War, theft and bankruptcy have marked its passage to these shores.' The King's expression changes. For a moment it becomes conspiratorial, friendly – in the way, West thinks with resentment, it used to frequently. 'Those same dangers threaten to take it away again – and I need you to prevent this.'

West nods. 'I am aware that the collection has already been divided in two since we first heard it was for sale,' he replies. 'It has attracted much interest on both sides of the Channel. It is an extraordinary coincidence that both the current owners have now brought their share of the collection to London for safekeeping.'

'An extraordinary coincidence and an extraordinary opportunity,' replies the King. 'We cannot afford all of them of course, but if we

were to secure the best, we could use them as the basis to open the National Gallery you have so often suggested.'

For a moment it is as if the sun has risen over their conversation. West looks at the King in amazement.

'That would be remarkable, Your Majesty.'

The King nods approvingly.

'I would like you to go and assess what the owner of the French and Italian part of the collection might be prepared to sell.'

West chooses to make his visit with Joseph Johnson's former lover, Henry Fuseli. Fuseli's impatient brilliance indulges no one he considers a fool, and into that category he places most of the human race. West's early acquaintance with him has been marked by a savage dislike on both sides. But over time he has realised that Fuseli's arrogance is part of a ruthless honesty that means it is possible to trust what he says in a way that he cannot quite trust anyone else at the Academy.

On the day they go to visit the collection, they meet outside St Clement Danes at the top of the Strand. As he approaches, West can make out Fuseli's distinctive white hair long before he recognises the details of his face. Before they discuss what they are about to see, Fuseli – as West has anticipated – wants to talk about the latest experiments he is conducting to test the relationship between body and imagination. Recently he has been eating raw pork before bedtime to see if the nightmares that transpire will prove worthy subjects for paintings. This has resulted in bouts of extreme sickness, yet though West fears for Fuseli's health, he is not unwise enough to betray his concern since he knows he will be dismissed for triviality.

Finally Fuseli is ready to talk about the matter at hand. 'Should I credit the rumour that the man whose family owned this collection has renamed himself Philippe Égalité?' he asks sardonically. Their carriage rattles through the stink and clamour of the Strand, lurching over large stones and chunks of debris.

'To be known as the Duke of Orléans has become somewhat awkward since the Revolution commenced,' replies West wryly.

'So he wishes to be known as Monsieur Equality.' Fuseli's lips twitch.

'From what I hear that will not save him from the guillotine,' replies West. 'He is a curious individual. He ran up gambling debts that ruined his family long before the Revolution decided their wealth should be stripped from them.'

The carriage suddenly jolts them both backwards. Outside, the dalmatians accompanying the carriage start to bark. West looks out of the window to see that a dead mongrel is blocking their course. The coach driver jumps down, cursing, and kicks the carcass to one side so they can proceed.

'There is some part of me that feels guilty about profiting from Monsieur Égalité's tragedy,' West continues, as the carriage starts off again.

'Why should it taunt you?' declares Fuseli. 'The man is a profligate and a hypocrite. How can you champion the rights of the people on the one hand, and gamble away one of the biggest family fortunes in France on the other? I cannot conceive how you can lose any money of consequence through gambling. I have tried hard on a couple of occasions. Yet even when I'm playing faro I've only managed to lose my breeches. And that, I must confess, proved ultimately pleasurable.'

The afternoon winter sun is low and golden. A shaft of it falls through the carriage window and across Fuseli's face, illuminating the complacent features animated by satyric humour. West refuses to acknowledge the innuendo. He knows that Fuseli wishes to provoke him, but with a faint self-loathing realises he is too uncomfortable to respond.

'How is your wife?' he replies instead.

'My beautiful wife is well. She sends her regards.'

The tone of his voice is icily amused.

'Égalité attempted to pay off his debts by selling the family gems to Catherine the Great,' West continues firmly. 'Yet even selling the gems did not raise enough money. So then he sold his entire collection of art.'

The carriage turns as they reach Charing Cross, rocking

dangerously to the right as it does so. Brightly coloured fabric shops are doing brisk business, while men and women are emerging from the gin booths interspersed between them. Some look as if they have just purchased redemption, others the last step towards damnation. A plague of stray cats darts between legs and under carriages.

'You say that it is a French Count who has now brought the Italian and French paintings here,' says Fuseli. 'What would he have done had the revolution not forced him to do so?'

'I think he bought them to preserve them for the French nation. But as you are well aware, the Terror is making that impossible. So much art is being destroyed by the Revolutionaries as a protest against religion as well as royalty.' West shakes his head. 'I never foresaw that it would come to this. At what point does liberty become the smashing up of statues, the burning of paintings?'

Fuseli's eyes are cold.

'Acquaintances have told me that it is a protest against the decadence of royalty, the corruption of the Church. Yet this wanton destruction is no less decadent. The loss to history at the hands of vandals perverting the cause of the Revolution is incalculable. The extent of the madness only struck me when I heard they had beheaded half the statues at Notre Dame Cathedral.' He looks towards West. 'You know how much I wanted this Revolution.'

West does not trust himself to talk.

Fuseli's voice softens. 'No rational man could have been satisfied with the way things were. But in place of Louis, we have the fanatic Robespierre. Do you realise he drinks only water? A man who trusts himself not to drink wine is a man whose impulses should be feared by everybody.'

West laughs weakly.

'You have been told, I take it, that the Dutch, German and Flemish paintings will go to auction later this year,' he says as they turn into the gardens of Leicester Square. 'These Italian and French paintings present a more delicate proposition, since we do not know how many the Count will part with – if any.'

'And the King desires you to be a negotiator. There is a good deal

of sense in that. As an American you are outside the establishment – in every other sense, for better or worse, you are very much inside it. You have the right perspective for dealing with such a man as our unwilling benefactor.'

It is not long till they reach the large white townhouse where the paintings are stored. As the carriage jolts to a halt, they descend with alacrity and regard the building for a moment before entering. The shutters of the windows are all closed, yet still it seems watchful, hostile to the world around it.

'The Count will not be here to receive us this afternoon,' declares West as he approaches the steps leading up to the front door. 'He sent me word that he has left his servants to open up two of the rooms where the paintings are stored.' He looks up towards the door. 'I feel great excitement at what we are about to witness, but I am also fearful of the damage they may have suffered in the journey from France.'

'I am impressed at the extent to which he clearly trusts you, though you have met but twice,' declares Fuseli loudly. 'In his position I would be concerned about thieves. Who can guarantee that we will not sneak out with a pair of Correggios in our breeches?'

West suddenly turns on him in irritation.

'Make not light of it,' he hisses, 'especially when we may be heard.'

His friend's eyes flare with mild amusement.

'My dear West,' replies Fuseli calmly. 'You know you have my full support. Be not so wary.'

As he speaks, a butler opens the door and examines them intently. As West stares back, he becomes transfixed by the flourishing eyebrows that are black at the point closest to the bridge of the nose and grey and white as they taper out at the end.

'Mr West, I take it,' the butler finally declares.

West dips his head in acquiescence.

'Welcome. This is your friend Mr Fuseli?'

'That is right,' replies West with severity, glaring at his companion.

'Will you both follow me?' the butler says.

West gives a sharp nod to Fuseli, who walks after him into the house, smiling to himself. As from the outside, there's an atmosphere of watchfulness – the walls of the noiseless corridors almost seem like spies listening to their footsteps as they click across the polished stone floor. The butler leads them up another flight of stairs, and finally into a room at the back of the house. As at the front of the house, all the shutters are closed.

In the semi-darkness West can see two large paintings hung on opposite walls, while on the floors lie other framed canvases, wrapped in cloth. There's a sense of slumbering, a sense of lives and secrets waiting to be revealed.

The butler walks over to the windows. Slowly and methodically he opens the shutters. In the hushed darkened atmosphere the sunshine feels like an intrusion. West's eyes are first drawn towards the light outside the window. Then he looks to see the paintings that have been illuminated.

'Good God, West.' The tension that has lingered between them since their entrance to the house is wiped away. Fuseli's hand clutches West's arm.

West feels a sense of unreality descending on him as he looks around. On one level he has been prepared for this. On another, he is struck speechless as he recognises the images of which he has only seen copies in the past.

The butler dips his head. 'I will leave you two gentlemen alone,' he says, 'and will be downstairs should you have any questions you want me to pass onto Monsieur Laborde.'

The moment he is gone, the two men rush to the walls and examine the paintings closely. Fuseli turns to West. A faintly manic light dances in his wide-set eyes, while his hands gesticulate to both walls.

'Can you believe what we are seeing?'

West shakes his head. 'This is remarkable, truly remarkable.'

'Titian's two greatest works, *Diana and Callisto* and *Diana and Actaeon*.' Fuseli looks from one to the other. 'I have never been in a room with so many naked women.' His eye briefly catches West's and he laughs at his puzzlement. He drops his hands and walks up to the *Diana and Callisto*. 'The luminosity of the flesh...' Now his

voice is more serious. 'He almost orders us to look at their bodies – most of the faces are in shadow.'

'When Titian places faces in shadow,' replies West, 'it is a sign that something sinister is about to happen.'

'Yes, but Titian was also very adept at making the human body as eloquent as the face,' replies Fuseli. 'Which of course allows the works to be as erotic as they are didactic...'

He swings round. 'He did not paint these for Charles, did he?'

'No,' smiles West. 'They were for his son, Philip II of Spain.' He coughs. 'A very different character. More sophisticated in his artistic tastes than his father...'

'... and also more sexually adventurous,' mutters Fuseli.

They are silent again. Fuseli continues to stare at the *Diana and Callisto.*

'They are both such wonderfully perverse tales,' he says distractedly as he studies it. 'Callisto was a nymph who was seduced by Zeus, was she not?'

'Yes,' says West calmly. 'She was one of Zeus's conquests.'

'Zeus disguised himself as Diana so that he might seduce her...' Fuseli turns and raises his eyebrows.

'He disguised himself as Diana in order to be alone with her,' replies West shortly, refusing to hold his gaze. 'Whether or not she thought he was Diana at the point of the seduction is not entirely clear.'

Fuseli laughs low.

'I suspect Philip would have relished the idea of Diana and Callisto making love. Though if Zeus left her with child, I presume the male member must have become obvious at some point in the proceedings.'

West sighs.

'Mr Fuseli. I rarely find that anatomy and mythology make happy companions.'

'Is that so?' Fuseli's voice sharpens as he stands back from the painting. 'Play not the prude, Mr West. In truth, I think Titian would disagree with you. This painting is full of anatomy. The whole story is told in the swelling of Callisto's belly, and Diana's beautiful white hand pointing angrily in her direction.'

West is silent. He turns determinedly towards the *Diana and Actaeon*. It is a very different work, and as he looks at it he wonders once again at the undertone of savagery present in so many of Titian's paintings. Here Diana's arm is raised up, as she glares at the man who has stumbled upon the glade where she and her companions are bathing. The sense is not of embarrassment but of fury – next to her a dog, its hackles raised and teeth bared, barks at the intruding Actaeon. The hunter stumbles back, almost as if he has been struck by her glance – his hands flung up defensively as he takes in the forbidden view.

Yet while Actaeon is horrified by what he sees before him, it is what he cannot see that is most sinister. Behind Actaeon stands one of his hunting hounds – the very same who will later rip him apart for his transgression after Diana, in revenge, has turned him into a deer. At the moment Actaeon does not know that the dogs who follow him will later be turned into the agents of his destruction. His doom is presaged in the shadows of the sky, the sense of the wind in the branches and an oncoming storm. On top of the pillar behind which one nymph is hiding is a deer skull – a memento mori that, for better or worse, he is still unable to understand.

'Actaeon had committed no crime,' West exclaims almost involuntarily. 'He was pursuing his passion of hunting – he had no desire to interrupt Diana as she bathed.'

Fuseli comes over and stands next to him.

'That is what is so powerful about the myth. It acknowledges what all rational men fear – that we live in an irrational and cruel world, and may be punished unfairly at any time.'

West nods. 'Indeed.' He returns to staring at the painting. At Actaeon reeling back, at his hounds behind him.

'It is a particularly cruel aspect of the story that he was devoured by his own hounds. Why would you present this to a king?'

Fuseli reflects for a few moments. 'Because great art is supposed to unsettle us,' he finally says. 'As Louis XVI has learnt to his cost, even when you are a king, your hounds can turn against you at any moment.'

'It is also about forbidden knowledge. Do we believe in that in

an age of science.'

Fuseli is quiet. 'Yes, we do.'

There is an edge to his voice, and West looks at him. 'And those in power will always reinforce that sense of the forbidden,' he continues with quiet anger. 'The concept of sin is a great method of controlling society.'

They hold each other's gaze for a moment.

West looks away.

'What do you think I should report to the King?' he says briskly.

Fuseli takes a deep breath.

'That he should offer every guinea that he has to buy these works, and if that is not enough, he should sell St James's Palace to raise the money.'

Yet the King was not prepared to hand over the money that was necessary, and West was forced to agree that he would try to persuade the Count to sell the paintings at a lower rate. He will never forget the rage and despair he felt at the decision – he knew that the Count would never accept the offer, and he bitterly resented the humiliation of having even to attempt the negotiation. Nor can he forget his own desire to possess the paintings when he saw them, that sense of being almost turned inside out by the contradictory feelings they inspired. If just once he could create a painting that had the same effect on the onlooker, he could go to his grave feeling some of the strife he had endured throughout his long and humiliating presidency had been worth it.

As the cold creeps up his fingers, like a twitch of irritation another image assails him. That moment when he walks back into this very studio after leaving the girl alone, when he sees the Venus and Cupid as she has altered it. He remembers the surge of jealousy, the disbelief at what she has created, the clarity of something that he does not want to know. For him this feels like a moment of forbidden knowledge. Though who has supplied the knowledge and by whom it is forbidden are questions that cannot be entertained

within the rigid walls of who he thinks he is.

Around him everything is silent. The fire in the grate has long since burnt out, and a shiver runs across the top of his shoulders. Briskly he rubs his hands together till the friction of skin sends blood back to the fingertips. He is finding the paint a little too viscous, so he adds a little more linseed oil and stirs it with the palette knife.

Once the exhibition is over, he tells himself, he will have the Provises to a meal, praise them enough to satisfy them, make them feel they have played a little part in history. Once they have seen what he has created on his own, they will understand. He is sure they will understand.

'But when will I understand?' he whispers to himself, almost involuntarily.

He dips his paintbrush once again and tentatively applies the colour to the canvas.

The tide turns
against Mr West

'... no knowledge however extensive in the mechanic of
colours can make the artist, without the scientific and sublime
enthusiasm of genius; but it is certainly narrow to hold back
assistance so far as it can be communicated, or to throw
impediments in the way of an art which hath met with and
merited the protection of the best and wisest men in all ages.'

William Williams,
An Essay on the Mechanic of Oil Colours, 1787

By the morning of 12 January the Academy is in revolt. Each
artist has had a different reaction to the Provises' visit, but as they
discuss the problem among themselves the suspicions about West's
conduct become more substantial. It is as if clouds of dust on a dry
London street have slowly mutated to grow limbs and horns until
finally they become a stampeding herd.

John Rigaud, once the Provises' greatest doubter, leads the
accusations. 'West brings shame on us all,' he cries to anyone
who will listen. 'From henceforth a new President of the Royal
Academy should be elected every year.' Richard Westall silently
mocks Rigaud's outrage, but still cannot disguise his delight at the

strength with which opinion has turned against Benjamin West. He himself has now carefully refashioned his account of Provis's assault against him as the act of an innocent man driven to desperation. 'If West has pushed him thus far without remorse,' he has declared to Opie, 'who can say what other transgressions our President has committed without our knowledge? I believe it is not safe to leave him in such a position of responsibility any more.'

Smirke, in a rare moment of indiscretion, goes even further at a late night meeting with Joseph Farington. 'If the Provises are proved to be in the right, and Benjamin West has deliberately deceived us all, then it reflects very badly on the judgement of the King that he has not got rid of him earlier,' he says, tapping his cane emphatically on the floor. 'A few years ago, that would not have mattered one jot, but in these more turbulent times…' He pauses. 'I am not suggesting this might bring down the monarchy. But King George might well have to dispose of West in order to make sure that his Royal patronage continues to exert its full authority.'

Even John Opie, when he wakes that morning, is starting to feel the wretched seductions of the case against West. His room is filled with a strange yellowish light that indicates another early-morning fall of snow. As he lies and stares at a spider crawling slowly across his ceiling, he reflects, like the other artists, on the severity of the accusations. At the same time he ponders that it is not this that disturbs him most. In the last week he has felt his most intense anger when observing each fellow artist's attempts to claim the Provises as their own. There is a stench of greed to all of this, he mutters to himself. Every single one of them harbours an agenda. The stench was particularly strong when he conversed with Farington. 'We must secure the Venetian Secret so only the appropriate people may see it,' Farington declared, holding Opie's arm in a pincer-like grip. 'The more people that discover it, the more its value decreases. We must ensure that the honest Provises go nowhere else with their manuscript.'

Opie's own impression of the Provises is – as Thomas Provis has observed – somewhat more guarded. In the father he perceives an appetite for self-education and a dignity that convinces him he deserves to be treated with a certain respect. Yet there is something

about Provis that disturbs him too, even though at this stage he is unable to say what. It is the same with Ann Jemima. He recalls the moment when she first sat down before him. The girl was so perfectly composed that he almost expected her silhouette to be cut into the air when she finally rose from her seat. His mind has reflected more times than he would like to admit on her silhouette. Yet the thought keeps recurring: 'She was too composed. Too perfect.' Why precisely this worries him currently eludes him. Yet his thoughts return again and again to the visit like a tongue prodding where a missing tooth has once been.

Mary Wollstonecraft picks up on his distraction within moments of receiving him at her house. They have gone into her parlour for the latest sitting for her portrait, and she has positioned herself by the window. The stark winter sun delineates the bridge of her nose and casts sharp shadows on her throat. Her white dress amplifies the sense of light. As she sits down, Opie reflects on how profoundly she has transformed from the severe female scholar whom he first met more than a decade ago. Then she seemed to absorb light rather than radiate it. She had just written her first book, and seemed torn between tempestuous emotion and over-earnest intellect. Yet he had liked her immediately, in a more straightforward manner than he had liked any woman before, even as he observed with amazement her crow-like disdain for female beauty and all its accessories.

Though her appearance has softened in the interim, her powers of perception have not.

'Mr Opie.' Her voice is sharp. He starts guiltily. 'You are not altogether present today. Pray tell me it is for happy reasons.'

His laugh jangles wretchedly.

'Happy is not the word I would use.'

'So what is it?' Curiosity like quicksilver in her voice.

He puts his palette and paintbrush down, and picks up a rag with which to wipe his fingers.

'My fellow artists are in a frenzy. Tonight they gather at Wright's Coffee House to debate what Benjamin West's punishment should be for keeping the secret of painting like Titian to himself, and how they themselves may gain access to the method.' He hesitates. 'If this

report proves to be true, like all of them, I will demand some kind of justice is done. But the reaction of my fellow artists has been...' he hesitates, groping for the words, 'I don't believe it is justice they want done... they are like dogs in a hunting pack – baying for West's blood with such enthusiasm that it is as if they desire to tear him limb from limb.'

She rises from her chair and removes her black hat. Now the light falls across the skirt of her dress. Long elegant shafts like stripes on the cotton.

'I take it that it is permitted for me to relax my pose.'

The tone of her voice indicates this is not a question. She walks towards the fire to warm herself. Opie laughs drily.

'The portrait is utterly contrary to your nature, Mary Wollstonecraft – it does not talk, it does not move. It is the ultimate challenge for me to keep you still enough to complete it.'

'But this time the fault is yours for providing the distraction. And, indeed, for being so distracted by it.'

He nods.

'I am happy to accept the responsibility.'

She sits by the fire and indicates with a motion of the hand that he should join her.

'You are disturbed by the other artists' reaction. Even though you yourself are angry with Benjamin West?'

He takes a deep breath.

'I am. If the facts are as they seem, the man has acted like a scoundrel. He should be made to apologise to the Provises, and acknowledge that the girl has helped him with his experiments. But I do not think my colleagues' real concern is that the Provises should be recognised. I think they are using self-righteous anger to mask their jealousy.'

Her glance is abrasive, but as she absorbs the impact of what he says it changes. 'Self-righteous anger is an ugly but powerful instinct,' she concedes. 'And there is a violence to it. They may not tear your Mr West limb from limb, but he will suffer damage from it.'

'Indeed he will. They may not be murderers... but perhaps they are something worse.'

'And that is?'

'Hypocrites. Half of them want to deprive Mr West of his job for a crime I believe most would have committed themselves. If any member of the Academy believed he had discovered a method that would make him the greatest artist of his age, well you can imagine…'

He shrugs, then comes and sits opposite her. Reaching his hands out to the fire, he gazes into it contemptuously. Flames dance on the surface of his eyes.

She leans forward.

'Why are the artists so interested in this formula?' she says. 'You and I have talked often about the importance of originality.'

He feels the jab of her provocation as strongly as if it were a needle.

'Many manuscripts deal with these techniques. The question with all of them is how good the scholarship is. Some of them are like scientific documents, some – which are of course more common – are more like witches' spells.'

'And this is more like science?'

'It is an intricate document of Venetian techniques, from a time when the Venetians were the most brilliant colourists known to history. All the evidence I have heard is that what the Provises have presented seems a most credible account from that time.'

'Yet you are not interested in the document itself.'

He hesitates, splaying the fingers of his hand on his breeches as he looks back at her.

'Mr Opie, if Ann Jemima is good enough to demonstrate the technique, why did she take the manuscript to Mr West at all?'

He reflects for a moment.

'I looked at the painting of Venus and Cupid in which she apparently assisted West. When she first told me which parts she had assisted with, my thoughts were that she was clearly better than any pupil I myself have taught. But then, when I thought back to my first reaction to West's painting, my conclusion was still more dramatic. I thought that it was better than anything he had done in recent years.'

She frowns.

'Your conclusion is extraordinary. Are you saying that this young girl has greater ability than the President of the Royal Academy?'

'If, like myself, you do not believe that a painting method – whatever its merits – could make a bad painter good, or a good painter excellent, then yes, that is the obvious conclusion.'

'You believe she is better than the President of the Royal Academy?'

Her tone is stern.

'She is certainly a better colourist.'

'Forgive my stupidity. What precisely does that mean?'

He smiles.

'A great colouring technique is one that manages to suggest something beyond itself.'

'And still I am no wiser.'

'Well then let us take flesh as an example. A person's skin and complexion can tell us of so many things – whether or not they are in good health, what their age is, whether they are feeling desire, whether they are in pain.' She studies him closely. 'This is not to do with the intrinsic colour of the flesh – it is to do with a quality of translucence, of luminosity…'

'Forgive me, Mr Opie. Now I am truly confused. Of luminosity?'

He shakes his head impatiently, recognising he is being teased.

'People who are happy glow. You have seen this. You have demonstrated it. Since you and Mr Godwin became close, you glow. When you were sad…' his voice becomes quiet. 'When you were sad you did not.' He moves on quickly as her expression changes. 'There is a difference to the way light plays on a young man's skin and on an old man's skin. Someone in pain… it is as if something has been leached from them. All artists understand about the subtleties of light and shadow, but the great artists know how to make it convey an entire state of mind – not just what is happening now, but what has happened before and what may be yet to come.'

'And beyond flesh?'

'We divine much from shifts in colour in the natural world. The time of day, the season, the advance of good or bad weather. A great

artist can go beyond this and infuse those colours with a sense of danger, or hope, or...'

He shrugs.

'Yes, I believe I understand.' Her voice is quiet. 'And Mr West cannot do this?'

'He is most skilful. Unlike the hyenas of the Academy I believe he deserves his position. But it is in the composition and detail of his paintings that he makes his mark. The face of the child that Ann Jemima painted lived... it lived in a way that I have never seen one of his figures live before.'

He looks directly at her.

'Then she should be celebrated.'

'Indeed.' He hesitates.

'Then what is the problem?'

He gets up and starts to pace around the room.

'You will find this hard to credit. But it is she as much as anyone else who denies her ability. I complimented her considerably on the work. But she responded quite firmly that it is the method she and her father discovered that allow her to paint as she does.'

'Do you think she believes that?'

'I think it is easiest for her, and those around her, to believe that.'

Mary's eyes narrow.

'You mean that it is more acceptable that she has discovered something extraordinary, rather than that she is something extraordinary?'

'She stands to make considerably more money at this stage if the version of the story she and her father are choosing to tell is perceived as the correct one.'

'So her desire is for independence.'

'It is for the certainty that money may or may not offer her. What she then chooses to do with that, you may guess as well as I.'

He comes and sits back opposite Mary.

'I went to see her painting teacher, Mr Cosway, last night.'

She looks at him archly. 'You have been assiduous in your research indeed. It is a credit to you,' she says out loud. Quietly she thinks to herself: and are you also a little in love with her? Opie returns her glance.

'No, Mary. I am fascinated, but I am not in love with her,' he replies acerbically as he reads her expression. 'Though I hope you will not find me vain if I say I had the feeling that she desired me to be.'

'I'm afraid I do find you vain in that observation,' comes her response.

'Let me be more clear – my sense was that she would have found it to her advantage had I been attracted to her. That is something else that troubles me.'

He looks down for a moment.

'How is the situation with Elizabeth Delfton?' she asks.

'There is no improvement,' he replies curtly. 'Let us talk not of it.'

Her face hardly changes its expression, but a sense of her concern pervades the room.

'What does Richard Cosway think?'

'When I made my observations about Ann Jemima, he was somewhat derogatory about her painting abilities, but not about her cleverness. He said rather than dwelling on such concerns, we would be better off to give her and her father the money and see what we could gain from the method ourselves.'

Mary looks at him closely.

'Which means that he is either in collusion with the Provises to make as much money from this method as is possible. Or that he too is unnerved by her talent.'

'Mr Cosway is a strange wounded fox. I know his wife – he belittled her for many years, was flagrantly unfaithful to her, and then proclaimed it was he who had suffered most when eventually she left him.' Seeing the fire has almost burnt out, he picks up a fat fresh log with tongs, and throws it into the hearth where it spits aggressively for a few seconds. 'His motivations are always questionable. He has no reason that I can comprehend for helping the Provises altruistically, so it is likely that he too finds it easier to praise the method than his pupil.'

'In other words the lie is easier to believe than the truth.'

'You are right, though the degree of that depends very much on each individual concerned. To my mind it is the artists at the Academy who are least talented who seem to be most interested

in this matter for the method itself.' He looks down for a moment. 'Benjamin West will never become a Titian, nor indeed will Rigaud or Farington. But it offers to them a chance as good as any of catching the Venetian light they all so desperately seek, and is therefore worth money – if not quite as much as they say.'

She stares at him for a moment.

'Something still further is worrying you. What is it?'

He returns her gaze. 'I had a sense that Ann Jemima was scared when she came to me.' The word seems to surprise him even as he says it. 'Yes, that's right,' he repeats softly, 'scared. On the surface she was extremely elegant and composed. She impressed me. But I also had a strong sense of her fear.'

Mary frowns.

'Whatever the truth of the matter, she is a very young girl challenging an establishment supported by the King.'

'Yes, but I felt that her fear went beyond that.'

He looks at his friend's puzzled face, and laughs ruefully.

'This is a complex enough matter as it is already. But I feel there is more to be known about both the Provises and the method before the final judgement is made.'

'Yet Mr West is inescapably at fault,' Mary says, 'What should be done about that?'

'He should be allowed to account for his actions before any decision is taken.'

'So on the one hand you want to stop West being torn limb from limb for reasons that you think are hypocritical, even though he is at fault. And on the other you think there are important questions to be answered about what exactly the Provises believe about their method.'

'I think that sums it up.' He rubs his eyes. 'My intentions, I assure you, are good ones. I would like to see this situation brought to a conclusion that preserves honour on all sides. Though who knows if that will be possible?'

She goes and sits down in her chair by the window again.

'Shall we try again?'

She puts on her black hat.

He returns to his palette to mix his paint to evoke the precise shade of red in Mary's cheeks. The bloom on her cheeks comes from somewhere profound – it gives a sense of troubles laid to rest, and an optimism of what is to come. It makes him smile to observe it.

'I apologise for bringing these troubles to your door. You look more content than I have seen you in a long time, Mary.'

Her dark eyes gleam.

'Perhaps I should not be. I am, it seems, with child again.'

Opie drops his brush in shock. Paint spatters across the carpet. She holds up a rebuking hand as he leaps down to wipe it with a rag. 'The carpet is the least of my worries. As you can imagine this has made Mr Godwin rather nervous. I am discovering I need to tread carefully. We do not, after all, want to repeat my last experience.'

'Mr Godwin is a good man. He will not abandon you like Mr Imlay did.'

'It would be unfortunate if he did so.' She smiles wryly. 'But I have independent means, and Joseph Johnson is urging me to think of a subject for my next book.'

There is an uncomfortable pause. Opie shakes his head.

'I know not what to say.'

'Then say nothing. As you observed, I am happier than I was a year ago.' She looks at him directly. 'It is strange, is it not – in this city every few seconds a new connection is formed, every few seconds a new possibility arises. One moment it can seem there is more confusion and misery than joy in the streets around you. Then suddenly the coin flips in your favour.'

Silently he indicates that she should turn her head back so that she can resume her pose.

'So many coins have been flung into the air in recent days. I know not what the sum of them will be when they finally land,' he declares.

'Then maybe you should cease to count them,' she declares firmly. 'There will be others of which you are not yet aware.'

The winter sunlight plays on her face again – he tests his brush on the palette. The clock beats its metallic pulse, and for the next half hour there are no more words.

CHAPTER SEVENTEEN

A meeting at Wright's Coffee House

'For what avails it that the ingenious youth finds no difficulty, but rather an easy access to initiation in the advantage of a Royal Academy, that he labours there that he attains—if at last he finds a cold countenance his reward, the royal and gracious founder has done his part, he cannot do all, and the art must have the patronage of the many, to protect and support the plentiful crop of real genius that Britain abounds with, and the academy matures.'

William Williams,
An Essay on the Mechanic of Oil Colours, 1787

As ever at Wright's Coffee House, the heat of debate could be felt from the moment a visitor walked in the door. Bodies swayed and hunched at wooden tables, coffee, conversation and smoke steamed up the windows, while the air was torn intermittently with shouts of derision or cries of assent. Here was an eternal blend not just of classes but of vice and virtue: clergymen could be found sparring with pimps, judges with fraudsters, and pickpockets with boot-menders. It was as if the coffee were a dark bitter oxygen for

the nervous spark of ideas, which under its influence took little time to burst into flame.

When Richard Westall, Robert Smirke and Joseph Farington entered, they believed they were the first of their party to arrive. Then they spied their fellow artists in the corner. Amid the jabber and holler of laughter all around, it was clear even from a distance that the men gathering there were prepared to debate something more exclusive. So far Stothard and Rigaud were present, along with a wan hollow-cheeked man whom Westall recognised as the artist John Hoppner. The men's movements were guarded, their glances opaque. Their eyes animated by the strange staccato light that often indicates that something of significance is about to take place. Sneeringly Westall thought to himself it was as if the bare wooden table around which they sat had become a pagan altar awaiting a high priest to reveal secrets of the occult.

It was the nature of the unremitting rivalry between the artists that none wished to discuss openly how preoccupied they were with the matter that had brought them to Wright's. When Westall reached their table, he realised they were expressing their excitement in the manner of most Englishmen – by talking of other subjects. It was largely their hands that betrayed their true feelings: fingers tapped in agitation, beat out rough tattoos on coffee mugs, trespassed onto faces to stroke mouths or scratch noses. At certain points the whole table would fall silent, and the men would survey each other guardedly.

'I heard a most unflattering report the other day about the prisoners the British have captured from the French navy.' John Rigaud was sweating and slightly more red-faced than usual – the vulgar twitch of his mouth indicated that he was about to make a rare sideways leap into tittle-tattle. 'It appears that they are often to be found stark naked.'

The laughter of Westall and Farington was splintered, as if they had responded to the cue to laugh but did not know as they did so what sentiment they were approving.

Smirke gazed at him as if slightly stunned by the observation. 'What do you think that proves?' he replied leaning forward across

the table. 'The barbarity of the French? Or the barbarity of the British that they keep them in such degrading conditions?'

Rigaud looked at him, clearly surprised by the challenge. 'Barbarity is not the word, Mr Smirke. And I am the last to denounce the true French – pray don't forget that my own family originates from Lyon. But it seems that the appetite of the Republic's soldiers for gambling is such that they are willing, quite literally, to sell the shirts off their backs to raise money for it!'

Westall and Smirke exchanged glances. Farington watched them acutely, as if anticipating the nature of what was to come.

'I do not know what I would do if I found myself in one of the hellhole ships that we currently use as prisons. Gambling is probably one of the more appealing vices in which to indulge,' Smirke finally declared.

Westall nodded. 'It is either selling the shirt off your back or watching your shoes be gnawed away by the rats,' he said. 'The stench of human and rodent faeces is so great, I hear, that in the hot weather the putrid Thames smells by comparison like a perfume fit for Queen Charlotte.'

'Your sympathy is impressive,' Rigaud replied sarcastically. 'Maybe you believe that we should be entertaining our Republican invaders at St James's Palace. Word is that there will be another attempted invasion before the spring is out.'

Farington, eager that there should be no more distractions from the matter for which they had gathered, rapped his hand on the table.

'For whom are we waiting now?' he asked.

'Opie should be with us momentarily,' replied Westall. 'Though he has spent the afternoon being tamed by Mary Wollstonecraft, so it is possible he will be delayed.'

'Most excellent,' declared Farington drily. 'Apart from that,' he consulted his notebook, 'we of course have Mr Provis. He informed me that he was going to see Mr Cosway just before he came here, and hopes to have him in attendance.'

'And what of the daughter?'

'She will not be attending this evening,' said Farington, looking

down. 'She has gone with Mr Provis to see Mr Cosway, and then she is returning home. I worry that it was thoughtless of me to arrange this meeting at a coffee house. Obviously it is not a place for ladies who value their reputation.'

'There was no need for her to take that view.' Stothard's disappointment blurted itself out more loudly than he had intended – he flushed and looked down.

'On the contrary,' said Farington firmly. 'From the little I know of Miss Provis, she is a young lady of exceptional taste and dignity, and is wise to stay away. Whatever we decide, she will witness our signatures to the agreement.'

It was not only Stothard who seemed to regret that Miss Provis was not in attendance. Sometimes disappointment can whisk its shadow across a group of people like a passing ghost. As the noise of conversation and eating clattered around them, that ghost seemed to touch all the gathered artists apart from Smirke, who signalled his amusement in a glance towards Farington. Farington, diplomatically, failed to observe it.

'Gentlemen!' Opie now approached their table. Westall noted that though his greeting was warm, his eyes looked warily between them.

'Mr Opie – it is good to see you here,' said Farington. The fondness in his voice was that of a father welcoming his profligate son. He held out his hand. After a quick sideways glance at Westall, Opie came and sat next to him.

'Now where is Provis?' Farington continued.

At his words, Provis came through the door. He walked towards them with a look of confusion.

'Sirs,' he said, as the artists rose to greet him. His voice came out slightly hoarsely – as they sat down he collected himself. 'I am glad indeed to see you all here.' He took another breath. 'I was hoping to bring Mr Cosway, but he has told me that he wants to talk to Mr West first.'

Farington nodded, while Opie leaned forward, intrigued.

'I thought it was Mr Cosway who had urged you to approach us without telling West,' he said.

'That is right.' Provis's face darkened. 'As you all now know, I have

not found Mr West to be straightforward in his dealings with me. But since Mr Cosway has realised how enthusiastically you have all responded to myself and my daughter, he thinks it might be worth approaching Mr West again.'

Opie looked at him in surprise. This is a change of tack, he thought to himself. Out loud he said, 'It reflects well on you, Mr Provis, that you have decided to give Mr West a further chance to explain himself.'

Provis nodded, but his nod was the jerk of a wooden doll animated by a puppeteer.

'It was always the aim of myself and my daughter to impart knowledge, not create rifts. If we had been dealt with straightforwardly,' now his eyes glinted, 'there would have been no need for going behind Mr West's back at all. Mr Cosway now urges charity.' He leant over and placed both his hands on the table. 'However, I believe it falls upon me to present you with fresh evidence of what appears to me to be West's deceptive conduct. If – and only if – he can defend himself against this, then I am happy to hear his arguments.'

Opie's curiosity deepened. Around the table he felt the sense of interest heighten.

He looked once more at Provis, whose outfit was eclipsed by the bright yellow waistcoat he was wearing. It did not suit the man – it emphasised the sallowness of his skin and made him look as incongruous as a canary at a funeral. Rather like his new confidence, it seemed to illuminate the less attractive aspects of who he was. Whereas before he had come over as self-deprecating and intelligent, now there was a sense of festering anger and of his own thirst for blood. Opie's eyes flickered quickly to Westall, whose expression at this moment was hard to read.

'Would you like to take your place at the head of the table, Mr Provis?'

Opie could see Farington also registering the new aspects of Mr Provis's appearance.

'I thank you kindly,' said Provis, as Farington moved obligingly to one side.

'Before we commence proceedings, shall we order sustenance?'

Farington asked, turning to Stothard. The latter beckoned across the room. A boy in a periwig ran over to take his request.

'Eight oyster and kidney pies?' said Farington turning to the table.

'I have already eaten.' Westall raised his hand.

'Very well that will be seven oyster and kidney pies at a penny each, and seven dishes of coffee.' The boy nodded and ran off.

'I trust all will be happy with that.'

As a murmur of accord went round, Farington turned to a fresh page of his notebook.

'I shall be taking notes. I know that Mr Rigaud was keen to make a point. If Mr Provis is happy with this, would you like to open the meeting?'

Provis dipped his head to indicate his assent. At his signal Rigaud rose. He clenched both his hands together, and formed a fist with them on the table.

'I first saw an example of the Process two years ago.' He looked round him. 'I believed it was worthy of a great deal of interest at the time. As the first to notice your excellent daughter's talents,' he paused, looking at Provis, 'I feel it to be my particular duty to make sure that she is honoured.'

'Flatulent fool,' whispered Westall loudly. Opie tried not to laugh. Rigaud's glare strongly conveyed the desire to punch both of them. 'I cannot hear what Mr Westall is saying, but I can imagine its tenor,' he said. 'If he does not cease, then I will be forced to ask Mr Farington to request him to leave.'

Farington raised his hand in the air to call for order.

'Let us not descend into squabbling, gentlemen. Obviously we are all especially worried about the allegations in regard to Mr West's conduct,' he said. 'Maybe Mr Provis should speak next, if he feels he has new evidence regarding this.'

Provis rose and surveyed them all. What does he think of us? wondered Opie as he looked at the resentment on his face. Does he perceive us as allies or view us as scavengers?

Provis cleared his throat.

'Gentlemen.' He clasped and unclasped his hands. 'The first point

I wish to make is new simply because it seemed an insignificant detail when I first heard it.'

Stothard bit into an oyster and kidney pie and cursed loudly as a piece of hot offal fell out and burnt him on the hand. His ears flared scarlet as some of the other artists started laughing.

'Each time my daughter returned from a visit to Mr West,' Provis continued, looking slightly more relaxed, 'she would comment on how he often seemed not to be listening whenever she gave him details about the method.' He looked down. 'You have all met my daughter – she is a girl who is accustomed to an attentive audience.'

Opie noticed that even Westall went quiet when Provis mentioned his daughter. And he has not even met her yet, he thought to himself. Noting the nodding and the intensified silence round the table, Provis proceeded.

'We laughed about West's apparent inability to concentrate on the matter at hand, even though he had invited her over to talk to him about it. But then a pattern started to establish itself. Each time she returned to his house, he would announce to her something she had told him on her most recent visit as if it were his own discovery.'

He paused.

'At the time she believed his conduct was that of an eccentric old man. We joked about it, I even used to quip "What has Mr West discovered today?" each time she came home. However, in the light of what we have recently found out, I think that you will agree that his conduct takes on a more sinister resonance. It was not absentmindedness but deviousness that informed him. I feel a fool not to have spotted it.'

'Scoundrel, scoundrel,' rumbled Rigaud.

'This is shabby behaviour indeed,' concurred Hoppner, shaking his head.

'I say we go to his house now and challenge him,' said Stothard loudly. At this suggestion, three or four of the artists stood up as if to go straight away. Opie leant towards Westall to comment 'this is madness,' but realised that he was one of their number.

'Sit down, gentlemen,' Farington said firmly. 'It behoves none of us to become a lynch mob.' He looked towards Mr Provis.

'Mr Provis, you are right that this is of concern. Mr West must be given the chance to defend himself against it, but I am noting it down.'

'We keep saying that Mr West must be given the chance to defend himself,' said Provis, fired up by the artists' reaction, 'yet the problem is that he has lied repeatedly. What I have told you just now is just one small aspect of it. I now find it my duty to report a recent incident that gives even more definitive proof of his mendaciousness. It is of interest to you all – since it shows the lengths to which he will go to deceive even those close to him.'

Farington went very still. He pretends not to enjoy this, thought Opie to himself, but he is in his element, presiding as the man of reason over the destruction of a rival. His quill was poised with lethal precision above the page awaiting the new evidence, while his eyes fixed themselves intently on Provis.

'I question how successful Mr Cosway will be in his visit to Mr West's house tonight because only two days ago I took it upon myself to visit your President,' said Provis. Farington's eyebrows shot up as if suddenly caught by a gust of wind. 'I can see that some of you are surprised,' Provis continued, 'that I myself was at pains to settle this disagreement between us, and hoping much that it would prove to be a misunderstanding. Unfortunately,' he paused, 'what I observed made me conclude that my suspicions were right.' He reached down for his coffee cup, and took a sip of the bitter brew. Grimly surveyed the waiting faces around him. 'While I was there,' he continued, 'he showed me a portrait he had been working on of his son Raphael. It plainly used techniques from the Venetian Method. But when I asked him how long it was since he started working on it, he said three and a half months.' He took a deep breath. 'Now, you may ask, why is three and a half months significant? It is significant, because it dates back to before the time he last received instruction on the Venetian Method from my daughter. I thought he had asked her back because up till that point all his experiments had been failures. If, however, he had painted the

portrait before the middle of October, it would have shown that he had already mastered it without her additional help.'

Opie studied his face as he said this. The case against West is beginning to look very black indeed, he thought. Provis had the look in his eye of a man who was about to deliver a killer blow. He looked across the table. Even Smirke was stroking his chin with disquiet.

'Before leaving the house,' said Provis, 'I talked to his servant about the length of time he had been working on the painting. I have learnt from my time at the court,' he coughed, 'that it is often entertaining to listen to the different versions of the same events reported by servants and their masters.' The table was still. Provis took a deep breath. 'He said it was but ten days since Mr West had started the portrait. Why would he bother to tell that lie?'

The silence was like a hole into which they had all momentarily fallen. Smirke was the first to climb out of it.

'Well, clearly the lie would be to show that your daughter had no influence on it. Yet we all know that she gave him lessons more than a year ago too. So the lie is ineffective.'

'That is right,' said Provis. 'But until she created the Venus and Cupid painting together with him, there was no proof that they had had anything other than a few interesting discussions. It is their most recent experiments that provide physical proof of how important her – how important our contribution has been. The fact that he denies her help in that painting too compounds the evidence that he is determined to leave her out of his the story...'

There was a surge of conversation around the table.

'I think it demonstrates beyond doubt that he is trying to take the credit from you both,' said Smirke loudly.

'It is proof for me, too.' Stothard's basso profundo resonated across the group. 'What form should our agreement take?'

'With respect,' Westall interrupted. 'How do we know...?' He hesitated as everyone looked at him.

'Mr Provis – first I must apologise. I was most remiss in not inviting you in when you came to visit me...' Provis reddened at the memory of his own behaviour, but contained himself, nodding

deferentially. 'Despite being told much about the method,' continued Westall, 'not all of us have seen its wonders.'

He gave Provis an irreverent smile, yet there was an element of pleading in his gaze. It confirmed to Provis that despite Westall's outward scepticism, he too was a man who would be happy to be convinced. The Chapel Sweeper acknowledged the smile before nodding gravely. This he was prepared for.

'You have every right to be doubtful, Mr Westall. My daughter and I are strangers to you, and we have come to you saying that inheritance has dropped this document in our laps. A potentially ridiculous story. It is no surprise that all true artists should want to see the proof of its worth for themselves.' He looked to Farington. 'I have agreed with Mr Farington and Mr Smirke that once an initial agreement has been signed, my daughter will demonstrate an application of the method in front of all of you.'

Talking resumed among the artists, this time much more loudly.

Westall cleared his throat. 'Forgive me for pursuing my point. I truly am as anxious that you are rewarded for your discovery as anyone. But would we pay you our money before or after the demonstration takes place?'

Mr Provis drew himself up to his full height. 'Once again I congratulate you, Mr Westall, on your shrewd line of questioning.'

Farington raised his hand. 'May I intervene here?'

Provis nodded.

'Mr Smirke and I have determined' – Farington turns his head towards Smirke, who nods, 'that we will sign our agreement with the Provises before the demonstration, but will only put down payment after it has taken place. I take it you are content with that, Mr Provis.'

A look of faint wariness crossed Provis's face.

'The payment will come immediately after the demonstration?'

He tried to deliver the question with levity, but Opie could sense the white heat of the words.

'Once the agreement has been signed,' said Farington firmly, 'there will be no delay in the handing over of the money.'

'The demonstration can take place at my house,' said Opie loudly. It was his first contribution to the discussion, but one he had decided on before entering the coffee house. Amid the growing hysteria he felt that it would be better for the Provises to make their case at his residence than, say, at Farington or Rigaud's house. Allow them to keep some distance from the salivating wolves.

All heads turned towards him in slight shock.

Provis, however, nodded firmly. 'That would suit us very well.'

He stared directly at Opie. Among the other artists there was a feeling of discomfort, like pins and needles in the air.

'Well, I am perfectly happy with that if Mr Provis is,' said Smirke briskly, to break the awkward atmosphere. 'Are we all happy?'

A grudging 'Aye' rose up from round the table.

'Have we arrived at the stage where we are all ready to move forward?'

The 'Aye' rose up again, more loudly this time. Smirke caught the eye of the boy in a periwig and indicated that he should bring more dishes of coffee to the table.

'The proposal is that the Academy will provide an Annuity for you and your daughter,' said Farington.

'That would be the most desirable way to proceed,' said Provis. 'But if the Academy as a whole does not vote for the Annuity, we would consider handing over the manuscript in return for your each paying a subscription.' He looked quickly towards Farington, who nodded approvingly. 'It has been indicated to me that this might be the most profitable way forward,' he smiled, 'for everyone'.

As the conversation round the table started up again, Farington raised his hand to indicate he wanted to speak.

'The sum, gentlemen, we want to convey to Mr Provis and his daughter, howsoever it may be reached, shall be £600.' He looked towards Provis, who nodded gravely. 'I know there was a time when the proposed figure was £1,000. Much as I would love to be able to give that money to the Provises, I feel that this is a more realistic figure, and I am pleased that following an earlier conversation, Mr Provis has agreed. In return for our money, not only will Mr

Provis give us the secret, but he will also assure us that he and his daughter will not communicate its details to anyone who has not paid their share.'

'Hear,' called out Stothard and Westall. The others applauded.

Farington sat back. 'Do I have everyone's agreement then that I shall go to the engraver and charge him to draw up a document that shall incorporate all of this?'

Another chorus of assent.

'Then for now our business is concluded.'

But it is just beginning, thought Opie to himself as the surge of noise signalled that the formal part of the evening was over. He watched the artists taking it in turns to go up to Provis, slapping him on the back and complimenting him, and noted how Provis was somewhat overwhelmed by their obsequiousness.

'They are like impatient pups on an old bitch's teats,' Westall laughed to him as he watched.

'And you are as an impatient a pup as any of them,' Opie returned.

Westall raised his eyebrows.

'Don't claim you are entirely insensible. A beautiful girl. The promise of a technique that might actually work.' A wicked grin grew across his face as he stared at Opie. 'You are as tantalised as any of us. Why else are you offering to host the demonstration?'

'You know not of what you speak,' replied Opie, staring at Westall. 'You play the wise man and sound like a fool.'

He looked to the other end of the table and saw that Farington had now got Provis's hand firmly in his grasp.

'Shall we bid farewell to Mr Provis before he is devoured,' he continued wryly. 'Then we can repair to the Globe Tavern?'

Mr Cosway demands his price

'A colour known as orpiment is yellow. This colour is an artificial one. It is made by alchemy, and is really poisonous. [...] Sparrowhawks are physicked with this colour against a certain illness which affects them. [...] Beware of soiling your mouth with it, lest you suffer personal injury.'

Cennino Cennini,
The Craftsman's Handbook, c. 1400

Cosway sat back in his chair and looked at her. The long simpering mouth twitched slightly, the watery eyes trembled with calculated amusement. No matter how many times I look at this face, I shall never warm to it, thought Ann Jemima. The lines tracked below his eyes were like fissures in a rock. To her surprise a teardrop suddenly oozed out of the left eye and made its way down the craggy skin.

'Fear not, I am not weeping,' he said, disposing of the tear dismissively with his silk handkerchief. 'It appears I have contracted some infection of the eye. The fool doctor has given me some powder or another to treat it. I believe it will make little difference, but the infection is not severe and it will pass.'

On the wall behind him hung a large copy of an early version of a Rubens nude. It was the 1636 *Judgement of Paris*, in which the goddesses Venus, Minerva and Juno had just disrobed on Mercury's order so that Paris could judge which of the three was the most beautiful. In this version Paris sat fully clothed, his foot poking out nonchalantly as he surveyed the female flesh in front of him. Venus was fully exposed, holding her arms above her head to show off her breasts to their full advantage, while Minerva and Juno gazed confrontationally at Paris, with velvet drapes only partly preserving their modesty. From the very start, Ann Jemima had been uncomfortable being in the room with Cosway and this picture. In their first lesson he had asked her to talk about the composition of the work, and sat there in silence, running his finger across his lips as she did so. She had felt the catch in her stomach as she started talking – she could smell him, feel the sense of him waiting. 'This is for educational purposes you understand,' he had told Mrs Tullett, who sat in the corner watching them.

Ann Jemima had experienced a small moment of malicious joy when she pointed out the detail in the picture of Juno's peacock hissing angrily at Paris's own dog, which crouched, terrified, between its master's legs. Yet as Cosway had swiftly retaliated, Paris himself showed no such fear – he gazed coolly at the goddesses' bodies, his right foot swinging nonchalantly over the peacock's head. 'He could crush that bird in one swift move,' he had told her. 'Look at how the curve of his foot perfectly mirrors the curve of its head and neck.'

Often since coming to London Ann Jemima had remembered her childhood as if it had belonged to a separate person. But it never felt quite so far away as it did when she was with Cosway. If she reflected too much on the difference between these lessons and those with Septimus, she knew it would undo her, so she would fight down the memories and reapply herself to the present.

Tonight was the first time that Ann Jemima and Cosway had been confined in the same space on their own since the lessons had started. It was a danger she had not anticipated – when she and Mr Provis came to see Mr Cosway before the meeting at the

coffee house the arrangement was that the two men would go on to Wright's together, while she returned to the palace. It came as a shock when Cosway announced he was going to see West one more time instead.

'Why?' she and Provis asked simultaneously.

'My dears, do you not understand how clever you have been?' he replied sibilantly. He walked over to Ann Jemima and did a circle round her.

'Your persuasive skills have exceeded even my expectations. There is no end to your surprises. You have created an extraordinary situation. You now have more power than Benjamin West among the artists at the Academy.' His words rang in the air as she and Provis looked at each other dubiously. 'I think it would be the *coup de grâce* if he were now persuaded to ask for your forgiveness,' he continued.

'No, it is too risky,' Provis hissed immediately. 'We have an advantage we expected not – let us reap its rewards. The proof I now have of his misconduct is incontrovertible.'

'I know this goes against all intuition. But please understand the wisdom of this. If West publicly acknowledges his crime, it will raise your powers of negotiation still further. It will also mean there will be no unpleasantness with the King, which there might be if one of his appointees is forced from such a prominent position.'

'You are trying to make an already complex situation more complex. Does not my father's recent visit prove we have given him enough chances?' This from Ann Jemima.

'Perhaps thankfully for all of us, we are not living in a morality tale,' he replied caustically. 'This is not about who has done right or wrong, this is about power. You have won a major battle, but I suspect it would be better for you both if you won the war. Sometimes in order to do this we must make allies of those we least want to. I am sure you would agree, my dear.'

Mr Provis had agreed – with many grunts and begrudging glances – to leave her at Mr Cosway's residence while he sped on to meet the other artists. 'My housekeeper is just downstairs,' Mr Cosway had said with dry amusement, watching his agitation. 'So we have a chaperone. Now begone, man. You have important

information to impart to the artists before the agreement is drawn up. Ann Jemima's carriage will arrive any moment to take her back to the palace. And I will report back to you on my meeting with West.'

Yet fifteen minutes later, the carriage had not arrived for Ann Jemima. The teacher and his pupil continued to sit opposite each other in the large well-lit studio where Ann Jemima had taken so many lessons. She was becoming increasingly sure that Cosway had lied to her father. The scrapes and thumps and occasional snatches of humming she normally associated with the housekeeper moving around downstairs were not there. With a slight tightening of the throat she realised they were entirely alone.

'Do you believe matters are progressing well?' asked Cosway, putting away his handkerchief. The whisper of a razor blade in his voice. 'Who would have ever thought it could have ended up like this?' he continued. 'After such beginnings?'

'It has involved much daring,' Ann Jemima replied, feeling her heart speed up in response to the silence around them. She could sense the small hairs on her arm standing on end. 'We have enjoyed the adventure of this,' she continued, attempting not to look disconcerted, 'and soon I will be in a position to pay you the money you asked for from Mr Provis. Then all debts will be settled.'

'Mr Provis. Your fiercely protective father.' He regarded her with sarcasm. 'You will have noted that I did not reply to your letter. Do you really think I did this in the hope of getting money?'

'No, I do not.' She saw she had shocked him. His dry lips pursed.

'You have done it to take revenge,' she continued.

'Revenge on whom, precisely.'

'On the world. It gives you a great satisfaction to bring out the baser motivations in those around you.' His eyes widened, but he did not speak. 'You have greater contempt for Mr West than anybody, because he is deemed to be your superior, and now you have revealed him as a liar. By coincidence you have ended up profiting Mr Provis and myself. But if the game had worked better by not profiting us, I am sure you would not have hesitated to play it thus.'

He took a deep breath.

'What precisely are you hoping to gain by such observations?' There was the grating of flint in his voice, but no spark.

'At some point I believe the game must start to bore you. Would you not prefer the money?'

'Oh I have a price. But I am not sure you would like to pay it.'

Ann Jemima became suddenly aware of the smell of rabbit glue simmering in a pot on the hearth. In the centre of the room was a large easel and a small plaster model of a Venus de Milo, while canvases in various stages of preparation propped against the walls. Brushes made of hog's bristle, badger's bristle and mongoose hair stood in jars on a small table. Without entirely comprehending why, she realised she was looking at her surroundings as if for escape routes.

Another memory suddenly assailed her. 'Colours can be dangerous as well as beautiful,' Cosway had declared during a lesson. 'Yellow orpiment is potentially deadly because it is an arsenic sulphide. In the past warriors used it to tip their arrows with poison.' He had stuck out his tongue towards the brush so it almost touched it, before retracting it, laughing loudly as she regarded him with disbelief.

She studied his face, increasingly anxious about what trick he was going to play this time. When the veneer of society wit dropped from his expression, it was a shock, even though she had felt the moment coming. 'Lift your skirt and petticoats.' His voice sibilant, sinister. Repulsion slithered across her skin as, heart beating faster, she shook her head. 'Lift them, I say,' he said, his gaze intensifying.

'Mr Cosway, I have told you in the past…' she began, and then gasped in shock as he pulled his breeches down to reveal an erect cock. His breathing fast. He lurched forward and grabbed her hand to guide it so she could pleasure him. She snatched it away and turned to run for the door, only to realise that it was locked. 'You cannot trap me like this,' she shouted, turning to face him again.

Fear mixed with contempt. As he came close to her she observed the bristle on his cheeks, the flecks of spit around his mouth. She looked around her frantically for some weapon with which she could defend herself. Her eye lit on one of the heavy granite mullers used to mix the paints. 'No, that would kill him, and I would be punished even further,' scudded across her mind. Next to it was a palette knife,

and it was this that she grabbed. She was not remotely certain what she would do until the very last moment when she jabbed it in his thigh. The howl of a dog in pain filled the studio.

'Is this what you do to settle your debts?' he cried, bending over double.

'I do not owe you this,' she shouted in reply, turning back to the door, her hand searching agitatedly for the key as she reached it. 'You blackmailed my father so you could give me lessons, but all you wanted was to try to reduce me to nothing. That is not chivalry – that is the work of a devil.'

He pulled the palette knife from his thigh. The blood trickled darkly down his leg. Next he took a rag from a nearby table and dabbed it over the wound, pulled his breeches up over his now flaccid cock.

'After tonight you are going to be a very rich young lady,' he said grimly. 'As long as no one finds out the truth,' he grimaced, 'because of my help you will be able to pick and choose who you marry.'

'Not if I'm carrying an old man's bastard,' she hissed. 'I cannot believe you stooped to this.'

He groped in his breeches, which despite the rag were starting to stain with blood, and pulled out an empty pig's bladder. 'There are other uses for this beside the storage of paint,' he declared bitterly.

Finally she found the key. Angrily she flung open the door. 'If you try and tell people that I have assaulted you, I shall make sure you suffer as much as I do,' she declared in a low voice. 'The worse you can do for yourself is give me nothing to lose.' She rushed headlong down the corridor, through the drawing room and into the entrance hall. As she looked briefly into the mirror hanging there her reflection screamed back at her – millstone eyes, the red riding angrily through her cheeks. She took a deep breath to assert her composure, then, after adjusting her hat, she opened the front door onto the street, where she saw, as if it were operating according to the cruel whimsical logic of a dream, that the carriage ordered by Thomas Provis earlier that evening was just drawing up to collect her.

• • •

She was shuddering when she climbed out of the carriage at St James's Palace. A mixture of disgust and exhaustion coursed through her body. If the meeting goes well at Wright's Coffee House tonight, she thought to herself, we will receive the first instalment of the money within a month. 'And then all this will be over,' she said angrily, her voice paper-thin with exhaustion against the evening air.

'What will be over?'

She gasped. Put her hand to her mouth as if trying, too late, to catch the escaped words. She turned to see Josiah Darton. He saw the mounting horror on her face as she backed away from him as if fearing another attack.

'Miss Provis, what ails you?' he asked.

She looked numbly at the parcel he was holding, at his face, at the sentry standing in the box behind them. The reality of what was before her speared through by the memory of what she had left behind.

'Why did you stop me from fleeing?' she cried angrily. 'Why did you stop me? Everything I feared has come to pass.'

His face became severe. 'Miss Provis, what has happened?'

She began to laugh, and found she could not stop. 'Oh, Mr Darton,' she said. 'I have been...' She felt the urge to vomit and swallowed once, twice.

He grasped her by the shoulders.

'Touch me not,' she spat, pushing him away.

She could see the panicked calculations on his face.

'Miss Provis. Who has... who has?'

'Mr Cosway,' she whispered bitterly. 'No matter what I do, he is always going to be there to drag me down.'

'Cosway.' She could hear the shock in his voice. 'What has he done?'

'Tonight should have been a night of triumph. But my father left me alone with him, and...' Her head was swirling, and the full gravitational force of her exhaustion suddenly became apparent. 'Mr Darton, I beseech you to let me go back to the apartment on my own.'

He stared at her intently.

'You need a physician.'

'No, no, I will be better soon.'

She hesitated a moment and put her hand to her forehead. She sensed Darton's hand held out behind her, as if anticipating she was going to fall.

'I am not going to faint.'

Her glance cut into him, defensive, hostile.

'Miss Provis, I know that you do not trust me on many matters.' His voice was trying to steady her, she could sense his fear. 'But my conduct towards you has always been honourable.'

'Honourable?! It is you who trapped me. You who brought me back to the wreckage.' As she cried out the words it seemed that something collapsed in her. Tears threatened again. Quickly Darton nodded at the sentrymen standing at the side-entrance to the palace, their expressions characteristically impassive, and escorted her through it.

As they walked into Green Cloth Court, he was struck by how slight Ann Jemima suddenly seemed to be. He wanted to ask her further questions, but it was as if she were trapped in another, uglier world in which he could not reach her. Normally, Darton reflected, whenever he'd seen Ann Jemima, the overwhelming sense was of her observing everyone else – coolly gauging her surroundings with her pale blue gaze. Then he looked down and saw the blood on her hand.

He was about to comment on it, but slamming footsteps accompanied by laughter were heard. A young dark-haired seamstress rushed across the court, closely pursued by a young man with a beard. The seamstress, suddenly aware that there were other people there, flipped her gaze over towards Darton and Ann Jemima. She stifled her laughter for a moment, then with a quick glance towards her suitor hurried into Great Court.

Darton looked back towards Ann Jemima. 'You have been hurt,' he said quietly.

She did not reply, it was as if she were in a trance.

'I had assumed you would be in France again by now, Mr Darton,' she said. Her words floated across the cold evening air like ghosts.

'It is better for me to be in England right now,' he replied evenly.

He realised his main concern was to get her to the apartment before she passed out. Slowly, steadily, he walked alongside her. Finally the small green door appeared in front of them.

Before he could knock on it, the door was snatched open. Mrs Tullett seemed to fill the doorway, her eyes malignant, her features scored with suspicion.

'What is she doing with you, Mr Darton?' Her voice a vulgar stripe of colour against the dusk.

'Miss Provis is unwell,' he replied.

Mrs Tullett's face had assumed a porcine grimace – it dissolved as she looked at Ann Jemima.

'My dear, what has happened to you?'

Ann Jemima said nothing.

'Has this man upset you?'

'He has not.' The words came out faintly.

'Ann Jemima.' Mrs Tullett's concern gushed out messily – she grabbed the girl as if she were a rag doll and dragged her into the apartment. Darton followed. 'I will wait just here, Mrs Tullett,' he said, sitting in an armchair by the fire. Mrs Tullett shook Ann Jemima hysterically. Darton wondered for a moment if Ann Jemima's greatest danger was her protector. But he knew he could not intervene, so he stood by as she bundled her through the door and into her bedroom.

Yaps of concern filtered through the wall.

When Mrs Tullett came back her suspicion still seemed to snip at the air. 'I warned her that it would come to this. I knew no good could come of persisting with her plans.'

She looked defiantly at Darton.

'She was delirious when I met her at the gate,' he replied. 'And she has blood on her hand. Did you see it?'

Mrs Tullett nodded, frowning.

'Is it her blood?'

Her shake of the head was almost imperceptible.

'Cosway's?' he whispered.

Mrs Tullett clasped and unclasped her hands.

243

'She said she could control him, but he has been an animal waiting to pounce these many months.'

Darton leant forward alarmed.

'If the blood is Cosway's, does one of us need to go there to check...?'

Mrs Tullett eyes darted. She was silent, but he could see the desire to talk bubbling up inside her.

'Mrs Tullett, it may be that we do not have time to lose. Shall I go to Mr Cosway's to check that there is nothing we need to conceal?'

'She has not killed him.' Her words smack out bluntly.

'Are you certain there has been no accident?'

'She was forced to defend herself.' Her chin trembles. 'But that much I did get from her. She still has her virtue...' Her voice shakes with outrage. 'And he is only wounded, the coward...'

He hesitated.

'It is known that Cosway has a large collection of pornographic literature,' he said finally. 'I have heard he is frequently to be seen in bookshops off the Strand. He considers himself a connoisseur of French works in particular.' He grimaced.

Mrs Tullett was quiet.

He leant forward. 'Mrs Tullett, if I know this of him, then it is impossible that you do not. What was Ann Jemima doing alone with him at night?'

'It was never meant to happen. She went there with Mr Provis. But Mr Provis had to go on to a meeting with the artists of the Academy...'

Darton frowned.

'Cosway has a hold over Mr Provis and Ann Jemima...' She gazed at him pleadingly.

He recognised that she wanted him to take the initiative.

'It is because he has played the go-between in the West affair, and may yet prove the saviour of the situation?'

Mrs Tullett took a deep breath.

'It is another kind of hold. He knows something of Provis and Ann Jemima's past that you do not.'

He looked at her.

'Is it connected to where I found Ann Jemima in Spitalfields? Where was that place? Why did the woman recognise her? She would say nothing when I asked her.'

She turned her face away from him, and he saw she would not be drawn further. 'Mrs Tullett, who would know Ann Jemima in Spitalfields? If you won't tell me, it would not be difficult for me to find out. Are you implying he can blackmail them about this?'

'If there were any virtue in this world, he would not be able to,' replied Mrs Tullett, 'for in truth, they have nothing at all to be ashamed of.'

Darton shook his head.

'Mrs Tullett, you are talking in riddles. What is the nature of the hold Mr Cosway has over them?'

She was silent.

'When Ann Jemima arrived from the country to live with Mr Provis three years ago, there was much joking and speculation about the fact that Provis had never talked before about his family,' he continued quietly.

'You yourself know Mr Provis is quite the clam when it comes to his personal affairs.'

'His wife died a long time ago. He never went to visit Ann Jemima, yet he has taken very naturally to late fatherhood. There is no doubt about the bond between them. Mrs Tullett, is Ann Jemima his illegitimate daughter?'

Her laugh escaped as a screech.

'No, no she is not.' She looked at him directly. 'Ann Jemima is legitimate.'

Darton nodded and frowned.

'Very well then.' He thought for a moment. 'Was it Mr Provis who suggested she come to join him in London after her grandmother died?'

Mrs Tullett was quiet for a moment. 'It was a surprise to Mr Provis when Ann Jemima arrived here. He is a good man. He has more than done his duty.' She looked at him with a beseeching air that he could not quite understand.

'He sent her away for a year before she finally came to live here, did he not?'

'She was at school in Highgate.'

'Was that truly where she was?'

Mrs Tullett nodded. 'Yes, indeed. I visited her often. She did not have many friends there. We would take a walk up around the woods, and then we would go out to tea. She seemed to enjoy my visits. We were great friends then.' Suddenly Mrs Tullett looked lost, haunted.

Darton thought for a moment.

'Then on what matter is Mr Cosway blackmailing the Provises?'

He could sense the tightness in her breathing as she wondered how to respond.

'Mr Darton, there is no true cause for blackmail, the way I see it. The problem is you can never account for the way people might perceive something.'

Mrs Tullett would not meet his eyes any longer.

'Where precisely did he meet her?'

'I have already divulged too much,' wailed Mrs Tullett. 'Please question me no further. Mr Provis will never forgive me as it is.'

He decided to try another approach.

'Whatever the truth of this sorry matter, Cosway needs to be warned off. I'd be happy to perform the task.'

'No.' The sound exploded across the apartment. Mrs Tullett wagged her finger violently and he looked at her with surprise. 'He should be punished, but not now.'

'Because of the method?'

She nodded.

'I have warned against the method all the way through. But if everything goes well at the meeting tonight Mr Cosway is on the point of helping them to make a lot of money. Neither of them would thank you for creating a scandal at this point.'

Darton shook his head.

'So you dare not take revenge?'

Mrs Tullett's eyes were glazed with stubbornness.

'I truly do not like what is happening,' she said more quietly. 'Frankly it disgusts me. Yet if the next few weeks go well, this whole

ridiculous affair may well conclude in the Provises' favour. There has been so much misunderstanding and suffering.' Her voice shakes. 'Please believe me when I tell you that a true friend of the Provises would tread cautiously.'

'Mrs Tullett?'

Ann Jemima's voice, slightly stronger than it had been, came from the direction of her bedroom.

'Is all well with you, my dear?' Mrs Tullett called, before putting a finger to her lips as she looked at Darton. There was a pause.

'I should depart,' said Darton. 'It is time for you to attend only to her.'

'Mr Darton, Mr Provis has been a great friend to you these many years. I can trust you not to meddle till the time is right?'

She looked at him hard. Her anxiety was like invisible flying arrows – he could feel his skin prickling beneath her stare.

'I will let myself out,' he said grimly. 'Please keep me informed on Ann Jemima's recovery.'

CHAPTER NINETEEN

Dinner at Joseph Johnson's

'Carmine is a bright crimson colour, and is formed of the tinging substance of cochineal brightened with aqua fortis, by a process similar to that used for dying scarlet in grain. [...] The greatest part of what is used here is brought from France; what is made in England not standing well in general, but being apt to turn purple on the addition of any kind of white, or even with the sweat of hands or face. Mr Godfrey, the chymist, is nevertheless possessed of a method of preparing it entirely free from this defect; and I have seen some parcels made by him which were equal to the best French I ever saw. The superiority of the French carmine, as well as of the scarlet dye, has been attributed to some qualities in the air and water of France; but nothing is more absurd than this supposition, as the air has very little concern in the production of carmine; and the qualities of water, if different, might be artificially changed.'

Robert Dossie,
The Handmaid to the Arts, 1758

The first lighting of an oil lamp at night, felt Joseph Johnson, was like a rebellion against the invading army of darkness. He had once observed that it was this, as much as language, or the power

of laughter, that marked out the human race from animals – the determination that their hours of light and warmth would not be set by the cycle of the whimsical sun. Tonight, being a Tuesday, there was a sense of occasion as his housekeeper lit the lamps. Shortly the guests would arrive for one of the weekly dinner parties celebrated throughout radical London. Thomas Paine, the novelist Mary Hays, and more recently the poet Wordsworth had all dined at his table, which was more notable for the rhetorical skirmishes that blew up there than the food served.

Even so, the nourishment was good if plain. Great loaves of bread and jugs of red wine were brought out at the start, then as the chimes of St Paul's clock rang out eight times anything from boiled cod to bowls of stew would be served. The large round oak table was untroubled by the fussiness of a tablecloth. Johnson sometimes reflected, as his housekeeper prepared the room for the meal, that there had been times when the knives and forks had been in as much danger of being used as weapons as eating implements. He remembered Paine jabbing his fork in the air as he swore, to an eruption of laughter, that he would skewer Burke on it. At another meal a female novelist had almost attacked Wordsworth with a knife when he revealed he had left an illegitimate daughter behind in France.

He gazed around his dining room. The walls were painted in a pale bluey green that took on an almost luminous quality when the lamps were lit. He had let his housekeeper choose the colour, and though at first he had been dubious, now he was convinced. In his more fanciful moments, generally after a few glasses of wine, he felt as if the entire company gathered round the table was submerged in an aquamarine river, and that any moment a fish might shimmer by.

A sharp knocking came at the door.

When it was opened, the man who walked in was unfamiliar. His complexion indicated he was around the age of thirty, though his bearing was that of a man almost a decade younger.

'I hope very much that you will forgive me for arriving unannounced in this manner,' said the man.

'Most people are welcome here,' replied Johnson, frowning. 'May I know your name.'

'Josiah Darton,' replied the man, holding out his hand. Johnson stepped back for a moment, slightly shocked.

'I must apologise – I was not...'

'Expecting me? Please do not be alarmed – I have long been an admirer of yours, Mr Johnson.'

A sceptical look crept into Johnson's eyes.

'Your friend Mary Wollstonecraft has asked many questions about me, and I thought I would come and see you myself so I could answer them.'

Johnson shook his head, as if rebuking himself.

'I apologise, Mary does not believe in secrecy,' he said.

'Do not concern yourself,' replied Darton. 'I wanted to assure you that you have nothing to fear from me. No matter what games Opie and I may have played on Mr Wolcot.' He and Johnson held glances for a moment. In the brief combat that seemed to ensue, Johnson finally relaxed his gaze.

'My sympathies were with the French Revolution, certainly until the Terror took hold,' continued Darton. 'I was inspired to travel to France after the revolution. Like Wordsworth I believed that "Bliss was it in that very dawn to be alive." I hoped it was a victory for reason.'

Johnson summoned his boy in. A glass of red wine was poured and handed to Darton.

'But man the savage cohabits very closely with man the rationalist,' said Johnson quietly.

'Indeed,' replied Darton. 'Moderation was quickly replaced by a shocking brutality.'

'Does that mean you worry about sedition here?' The tone of Johnson's voice was severe.

'I am a musician before I am a spy. I do not believe that is my job to stifle debate.'

'Yet you do not believe any more that it is worth fighting for liberty and equality? You believe we should allow the corruption of

privilege to persist – accept that some are born to a good life, and others to a wretched one?'

'I simply ask at what point death becomes preferable to an unequal existence.' He took a deep breath. 'Surely there are less violent ways to change society. I believe that the work you yourself do is extremely valuable. But you understand the risks…'

Johnson looked at him sharply.

'Why else did you decide,' Darton continued, 'to remove Paine's *Rights of Man* from your printing presses at the last moment?'

Johnson was briefly quiet. For a moment he felt nauseous.

'I was threatened directly,' he eventually declared, staring at Darton. 'It would have been the last work I published. Thomas Paine understood. But many of my friends did not. You do not have to dig very deep in our great democracy,' his words rang out sarcastically, 'to find the menace beneath.'

Darton was about to respond, but a second knock on the door interrupted them.

The heavy tread in the hallway announced Mary's lover, the radical philosopher William Godwin. Tonight he was dressed in clerical black. His eyes impatient, his cheeks sallow. A small vertical line was scored between his eyebrows – more pronounced, Johnson noted, than it had been of late.

'Welcome, Mr Godwin,' he declared. 'May I introduce you to Josiah Darton.'

Godwin appeared not to note the coldness of Johnson's tone when he was making his introduction. He nodded perfunctorily, while his expression was quizzical.

'Is all well?' continued Johnson, sensing his distraction.

'All is well, all is well, thank you. I suspect that you have heard our news.' His voice was like sun on frosted grass. 'Mary is with child.'

Johnson dipped his head. All the while he studied the expression on Godwin's face.

'Yes, my congratulations, William.'

Godwin flinched slightly.

'Her condition has been making her rather unwell today. I am

assured that all is fine, but, unusual though it is for Mary, she has decided she should rest tonight.'

'I received her card,' replied Johnson. 'She has suggested that the young writer Amelia Alderson come in her place. I look forward to meeting her, but I am sorry Mary will not be here.'

He looked towards Darton. 'It was indirectly Miss Wollstonecraft who brought you here. Have you met her in person?'

'No, though obviously I have heard much of her through Opie.'

Godwin looked between Johnson and Darton enquiringly.

'By chance, I have invited Mr Opie here for the first time tonight,' said Johnson. 'Why don't you stay for the meal, Mr Darton? It will be a good chance for all of us to get to know each other better.'

It sounded less like an invitation than a challenge.

Darton's eyes widened. 'Very well,' he replied. 'If Mr Godwin is amenable, I would be happy to.' Godwin dipped his head non-comittally. 'Not least for the chance of eating with the author of *The Adventures of Caleb Williams*,' continued Darton. 'It was entirely absorbing – I read it in one sitting.'

Johnson took a sip of wine.

'Was it the subject matter that appealed to you, Mr Darton?' The tone of his question was not polite.

'It's a story of an innocent being persecuted by corrupt lawyers and spies,' replied Darton. 'Mr Godwin – you published it, did you not, on the same day Pitt ruled that radicals could be sent to prison without trial. If you had gone and kicked Pitt's arse, your message could not have been clearer.'

A chilly smile from Godwin. 'No one has expressed their appreciation in quite that language, Mr Darton. But I thank you for it.'

Johnson tutted impatiently under his breath. Yet other things were starting to concern him beyond Darton's arrival. As he called the boy back in to pour wine, he noted with alarm the sobriety of Godwin's dress. Though clad in black for much of his adult life, just a couple of years beforehand Godwin had started sporting more colourful outfits. Outlandish certainly – they included a blue coat

worn with yellow cashmere breeches, and a green coat complemented by red Moroccan slippers. Yet they seemed to symbolise a happier period of life for the severe intellectual – and it was little coincidence that the flamboyance had coincided with the success of *Caleb Williams*. This sudden return to black made Johnson worry for Mary as much as for Godwin himself.

The burgundy tipped from the bottle, turning the wine glass into a glinting red jewel. Another knock came on the door. The lighter touch of footsteps in the hall suggested to Johnson that the only female guest of the evening had arrived. He could see from the straightening of Godwin's back that he concurred.

'Mr Johnson.' Amelia Alderson walked neatly into the room. Immediately he was impressed. Her shiny dark brown hair was piled on the top of her head while her glowing complexion indicated vitality rather than delicacy. Although she was very pretty, with rosebud lips, and heavy – but not over-heavy – eyebrows above her dark eyes, it was her good-natured expression that made its impact first. Her high-waisted dress with its flattering drawstring neckline was a Wedgwood blue. The overall impression she gave was of someone who had taken care of her appearance, but was not obsessed by it.

'Miss Alderson. It is always a joy to see you.'

Johnson realised, to his amusement, that Godwin was fighting to stop his smile from reaching his ears. Yet in the same moment that he perceived Godwin's admiration for her, he could see precisely why Amelia Alderson was no threat to Mary. The glint in her eye indicated that she saw Godwin as faintly comic even though her overall manner conveyed a respect for the man. This is a flirtation, but one whose chief pleasure derives from the fact that there is little danger of anything serious happening, he thought to himself. In the distant caverns of his memory, he suddenly recalled that Godwin had once proposed to Amelia. But if there had been any profundity of emotion then, it had comfortably receded now.

She turned towards Johnson.

'It is very kind of you to invite me to one of your dinners, Mr

Johnson. I grew up hearing about them, but never thought I would be fortunate enough to attend one.'

He dipped his head.

'Miss Alderson, I am delighted you could attend. You must forgive me – tonight you will be a rose amongst thorns, all the other guests are men.'

She surveyed the room briskly. 'I will do my best to rise to the task,' she said. 'I hope they will not regret too much the fact that I have come in Mary's place.'

Johnson smiled. 'Let us hope it is not we who disappoint you. We have quite diverse group tonight. Allow me to introduce you to Josiah Darton, a singer at the Chapel Royal.' Darton bowed. 'Fuseli the painter will be here,' he continued, 'and he will be bringing John Opie.'

At the mention of Fuseli's name Godwin's eyebrows levitated.

'Was Mary aware that he was going to be in attendance?'

'I had not mentioned it.'

Amelia looked between them, alive to the sudden tension.

'My dear William,' Johnson said. 'I hope you do not feel I have been insensitive. It is a long time since Mary…'

'… proposed a ménage à trois with Fuseli and his wife,' Godwin concluded crisply. 'I know.'

Darton started coughing. Amelia cast her eyes to the ground.

'Fuseli invited himself,' said Johnson, momentarily discomfited. 'I did consider saying no, but then thought that in these happier times for everyone it would not pose too much of a problem.'

Before Godwin could respond, there was a further knocking at the door, and John Opie and Henry Fuseli entered the room. After a start of surprise at seeing Darton, Opie came and introduced himself to Johnson.

'Mr Opie, Mr Opie, you have still not given me your reply, and I am fearful the conversation will distract us from the question.' Fuseli's Swiss-Germanic accent was loud and insistent. As he intended, the murmured greetings that had started up around the room were silenced.

Opie was thoughtful for a moment. 'If you ask me for my honest reply, I would say Joseph Turner.'

Fuseli nodded approvingly.

'An excellent response.'

'May we be apprised of the question?' Amelia asked brightly. Johnson smiled at her with approval. He was long used to Fuseli's attempts to ensure that he was the centre of attention. Creating an air of mystery through elliptical conversations was among them.

Fuseli's glance was dismissive.

'I was asking Mr Opie which of the artists at the Royal Academy he thinks shall achieve immortality. You are?'

'Amelia Alderson,' she replied firmly. 'You say Mr Opie has given an excellent answer. Are you in agreement with him?'

The wide set eyes were opaque for a moment.

'My own preference inclines towards Thomas Lawrence,' he replied. 'Mr Turner is extremely young, and unknown by most. Mr Lawrence has shown his aptitude for a wider range of styles. But in a couple of years, who can foretell? Turner may prove the greater artist, or some other young person of whom we yet know nothing.'

'Would everyone like to take a seat?' Johnson extended his hand towards the table. He himself took the chair nearest to the dining room door, while indicating Amelia Alderson should sit on his right, and Godwin in the place to the right of her. Darton came and sat next to Johnson on the left, while Fuseli and Opie, who had now been offered wine, took their respective places on the other side of the table.

'I have heard of Thomas Lawrence,' declared Johnson, 'but not this Mr Turner. Who is he?'

'A barber's son,' replied Opie. 'Sir Joshua Reynolds accepted him into the Academy when he was only fifteen. He has very little to say for himself, and his manners can be crude, but I have always believed him to be exceptionally talented. His painting, *The Rising Squall*, was the first to show he might be more talented than the rest of us.'

'It is a dreadful title,' declared Fuseli with a loud sniff.

'It is a description,' said Opie firmly. 'And the painting itself is of sheer brilliance. Everything he depicts – the hills in the background,

the ship coming into dock – seem almost to be dissolving in the light. Their silhouettes are clearly to be seen, and yet somehow they are suffused with colour.' He paused for a moment. 'I have seen no other painter of our times come close to his use of colour, till recently.'

Fuseli looked at him sharply.

'Which painter are you talking about?'

Opie was quiet for a moment.

'I am not at liberty to say at this stage.'

'How do you gauge whether or not a painting might achieve immortality?' Godwin's faintly acerbic tones made themselves heard across the table.

Fuseli's responding stare was insolent. He is like a stag in the Scottish Highlands wondering whether or not to address this with his antlers, thought Johnson to himself. Even though he rejected Mary as a lover, it is still in his nature to see Godwin as an adversary.

After a short, calculated pause, Fuseli replied. 'Mr Godwin, you are a great rationalist. One of life's *balanceurs*.' His pronunciation of this last word languorous, appropriately measured – to one who does not know him, reflected Johnson, it is not clear whether or not it is a compliment or an insult. 'So it will obviously come as some disappointment to you that there is no precise way of measuring whether or not a painting will be immortal.'

'I believe you underestimate me, Mr Fuseli. I appreciate that for a man like yourself precision is not always desirable. But surely you can posit some kind of criteria.'

There was a flicker of light in Amelia Alderson's eye. Johnson caught its meaning, and they both smiled.

Fuseli's glare was pronounced.

'I cannot give you a list of traits to be ticked off on a list,' he declared sardonically. 'The Italian Ludovico Dolce described it as the "*non so che*" – the ineffable – that which "fills our souls with an infinite delight without our knowing whence arises the thing that pleases us". But if I were forced to give some kind of definition, I would say it is a painting that ambushes us by presenting something in a way that we could never have imagined ourselves, yet at

the same time creates a sense of something we have always known. It is both new and eternal, disconcerting and reassuring. I believe this applies to all great works – whether it is Dürer's *Knight, Death and the Devil* or Leonardo's *Last Supper*.'

'Do you think London's art critics are able to recognise it when they see it?' asked Opie.

'I believe most critics to be eunuchs,' said Fuseli dismissively. 'Anthony Pasquin, the most notorious, is well known to have started out as an artist and failed. Peter Pindar, as we know,' he looks at Opie, 'is a charlatan. In truth I do not know why we allow any of them to sit in judgement upon us.'

'Yet surely you need some kind of sceptical voice,' declared Amelia Alderson. The table went quiet. 'And if that individual is not an accomplished artist, it means they are not in competition with you, which would surely distort their judgement,' she continued. 'I approve of the critics, perhaps because my father is a physician. If he sees there is something wrong with a patient, but fails to say it, there is a chance the problem will become worse and may even lead to death.'

Opie looked at her. 'Are you saying that without critics we will die, Miss Alderson?'

'No,' she replied briskly. 'But I am saying you will be susceptible to something possibly worse than death, self-indulgence.'

Johnson smiled. 'Miss Alderson makes an excellent point.'

The rabbit stew was brought in and served without ceremony. Johnson noticed Amelia's surprise as the guests immediately fell on their food without waiting, and felt quiet admiration at her determination to conceal it.

There was a mischievous light in Fuseli's eyes as he looked up.

'Do we think Benjamin West is in need of a cure for self-indulgence?' he asked lugubriously. 'Many months ago he showed me this Venetian manuscript that seems to be causing so much fuss now. At the time, he confided he thought it would allow him to surpass Sir Joshua Reynolds. I confided in turn that I thought he was delusional.'

'If Benjamin West is so enthused by the document, he should

have been more honest about where he found it,' replied Opie. 'I myself am sceptical. But since our President clearly values it so highly I am allowing Miss Provis to give a demonstration of it at my house. If the other artists are as impressed by it as he is, they will pay her and her father the sum of money that he did not. Will you come? Maybe you can shame him where so many others have failed.'

Fuseli's hand brushed away an imaginary cobweb in the air.

'I am too occupied with other concerns right now. I remain a sceptic. Titian's secret was that he was taught by a genius like Giorgione and spent most of his life in Venice. The light constantly shifts there because it is endlessly reflected by the water – colour swirls and evaporates, it has a quality unmatched anywhere else in the world. That is not something you get from a manuscript.'

'Did any artist at the Academy encounter Miss Provis before she and her father took the Venetian Secret to Benjamin West?' said Darton.

Opie looked at him.

'What is your interest?'

'I have known Mr Provis over the course of many years during my time at the Chapel Royal. I have also come to know Miss Provis since she arrived at the Palace three years ago. I have much admiration for her. I am curious to discover how she is perceived by eminent artists such as yourselves.'

Opie slapped his hand on the table. 'Of course you know both of the Provises. You must be better acquainted with them than any of us.'

Darton caught Johnson's eye.

'To an extent,' replied Darton. 'I have seen how Miss Provis attracts the fascination of all who encounter her. I am not well acquainted with her painting, but she has an extraordinary talent for caricature that has caused much amusement among the few who are invited to see her work. I once saw her draw the Prince of Wales as Bacchus, riding an exhausted donkey with the word DEBT branded across its haunches.' Quiet laughter went around the table. 'Obviously such a talent is considered inappropriate for one of her sex.'

'Not at this table,' commented Johnson quietly.

Opie frowned and was about to respond, when Godwin's voice rang out loudly across the table.

'So you sing at the Chapel Royal, Mr Darton. And yet you are in attendance here at in one of London's more left-wing circles. What kind of double life is it that you lead?'

'Music is a pure form,' declared Darton straightforwardly. 'It need not express your beliefs on any level. Singing Mozart or Bach in front of the King does not commit me to being a royalist.'

Johnson cleared his throat. 'Nor indeed does it convince anyone that you are a socialist,' he said wryly. 'Mr Darton,' he declared to the table, 'was telling me he has travelled to France since the Revolution.'

'He has indeed,' declared Opie. 'Just one and a half years ago, he encountered Napoleon in Paris.'

Johnson saw Darton look down.

He did not want the table to know this, he thought.

'It was a chance encounter, nothing of significance,' Darton said quickly. But the whole table was watching him.

'Was this after…?' began Amelia.

'No, no, no,' replied Darton anticipating her question. 'It was before he distinguished himself as a soldier. The man I met was not a hero at all.' He took a sip of his wine and looked towards Opie, as if inviting him to change the conversation.

'How did he seem, then?' Johnson asked crisply, keen to prolong his discomfort. Darton cleared his throat.

'Circumstances looked bad for him. He had written a poorly received novel called *Clisson et Eugenie*. It was clearly a *roman à clef* about himself and his lover.'

Fuseli's loud laugh rang cruelly across the room. The others remained still and quiet. 'He had been removed from the list of generals who could serve regularly,' continued Darton, 'because he had refused to serve in the Vendée. So he was heading towards bankruptcy and didn't seem to have very good prospects as a soldier at all.'

Amelia gasped, and Godwin looked at him intently. His gaze was no longer condescending.

'Many see him now as the saviour of the revolution,' the philosopher said.

Darton nodded. 'He has been extremely successful in Italy. They say he will capture Venice this spring.' A frisson crossed the table. 'Thank goodness, all his energies will be concentrated there,' Darton continued. 'It is unlikely that the French will attempt another invasion of Britain after the failed attack at Christmas.'

Johnson looked warily round the table. I was a fool to invite him in, he thought. Out loud he asked, 'Was your first encounter with Napoleon also your last?'

Darton nodded. 'It was indeed. Most inauspicious. I had to lend him ten francs. No one at that stage could have predicted his rise to being one of France's most important generals.'

Fuseli's eyes flash. 'I find it rather fascinating that his novel was so terrible. Imagine if it had been good. Then France – indeed the world – might have been deprived of one of its greatest soldiers.'

After the spiky start, it proved to be a convivial evening. The altercations continued, though the full antler clash between Fuseli and Godwin never manifested itself. Amelia's carriage arrived for her at ten, and shortly after she departed, so did Godwin, saying he needed to see how Mary was. It was at the point when Johnson and Fuseli were engaged in discussion about Edward Jenner and vaccinations that Darton caught Opie's eye and indicated that they should leave together.

The two men walked into St Paul's Churchyard and up the steps of the cathedral to the pillars outside the Great West Door. There were only a few carriages abroad at this time of night, rattling around like lost souls in the dark. From time to time the candles carried by link-boys dotted themselves against buildings shrouded in blackness – the silhouettes of the weary trudged behind. In front of Darton and Opie, Ludgate Hill dipped its shadowy course down towards Farringdon and over to Fleet Street.

'You have taken affront at my conduct this evening, Josiah,' declared Opie.

'Not at all.' His friend looked at him guardedly.

'You cannot conceal it. I saw the change in your expression when I mentioned Napoleon. Why did you resent my talking of him?'

'The fault was mine. It suited me for Johnson to believe I was an idealist who was interested enough to travel to France, but little more.'

'It suited you? What mean you by that?'

Darton looked down.

'As you yourself told me, Johnson is concerned that I am a spy. I wanted to assure him he had nothing to fear from me.'

'And he does not.' Opie's eyes narrowed. 'Though I noted you said you did not anticipate another invasion. That is a lie – you have mentioned the prospect to me. I could not understand why you told it.'

He stared at Darton waiting for a response. None came. The suspicion on Opie's face grew.

'What were you doing at the dinner?'

Darton was still silent.

'When Mary asked me who you were, I felt able to reassure her that you spy for the left. Is this true, or have things changed for you?'

Darton took a step back.

'This whole world is changing all the time.'

'Cease your flippancy. Am I putting my friends in danger by talking to you of them?' Opie grabbed him by the shoulders and started to shake him.

'Desist, man.' Opie found himself sprawling on his back on the black and white chequered stones. He got up, eyes blazing. Darton held up his hand.

'I told Johnson this evening he was not in danger from me, and I told him the truth.' He was shaking slightly. 'Do not chastise me.' He closed his eyes and took a deep breath. 'Johnson is friends with Wolfe Tone.'

'Go on,' said Opie dangerously.

'The first attempt to invade Britain was – as you know – laughable. But if a second attempt is made, the consequences could be

much more serious – for all of us. I do not think it should happen.'

Opie was silent for a moment.

'Are you spying for Pitt?'

'I have betrayed nobody. I simply seek to stop further bloodshed.'

Opie shook his head.

'So you inveigled your way into Johnson's dinner party and tried to see what you might discover about his associates.'

The fist flew into Darton's stomach. He doubled over, trying not to vomit.

'Johnson suspects me as it is,' he said, painfully straightening himself up. 'I knew he was too clever to incriminate himself on any level.'

'Enough with your moral equivalence, man. What would you have done if one of his guests had revealed themselves to know something about the plot to invade?'

Darton dusted himself down. Checked himself for blood. Found none.

'No one would have been arrested,' he replied grimly.

He could see the faint disgust in Opie's eyes.

'I never meant to deceive you,' he said.

Silence.

Darton walked over to a pillar and put his hand against it. He stared down Ludgate Hill.

'The whole world is on fire,' he said quietly. 'Can't you feel it?' He turned. 'The whole world order is changing. Many of us thought that if you burnt away what was bad and corrupt, then only good would be left. But oppression comes with different masks, and it is more and more difficult to recognise whether new or old is the worst. None of us truly knows of what we are capable. None of us truly knows – till we are tested by that fire – what we might sacrifice for what we call the greater good.'

Opie was quiet for a moment. He could sense the Great West Doors of the cathedral looming behind them.

'Who else in London knows of your shift in sympathies?' he asked quietly.

'Apart from Pitt? One person,' came the response.

'Do I know this person?'

'You do.'

'Who is it?'

'We talked of him at dinner. It is Thomas Provis.'

Opie frowned.

'He has been a discreet and reliable confidant of mine for many a year.'

'Yet you have never talked of him to me.' Opie's voice became wilder. 'Why the secrecy? Is he a spy too? Is this affair involving West part of some larger conspiracy about his political sympathies?'

Darton shook his head. 'No, no. Mr Provis is no spy. The affair is not political.'

Opie's laugh was black, disbelieving.

'And yet the Provises are concealing something.'

Darton was silent.

'What is it?'

As he considered his reply, several images ran through Darton's mind. The house where he had found Ann Jemima in Spitalfields, her distress when he had met her coming back from Cosway, Mrs Tullett's outrage, the blood on the girl's hand.

'It is difficult to say at this stage,' he replied shortly.

'Is your friend a good father? Might Ann Jemima be trapped somehow?'

'She is not trapped by Provis. He is a devoted father.'

'Do you think they really inherited the manuscript?'

Darton's eyes widened. 'I have never asked myself that question.' He paused for a moment. 'But I am worried that they have both taken on more than they anticipated, and now find themselves prey to dangerous forces.'

Opie stared hard at him.

'I can offer you this to show how much I value our friendship,' Darton continued. 'Tomorrow, I am being dispatched to the West Country to take messages to the coast. There are worries that the French fleet plans to attempt their next landing there.'

'Why is that significant?'

'I have various possible routes. One could take me through Somerset, which is where Thomas Provis lived. It will be easy to pass

through the village he came from. No one in London is going to give us any direct answers on this matter. Since I am being sent in that direction, why don't I go and see what the villagers have to say?'

Opie's eyes widened.

'You believe it is that important?'

Darton thought of the blood on Ann Jemima's hand again.

'Yes, I do.'

'There are no secrets in villages.'

'Indeed there are not. And I have many questions. About why Thomas Provis never visited his daughter while she was growing up, about the grandmother who brought up the educated, self-possessed young woman who tantalises us all. Someone there might well be able to illuminate some aspect of what is happening here.'

Opie started to whistle and pace back and forth.

'This world feels more and more like a game of chess which one must forever play blindfolded.'

'Forgive me, friend,' replied Darton. 'We live in dark times. I rebuke myself that you have seen my secrecy as a betrayal. Please do not.'

'When do you think you will return?'

'I hope to be back in a week and a half. In the meantime, can I trust you to keep your counsel?'

This last statement was less of a question than an instruction. Without taking his leave Darton ran swiftly down the steps and towards the top of Ludgate Hill. Opie watched him for a brief while, and then – lurching slightly from the red wine – made his own way down the steps. By the time he looked again, Darton had turned right into Ave Maria Lane and disappeared from view.

Ann Jemima recovers

'My Design in this Book is not to explain the Properties of Light by Hypotheses, but to propose and prove them by Reason and Experiments.'

Isaac Newton,
Opticks, 1704

Over the next two days she wakes intermittently. Voices come and go in her bedroom, some jab at her sleep, some soothe. In her head the birds' wings flutter. There is a sound of glass breaking, and screams of pain. At one point she sits up, looking wildly all around her, but there is no one there. She has a memory of the knife, of Cosway's howl of outrage, of leaving his house in anger. Then she is in front of another house, holding a small suitcase. It looms in a Spitalfields alley, its front door open like a toothless mouth. A woman's voice is heard. She walks into the passageway – the doors on either side of it are closed, but they are rattling as if beasts are trying to get out. She drops her case, and the rattling intensifies.

Then it is afternoon. The sun reaches into her bedroom, and a doctor with a dark beard and green eyes is sitting by her bed. Behind him Thomas Provis stands anxiously. The doctor tests her forehead for fever, then nods approvingly. Extra pillows are brought, she is sat

up in bed. A glass of hot elderberry wine is offered to her – when she drinks it she can taste its tartness, its redness. After the days of sleep, it feels like the first sensation in a crisp new world.

She realises that she is being watched closely as she sips the drink. She regards the doctor, who asks her how she feels. Satisfied with her answers, he departs the room. Provis sits uncomfortably; she can see his distress has almost robbed him of his ability to speak. Eventually he finds the words.

'What did the bastard do?'

'I offered to pay him off.'

Her voice sounds unfamiliar to her – thinner, smaller. Provis offers her another sip of elderberry wine. She clears her throat and starts again.

'I told him we were going to pay him to go away. But he will not.' She shakes her head and the tears start to her eyes. 'The nightmare will never end. He will always try to use what he knows to bring me as low as possible. You were right. You were all right – you, Mrs Tullett. It matters not one wit what powers of invention I use. He will never be gone.'

At what point will the fox ever build the escape route for the chicken? flashes across his mind. Out loud he says, 'We were not right.' It is an apology he has rehearsed to himself several times. 'Everything has changed. The Academy is going to give us the money. I chastised you for your ambition, but see – again it has worked. I must ask your forgiveness. Your ingenuity knows no bounds. I was ever Thomas the Doubter.'

The small joke is delivered as an offering. In response she shakes her head. She feels the anger diffusing through her limbs – cold and deadly as a dose of arsenic.

'I feel like the man who discovered phosphorous.'

Provis looks anxious. His head flicks towards the door, as if wondering whether to summon back the doctor.

'No, I am not delirious,' she says. 'I have not felt such clarity for a long time. The man who discovered phosphorous was not looking for it. He fancied himself an alchemist, and filled a vessel with gallons of urine.'

Provis watches her helplessly – it is as if he can see the thoughts staggering, exhausted round her head.

'Ann Jemima, I beg you...'

She holds up a hand.

'He boiled it, and separated it, and recombined it. He was hoping for gold, but all he found was a substance that emitted a strange, cold light.'

Tears come into Provis's eyes.

'I comprehend you not.'

'Is that not all we are doing? Selling these artists something we claim to be gold, when all it is is phosphorescence.'

He leans forward and grasps her hand.

'Cosway's attack has rendered you melancholic. The manuscript is an extraordinary possession for these artists. Please do not relinquish hope.' He looks around the room, as if seeking inspiration. 'I say again, you were right about it, and I was not. At the meeting I went to at the coffee house, more than half the artists of the Royal Academy agreed they would sign a legal document to promise they will give us the money. I received it this morning. We have it in black and white.'

A small surprised smile comes to her lips at this, and for a second there is a spark in her eyes. 'They have signed the agreement?'

He nods vigorously as he sits back.

'Yes, they have signed the agreement.'

Her eyes dim.

'Yet Cosway is the wolf who is always watching.'

She can remember the smell of him now, the bitter perspiration, the port wine on the breath.

'He did not...?'

'No.' Her eyes glint. 'I injured him and got away before he got what he desired.'

She bursts into tears.

Provis is quiet. He feels the circles of power that surround them as if they were trapped in an orrery. One band of influence represents the court, another the Academy, still another the perversity of Fate.

'What was the injury?' he asks softly.

She clenches her fists. 'I grabbed a knife – it went into his thigh.'

'It will take a while to heal?'

She frowns, unable to understand the question.

'At least a fortnight…'

'I ask myself how easily he would account for his injury if questioned.'

She looks at him disbelievingly.

'We have no recourse to law. He will simply play his card against us.'

'But if we have the money from the manuscript it will be of no matter.' She inhales to reply and then stops. 'It is just over a week till you must perform the demonstration,' he continues. 'The payment will be handed over there. After that, you and I can make him a different offer.'

'And that will be?'

'Two hundred pounds and our silence. I do not think Mr Cosway is an animal who would tolerate prison well.'

She is silent for a moment as his eyes gleam.

'He will never be sent to prison,' she says.

But he can see something kindling in her eyes.

'You are a most ingenious young woman,' he replies. 'We will not bury that in a grave just yet.'

Still he senses the circles of power swirling around them. Thinks back to the first visits to West's house, to the months of terror and doubt that have ensued, to his quiet amazement when he saw the artists waiting to acknowledge his account of the affair at the coffee house.

'I think I am ready to get up now,' Ann Jemima says quietly.

He stands up and makes to leave.

'Mrs Tullett is waiting. I will ask her to come and help you dress.'

Benjamin West confesses

'In our profession we have to use two kinds of brushes: minever brushes, and hog's-bristle brushes. The minever ones are made as follows. Take minever tails, for no others are suitable; and these tails should be cooked, and not raw: the furriers will tell you that. Take one of these tails: first pull the tip out of it, for those are the long hairs; and put the tips of several tails together, for out of six or eight tips you will get a soft brush good for gilding on panel, that is, wetting down with it, as I will show you later on. Then go back to the tail, and take it in your hand; and take the straightest and firmest hairs out of the middle of the tail; and gradually make up little bunches of them; and wet them in a goblet of clear water, and press them and squeeze them out, bunch by bunch, with your fingers. Then trim them with a little pair of scissors; and when you have made up quite a number of bunches, put enough of them together to make up the size you want your brushes: some to fit in a vulture's quill; some to fit in a goose's quill; some to fit in a quill of a hen's or dove's feather.'*

Cennino Cennini,
The Craftsman's Handbook, c. 1400

Winter sunlight splashed blindingly from a duck-egg blue sky – the day's colours vivid, the outlines sharp. On Bond Street,

* By the eighteenth century a wider range was available, though hog's bristle was still the main type used.

the wealthy promenaded like exotic species in a social menagerie. Feathers soared from headdresses, wigs paraded in herds. Above the rattle of conversation, a commercial babble prevailed as jewellers, ribbon traders and bootmakers barked the news of their latest bargains into the street.

As they walked together along the street, Mr Farington and Mr Smirke paid little heed to what was around them.

'Why has the confession been made now?'

Smirke could hear the disappointment in Farington's voice.

'We have all had our suspicions,' Farington continued, 'but I never expected to receive a letter of that nature.'

Smirke regarded him caustically.

'I think it is outrageous. We should be extremely suspicious of the motives.'

Farington nodded.

'I have no doubt that it was sent because of a desire to be forgiven, rather than any desire to be honest. It has put a huge strain on the lives of all of us. All those months without the truth being known.'

'I find it is extraordinary that there is any question at all about whether a crime has been committed or not. In my eyes it clearly has.'

A young man with a toothpick between his teeth walked past them. His face was thin and drawn, while he walked with a distinctive swaggering gait. Farington gave him a quick glance.

'Is that what is described as the Bond Street Roll?' he asked Smirke.

'No, I believe he is blighted by haemorrhoids,' Smirke replied lugubriously.

Farington laughed. 'You take a very black view of the world, my friend.' He looked towards Smirke again, and Smirke suddenly observed the tiredness on his face. The normally faintly flushed cheeks were wan, while the skin beneath his eyes was grey.

He stopped for a moment. 'I fear this business with the Provises has taken all your energies over the last week.'

Farington dipped his head. 'There has been much to chronicle. It has been a difficult and complex business.'

A softer light entered Smirke's eye. 'It is one of life's puzzles, is it

not,' he declared, as he started walking again, 'that exhaustion often accompanies a successful resolution.'

'We were all prepared for a fight. But now that Mr West has confessed, no fight is necessary. It feels as if we have all been pushing at a door that has finally fallen in.'

'When do you think he decided to write the letter?'

'Much later than he should have done. He clearly judged that the method was authentic at least three months ago. The Provises have suffered greatly through his negligence.'

A vendor selling song-thrushes crossed their path. Birds swayed on stick legs, beaks jabbed in the air.

'The more I think about it, the harder I find it to credit his audacity.' Smirke's tone became more severe. 'And while he has given us a confession, there is no sense of an apology.'

Farington regarded Smirke. 'You persist in calling it a confession. I think West would call it a resolution of a misunderstanding. He believes there are two sides to the story, and now the situation has been resolved.'

'He is most lucky that more unpleasantness has not resulted from the affair. This has been a regrettable episode. The fact that he only made his admission after he became aware that half the Academy was championing the Provises is a disgrace.'

Farington was thoughtful for a moment.

'What is in no doubt is the Provises' generosity. I, like you, would find it hard to conceal my rage. But Miss Provis has thanked Mr West, and has declared herself perfectly content with this turn of events. Considering all the adversity she has faced, I think it incredibly gracious of her.'

'The account he gave in his letter was very self-serving. I would even describe it as Machiavellian. Do you think still that it was right of us to conceal from Miss Provis his assertion that he had repainted most of the work she did with him.'

Farington's cheeks become slightly hollower as he considered the question.

'It was an ungentlemanly comment. Clearly designed to absolve him from the fact that he had signed the *Venus and Cupid* painting

with his name alone. I saw no reason to cause further pain to Miss Provis by pointing it out.'

'I also think it was a lie. What he next wrote was entirely inconsistent with that explanation. He asserted that many great artists had signed canvases painted by their pupils with their own names alone, which suggests that we can still see what she did.'

'Did that not happen when the masters passed on the technique to the pupils rather than vice versa?'

Smirke's disdain was discernible in the faint twitch of his lips.

'No, he has not absolved himself at all,' continued Farington briskly. 'Hopefully that will become clearer when Miss Provis demonstrates the technique today. Our President has many questions left to answer about his behaviour. But his letter means we are in no doubt at all about the quality of the manuscript.'

'No.' Smirke's voice went quiet. 'He has said that the many, many months of experiment have convinced him that what the Provises brought him is extraordinary. He has said that nothing less than a new epoch in art would be formed by this discovery.'

The two men looked at each other.

'Whatever West's transgressions, he does not tend towards exaggeration,' said Farington.

They walked on again in silence. Around them vendors' cries pummelled the air. 'I cannot imagine what I would do with Brussels lace or Dutch ribbons,' Smirke said looking around, 'but it is these people's intent to make me believe that they are essential to my happiness.'

'It is a veritable dawn chorus of useless desires,' concurs Farington.

'Though they would understand no better our excitement at what we are about to purchase,' Smirke declared.

'I hardly slept last night. Nothing could excite me in the way the promise of this manuscript does.'

'I too found sleep difficult. Sitting in the dark, deprived of colour, it made me reflect on how wretched this world would be without it. When morning finally arrived I looked around me and thought that colour is the returning of the light. What could stir us more profoundly?'

Farington was suddenly distracted.

'What is happening over there? It looks as if there has been some incident.'

Smirke looked towards where Farington was pointing further up the street. Human bodies were being drawn towards the area like iron filings towards a magnet. Some were immediately repelled.

'It is a monstrosity – an abomination in the sight of God,' said a man, pacing fast down the street towards them as if intent on escape.

'Excuse me, my dear sir, what…?' But it was as if Farington's words were scattered by the motion of the man's body as the stranger rushed past them.

Smirke and Farington started walking towards the cause of the disturbance. When they finally reached where the crowd was gathered, they found at its centre a man standing next to a large cage. The man's dark brown hair stood on end, while a straggly reddish beard clung precariously to his chin. He was dressed in breeches and a jacket that seemed to have been tailored for someone smaller. As he spoke, he gesticulated to the crowd with long thin arms.

'Do we have any explorers among us today?' His blue eyes glinted. 'Anyone who has just returned from the Indian jungle?' He gave a smile in which all but three or four teeth were missing – it grew as he realised most of the crowd was too horrified to respond. 'No we have not? Then you will never have seen what is about to take place before you. It is a miracle of nature, all the way from the subcontinent.'

'Another miracle for a farthing on the streets of London,' muttered Smirke to Farington. 'Is "miracle" not the most over-used word of our times?'

Farington ignored him. 'This is of great scientific interest. Forgive me. I would like to stay for one moment?' He reached inside his pocket, and drew out an ivory leadholder and a calf-bound notepad. 'I have never seen a snake in real life before. It is both horrifying and beautiful. The way it moves is quite hypnotic.'

'Is not hypnosis generally the first sign that things are going in favour of the snake?' replied Smirke. He started to walk on purposefully.

Farington stayed where he was. In front of him the reptile – twice the length of a grown man – writhed inside its cage. Its coils glistened in the winter sunlight, its darting tongue and tiny jewel eyes moved backwards and forwards behind the bars. Each time it shifted towards a section of the crowd, several members moved away.

'Some breeds of snake kill by spitting poison,' declared Smirke from a distance.

'If that were the case here, then we would all be corpses. Pray stay your cynicism for a while, Mr Smirke. It will be something most interesting to relate, and indeed perhaps draw for the other members of the Academy.'

As Smirke took up his position next to Farington the crowd grew around them steadily. Some shrieked as they approached, others were immediately silenced. The smell of fashionable perfumes and colognes cloyed the crisp winter air. Smirke clapped his hands to his pockets as he noted two small boys in rags starting to skulk around the capes and jackets. He felt a quiet fury that he was in this situation at all. But he knew from long experience that for all his apparent politeness, once Mr Farington was engaged no force, however strong, could distract him. Smirke looked once more to the snake. Its owner was pacing round and round the crowd, ensuring enough space was created for everyone to be able to view the cage properly. Out of the corner of his eye, Smirke sensed a quickening motion, and looked down to see one of the boys running off, stuffing a lady's silk handkerchief into his pocket as he did so. He thought of breaking out to chase him, but as he turned about the row of people behind him shushed him, and pointed him forward again.

The snake's owner climbed onto a soapbox. A look of quiet triumph crossed his face as he looked at the horror spattered across the faces around him. 'A python, ladies and gentlemen,' he declared defiantly. 'This is a python, brought all the way here from India. It can swallow rats, birds, small dogs…' His eyes continued to read his audience

with sadistic amusement. 'On occasions it has been known to eat a man,' he continued.

'I can well believe it,' said Smirke disparagingly, looking at the python. 'If I were its keeper, I would be very circumspect about opening the cage door to feed it at night.' He spoke as if regretful that the task had not already proved fatal for its owner.

'Its mouth may look small,' continued the man, 'but this creature is a marvel, both in terms of anatomy and in its ambition. Once it has cornered its prey, it dislocates its jaw and stretches its skin round the animal's head.'

'Extraordinary,' said Farington as he started to make notes.

'Sir, I see you are particularly interested,' said the man, noting Farington's actions. 'Would you like to come over to the cage for a demonstration?'

Farington gave a dismissive smile.

'Perhaps this young lady is braver than the gentleman,' continued the man, looking at a woman wearing a large plumed black hat. She laughed contemptuously, but took a step back as she did so, pushing against another woman who cried out. There was a brief commotion. Smirke realised the second woman was holding a pet marmoset which she had almost dropped. She held it to her like a child, before turning and making her way further up the street.

'Very well.' The keeper proceeded with his macabre theatre. 'There is nothing for it but to feed him my best friend.'

'I cannot bear this,' murmured Smirke.

Farington put his finger to his lips. The snake-owner lifted a box up from beside him and opened it. The nose of a white rat tested the air, then quickly the entire animal came out and climbed up the man's sleeve.

'This is my friend Monsieur Rat,' declared the man. His blue eyes were slightly manic now. He started to walk round the edge of the crowd, offering onlookers a chance to stroke it. At the shrieks of both men and women, his expression took on a darker tinge. 'As some of you may have guessed, he is a French rat…' jeers rose up, '… an admirer of Mr Bony-part. I have been given special dispensation by Mr Pitt to carry out what I am about to do next.'

The crowd's responding laughter was replaced by gasps as the man quickly walked over to the cage and tipped the rat through an aperture. The creature scuttled around manically and the python's gyrations increased. Finally the snake reached its head down and grabbed the rat in its jaw, before coiling the top of its body round it to smother it. At the moment the teeth made contact with its body, the rat let out a screech. It struggled a little, but after a minute or so all that could be seen was the thrashing of the tail. It was not long till that too had stilled.

'Mr Farington, can we move on now?'

Smirke was beginning to feel ill.

'The most interesting element of the experiment is to come...' said Farington, waiting for the python to dislocate its jaw to eat the rat.

But Smirke had had enough. This time he ignored the rebukes of the crowd as he turned and pushed his way for an escape. After a last quick glance Farington realised he would have to follow him.

He caught up just as Smirke was about to turn into Oxford Street. His friend's pallor had a greenish hue to it and he continued to stride rapidly. Finally he commented dourly, 'I did not enjoy that, one bit.' He took a deep breath. 'Though at least the python was honest about his intentions. It is clearly no relative of Mr West's.'

Farington laughed grimly. He looked quickly at his watch and exclaimed. Smirke regarded him questioningly. 'You were right to move us on, Mr Smirke. Our appointment is to be at Mr Opie's in ten minutes' time. We must quicken our progress.'

A few minutes later John Opie looked at his own watch. He walked once more around his double drawing room to check that the house-keeper had set up the right number of chairs for the demonstration. Then he returned to his studio to survey Ann Jemima Provis and Thomas Provis as they busied themselves with the final mixing and grinding of the colours.

They had arrived at ten o'clock that morning. He had not been sure how to greet them. He had pondered much on what the secret might be that was allowing Cosway to blackmail them. He wondered about what had happened to Ann Jemima's mother, about how the Provises had first encountered Cosway, about business deals that Provis might or might not have conducted in the past. Mr Cosway himself had insinuated that though he had bought artefacts from Provis himself, he was always careful to make sure the origins were not dubious. Maybe the manuscript itself is stolen, Opie thought. Maybe that is why Ann Jemima is so afraid.

Now she was here to perform the demonstration there was no doubt about the seriousness of her intent. In the studio he noted the absorption on her face as she and her father prepared and set out the paints with precision. Her focus was total. Every detail had to be closely observed. It is almost, he thought wonderingly, as if her life depended on it.

'Burnt Umber,' she called.

He could see that Provis was shaking as he got the jar of powder out of a large wooden case.

'Carmine Lake.' The verger looked into the same case. Panic drained his expression as his eyes darted back and forth.

'It is in the second case. On the left, right at the top. Remember, we put it there this morning.'

Provis nodded, and went to the second case where the powder was as she had instructed.

'Ivory Black, Indigo, Blue Hungary and Minium. Those are all in the first case again. And Dutch Pink and Verdigris. Those are in the third, with the containers of oil.'

Opie realised Provis was acutely conscious of his gaze as he fumbled to open the third case.

'Forgive me,' he said. 'I mean not to discomfit you. Your daughter's feat of memory is considerable.'

He looked at them both searchingly. Who are you? he thought.

'You have seen nothing of note yet,' responded Provis.

I suspect not, Opie thought.

Out loud he said, 'Did Mr West see this?'

'He did. He was most complimentary.'

'You must feel gratified that he is now acknowledging you.'

'It was a very unfortunate misunderstanding. A man can become a monster in your thoughts by seeming to oppose you thus.'

'If he had responded to any of our earlier approaches, then we would never have needed to go against him,' said Ann Jemima briskly. With precision she measured vermilion into a clear jar.

'You look like an apothecarist setting out her wares,' said Opie.

There was a crash as Provis dropped a jar that Opie saw was labelled 'Titian Shade' to the floor. Ann Jemima looked towards him angrily and rushed over.

'It is not broken,' he said. 'Please, Ann Jemima, do not fret.'

She stared at him for a moment, and then relaxed.

'I am sorry,' she said. Her eyes met Opie's briefly. 'We are both somewhat agitated.'

Opie left the two of them to continue with their preparations. It was eleven o'clock when Ann Jemima next emerged from the studio. 'Have you a table on which I can place my palette while I am explaining the process?'

Now, he noted, she was deciding to use her charm again.

'Indeed I have.' Unwillingly he found himself noting the small pretty mole on the right side of her nose, the blue clarity of the determination in her eyes, the light flare of pink in her cheeks.

'Is there anything else that you need?'

'Not on this occasion, thank you, Mr Opie. I think that other than the table we are fully prepared.'

All around there was a sense of the momentum picking up. Soon the sounds of horses' hooves and carriage wheels were heralding the arrival of the artists. Opie's housekeeper had an appointment to go and have porcelain dentures fitted that day. She knew that Opie needed help with showing the artists in and out of the house, so she had offered her fourteen-year-old brother to help. Opie realised, too late, that the boy could not repeat the names he had to announce without mangling them. As Smirke, Stothard and Farington arrived, they were translated into 'Firke, Bathard and Storrington'. 'Hoppner' became 'Hopper', and 'Rigaud' and 'Westall', 'Wigall and Westor',

with considerable uncertainty on the last syllable. Smirke's eyes looked as if they were about to fall out and roll down his cheeks, he was so amused. Yet the general mood was ebullient, and the absurdity of the situation merely added to the sense of gathering excitement.

At last the entire company had arrived. Opie motioned to the artists to take their places in the semi-circle of chairs arranged round Ann Jemima sitting in her long smock at the easel. For a second before her lesson began there was absolute stillness in the room. Sitting at one end of the semi-circle, Opie could see the artists' different expressions, some guarded, some openly expectant – a room of sophisticates waiting to be transformed to believers. A friend at the Royal Society had once shown him insects preserved in amber, their bodies perfect, but their motions frozen forever in the golden glaze. If the translucent sap were to fill the room at this very moment, he thought to himself wryly, most of us would die happy.

She looks out at her audience. For a moment she sees the men in front of her as if they are figures in a painting. All eyes fixed on her. A sense of unreality. When Provis came to her and told her that West was openly praising the method, she had felt the years of other people's doubts fall away as if they had been a great weight. In this room, she thinks, we are all brought here by the same desire. Desire has created hope, and hope is never stronger or more vulnerable than at the point when it may be converted to truth.

With a catch in her throat, she finds herself thinking of Septimus Green. In this fleeting memory it is her fourteenth birthday, and rather than being so distracted that he hardly notices her, he is smiling at her excitement at what is about to happen. A science experiment has been set up as an entertainment for her on the kitchen table. There is a transparent glass vessel in front of them, sealed by a cork, and it contains a red powder. A glass tube leads from it to another glass vessel, which is partly submerged upside-down in

water. He is holding a lit spirit lamp, and as he brings the flame to the bottom of the vessel containing the red powder, the powder starts to blacken and a thin vapour spreads up the tube.

'Desire is like a flame that converts one substance to another.' The sentence flickers briefly in and out of her head, but she pays little heed to it. In front of her the room full of men, waiting for the transformation to happen. Waiting for her to apply paint to the canvas and demonstrate the technique that will allow them both to resurrect the ghost of Titian and look to the future.

She picks up the palate and paintbrush and looks at the canvas. The memory comes to the front of her mind more strongly now – as her painting master holds the spirit lamp to the first glass vessel bubbles start to appear in the water, rising up into the second vessel. In the first vessel dark grey specks begin to spatter against the glass, becoming more and more metallic in hue until a tiny silver ball appears. The bubbles rise faster and faster.

'What is the powder called?' she asks, staring at the silver ball.

'It is mercury calx,' he replies. 'It can be used in paint. The silver is mercury. But for many years, nobody knew what gas was produced.'

Now he withdraws the spirit lamp from the bottom of the glass vessel. He takes a wooden splint and hands it to Ann Jemima so she can light it with the flame. She holds it for a few moments.

'Now blow it out – gently,' he says.

She purses her lips. The flame is extinguished, but the splint still glows. He takes the second vessel from the water, and invites her to place the splint inside it. The flame reignites, and they look at each other with triumph.

'The gas is oxygen,' he says. 'It sustains all human life.'

And still the men are waiting.

Now there is another memory.

'When does a painting come alive?'

West is talking to her.

'When is the moment of transformation – when does it cease to be lines and colours, and start to live and breathe?'

She says nothing.

'Do you think that is something the manuscript reveals?'

She realises what he is trying to say, and nods cautiously. 'It shows how Titian's colour is transformative,' she replies. 'You see how he could trap movement in a still image, give a sense of past and future where we can only see the present.'

'I had a friend, Benjamin Franklin,' he says. 'He conducted experiments to catch lightning from the sky. In the past, when I've tried to look for the life contained within Titian's colouring, I've felt as if I'm engaged in the same impossible pursuit.'

'It is the impossible that tantalises you, is it not?' she declares, with a sudden jolt of recognition.

He smiles broadly – it is as if a screen has suddenly fallen away from who he is. 'What kind of life can we have if we do not push at the edges of what has already been achieved?'

Opie saw Ann Jemima pause for a moment before she began to talk. The look of intense concentration on her face. She was quiet for longer than he expected as she started to mix the paint on her palette, and he worried that she was too scared to speak. He felt the tension build in the room.

When she finally began to talk, her words came out a little fast and loud. He saw her chide herself, placing her hands firmly on her knees to stop them shaking.

'When Michelangelo first saw a painting by Titian,' she said, 'he declared how regretful it was that Titian had learnt to paint in Venice, since it meant he had not been taught how to draw,' she began.

Some of the men laughed.

'Yet Titian was disdainful of perfect draughtsmanship. Like many Venetian painters, he believed that creating strong outlines was untrue to what he observed in the world around him. It was through the shadowing and blending of colour that objects took on their reality.'

She took a sip of the tea that had been brought for her.

Opie began to feel anxious. Her youth is greater than we have all given her credit for – I trust she is not overwhelmed by this, he thought to himself.

'In Venice,' Ann Jemima continued more steadily, 'he could choose colours imported from all over the world. Lapis lazuli from Badakhshan. Malachite from Hungary. Realgar from Bohemia. Cochineal from India. Earth colours from Umbria and Siena.' She walked over to the table where some of the jars of paint powder were standing. She picked up a jar of Crimson Lake, her fingers thin and pale against it. 'Getting precisely the right colour became an obsession for him. When his patron Emperor Charles V rode out into battle, he did so to blaze the glory of the Catholic Church. When Titian was painting Charles, he wanted to use the most beautiful and intense red possible to convey this. He was in Bavaria, but sent a courier three hundred and sixty five miles across Europe to Venice just to obtain him half a pound of Crimson Lake.'

Opie looked around the faces of the gathered artists. So far she was telling them little that they did not know. Yet there was a quietly growing sense of how impressed the company was at Ann Jemima's mastery of information. Farington's eyes had a lizard's glaze, it seemed that he was hardly daring to blink for fear of missing a word. Westall's acute concentration was marked by a watchful smile.

Ann Jemima took some lead white paint and started to apply it to the prepared canvas. Opie leaned forward. In contrast to the slight nervousness of her speech, her movements were deft and well executed. Yes indeed, she has talent, he found himself thinking. He noted that her hands had stopped shaking. As her paintbrush moved across the canvas, the shape of a young man's head quickly began to emerge.

'You never knew who you were going to encounter in Titian's studio,' she said after a few minutes. She frowned slightly as she stood back and scrutinised the canvas. Most of my pupils would be happy to have produced a silhouette that was half as good, Opie thought. This girl places high demands on herself.

'Aristocrats, writers, politicians, harlots,' she continued, turning back to her audience. 'All became equal before him. Any of them

could appear on his canvas, the harlots raised to goddess status, the aristocrats revealed as humble men.' The look in her eye became intent. 'Titian understood that it is not where you come from that makes you, but the way you respond to life.' Opie frowned, he could suddenly hear the barely suppressed anger in her voice. 'He saw the humanity in everyone…' here she paused for a moment before looking down and reasserting herself.

The words are in her script, but the emotions they have inspired are not, he reflected. He glanced over towards Thomas Provis, who was at the other end of the semi-circle of chairs. He found it striking now, and later even more of note, that he seemed to be the most fascinated pupil in the room. The contentment shimmered off him. Unlike everyone else, he was gazing not at the canvas but at Ann Jemima, nodding his head every time she spoke. Opie fought the desire to grab a sketchpad and draw him. He noted the tuber-like nose, the mottled skin, so unlike his daughter's features. Again he wondered about her dead mother. That is obviously where the beauty came from, he thought to himself.

He forced himself to focus again. The first canvas was removed from Ann Jemima's easel, and was replaced with one where the lead white paint had dried. Deftly she added the light and dark shadows in the face. Then this canvas in its turn was removed and replaced by a painting where the shadows also had dried, and all that was left was for her to glaze. 'Colour comes from reflection and refraction,' she said. 'Titian would constantly adapt an image as he was working on it. But he would also build that sense of shifting light into the painting by using layer upon layer of transparent glazes over the opaque body colour, scumbling in order to soften the effect.'

As she talked, she applied and blended Dutch pink and brown pink with dabs of crimson lake. Again Opie was struck by her ability. Slowly he gained a sense of blood flowing beneath the skin of the anonymous young man being depicted, the feel of the slightly coarser skin on the cheeks and oiliness on the nose. There is that movement of emotion on the face that I noted in the Venus and Cupid, he recognised with a start. West lied when he said he

repainted it – it was her work. Farington and Smirke must be having the same thoughts. He looked up towards them to see if there was any acknowledgement. But Farington was now writing frenziedly, while Smirke stared transfixed at the canvas.

His eye now fell on Stothard. The expression on his face was one of furtive lust. So he is won already, thought Opie, regardless of what he thinks the method's merits are.

He looked back to Ann Jemima. I can see clearly that any of us could use the same combination of colours, he reflected, and yet not achieve the same effect. It is about her brushwork, about a certain instinct. The greatest aspect of painting is the moment when it goes beyond rational explanation. She has something that no one here can buy. I wonder if even she fully comprehends it.

He was fascinated to see how the other artists would react when the session had ended. Would any be openly hostile? Might others be politely dismissive? He had made up his mind to lead the applause, just to make sure that Miss Provis was not discomfited, but when she finally put her palette and brush down, he was surprised to find himself eclipsed by the eruption of delight from the other artists in the room.

Farington's notebook fell to the floor in his distraction.

'As we all knew, this is a discovery of great importance,' he declared loudly. 'Well done, my dear, you have demonstrated it beautifully.'

Westall came up next to Opie. 'I shall not sleep tonight, I am so excited. It is so subtle, and yet so profound. What is your opinion of it?'

He looked straight at Opie, his face alight. Then he frowned slightly as he saw Opie's own expression, and started to laugh.

'We have a doubter in our midst?'

'No, no.' Opie shook his head. 'I am not a doubter.' He coughed. 'I believe I have seen something amazing, but I am not sure it is Titian.'

Rigaud overheard him as he joined them. 'You are an oaf, sir,' he declared belligerently. He took a silk handkerchief folded into a square and wiped the sweat from his forehead. 'I should not be

surprised you do not comprehend it, it is clearly suitable only for refined sensibilities.'

Opie decided it was best not to reply. He went over to Ann Jemima and her father, who were now with Hoppner and Farington.

'Mr Opie.' The sheen in her eyes was that of the victor. 'I must thank you.'

'It is no trouble at all,' he said, unable to stop himself smiling as she grasped his hands and looked at him. 'It is we who must thank an artist of such talent as yourself.'

She caught his choice of words straight away.

'What was your verdict on the method?' she asked quickly.

'I was very impressed by your painting,' he replied, lifting the enthusiasm in his voice. 'You are aware that Angelica Kauffman, one of the first female members of the Academy, will be visiting London from Europe next month. I can arrange an introduction if you would like.'

He looks directly at her.

'You cannot deceive me,' Ann Jemima said smiling archly. 'I can see you need further proof that the method itself works. Mr West was of the same opinion as you to begin with, yet he eventually changed his mind. It is most kind of you to offer the introduction, and I would be glad to accept your offer. Maybe I can talk to her of the method.'

She looked intently at him.

'You are dangerously perceptive,' he said, charmed despite himself.

'You will be my ally in this, will you not, Mr Opie?'

He bowed.

'Of course, Miss Provis. Please do not imagine I could be anything else.'

The events of the last week flipped and whirled in his head.

'You are a most fascinating woman,' he found himself saying.

She smiled. And so I am considered won, he thought.

Josiah Darton travels to the West Country

'Let's talk of graves, of worms, and epitaphs;
Make dust our paper, and with rainy eyes,
Write sorrow on the bosom of the earth...'

William Shakespeare,
Richard II, **Act 3, Scene 2**

Darton left London before the news of West's confession broke. He arose in the dark at six in the morning after the dinner at Johnson's. The cold felt brutal. He had to break ice in the pitcher before pouring the water into a bowl to take a wash. Then he tipped out into the jaws of the morning to take the seven o'clock stagecoach to Weymouth.

From the window so many fragmented impressions. London's dirt – tyrannical, colonising every detail of life – gradually yielded to the sodden blacks and browns of the January countryside. As the coach gathered pace, Darton became hypnotised by the long stretches of fields and hedges interspersed by sporadic outbreaks of small houses and churches, islands of snow on the shivering grass, and chimneys fluting smoke into a white sky. When the evening drew in, it was possible to spot rabbits leaping around

huddles of livestock. For the first time in months, London felt like a dream.

It was too dark to see the city of Weymouth properly when he arrived that night. It was the other senses that informed him: the clacking of the horses' hooves faintly echoed by the surrounding buildings; the sensation of frosty air scraping against the skin as he climbed out of the coach; the smell of singed meat surging from a nearby kitchen. His instinct after a day of being confined in a small darkened space was to head for light, food and conversation. He deposited his bags at the Golden Lion Inn, and then made his way to the Royal Assembly Rooms. He could hear the place in his mind before he walked in the doors – the leisurely clicking of the billiard balls, the gentle percussion of glasses, the soft rumble of low laughter. Many officers of the Navy were there to play billiards, and he made it his business to talk to them. Whisky proved the alchemist he sought to transmute idle conversation into useful indiscretions on the sailors' part. Many of them were disillusioned – dissatisfied with their pay, and contemptuous of Pitt's foreign policy. Five glasses later Darton was unconvinced that the Navy was any more prepared for a second French invasion than it had been for the first a month beforehand. Then a bottle of rum was introduced, and one of the sailors offered to teach him an Italian card game, briscola, that he had never played before. The next he knew it was four o'clock.

The image of Opie's outraged face danced and swayed in his head when he eventually fell into bed. Quickly it was supplanted by the memory of Ann Jemima walking like a ghost across St James's Palace. Mrs Tullett's words, 'You can never account for the way people might perceive something,' kept running through his mind. He groaned and rolled over to try to get into a comfortable position for sleep. London is full of trouble for those who seek it out, was among his last thoughts. Sometimes the craftiest of us find ourselves in quicksand.

He awoke the next morning feeling as if a herd of cows had trampled across his body. He was uncomfortably aware of every movement – the blinking of eyes in an aching head, the swallowing accompanied by a faint sense of bile, the stiffness in his arms and

legs. It was more than an hour before he managed to rise, and an hour beyond that before he could gather himself together to hire a horse to ride to Yarlington.

He almost threw up as he mounted the horse. But once he was on the road, even beneath the black clouds of hangover, he realised the countryside around him was beautiful, almost an antidote to his physical discomfort. He remembered once hearing Provis say that King Arthur had supposedly had his castle near to the village where he had lived. Wreaths of mist round skeletal dark trees gave the landscape a mythical quality. In his distorted state of mind, if it had suddenly revealed a witch he would not have been greatly surprised.

He arrived at Yarlington shortly after lunch. By now he knew what any other individual could have told him – he was in no fit state to ride on to Bristol that day. A small inn built in mustard-yellow stone seemed to offer suitable sanctuary. He deposited his battered travel bag with its owner. Since cold fresh air still seemed to be what his body most desired, he then went for a ride round the neighbourhood.

His horse took him past thatched and stone-roofed cottages to the outskirts of the village, where there was a large stately home in soft red brick that appeared to have been built only recently. The cedar trees he could see on the edge of its grounds were gawkily immature, while the gardens were still in the process of being tamed. The main house would not even have been here when Provis had lived in Yarlington, Darton thought. But Ann Jemima would have been a small child when it was being built. Right now it was as if the house were hibernating. There were no people to be seen in either the gardens or at the windows. Around the cedar trees, snowdrops dipped their heads while dark flowerbeds gave little sign of the life unfurling beneath.

Darton guided the horse's nose back towards the centre of the village, letting it trot till they were going past the old Norman church of St Mary's. Unlike the stately home, there was a sense that the church was at one with the landscape. He could almost imagine it having roots instead of foundations, reaching long gnarled fingers towards the centre of the earth.

Just outside the church, he could see a young man standing with his head bowed in front of a grave. He waited on his horse until the man's prayers were finished. The man was startled at first when he turned to see him. Darton apologised. He asked him if he had heard of the Provises. The man said he knew the name, but further questioning made it clear his recollections were of an old woman, now dead – who Darton assumed to be Provis's mother. When Darton asked if he knew Thomas or Ann Jemima, he said he did not. He explained he had been working in Bath these last four years and was not close to many in the village beyond his own family.

With a faint sense of defeat Darton returned to the inn. He took bread, pickled oysters and water for his lunch, then retired upstairs, overcome by weariness. When he awoke a few hours later his hangover had gone and his thirst returned.

The evening around him was soft, muted. Against the quiet, his footsteps rapped like carthorse hooves on the stairs. Two old men sat at a table by the window. At lunch a stern woman with pepper and salt hair had served him. Now a young girl worked behind the bar. She regarded him knowingly as he walked across the wooden floor and ordered a tankard of Somerset Cider, before positioning himself warily on a barstool.

'Where do you hail from?' she asked. She had pale red hair, and a face that was attractive, not least because of its direct unbashful gaze. He thought, with approval, that she would never have graced an illustrated pamphlet on conventional female beauty.

'I rode from Weymouth this morning,' he replied, sensing the inadequacy of his response. 'Before that I was in London.' He surveyed the cider she had just poured as if unsure whether it were friend or foe. She snorted. 'I see it was not the waters you were taking at Weymouth.'

He grimaced. 'It was the firewater. God have mercy on my soul.'

One of the old men sitting behind him walked up to the bar.

'I'll drink to that.' His white hair was sparse, his eyes gleamed darkly from raisin skin. Behind him, his companion sat silent.

As the barmaid refilled the old man's tankard, Darton took a sip of cider.

He looked over to the barmaid again.

'What brings you to Yarlington?' she asked.

He felt her desire to be relieved from boredom as if it were an undercurrent in a river threatening to tug his feet off the ground.

'I take it you do not have many visitors here,' he threw back at her.

She shrugged.

'We've had more since the large house was built,' she replied.

The old man raised a finger in the air. 'Last summer we had two poets, Wordsworth and Coleridge pass through,' he rasped. 'They were on their way to the Quantocks.'

Darton forebore from commenting. He could still remember an evening spent with Wordsworth some years beforehand where the poet had told him about John Stewart, a man who had walked from India to Europe. To Wordsworth the man was a visionary. For that one evening Darton too had felt the fire of a mind that had witnessed humanity in remote mountainscapes and turbulent cities, and had felt compelled to seek a truth that addressed society's ills through the miracle of nature.

The old man's memories were less exalted.

'They certainly supped their fill of the cider, did they not, Miss Lydia?'

'Indeed they did, Ozias,' she replied dismissively. 'They supped their fill, and then they vomited it all out again. After their visit we shall not be welcoming poets again. I take it you are not one?'

Her gaze was now stern. Darton took another sip of cider.

'Being a poet is not one of my sins,' he replied drily.

The girl walked over to the other side of the bar, and began to polish some of the tankards. He watched her for a while. This inn is her parish, and she knows well that no matter how long he bides his time, each man will eventually make his confession, he thought.

'Did you grow up here?' he finally asked.

'I did.'

She was clearly older than Ann Jemima, but only by a whisper, he thought.

'May I ask your age?'

She waited a moment to answer him, polishing the tankard vigorously before holding it up to the light.

'I am twenty,' she finally replied.

'Did your family ever know a man called Thomas Provis?' Darton said.

She frowned.

'I remember a Mary Provis very well, but not a Thomas Provis.'

Finally the second old man spoke.

'I remember Thomas Provis.' He winced, as if the memory had given him a physical pain. 'It was a tragedy, what happened to his family. I wasn't surprised he left here. Couldn't live with the ghosts.'

Darton swung round on his stool. He could feel his heart starting to beat faster.

'I am a close friend of his. It is clear to all those who know him that he has suffered,' he said.

The man nodded solemnly. A prominent chin jutted from his thin face, while his white hair came down to his collar.

'His wife was a good 'un.'

The judgement was delivered in a monotone.

The girl laughed quietly, now polishing the bar. 'George either describes people as good or bad 'uns.'

'It is a useful enough distinction,' said Darton. He paused for a moment. 'Mr Provis never said how she died.'

The girl looked sharply at the two old men, and back at him.

'Why are you here asking about your friend?' she asked suddenly. 'In truth it is a long way to travel here from London. What is your business here? Is he in trouble?'

Darton had been expecting this.

'Not at all,' he replied.

He was aware of a shift of atmosphere in the tavern. Six inquisitors' eyes bored into him.

'I was coming in this direction because of my own affairs. I am travelling to meet my cousin, who is a riding-officer,' he said. The half-truth slipped out easily.

'One of the men who patrols the coast?' asked Ozias.

Darton nodded.

'Looking for smugglers and the like? 'Tis a hard job.'

'It is indeed,' said Darton dismissively, anxious for the conversation not to be entirely diverted.

'Was there something suspicious about how she died?'

He was not quite sure exactly what made him ask the question, but Ozias sat up straight.

'Never let anyone tell you he killed her.'

Darton suddenly felt a shiver course through him.

'Why would they say that?'

'It was a terrible accident.'

'An accident?' He looked swiftly between the three of them.

'That is precisely what it was.' Ozias started to become hostile. 'The inquest confirmed it beyond a doubt. Those who whispered otherwise did not see what happened.'

Thoughts raced through Darton's head.

'The man I know is not a murderer,' he finally said. But he did not know what to think. He had not expected the conversation to take this turn at all.

'He was trying to save a life,' George declared mournfully.

'His little girl ran out in front of the horse his wife was riding,' said Ozias. 'The horse started to play up, Mr Provis dashed to get the little girl, and then the horse reared. His wife fell off.' Tears were starting to redden his eyes – he grabbed a coarse cotton hanky, and wiped his nose. 'She died straight away. Broken neck. Some had the audacity to say that he had caused the accident on purpose.'

The words fell like blows on Darton's ears. In the silence that followed, his heart wept for his friend, for his loss, for all the years he had felt forced to keep quiet. Is this the cause of Cosway's blackmail? he wondered.

'Was the little girl his daughter Ann Jemima?' he eventually asked.

Ozias sighed.

'It was.'

'We all wondered why it was only three years ago, when she came to live with him in London, that anyone knew he had a family at all. Now it is all too clear.'

George's eyes became dim, confused, as if he had been posed some impossible riddle.

'Did you know her?' Darton asked Lydia.

The atmosphere became charged with something he didn't understand.

George and Ozias looked at each other uncomprehendingly. Finally George cleared his throat. 'What has Thomas Provis told you?' he asked falteringly.

'In truth, very little. I know her just enough to know she is charming and highly accomplished.'

George banged his tankard on the table. Cider frothed out impatiently.

'It is impossible that you have met Ann Jemima Provis!'

Darton looked at Ozias, who also looked shocked. 'Why is it impossible?' he replied in consternation. 'Where do you believe she is?'

'The question is not what I believe,' said George slowly, almost angrily. 'The question is what I know.'

Lydia held up her hand.

'George, be calm!' she cried, though her own expression was filled with horror. 'What enrages you so?' She looked towards Ozias. 'Is he altogether well? Do you know of what he speaks?'

Ozias nodded sombrely, while looking towards Darton. 'I know precisely of what he speaks.'

Darton's mind was running through dark fields – he could sense the speed at which he was travelling, but had no sense as yet of his destination.

George began to mutter, then he stood up. 'I think you should accompany me,' he said. 'It is probably best for you to read the truth. I cannot tell what knavery is being practised in London, but...' His words trailed off.

He nodded towards Ozias. 'You stay here and keep Lydia company.' His breathing was slightly laboured. 'I will show our visitor. Can I trouble you for a lamp?'

She too was trying to take measure of the situation – her eyes darted back and forth between the three men. She went and fetched

a lamp from the back of the tavern and gave it to George, who took it with his right hand, while placing his left hand briefly on her arm.

'There is no easy way to tell this story. He must see the truth for itself.'

He gestured to Darton to follow him. As if caught up in a nightmare, he put on his cape and followed George outside the pub. Cloud hung like cobwebs around the moon – the rest of the landscape was swept with black paint. It was so quiet Darton almost fancied he could hear the sky breathing.

'Where are you taking me?' he asked. 'Why this mystery?'

'Be patient, man,' came the answer. 'You will discover soon enough.'

Darton's first instinct was to check the stars – though few could be seen, he could distinguish the Great Bear and the Little Bear in the sky. A long thin creature scudded out onto the track in front of him, then was gone into the bushes. George looked behind him.

'Stoat,' he muttered.

Darton felt under his cape. He had no intention of using the small sword concealed beneath it, but his fingers groped to feel the metal in its leather sheath, and were reassured to find it there.

Now he realised they were turning off into St Mary's churchyard. The square Norman tower stood solemn in the darkness.

His frame is slight, it is his determination that carries him, thought Darton as George teetered resolutely through the graveyard. First he went to the row of tombstones next to the church, but what he wanted was not there. Then he went to the next row. Darton could see his entire silhouette lit by his lamp as he carefully read the names on the graves. He looked around him – watched the other graves extending into the distance. As a sudden breeze set the trees dancing around the edge of the churchyard, an exclamation from George in the dark indicated he had found what he was looking for.

'Come over here,' he cried. 'Come and read for yourself.'

Darton went over. He looked at the letters on the grave as the candlelight leapt and flared. He shook his head. Then putting his hands on the ground he crouched down to read them closer.

'This is impossible,' he finally said.

'It is the truth,' said George.

'It cannot be so.'

'It cannot be any other way.'

Darton looked again. Reached out to touch the letters carved into the stone with a hammer and chisel.

'Ann Jemima Provis, daughter of Thomas and Belinda Provis. Taken to our Lord aged two years,' he read out.

'She died fifteen years ago,' said George. 'It was a tragedy. Thomas Provis had risked everything to save her. And then she died six months later of scarlet fever.'

Darton looked back at the inscription.

'She would have been exactly the same age as the girl I know.'

'But she is not the girl you know.'

'So if it is the real Ann Jemima Provis who lies here, who is the girl who is living in London?'

He tipped his head back and looked at the moon. He felt as if the past were a jigsaw puzzle, and some malevolent child had just kicked the pieces everywhere.

He took a deep breath and looked at George.

'How strange the human heart is,' he continued. 'Provis lost all he loved. So he has taken revenge on the world by making sure that no one would ever know enough about him to do him harm again.'

George made a small groan as he bent down in the darkness to pick up the lamp.

'What will you do now?'

'I must continue to Bristol tonight. My business there is but brief. If I go there now, I can leave for London by mid-morning tomorrow.'

'What will you say to Provis?'

'I do not know. I love the man like a brother. Right now I cannot see how to start this conversation.'

A barn owl carved through the air in front of them.

Darton felt in the pocket of his breeches. 'Please take this small purse as a sign of my gratitude for your help.'

'Keep your money.' The words sat heavy in the bitter air. 'It has been no pleasure to enlighten you.'

CHAPTER TWENTY-THREE

Benjamin West is forgiven

'How many with great abilities, and fine genius in design, have fought for the attainment of knowing the Mechanic of Colours, yet have ever been in the dark, 'tis much to be regretted that an early help has not been at hand, that the utmost time might be given to the more material and scientific studies, as the longest life is too short for the acquisition of perfection in all.'

William Williams,
An Essay on the Mechanic of Oil Colours, 1787

Does the air seem different to a man who, once condemned, has now been acquitted of his crimes? Certainly, thought Benjamin West, it felt easier to breathe these days.

He recalls once more the moment when the letter arrived at his house. He had quickly recognised it to be in Thomas Provis's hand, and had recoiled when it was handed to him.

He did not read it for a couple of hours. When he eventually opened the letter, he could feel his mouth was dry, and he cursed to himself. Then his eyes fell on a sentence that contained the phrase 'a great misunderstanding'. He skimmed the letter further, and saw the word, 'generosity'. Trembling, he went back to the top of the letter to read it properly. 'We had never meant such enmity to spring up between us,' it declared. 'We wish to convey our joy at the discovery

that it was all a great misunderstanding. That you chose to make this clear to Mr Cosway is yet another example of the generosity that we had observed in your behaviour from our first meeting. We are profoundly happy at this resolution of the situation.'

West remembered once in Pennsylvania being caught up in a storm on a lake. The sky had seemed entirely clear when he had set out in his boat. But within ten minutes of the first warning breeze, the waters were agitated, the clouds loomed like black rocks, and lightning was spearing the water. He had felt lucky to reach the shore alive. It had been the same when he heard from Cosway that the Provises were accusing him of concealing their secret from the Academy. Up till that point he had persuaded himself that his conduct had been essentially honest, and that in time he would acknowledge the Provises. But once the scandal had struck, even he was forced to confront the reality that his refusal to inform Ann Jemima the moment he decided the method was authentic was, from whatever angle you considered it, reprehensible.

'I would not have been worthy of my position as President if I had raised the other artists' hopes about the secret without performing a full range of experiments,' he found himself saying to Cosway. In that moment he almost believed it. 'The method is not perfect on its own.' How he hated the man. Like so many men who were fundamentally weak, Cosway revelled in pretending he was doing his superior a service at the same time as he clearly enjoyed his discomfort.

The portraitist spared no detail in telling West of the outrage of the other Academy artists. He looked coolly at West every time he repeated the accusation that he intended to keep the secret to himself purely to gain an advantage for the Royal Academy Exhibition. How West damned the Provises' argument at the same time as he was angrily forced to concede its ingenuity. No one, he kept repeating to himself, no one who had not seen the secret could realise how much work he had to do on his own in order to make it effective. Did I simply desire an advantage over the other artists, he was on occasion forced to ask himself? I was caught up in my obsession – what crime was that?

He recalled when he had first heard about Mariotte's blind spot.

As a boy it had delighted him to carry out the experiment in which he drew a dot and a cross on a piece of paper, between six to eight inches apart. He would cover his right eye with his right hand. Then he would stare at the cross with his left eye. Gradually he would lean closer and closer to the paper until the magical moment when the dot disappeared entirely.

'Was that the case here?' he asked himself at one point. He thought back to the painting of the Venus and Cupid. 'Did my vanity mean that I could not see that what she created when I was out of the room she created without my help?' He put his head in his hands. 'I have been a foolish old man.'

He tried to tell Cosway that as President of the Royal Academy it was his job to be at the forefront of any such discoveries. That he would be doing Ann Jemima and everyone else a favour by creating works of art on his own that, with this new knowledge, would outshine everyone else's. That once he had been heralded a success by the critics, he would be able to give a series of lectures explaining his methods to the other artists.

Yet spoken out loud, such noble sentiments seemed revealed for the shabby dreams they were. 'What should I do?' he had said to Cosway. He detested himself but detested Cosway even more for his feeling of helplessness. He found himself thinking, if it were not for Cosway I would not even be caught up in this mess. It was he who decided to introduce me to the Provises in the first place. The swell of anger he felt at this point was irrational, and he recognised that. He managed not to punch Cosway as he replied calmly, 'I think this can all easily be resolved.'

'Easily?' West replied with some astonishment.

Cosway nodded. 'I think all the Provises ever wanted from you was acknowledgement they should be paid. If you had not ignored them repeatedly when they approached you, things would never have come to this pass.'

West's head felt like a metal pot – in it, his fury started to steam. He had wanted to say to Cosway, 'You yourself declared it was ridiculous that a man like Provis should have come by such a document. You yourself averred that without me they could never have

proved the document's authenticity.' But where Cosway had been all flattery when he had first approached West about the matter, now he regarded him with sour disappointment.

'Miss Provis particularly felt that she had achieved some kind of friendship with you. I think hers is the anger of someone who placed a great deal of affection and trust in you, and felt that both were trodden underfoot.'

His tone was never anything less than polite. Cosway would never be vulgar enough to make a direct accusation – it was all about insinuation, nuance. 'Because of your secrecy about the reason for Miss Provis's visits, she suffered even more than she had anticipated,' he continued. 'There were certain servants who witnessed her comings and goings, who drew unseemly conclusions.' The eye contact was momentary, the voice velvety with impudence.

West leapt from his chair. 'They thought that we were... that I was...?'

The words guttered out as he paced backwards and forwards. 'Dear me,' he started up again, 'that I would stoop to...'

He looked at Cosway, who nodded gravely. Damn you again, West thought to himself, damn you. Truly we have reached the heights of absurdity. That you, who are renowned for your flirtations, should be in a position to accuse me.

'She has, I trust, confirmed to you that there was nothing improper going on,' he said. He felt the potential of the ground to disintegrate beneath his feet even as he issued the statement. Cosway was silent. 'That is one impropriety, I hope, of which I have not been accused,' continued West. Eventually Cosway replied,

'No, of course. She is emphatic that your behaviour on that score has been without reproach.'

Again, the gentle emphasis on the words 'on that score'. West flinched even as he felt relief.

The idea that he should write the letter explaining his conduct had been Farington and Smirke's. There had been something cathartic about the process, he had to admit, as if the written words had acted as fastening pins for the reality that for several days had seemed to shift before him. He had slept easily that night for the

first time since the accusations had been made. And the result was most unexpected. To his surprise, two days later came the written acknowledgement from the Provises that they accepted his version of events. So Cosway, West thought, regarding him more favourably now, had been right. The Provises' attack had been motivated by hurt rather than cunning.

A week later Thomas Provis left his visiting card. That afternoon Provis and Ann Jemima were shown into West's drawing room, just as they had been two years beforehand. West wondered if they were going to show any anger despite their supposed absolution of what he had done. But Ann Jemima in particular appeared friendly, deferential, even regretful of what had happened. West congratulated them, and thanked them for their charity. Yet the human heart is complex, and even as the pleasantries were exchanged between them, West felt as numb as a plank of wood. He realised that despite his relief, he had been stripped of any capacity for expression following the accusations. When the door finally closed behind them, he realised he would be quite happy if he never saw them again.

'February 2, 1797 *Newman Street, London*
 'William, my dearest brother,'

He sits once more at the desk in his study. Outside the day is painted in greys – a cold drizzle washes through the streets and gutters.

'I trust this finds you in good Health. Since we last corresponded, I fear to say that I have been thru' the greatest upset of my Presidency, and know not if the Repercusions are yet over. I have written to you twice now of the girl Ann Jemima and the method she did bring me. After what seemed a most Excelent and fruitful exchange on art and the subject of Titian, I was considering what recompence I should give her for it. But while I prevaricated she and her Father did approach several members of the Academy and accuse me of theft.'

He thrusts the quill in its holder and puts his head in his hands.

'Theft?' he says to himself. 'As if I were some vulgar pickpocket, or some petty house burglar. My reputation marched to Newgate gaol. It is a travesty.'

'As you know,' he continues, 'such an accusation should instantly have been seen as Risible. But to my horror I realised many members of the Academy were convinc'd. Thus I was forc'd into declaring that the method itself was of Significant merit, regardless of my contribution, and that I had been wrong to withhold it from the other Artists.

'Personally I Suspect'd that the accusation was that of the father and not of the girl. Its vulgarity and distorsion Seem'd out of keeping with her character. I sought to explain that it was my intention all along to present it to the Academy and acknowlege the Provises' part in it at a time of my Chewsing. Thankfully the girl's honesty and Perspicacitie did prevail. The Provises did agree that what had happened was down to a misunderstanding, rather than any crime on my part. After letters had been written on both sides, I was Absolv'd.'

Wearily he looks up at the painting on his wall that depicts a peace treaty between William Penn and the Lenape Tribe in Pennsylvania. It is a copy of a work he created for Penn's son, Thomas, some years beforehand – at the point, he reflects bitterly, when he was riding high in both England and America following the success of *The Death of General Wolfe*. As requested, he had painted it so that it appeared to show perfect harmony between the Europeans and the natives of America. He had received much praise for it, but in his uneasy state of mind it strikes him with force that the painting depicts a lie, that it is a mask for hidden tensions that would play themselves out for decades.

He starts to write again.

'What has transpired since has, I believe, vindicated me further. Ann Jemima did perform a Demonstrasion of the

method to the artists, and several of them have now try'd it. Reports are now reaching me that a Number of them are unable to make it work. There is a young prodigy at the Academy called Thomas Lawrence. His Arroganse knows no bounds, and we have suffer'd Disagreements on a number of occasions. However, yesterday he came to me after taking a Lesson in the method with the two Provises. He told me he felt as if he had surendered his Paintbrush to two fools who knew much less than he did. In no small ironie, I did find myself defending the Provises. Yet he is now firmly resolv'd that it is Folly on the part of the other artists to credit them.

'Mr Farington, most Insidi'ous individual that he is, is I should confess, having a little more success. Yet in truth, I have never had a great Admiration for his art – he is as cautious and calculating on the canvas as he is in Politicks. While his experiments with the method are no cause for embarrassment, there is equally Nothing that announces him to be the next Titian. Increasingly I believe I was right to delay handing over the sum of money, but I know better now, than to Declare such thoughts out loud.'

For a moment his face looks less weary. A half-smile starts to play on his lips as the quill continues to scratch across the paper.

'No, the best way to acquit myself in Triumph is to enshure that even tho' the Secret has now been shared, it will be I who displays the most impresive painting at the Academy's forth-coming exhibition. Permit me a little Arroganse in this. The question of an apposite subject has taunted me for a while. If I did consult my heart, I would choose to paint my late dear friend Benjamin Franklin, whom I still believe to be the greatest American of our time. Since the method brings together science and art, it strikes me that his experiment to capture Electricyty from the sky would make an excellent subject for a work demonstrating its Merits.

'Yet to my Sorrow it is – once more – a wretched time to celebrate being an American in this cold little ile. After a failed attempt this Christmas last, there are fears in Britain that there will be another invasion led by the French in Collaborasion with Irish Republicans. One of the commanders is said to be a certain American, Colonel William Tate. His family was kill'd by Native Americans who supported the British side in the American War of Independence. Thus he does hate the British.

'I have never met this Colonel William Tate, nor am I Sympathetick to his immediate intentions. But because of him I must once more tread carefully in displaying the pride I have in my home country. Since Mr Franklin's extraordinary Intellekt is considered in many quarters to have played an important part in pushing France towards its Revolution, I am in little doubt that I would invite considerable Opprobrium by creating his likeness.'

He looks out of the window. 'Damn them,' he whispers. 'Damn them all. How often have I had to conceal my thoughts to remain acceptable to those around me? And still they have found a way to condemn me. I detest and loathe them all.'

He composes himself.

'There is something stubbern in me', he writes, 'that cannot altogether Relinquish cherishing the memory of my dear friend. So I plan to do what many opress'd artists have done before now, and reach into history to pay a more Subtil tribute. The painting I plan to create will be set in Sicily, almost a century before the birth of Christ. Imagine if you will the heat of the sun, the darting of lizards, the sounds and smell of the sea. In front of you is the great Cicero, a politician and philosopher whose renown extends across the Roman Empire. He is leading the people of Syracuse to discover a secret that has lain hidden for centuries. That secret? Nothing less than the tomb of Archimedes, who, like my great friend

Mr Franklin, was one of the great scientists and inventors of his time.

'Consider the scene once more, and you may note another Seeries of parallels. Cicero – tho' greater than your humble brother – resembled myself in many Aspekts. He too had raised himself up into public life through the Merits of self-education. He too had been forced to thrive in an environment dominated by civil unrest. He too had striven for moral uprightness in a time of conspiracy and corruption. And at the moment I want to capture in this painting, he was far from home on a small island. Archimedes had been a native of this island, and was probably its greatest son. Yet despite this fact, the natives of Syracuse had neglected his legacy so greatly that his tomb was overgrown, and people by this point had forgotten that it was there at all. What they needed was an outsider to reveal the value of his legacy, just as I am sure the Gentlemen of the Academy, need my insights to unlock this method.'

His foot starts to tap impatiently as he writes. 'Perhaps it is too much,' he mutters. 'Perhaps I exalt myself too greatly.' The expression in his eyes hardens. 'Yet it will be sweet revenge. When they see that I can interpret the method like no other, when they realise that both in the subject I have chosen and in its execution I have had the last laugh…'

He grits his teeth.

'We shall see how this plays at this year's Exhibition. My sentiment is that even if it is Hail'd as a success, I am tempted to Resign my post and return to my beloved America. I have been away too many years now. In the Meenwhile wish me good fortune.

Your brother,

Benjamin.'

The ingenious Miss Provis

'So did the selfe-conceited Megabyzus, when hee was sitting in Zeuxis his shop, presume to prattle something about matters of art, even as if his big lookes and purple coat should have made his unadvised discourses good; but he found himself very much deceived: seeing Zeuxis did not sticke to tell him to his face, that he was both admired & reverenced of all that saw him, as long as he held his peace: whereas now having begun to speake senselesly, hee was laughed at even of the boyes that did grinde colours.'

Franciscus Junius,
The Painting of the Ancients, 1638

The stone hit the window of John Opie's bedroom at six o'clock in the morning. The thwack of it on the glass made him wake with a yelp. A half-chewed dream fled from his head without a murmur. He lunged from the bed and hurtled to see what had awakened him.

In the darkness he could see a dishevelled heap of a man. He flung up the window just as the second stone came and clipped him on the ribs. Opie opened his mouth and bellowed. Even he wasn't sure what the word was: it expressed some incoherent hostility that froze in the darkness before collapsing in splinters.

'Let me in, Opie.'

The dishevelled heap asserted itself. The familiar voice allowed Opie to discern the face cloaked by darkness.

'Darton, you jackanapes. Why are you waking me at this hour?'

'If you leave me on the pavement much longer, I shall freeze to death and be unable to tell you,' came the response. 'Come down and open the door.'

Cursing, Opie lit the lamp by his bed. Every move, both mental and physical, was an effort. He made his way downstairs to the front hallway, holding up the lamp as he slid back the latch and opened the door.

Darton pushed his way past Opie and into the hall.

'Brandy,' he declared.

'Are there not houses of ill-repute which could give you brandy at this time of the morning?' exploded Opie.

'Oh, the brandy is as much for you as it is for myself,' declared Darton, looking at him with a half-smile. 'After what I am about to tell you, you will find yourself in need of it.'

Opie frowned. He gestured sharply upstairs towards the drawing room before rubbing his eyes.

'Tell me not. The French have invaded London and King George's head is already on a stake.'

'No, this is far better.'

Opie walked to the drinks cabinet and got out a bottle of brandy and two glasses.

'Have you slept tonight?'

'Not at all. I arrived back by stage close to midnight, and went straight to my house, but the importance of what I have to tell you refused to let me go to bed. You are lucky that I woke you as late as this.'

Opie frowned as he handed him the glass of brandy.

'What are you talking about? What have you discovered?'

'Your Ann Jemima Provis.' Darton stared at him impudently. 'Your Ann Jemima Provis,' he pointed his finger accusatorily, 'does not exist.'

For a second the thought flashed across Opie's brain that his

friend had contracted syphilis and was now suffering the madness of its last stages.

He looked once more at his dishevelled appearance and the wildness in the eyes.

'Josiah, she does exist,' he replied gently. 'You and I have had a number of encounters with her…'

'No, no, no,' laughed Darton, waving his hand in the air as if to brush away Opie's interpretation. 'I do not mean that the girl we have met does not exist. I mean that her name is not Ann Jemima Provis.'

Opie took a sip of the brandy. Darton's assertion kicked round his head.

'You are telling me that she has an assumed identity?' he said finally. Darton nodded.

'That she is…' he hesitated, frowning, 'not Provis's daughter?'

Over the next few minutes, Darton told him all he had discovered in Somerset. Opie exclaimed at the suffering Provis had undergone.

'Do we think this is the cause of the blackmail? That Cosway has heard it from someone who has not told the story in a way that shows Provis's innocence?'

'At first I thought that must be it too. But Cosway's attack on Ann Jemima shows that he holds both of them to account.'

'And if we now know her not to be his daughter…' Opie had a larger mouthful of brandy, 'it seems more than probable that Cosway does as well.'

The silence that ensued rang around them.

'What does this mean for the manuscript?' Darton eventually asked.

Opie laughed sarcastically.

'Benjamin West wrote a letter to the entire Academy, shortly after you left, saying that he should have acknowledged the Provises. He considers their method to be genuine.'

Darton's eyes widened.

'So Thomas and Ann Jemima Provis stand to make their money. Unless someone ruins it by revealing that Ann Jemima is not who she claims to be.'

They stared at one another for a moment.

'Who do we talk to about this? Opie asked. 'We don't want to smash bottles before we know why we are smashing them.'

'Indeed,' replied Darton. 'I think one individual stands out as holding all the keys in this business.'

He looked hard at Opie.

'Indeed, it is evident. Shall we see him first?'

Darton nodded. 'Let me return home and wash. We shall call on him after breakfast.'

The look on Richard Cosway's face when they were shown into his drawing room was detached, gently amused. Yet the red eyebrows levitated gently as he surveyed their faces.

'Gentlemen, I see you have arrived on a matter of some urgency.' The pale mouth pursed itself in faint amusement.

'Who is she?' Darton's voice punched across the room.

'I'm sorry, my dear Josiah, I do not see the she to whom you are referring.'

'You know precisely of whom I am talking,' said Darton.

Opie could see a faint flare of alarm in Cosway's eyes.

'It would seem Ann Jemima Provis is not precisely who she claims she is,' Opie said more calmly. 'Since it was you, my dear Cosway, who introduced her to West, we thought you might know the truth about her background.'

Cosway essayed a smile.

'This is a curious assertion, gentlemen. Benjamin West himself has confessed that the meth…'

'We are not talking about the method,' interrupted Opie, 'though I suspect what we have discovered discredits that utterly, whatever West may say.'

Now he noticed Cosway's swallow of discomfort. He knows for certain, he thought to himself, but he is trying to work out a way to deny it. Darton had noticed the swallow as well. He looked quickly over to Opie.

'Can you explain to me, Cosway,' he said menacingly, 'why there

is a grave in Somerset with Ann Jemima's name on it?'

It was as if the truth were quicksand, and Cosway had suddenly found himself in it up to the neck.

'There has presumably been more than one Ann Jemima Provis in this world...' he said, but the tone of his voice was somewhat strangulated, even as his words attempted to feign some composure. He cleared his throat. 'Neither our names nor we ourselves are as unique as we imagine ourselves to be...'

'Desist from your mock philosophising, Cosway,' spat Darton. 'I talked to people who knew her father. There is no doubt that it is Thomas Provis's daughter who lies dead there. Who is the woman who has taken her name?'

Cosway shot him a caustic glance. 'There is no reason to be so aggressive, Mr Darton.' Distractedly he rang a bell for a servant. 'May I offer you a drink, gentlemen? Some coffee perhaps?'

Here he looked particularly hard at Darton.

'This is not, as you may have gathered, a social visit,' said Opie.

'Well, there is no harm in playing at dignity,' replied Cosway.

The man is loathsome, Opie thought to himself. As Cosway calmly ordered coffee for all three of them, he planned the next line of attack.

'Did you realise she was not Provis's daughter when you first introduced her to West?' he said, as the servant disappeared to the kitchens.

'I had no idea there was anything amiss...' began Cosway, but Darton interrupted again.

'Why did you attempt to rape her?'

Again Cosway started.

'Do not deny it,' Darton continued. 'She has told me herself.' He knew Cosway was in no position to contest what he said. 'I believe you sustained a nasty wound during the attempt. Since then you have tried to atone for your transgression by approaching Mr West and ensuring that, despite the doubts, the method was successfully sold. Some small compensation for what you made her suffer.'

Cosway bowed his head down for a moment. When he lifted it, he sighed.

'I first met Ann Jemima four years ago at a seamstress's.'

'Which one?' asked Darton sharply.

'Mrs Gage's, in Moor Lane.'

The atmosphere in the room changed.

'Not an establishment that gentlemen visit for the sewing,' said Darton.

'Quite,' said Cosway. 'I suspected you would recognise the reference, Josiah.' His impudence was laconic.

'So it was close to the house in Fournier Street where I found her knocking on the door.'

'I will come to that.' Cosway rolled his eyes. 'I was most surprised that Mrs Gage offered her to me,' he continued. 'She was much too young for my tastes. There is a bishop who visits who apparently has an inclination towards that sort of thing. But though I am not averse to experiment, I like women and not girls.'

Opie and Darton exchanged glances.

'It turned out she had become quite agitated when she heard I was visiting. I was told her grandmother had possessed some miniatures of mine.' His eyes flickered. 'We were shown to a room. Mrs Gage disappeared. I sat there, feeling somewhat disinclined. She was in an absurd dress and bonnet that were meant to make her look more like a woman, but simply emphasised her gawkiness. I was about to hand over my payment and leave, when suddenly she burst into tears and flung herself on my mercy.'

His foot began to tap.

'It transpired she had come to London from Bath following the death of her father and grandmother from smallpox. Her mother died when she was an infant. Her father had been a doctor, and a colleague of his in Spitalfields agreed to take her in as a servant for his wife.' Here he stared at Darton. 'That will have been the house where you found her. She realised quickly his interest in her was more anatomical than philanthropic. He made such goatish advances towards her whenever his wife was out that in the end the girl fled. That night she slept on the street.'

'Who was the girl who came to the door?'

'The family had a daughter, about the same age as Ann Jemima.

It was the first friendship she had when she came to London. Yet of course the friendship could not endure once she had fled. She would have had to explain why living in the house was impossible. The risk of whether her friend would believe her or her father was not one she wished to take.'

Darton was quiet for a moment.

'How was she rescued from her situation by Mrs Gage?' he eventually asked. 'From the cauldron to the bonfire in one fell swoop?'

'She did what many girls from the country do when they find themselves in London without friends or family,' Cosway chided him. 'She went to an intelligence office to find domestic work. When Mrs Gage appeared there, she of course had affected a veneer of respectability so convincing that the girl had no hesitation in going with her. By the time she knew what was happening, it was too late. She was installed, and Mrs Gage had most of her possessions and the little money she had locked safely in a cupboard.'

'What did you say to her?' said Opie swiftly, before Darton could respond.

'I assured her that I would not take advantage of her,' said Cosway.

'At that stage,' muttered Darton. Opie glanced towards him warningly.

'In the last three years she has become a woman,' said Cosway. 'Are we here to gauge my levels of morality against yours, or do you wish to hear her story? Because let me assure you, if we were to play the former game, I am far from sure I would lose.'

Opie opened his mouth to reply angrily, but Darton silenced him with a warning glance.

'I will take that as an indication that I can continue,' said Cosway. 'I did not feel at that point that I could offer her lodgings myself. By chance I was meeting Thomas Provis in a coffee house – he had procured me a small statue I had been looking for for some time. His mother had just died, so I found myself mentioning the girl since she too had been recently orphaned. To my amazement he said he would take her in.'

He shook his head, as if still in disbelief.

'He said he would pretend she was his daughter. It was much

later that I discovered his own daughter had been born in the same year as this girl. At that point I just knew that she had to be abducted fast from Mrs Gage's establishment before someone even less scrupulous than myself decided to ruin her.'

Darton folded his arms. 'So you both rescued her?'

Cosway's eyelids closed and opened rapidly.

'I do not pretend to be a virtuous man. I did wonder about the wisdom of what we had done. I think the sudden experience of fatherhood unnerved Thomas Provis. He found the task of providing her with a new life rather harder than he had anticipated.'

'It does not any more,' declared Opie. His voice quiet and intense.

'No, it is interesting isn't it?' Cosway paused for a moment. 'Grief works in strange ways. In Thomas Provis's case, after concealing his bereavement for years, he has now found something rather better than the ghost of his daughter to love. He has proved most possessive.' His lip curled disdainfully.

There was silence in the room for a moment as the men absorbed what Cosway was saying.

Darton rubbed his forehead, as if to dispel an ache. 'Is she happy to play his daughter?'

'She has clearly thrived. I believe her real father spent most of his time at work, either seeing patients or corresponding with scientific societies. He and her grandmother hired tutors so that she had an education. Her painting tutor, Septimus Green, appears to have had a particularly strong effect. But the doctor himself was not interested in the girl. In a strange way, Thomas Provis may have proved the truer parent.'

'We know now that her name is not Ann Jemima,' said Opie.

'I think her name is for the girl to tell you,' said Cosway. 'We have all known her as Ann Jemima for the last four years. Certainly I intend to carry on referring to her in that way – if you gentlemen will permit.'

Now he stared intently at Opie.

'So what implications does this have for the manuscript?' Opie found himself asking. 'If the girl's identity is counterfeit, then did she inherit it from her family? Or is it stolen?'

'The Venetian Secret is a situation which has,' Cosway coughed, 'spun rather out of control. It was Ann Jemima's conception. As you can imagine, after spending time in a madam's house, she never wanted to find herself in a position where she was financially destitute again. So she herself put together the formula.'

Opie looked incredulously, first to Cosway, then to Darton, then back to Cosway again.

'You are telling me that she wrote the manuscript herself?'

'She,' Cosway coughed, 'had a little help.'

'From?' Opie pointed at Cosway. Cosway looked down for a moment. 'I cannot take a huge amount of credit. I introduced her to various treatises on colour. She is a very clever young woman. Septimus Green was a young friend of her father's. He needed money to pursue his interest in practising science. So the doctor came to an arrangement that he could teach his daughter art. Being Ann Jemima she worked out what his true fascination was, and made it her fascination as well.'

'So the language of formulas was well within her grasp.' Opie shook his head. 'How much of it did she write?'

'It was a little rough when she brought it to me,' Cosway said. 'Some crude elements had to be removed. I helped give it an air of authenticity. But it could never have been what it is without her efforts. Nor, indeed, her ability to paint.'

Opie's laugh came from the pit of his stomach – it became a howl as it reached his throat, and the tears sprang from his eyes.

'And Thomas Provis's merchant grandfather? All invented too?'

'No, he did exist. He traded in Bengal and East India, and then he went to Venice. But all he brought back with him from the latter, I fear, was a case of the clap. No secrets from Titian.'

Darton started whistling. He walked backwards and forwards up and down the room.

'The confidence in her own ability needed to do this… the extraordinary cleverness.' The words trailed away. 'What did you think would happen when she and Provis presented the manuscript to West?' he said, turning to Cosway.

'I was not sure. I thought there was a possibility he would see

through the device and reject it. But equally I thought he may view it as a curiosity, and give her some of the money she asked for. What none of us had anticipated was that he would try and cheat the Provises.'

'Even though he was not truly cheating them,' pointed out Opie.

'As far as he was concerned, he was,' said Cosway. 'The irony is that if he had handed over the money straight away – or even a fraction of the sum they had initially asked for, the whole affair would have ended there.'

Darton sat down. 'A lot of money was at stake. Did that not worry you?' His voice was stern now.

'I was sure that West would not pay more than he wanted to,' Cosway replied. 'He is something of a self-regarding fool,' he continued. 'I did not think the world would be a worse place if his foolishness were proved, and he had slightly less money.'

'You yourself could have given money to her,' said Opie.

'My financial situation is somewhat complex.' Cosway regarded him as if the suggestion were vulgar. 'Besides, she is not looking for charity. She wanted to feel she was earning her independence.'

'You are betraying me.'

The voice was quiet but unmistakable. All three men looked towards the door in shock. There she stood, dressed in dark blue, imperious, disdainful. Thomas Provis was at her side. 'After all the indignities I have had to suffer to keep your silence.'

A tremble of anger in the word 'indignities'. The pale blue eyes like ice.

Cosway leapt up. 'My dear… I did not hear anyone let you in.'

'Do not call me "my dear".' Her fury controlled, deadly. 'You could not endure the thought that finally I had the means to keep you quiet.'

Provis walked into the centre of the room.

'How is your thigh, Mr Cosway?' Cosway flinched slightly. 'Mr Darton is a witness too,' Provis continued with menace. 'He encountered Ann Jemima in some distress after she had fled from your house. Between us, we have enough influence to bring you to trial.'

'You dare attempt it?' Cosway replied. 'When all of us in this room now know you and your plan are not what you claim? You are willing to lose £600 and risk imprisonment yourselves?'

'What did you tell Mr Darton and Mr Opie?' she asked. 'What was your price?'

'On this count at least,' said Darton, 'it is myself who you must blame. I wanted to find out the hold this wretch,' he gestured to Cosway, 'had over you. Some business took me near Yarlington, so I visited.' He looked directly at Provis. 'I suspect I need not tell you what I found there.'

There was no sign of remorse on the girl's face at this point. Merely an increased contempt.

'It seems your business takes you wherever it pleases you, Mr Darton. I should congratulate you for your considerable efforts.'

The look on Provis's face at Darton's revelation, by contrast, was of devastation.

'I shall take what I discovered there to the grave,' Darton said looking at him. 'I am disgusted that Mr Cosway sought to profit from it. How did you know?'

He swung round.

'I was with the royal household when it travelled through Yarlington five years ago.'

His eyes flicker to Provis.

'The man I talked to was not entirely clear about Mr Provis's innocence.'

'That is your favourite territory, is it not, Mr Cosway?' Ann Jemima's eyes blazed. 'You seek out ambiguity, and breed maggots in it.'

The look that she flung towards Cosway at this point was arrow-sharp – he winced at it, even though his smile remained in place.

'In terms of the manuscript,' continued Darton, 'we admire your cleverness perhaps even more than we did before.' He turned to Ann Jemima. 'Yet several people are being defrauded of a large sum of money. You have both suffered greatly. But that is still wrong.'

'I thought Mr Opie had guessed on the day of the demonstration,'

she replied. 'You were clearly unimpressed by the method. Why did you say nothing then?'

'I was trying to work out why someone of your ability was bothering with the method,' Opie declared evenly. 'I felt there must be some good reason, so I stayed my counsel till I knew more.'

For a moment the expression on her face softened.

'You are an honourable and clever man. The person I have respected most in all my dealings with the Academy.'

They stared at each other for a moment, then quickly he looked away.

'Yet Darton is right,' he said quietly. 'West's crime was one of theft, but yours is one of fraud. How shall this be resolved?'

'I think it bears pointing out that no one – with the exception of Mr Opie – is revealed in a particularly good light by this incident,' declared Cosway sardonically. 'Before you entered, I was explaining that it was only Benjamin West's dishonesty that made your scheme as profitable as it has proved to be.'

There was a silence.

'And then there was the mixture of envy and vanity that has led the other artists to demand their share in it,' she declared briskly.

'Indeed,' said Cosway. 'Envy, vanity,' he paused, 'and greed have all helped your cause. An unholy trio of vices.'

The girl surveyed them all. She was starting to breathe slightly faster now, as her anger receded and the white heat of fear started to set in.

'What am I to expect from you now, gentlemen? Are you going to expose my crime to the Academy?'

Even in her fear she maintained her dignity, though, Opie noticed, she had started to tremble. Again he looked over to Darton. For a moment the noise from the street became clearer to all of them, as if the windows and walls had briefly become thinner, more permeable to outside influences. Shouts of coach drivers, the rhythmic clacking of horses' hooves, little flutters of passing conversation – all signs that some kind of normality was continuing at a point when it felt it had deserted their own company.

'Why could you have not used your talents honestly?' said Opie finally.

She took a deep breath.

'I felt I would merely have been allowed to become a curiosity before being married off and having my claws removed.'

'I cannot imagine the man who could tame you,' he replied quietly.

Her eyes flashed.

A brief silence ensued.

'So what are you going to do?' she finally asked.

Provis growled. He looked at Darton. 'I know this is a world without justice. But if we go to prison and Cosway does not...' Darton nodded in understanding. 'We came here to offer our silence in return for his silence,' Provis continued. He surveyed Cosway venomously.

There was a mild but discernible tremor in Cosway's voice as he responded. 'You are right. The time for playing with people's lives is over.' He looked at his fellow artists. 'Though we still have no idea what Mr Darton and Mr Opie are going to do with what they know.'

Provis looked quickly towards Darton. Opie started to pace backwards and forwards.

Cosway took a deep breath. 'If I may make a suggestion,' he said quietly, 'and try to atone for my own sins in this situation, I think this all has ample opportunity to resolve itself without any kind of confession. Mr Opie, after all, has not been the only naysayer of the method.'

'No indeed,' replied Opie.

He turned towards the girl. At this, for the first time, he saw her cheeks flush.

'There have been plenty of chances for people to stand back from the scheme,' he continued. 'Maybe we can let this situation play itself out without interfering – at this stage.'

'So you are not going to expose me?'

'You already have the money?'

She nodded. 'I believe the method is good, I believe that it has genuine worth. Not as much as if it had come from Titian's studio.' Her voice fills with emotion. 'But I did not work on it cynically. I too wanted to find the secret of how he used his colours.'

'And according to Benjamin West, you almost did,' said Opie quietly. 'I hope that you at least can take from this the knowledge that you are far, far better than your manuscript.'

She did not reply.

Darton looked directly at Cosway.

'How much would you say the method was worth, if it were not ascribed to Titian's studio?'

He rubbed his forehead.

'Fifty pounds if you were not being generous. Up to two hundred if you were. So much of it is a matter of opinion.'

'Keep two hundred pounds, and stay out of the clutches of men like this,' Darton said brusquely to Ann Jemima. 'The rest you must return to the Academy, in whatever manner you decide.'

That sense of a barely audible ringing in the room was discernible again – they all looked at each other, faintly dazed.

'What is your name?' Opie eventually asked.

She looked at him, then dipped her head. 'Jane,' came the brief reply. 'Jane Emerson.' She looked up again. 'Though it is so long since I have used it, I hear it as if it is the name of a stranger. I would prefer it if you continued to call me Ann Jemima.'

She turned and looked over coldly towards Cosway, who attempted a smile but failed. The expression on her face when she looked at Darton was more difficult to discern – it was angry and watchful at the same time. She swept round and left the room, throwing a quick backward glance towards Opie. Provis followed shortly behind her.

A few moments later the men heard the front door slam. The silence that followed lasted for some considerable time. It was broken by Cosway standing up and walking out of the room without saying a word. When Darton and Opie finally left it was without formal goodbyes.

The lamentations of Thomas Provis

'The thoughts of our minde can conceive the images of any thing, sayth Tullie. Our thought can conceive any Country, sayth another, and fashion in it such a situation of place as may best agree with our liking. Maximus Tyrius presseth this same point somewhat neerer, when he maintaineth that Invention is proper and naturall unto the minde of man: see Max. Tyrius Dissert. xxviii. Although then a man, for as much as he is a man, cannot but be full of Invention; yet such men as have studied do excell in their Inventions.'

Franciscus Junius,
The Painting of the Ancients, 1638

I n the dream Thomas Provis has repeatedly over the next couple of months, he is in a hot air balloon. It rises from St James's Palace into a pale blue sky, but as the crowd below gasps and cheers all he is aware of are the squeaks and whines of the wicker basket. His hands tremble as they hold tightly to the edges, he is conscious of the sweat on his temples. The louder the cheers become the more sickened he feels. Then he looks up and sees the black cloud.

Yet it isn't a black cloud. The way it moves is different. As it comes

closer he realises it is a murmuration of starlings, striping themselves against the winter sky. The first time they pass over, he becomes aware of the vibrations of hundreds of tiny wings. As they pass again he sees that some are breaking out of the flock to peck at the balloon. At first they have no impact. The balloon continues to rise, and the starlings swoop and dance around him. Then all the birds start pecking at the balloon at once, and it pops, yet still he is suspended in the air. He looks down at his feet, which are treading the air as if he were in water. It is at this point that he normally wakes up.

Though Darton and Opie have assured him that they will not reveal the secret, he does not trust them. His worries devour him from the inside, he feels like a silhouette of a man. The method has been sold, and now the artists of the Academy are preparing their paintings, ready for the critics to confer their final judgement. With every week that passes, Provis and Ann Jemima find the demands to pronounce on the latest experiments becoming more and more urgent.

It is on the second visit to Farington that Provis feels the first fluttering in his chest – as if one of the starlings has become trapped inside him. At first it is mild, but soon it becomes so strong that he has to sit down, coughing. Both Ann Jemima and Farington turn to him in concern, but he waves their anxieties away. He takes a few deep breaths and feels the fluttering die away.

Thoughts jab at his mind all the time now. It was only the daze of bereavement that made him offer to take the girl in. His mother had just died. Wounds had opened up that he thought could give him pain no longer. New grief breeds with old grief, he had ruminated. He regretted the passing of his mother. But he regretted more that it made the grief for his wife and his daughter bleed afresh. The horrors of a decade and a half beforehand walked beside him once more. He talked to his wife and daughter in

dreams, wept when the cold mornings woke him and they were no longer there.

He had gone one night to St James's Coffee House to meet Richard Cosway. He had discovered a rare bronze, a miniature of Laocoön, and thought he might be interested. 'Beware the Greeks bearing gifts,' Cosway had quipped. He had regaled him with the strange story of the gawky little girl he had met at a brothel earlier that week. Provis had not wanted to listen. Shreds of words worked their way into his understanding. Then he heard how old the girl was. There was not one day when he did not think of how old his daughter might have been had she lived. Straight away he realised they would have been the same age.

He heard himself, as if in a dream, offering to take her in. He said he would pretend she was his own. Mrs Tullett was his confidante those days, and he had told her his plan. Predictably she was outraged. But his idea was straightforward. The girl would not live with him, he would send her away to school. When the scraggy little thing turned up, he did not warm to her – he just thought of her as a soul saved and packed her off to Highgate in carriage.

It had been, he remembered wryly, her ability to draw that awoke him to the idea there might be some affinity between them. He had visited the school one day, and flicked through one of her notebooks while he was waiting for her to put her cape on to go out for a walk. In it he found caricatures of Mrs Tullett alongside a grotesque's gallery of her teachers and fellow pupils. If the name on the notebook were Gillray, he remembered reflecting, he would have been able to sell it for a few guineas.

Intrigued, he had taken her to tea on the high street and had talked to her about her drawing. The cross little girl who had been too numb from grief and shock to talk to him properly suddenly opened up, and a friendship was born. In that first glimmering of affection between them, he now realised, lay all the ingredients that had finally led them to disaster. She had talked to him then of her painting master lighting a glass of brandy with static electricity from his finger. He had been beguiled, but that night he had dreamt of a conflagration.

• • •

A Tuesday morning. The wind was making leaves dance in the air and reddening the cheeks of anyone who ventured out in it. She had announced she had something important to say to him.

He did not know what to say when she had presented him with a sheaf of papers. She had asked, 'What would you say if I told you I had devised the secret of painting like Titian?'

'To what end?'

Stupidity scrawled across his brain.

'To sell it, Mr Provis.'

Something inside him shrank, both at the nature of the address and its content.

'You have given me so much. I cannot possibly ask for you to provide for me until I am married,' she continued.

'You will sell it… as your own work?' he asked, his voice faltering.

'No one with money will be interested in a text written by myself.'

On that level, you see sense at least, he thought to himself.

'I decided an anonymous text would have more…' she hesitated, 'allure.'

He wanted to laugh – but the intentness of her expression forbade him.

'You are a man of the world – you can help me.' Something flared in her eyes – insolent and conspiratorial at the same time. 'You sell objects you have discovered all the time – what makes people desire certain things and reject others? You have often told me that you believe it is the story behind a thing, as much as the thing itself that gives it its worth. What story might we tell to sell this?'

He had promised her he would think on the matter, but in truth hoped that it would drop from her mind. That, he laughed to himself, was genuine self-deception. He had never known her let any intention go before it had borne fruit. After repeated goadings on her part, he had finally come up with a fiction that pleased her – his grandfather's pursuit of esoteric secrets in Venice. She clapped her hands and danced around. 'To say I have found it in family papers – why that is perfect.' And so he had become her co-conspirator. Built

up the image of his grandfather in her mind, taught her to evoke him just as powerfully as if she had known him.

How many times does a story have to be retold till it becomes like truth? They had rehearsed it several times before approaching West. Ann Jemima had reported that Cosway was delighted on hearing it – he had declared it to be the apple that garnished the roasted hog. Provis had been nervous that West would see the artifice of the scheme within minutes. But as he saw the belief on the artist's face grow, he found his own belief growing. His outrage when he had eventually realised that West was trying to cheat them was surprisingly authentic. It occurred to him his fury was inappropriate, but by this point there were so many fictions in his life he decided to play the lie's logic to the bitter end.

Over the weeks the starling flutterings became worse. Provis started to wonder if he was going to die. He would find himself suddenly awake in the middle of the night, gazing into the dark as he tried desperately to catch his breath, his heart hammering in his ears. He became grimly fascinated with where he was most likely to expire. In the drawing room of an artist he detested, or in the Chapel Royal during the last throes of Sunday communion?

The madness reached its most transcendent moment a couple of weeks before the Royal Academy Exhibition opened. It was the start of April, and the sunshine was beginning to assert its dominance. The painters had delivered their pictures to the Academy, and the debate over who should be selected had been superseded by the bloodier quarrels about which painting should be hung where. In a rare moment of calm Provis stood alone in front of the fire in his apartment. Beside him was a bottle of claret, two-thirds emptied.

Who cannot say this has all been for the good? he thought. Reality has caused so much unhappiness – to myself, to Ann Jemima. Through a few harmless falsehoods, on the other hand, we have made many individuals ecstatic. The artists have shown their admiration for Ann Jemima in a way that they never would have

if they had realised it was she who had devised the method. Their belief that it is an anonymous work both satisfies their pride and allows her to receive accolades for her cleverness.

He looked with some satisfaction at the ivory sphinx on his mantelpiece. Then suddenly the fluttering in the chest began again, and he coughed. It would not stop this time, so he sat down and puts his head in his hands. 'If this foretells the end of my life, then so be it,' he said to himself. When he was sure it was safe to move again, he went to the mantelpiece and poured another glass of claret.

The fate of a respectable woman

'Take note that, before going any farther, I will give you
the exact proportions of a man. Those of a woman I
will disregard, for she does not have any set proportion.'

Cennino Cennini,
The Craftsman's Handbook, c. 1400

'So now you condemn her for not being a perfect, virtuous
woman?'

Her tone was satirical, accusatory. Opie felt discomfited. The air
around them seemed dangerously combustible. That sense had been
there from the beginning of the visit, but the sarcasm had only truly
begun to ignite now.

He looked at Mary, and saw something in her eye he had never
seen before. The pallor of her cheeks emphasised the dark glint. It
verged on the desire to annihilate. Quite how this would manifest
itself he could not predict at this stage.

'No, I do not condemn her,' he declared.

'The first thing you said was that she had defrauded your
colleagues.'

'I said she was brilliant, and could not have done it without

significant talent. She is a formidable woman. Yet the fact remains that she has taken a lot of money.' He looked around Mary's study at piles of books that seemed to teeter more precariously than usual.

'She attempted to take an honest path when she first came to London, and it landed her in the whorehouse.' Her hand slapped the arm of her chair, and a small cloud of dust exploded in the spring sunshine.

'But surely…' Fragments of argument rattled through his brain. 'Surely,' he repeated, 'the author of *A Vindication of the Rights of Woman* is not advocating that women who wish to advance themselves should take up a life of crime.'

He attempted to throw her a playful glance.

She gave him a look of contempt.

'Girls without money or family are often at the mercy of the worst elements of our society,' she declared. 'Dishonesty is not the preferred path to take. But virtue all too often brings no reward. The poorhouse, prostitution, or life as a companion to some sadistic bully – these are all likely fates. Which of them would you pick?'

The last syllable flew angrily through the air.

'We have no intention of revealing to anyone what she told us. I was moved by her story and outraged by what she had suffered at Cosway's hands,' he said. 'She has not committed the worst crime in this situation.' His voice becomes quiet. 'Yet the artists should have their money back, however we organise it.'

'John – when you first talked to me about this you condemned the Royal Academy artists for their greed, now you pity them for their gullibility. You are blown back and forth by the winds of your conscience. It seems to me you never know precisely in which direction you are heading.'

He felt utterly disorientated. It was as if the invisible contract that underlay their friendship had been suddenly ripped up. They were at Mary's house for the final sitting for her portrait. But the anger agitating the face in front of him made it bear little resemblance to the woman on the canvas. True, he and Mary often argued.

But there was always a sense that they were on safe territory, and that no matter what was said there would be a way for them to reconcile afterwards. Right at this moment, however, he felt that what he said was crucial to whether or not he would be allowed to return.

'I think you are misreading me,' he said steadily. 'Of what precisely are you accusing me?'

'I suppose,' she declared, 'you are no worse than any other member of polite society. This girl is clever, educated, and talented. Such women, as we know, can, if extremely determined, make something of themselves. Yet without the protection of her real father and an inheritance all her talents were to go to nothing.'

'You have succeeded without an inheritance and protection from your family,' he replied.

'I have still battled debt and opprobrium. There are many who would not entertain me in their houses, even today.' Now her voice became dangerously quiet. 'Who deserves greatest praise in your estimation? Women who use their virtue to win approval from an unjust society? Or women who shun virtue in order to lead an existence that might give them greater happiness?'

'The latter, of course.'

'Then be careful whom you choose to rebuke.'

He frowned. Felt her words scorch the dry air, realised he was finding it increasingly hard to swallow. He wondered whether it was best to depart now. It seemed there was little more he could say that would acquit him favourably in her eyes.

'Forgive me, Mary,' he said finally. 'It seems as if we are discussing more than one matter... I...'

As he searched for words, she got up. Looked out of the window. Let her fingers tap for a moment against the cold glass.

She took a deep breath. 'I too have had a harsh reminder that society often punishes women, even when they are supposedly virtuous.'

He was silent, recognising that this was the best course. Grimly she continued.

'William and I were married a week ago.'

He started from his chair.

'You and Godwin are married?!'

He chided himself for the shocked tone of his voice even as he heard his words ring out. Her laugh clipped ruefully across the room.

'You see. Even you are dismayed.'

He shook his head.

'Dismayed is not the word. I am just... surprised... Part of Godwin's philosophy is his opposition to marriage, is it not?'

She laughed again and looked out of the window at the daffodils bending their heads under the attack of a stiff March breeze. 'He has staked his reputation on his opposition it. But we had little choice.' All the fire had gone from the room now. 'Now I am with child again, even I recognise that the poor unfortunate child must be safeguarded legally.' She sighed loudly. 'So I have broken my principles and William has broken his.'

He walked across the room and seized her by the hand. 'Mary.' Now he had recovered from his surprise, there was genuine warmth in his words. 'Surely this is cause for rejoicing. His decision to marry means far more than to anyone who walks down the aisle because society tells them to.'

'We have been most unkindly treated since. William's great friend Mrs Inchbald snubbed us publicly at the theatre. She looked as if she was about to slap him, then restrained herself. She walked away without exchanging a word with either of us.'

'I am most sorry to hear that.'

'The letters he has received since news broke of our union have been even crueller.'

She shook her head. Slowly she pulled her hand away from Opie's.

'Is life not extraordinary?' she continued. 'We have done the very thing most women and men do to make themselves acceptable in the eyes of society. And we have made ourselves even greater pariahs than we were before.'

Now Opie came and sat down.

'I am sorry,' she said quietly. 'I should not have attacked you as I did. I have allowed the complications of my life to make me

consider only myself. I have been through so much. I did not think emotional wounds could sting so much any more.'

He raised his hand.

'It is not important. I feel fury on your behalf.'

'I am truly angry on Ann Jemima's behalf too.' Her voice sharpened. 'Perhaps not with you, but certainly with the other artists of the Academy.'

He regarded her steadily.

'Why do you think my colleagues – all educated, talented men have been deceived? West in particular?' he asked.

She frowned briefly as she considered the question.

'Education is not always a protection against stupidity.' A needling glance. 'And it is certainly no protection against being deceived. The girl is clever because she has recognised an obsession. Whether someone's obsession is connected to romantic desire, or personal ambition, it diminishes their capacity for reasoning.'

'Yet education protects by making you ask more questions.'

'Sometimes it does, sometimes it does not. When you think you are achieving something you have dreamed of for a long time, the desire to believe is stronger than the desire to doubt. In which case you use your education to build castles that have no foundations. Sometimes what's needed is the simplicity of a child's view. The Emperor's New Clothes springs to mind.'

'You believe that is what she calculated?'

'I think she understands vanity and gullibility more than any of you. She has proved herself – if you will – an expert in people's blind spots. But she also has a passion and an extraordinary ability for art.'

'So she has managed to deceive us because she is like us?'

'In as much as society allows her, yes. From what you say she is – both in talent and what she desires. Could she have begun to create a scheme like this if she did not understand your strongest motivations at every level?'

He placed his little finger in the splash of Burnt Umber on his palate. Idly he traced circles in it.

'I am sorry I have not had the chance to meet her,' continued Mary.

'She would not…'

'Oh I am quite aware. She has no desire to make the acquaintance of anyone else who knows her secret – that is not her style. What do you think will happen with her once the exhibition is over?'

'She and Mr Provis will find some device for returning most of the money to the Academy – possibly through the gift of a painting they have bought at auction. Then she will leave London.' He wiped his hand ruefully on his cotton rag. 'Farington told me she would like to travel across Europe to see Venice.'

'Will you ever reveal her secret?'

Her tone rebuked him.

'No – she has nothing to fear from me.' He grimaced. 'It will all be over soon.'

'Do you think someone else will be clever enough to tell all the Academy artists they are not wearing clothes?' Suddenly her tone was lighter.

He looked at her.

'First you accuse me unfairly, now you taunt me,' he declared drily.

'It is nothing more nor less than you deserve.'

The Exhibition

'PRUSSIAN BLUE'

'To make this Blue, first prepare a lixivium of blood, which is done by burning in a Crucible one part of Tartar Alkali to two of dried blood; preserve this mixture in a state of incandescence for a quarter of an hour—afterwards throw it into distilled water, and filter the solution. This lixivium being prepared is of a Yellowish Green. If you wish to make Prussian Blue, dissolve in clean water one part of Martial Vitriol to three of Alum, and pour it into the lixivium. This mixture becomes of a reddish Brown, and exhales a vapour of Liver of Sulphur; when filtered, it leaves a sediment whose surface is Blue, and the centre of a yellowish Green; but as soon as the surface comes in contact with the air, it becomes Green, and then changes to a fine Blue.'

Constant de Massoul,
A Treatise on the Art of Painting and the Composition of Colours, 1797

The morning of the opening of the Academy exhibition dawned with a blue sky dirtied by wispy grey cloud. Larger white clouds swelled behind the grey, tinged an eerie orange by the rising sun.

In Mr Provis's apartment, Mrs Tullett delivered a dish of hot chocolate to Ann Jemima with a look of foreboding. The girl sat looking into the middle distance. She had awoken that morning only able to think of her real father. What would he think of what

she had achieved now, she wondered. The thought that he would disapprove sent a faint frisson of excitement through her.

Dr Emerson's legs had been long and angular, his lean face was constantly possessed by impatience, while his ice-blue eyes seemed to look straight through her. He had had no time for the girl his wife had left him. Sitting in his study in Bath, he was far more comfortable devoting his spare hours to correspondence with different scientific societies. Denied a male heir, he hired tutors to educate her as rigorously as if she were a boy. But she knew he was of the opinion that little was being achieved through this education. He had chastised her bitterly when he saw how her notebooks on maths and astronomy were covered with drawings.

There had been a particularly painful incident shortly after her painting master had introduced her to Hooke's *Micrographia*. She had been unable to resist adapting some of the illustrations to satirise both her father and certain of his friends, and on the evening he discovered it he had chastised her bitterly and sent her to bed without supper. Eavesdropping can often prove crueller to the eavesdropper than to the one being spied on – and so it proved when she crept back later to look through the door of the parlour where he was having supper with her grandmother. 'I look forward to a time, maybe a few years hence, when she can prove to me that her mind is not entirely empty,' she had overheard him saying. She could not see his face as he said it, but could imagine it – ruthlessly stripped of sentiment, eyes wandering restlessly until they found something worthy of engagement.

Two weeks later he was the first to die of the smallpox that swept through their neighbourhood. When she wept she did not know whether it was because she would never see him again, or because of the lacerating sense of exasperation that he had left behind. Her grandmother died a week later, and Septimus Green one week after that. While her father's and grandmother's deaths had cast her down, her painting master's death had made her cry out against the impossibility that someone so young, so full of life and curiosity, was no longer there. She wondered what was written next in the cruel script of her life.

'Drink your hot chocolate, Ann Jemima.' Mrs Tullett's voice cut sharply into her reminiscences. 'The morning advances, and it is time that you got dressed. I have made the chocolate with orange blossom – it is believed to steady the nerves.' Ann Jemima banished the images from her past as she made herself focus on the day ahead. She took one sip of chocolate, then got up and stepped away from the table leaving a plate of clear almond cakes untouched. 'I am ready,' she said brusquely. A smile trembled on her lips. 'Let us prepare ourselves for the ordeal.'

She had planned the day meticulously. She knew it was a performance, but it was a performance she would execute to perfection. As Mrs Tullett helped her, she stared resolutely ahead into the looking glass, looking at the feathers once more rising up from her hair. This time they were accompanied by a demure black and white spotted gown, a crimson robe arranged over it and a white fur boa hanging round her neck.

'I do not recognise myself any more,' she said.

Today Mrs Tullett had decided not to play the prophet of doom.

'You are beautiful,' she said simply. 'You have gone to the bother of stirring up a great bee hive so you should at least walk away with some of the honey.'

'You have been like a second mother to me.' Ann Jemima's eyes suddenly brimmed with tears. 'I could never forgive you for not being my real mother. I have been harsh on you.'

'I have not risked as much as Mr Provis.' Mrs Tullett's voice was dour, but there were tears in her eyes too. Seeing this in the mirror, Ann Jemima got up and turned to give her a hug, which she returned warmly. 'You were such a wretched little thing when you first arrived. You trusted no one, you were rude, and when you weren't answering back you hid yourself in books. I said at the time to Mr Provis it was as well you were clever, since you didn't have the looks to attract a good husband. We both thought your only future lay in being a governess.'

Ann Jemima stood back. 'I would have made an impatient and bad tempered governess.'

Mrs Tullett gestured to her to sit in front of the mirror again.

'Then you became beautiful,' she continued.

Ann Jemima looked straight forward.

'Beauty is a strange kind of currency,' she remarked dourly. 'It bestows power and value until you meet a predator like Cosway. He tried to use his desire for me to make me worthless.'

She turned again to look at Mrs Tullett, who put her finger to her lips.

'He will be gone from your life soon enough.'

The plan for today was that she and Provis were going to take their carriage over to Farington, before going with him to Somerset House. Now she came out of the apartment and walked through Green Cloth Court and past the Chapel Royal. There he was waiting at the side entrance to the palace. She felt relieved to see how cheerful he looked, almost – the thought strangely flashed across her mind – as if he were a father waiting for his daughter on the morning of her wedding. He took her hand and looked her in the eye. 'You look every inch the part, my dear,' he declared.

Just as he had so many months before – when they made their first visit to Benjamin West – he held the door of the carriage open for her. Just as she had all that time ago, she placed a wary hand to her headdress before climbing in. 'What can go wrong now?' whispered in her mind. She was struck by a sense of time looping round on itself.

By mid-morning, the clouds had become heavier and darker. While there was still an eerie orange tinge to them, the white clouds had been replaced by swirling blue-greys and blacks. In the twenty minutes it took Provis and Ann Jemima's carriage to reach Farington's house, icy drops were starting to fall.

Ann Jemima realised, as she saw him, that the diarist's vanity meant he considered it to be his great day as much as she was supposed to consider it to be hers. He was standing at his front door – for a second it framed him as if he were the final painting to be hung at the exhibition. He gestured dismissively at the rain.

'Merely a sign that today the best views are to be enjoyed indoors,' he declared as he climbed into the carriage.

It took twenty minutes for the carriage to reach the top of the Strand. Once it did the rain turned to hail – an elemental battering against the sides of the coach that made it sound as if a crowd was pelting them with stones. Ann Jemima thought it would stop quickly. But it continued for a while. She felt her sense of fear growing at the impending exhibition opening.

Oblivious to her worries, the men continued their conversation in raised voices.

'I was in Wright's Coffee House last night,' declared Farington. Ann Jemima could smell the sherry on his breath. She looked quickly at Provis, who was nodding. A strange friendship had sprung up between the two men in recent weeks, as Provis's palpitations had revealed Farington's own obsession with health and unconventional remedies – none of which, she noted, had yet been tried by Provis. 'A young gentleman gave me a pamphlet about the French invasion of Wales,' Farington continued.

'What more is there to be said about another failed attempt to invade our shores?' Provis declared. 'It seems that when the French military proceed east they are successful, but when they come west across the Channel they are doomed to look like fools. They did not intend to invade Wales at all. Their course was set for Bristol.'

Ann Jemima looked down.

'You are, as ever, correct, Mr Provis,' Farington continued.

The hail continued to beat down.

'At breakfast, however,' the diarist continued serenely, 'I decided I would read the pamphlet. I was most glad I did so, the story was unexpected and,' here he looked at Ann Jemima, 'seemed most auspicious. It appears that when the French army landed at Fishguard in Wales, they started off by looting as much food and wine as they could, and quickly became drunk. As a result they were in no state to resist when they were approached by a battalion of Welsh women. The bravest was a cobbler called Jemima – a fearsome, modern-day Boadicea. She threatened twelve men with a pitchfork, overcame them, and ended up locking them in a church.'

Both Ann Jemima and Provis were silent.

'It is impossible that one woman could have done that,' Provis eventually replied.

'Mr Provis,' Farington shook his head sternly. 'We should never underestimate the determination of a woman by the name of Jemima. Look at what your daughter has achieved over the last few months.'

Ann Jemima felt a strong desire to laugh. Quickly she turned to stare out of the window at the icy blur. She could hear the horses whinnying their discomfort. She was about to speak, when, as unexpectedly as it had started, the hail suddenly came to a stop. They descended from the carriage. Everything felt very quiet.

They walked through the gates of Somerset House and into the entrance of the Royal Academy. There they made their way past the busts of Michelangelo and Newton and paused for a moment as they came to the spiral stairway coiling its way above them to the Exhibition Room. Ann Jemima turned to Provis. Once more she marvelled at how perfectly composed he seemed after the weeks of worry.

She extended her right hand to him so that they could walk up together.

'The wild beasts are waiting for us,' he said with a dark smile.

'The wild beasts?' remarked Farington. 'Dear me, I would not be afraid. You will find only friends here. All of London wants to know you.'

They walked through the ante-room and into the main exhibition room. Rows and rows of pictures tilted out diagonally from the walls. With a shock, Ann Jemima realised she was gripping Provis's hand so hard she was causing him pain. With a thin crescent of a smile, she let go.

As if led by the same instinct, they both walked towards Benjamin West's *Cicero*, which dominated the wall immediately opposite them. She had determined before she saw it how she

would respond, the precise nature of the smile, the air of pride. But as her eyes surveyed what West had painted, she could feel her smile petrifying.

'He has not followed any of what I told him,' she thought. 'It is absurd for me to feel anger. But the painting is terrible. There is nothing redemptive about any aspect of it. There is no clarity to the colours – it as if they have been inspired by mould in a damp parlour.' She forced herself to be calm – to focus on the proportions of the painting. On the way the figures had been drawn. Yet there was no comfort here either. Cicero resembles a desperate actor, trying to impart significance to a lump of badly carved stone, she thought. It is an embarrassment. She started to breathe more quickly.

As if echoing Ann Jemima's thoughts, Provis declared, 'West's history painting is rather more subdued than people have said it was. It is interesting, is it not, how differently position and light render a painting.'

Farington's pause, Ann Jemima realised, was as eloquent as anything he had said to her in the weeks running up to the exhibition.

'There are some – Rigaud and Westall included – who do not think he has been true to the method.'

'No, he has not at all,' exclaimed Ann Jemima with anger. 'I thought he had worked it out. I thought this was why he wanted to keep it to himself. When we worked together...' The words failed her. 'All those demonstrations were for nothing.' Her voice was brittle. Provis tried to catch her eye, but she would not look at him. She moved back a little to look at the painting from a different angle.

Provis coughed.

'Mr Farington, you said a week ago that you had seen West's work and thought it was greater than any of Poussin's landscapes.'

'Yes, well – as you cleverly point out, position and light can reveal a painting differently. I still think it has many merits,' replied Farington.

He is positioning himself so he can swing equally towards praise or criticism of the method, Ann Jemima thought to herself. He has been our most prominent champion, yet even he can see that West's

painting cannot be praised unguardedly. She looked swiftly towards Provis and noted yet again his perfect composure. Swiftly she started to make her calculations.

'We cannot be blamed if Mr West has not followed our instructions,' she declared with a coolness she did not feel. 'Once he was being honest, I would have been happy to see that his interpretation of the method was superior to mine. Yet this seems not so much an interpretation as a complete transgression. You, Mr Farington, have understood it far better.'

Farington stared at her for a second – then a gleam of approval came into his eye.

'We shall see how others judge it,' he replied. 'We have all become perfectionists as regards to how the Venetian Secret should be executed. Maybe we have become too close to it.'

He touched her arm lightly. At the same moment, she sensed his attention shifting to an event that was taking place behind her. She looked round to witness Westall and Rigaud walking through the door, followed by a short man with hooded eyes, a sallow complexion, and artfully dishevelled clothes. He surveyed the room with contempt.

'Who is he?' she asked Farington.

'That,' Farington replied, allowing the word to hang in the air, 'is Anthony Pasquin.'

'The critic?' she asked.

'One of them.'

She looked once more at the man. This time she looked down to see that his shoes had holes in the toes.

'I find it hard to believe,' she said, turning back to Farington with incredulity. 'He looks like he has just come from the poorhouse.'

'That is part of the intention,' declared Farington. 'He has an attitude that he describes as a philosophy, in which he believes he need not stand on ceremony with anyone. There is as much vanity in the informality of his dress as there is in the outfit of a Bond Street Lounger.'

Pasquin walked to the middle of the room and started turning slowly. Ann Jemima observed how his act demonstrated the same combination of vanity and disregard for the opinion of others as did

his outfit. It was almost as if he were enjoying the fact he was at the axis of a world now depending on his approval. She tried not to appear to be looking at him, but her eyes kept on being drawn back to him as his eyes glitteringly perused the rows of paintings. Suddenly Pasquin gave out a loud 'Hah', and she jumped. All those who weren't already looking at him swung round. His gaze had come to rest on the largest painting in the exhibition.

'Was the artist drunk who submitted this?' he exclaimed loudly. A frisson ran across the room accompanied by gasps of laughter. He walked over to scrutinise it more closely.

The image was of a naked man standing legs astride, with muscular arms raised above his head. He wore a helmet, while his face and body were illuminated by an unearthly light. Next to him stood another naked man, but he was more in the shadow. His hands were resting on a lance. Behind them swirled an apocalyptic landscape.

Farington nodded knowingly.

'It is Thomas Lawrence's painting of Satan summoning his legions. Many of us suspected it would cause something of an upset.'

'That is precisely what Lawrence desired,' declared Westall laconically as he approached them. 'It no longer amuses him to create nice society portraits. He wanted to do something that would jolt polite society.' He bowed, laconically, in Ann Jemima's direction. 'If it prompts letters of complaint and makes at least one person faint it will have achieved its end.'

'It will be the talk of London,' said Ann Jemima with barely concealed irony. A quietly malicious sense of relief had stolen upon her. No matter what criticism would greet Benjamin West's painting, she quickly realised that Lawrence – who had been so contemptuous of their method – could be an even greater cause of disapprobation. She saw Pasquin walking towards them.

'He calls it Satan. But it looks like a mad German sugar baker dancing naked in a conflagration of his own treacle,' he declared. As he laughed, Ann Jemima noted the greasiness of his hair and skin, and a faint unwashed aroma that made her want to stand back. With difficulty she contained herself as he looked at Westall. 'You once shared a house with Mr Lawrence, did you not?'

Westall nodded. 'I am proud to say that I did,' he replied insolently.

'Did you notice any insanity at the time?'

Westall's contempt was almost tangible. 'Sadly not.'

Around them the room began to fill up. Ostrich feathers, floral perfumes, arch aristocratic voices, the exaggerated cadences of personal introductions – all indicated that one of London's most important society events was in full sway. Ann Jemima was aware she was receiving several gazes and comments of approval, but the fuller the room became, the more she felt as if she was in a social sea, being pushed back and forth by competing currents. In the far corner she saw, with a shudder, that Cosway was essaying a flirtation with a young lady dressed in pale green with a white fur boa like her own. She turned away, briefly unable to cope with the memories brought back by his presence. Now Rigaud was to her left – but since he was in the middle of a lengthy and complex disagreement with one of Westall's patrons, she chose not to interrupt the exchange. Slightly further away Stothard was squinting at a small work by an artist whom Ann Jemima did not recognise. Provis, she realised, had been diverted by Smirke who appeared to be talking to him at length in the ante-room.

She considered whom she should approach next. As her eyes roved the room, her attention was caught by a painting that showed a gale whipping up over the sea. The swirl of the wind gave the trees on land a turbulent almost liquid aspect that made them look like an extension of the choppy waves. 'Who painted *Fishermen Coming Ashore at Sunset?*' she asked, lost for a moment in the image's beauty. She did not realise she was speaking the words out loud.

'That is Joseph Turner's submission,' she heard Benjamin West's voice saying. She turned to him with surprise, noting the grey shadows etched under his eyes.

'It is a pleasure to see you, Miss Provis,' he said shaking her hand.

'It feels as if it has a been long time since we last talked,' she replied. As she stared at him, she realised she was being consumed once more by the irrational anger that he had let her down. In all

the turbulence of recent months, amidst the truths and untruths, it had not occurred to her that at the climax of the whole process he would fail to produce a painting that would be anything other than impressive. 'Mr West, I have seen your painting of Cicero.' She hesitated. 'It is wonderful to see it hung here in its full splendour. Yet it looks different from how I expected it. Have you been entirely faithful to the method?'

West looked at her with some hurt and confusion.

'Miss Provis, I can assure you I have expended every effort to be faithful to the method and to what we discussed together.'

His eyes held hers for a moment. For the first time she saw him faltering for what to say.

'Indeed, I am now convinced that any serious artist would benefit from using the method. Who knows what a most promising individual like Mr Turner could achieve? Maybe I shall suggest to him that he buys a subscription.'*

He bowed angrily, then – it seemed – he was moved on by the swirl and eddy of the room. Assailed by feelings she could not understand, she studied the paintings intently, in the hope that she could collect herself before her next conversation. Smirke's scene from *Don Quixote*, she was relieved to see, displayed the method somewhat better than West. Westall's picture of the infant Bacchus was – while not one of his best works – certainly striking.

The room was now so packed that it was difficult to see who was standing even two feet away. As she surveyed the *Bacchus* she heard a conversation behind her that made her neck rigid. The loud pronounced Swiss-Germanic accent of the first speaker cut through the babble of the surrounding crowd.

'From what I see this Venetian method diminishes the work of everyone who has dabbled in it,' declared the voice. 'Only you, Mr Farington, have achieved anything that is worthy of being displayed at an Academy exhibition.'

* Turner is referred to in Gillray's cartoon *Titianus redivivus;–or–the seven-wise-men consulting the Venetian oracle*; he appears on a portfolio of sceptics of the method attacked by a monkey. Later in his career, however, he did become obsessed by Venetian glazing systems, some critics say to his detriment.

'That is very kind of you, Mr Fuseli,' concurred Farington's distinctive tones. 'It does have a lot of critics. Many have confided to me that they think it overrated. I myself have had my concerns. But the girl is charming, even if her father is an eccentric. And I think with the correct, methodical approach it is possible to do well from it.'

'Which critics are here today?' replied the first voice.

'Pasquin is here – and some rather more human critics from *The Observer* and *Bell's Weekly*.'

'I predict the response will be a massacre.'

She stayed until she was sure the two had moved on. It felt almost as if she could not see any more. Her eyes could not fasten onto the details in the paintings or in individuals' faces, while there was a humming sound in her head. She had always observed that Farington was a social weathercock, happy to modify his direction according to the winds of the strongest opinion in the room. The shift in the pronouncements he had made about West before and after West's letter showed this markedly. But his concurrence with such an unremittingly savage attack on the method alarmed her.

She could feel her smile becoming more fixed, more desperate. It was clear to her that she had to escape the room as quickly and with as much dignity as possible. Yet the faster she tried to move, the quicker the current turned against her. As she first pushed through the crowd she saw Josiah Darton talking to John Opie. Opie in turn saw her and walked towards her.

'Are you all right?' The simplicity of the words made her want to throw her arms around him.

'Mr West's painting – it seems – has not benefited from the method on any level.'

Her words felt stiff, stilted, in front of him she could not conceal her distress. At the same time she rebuked herself. Why would he show any sympathy at this stage?

'I have always held that most of the artists failed to see where your fake, but even so ingenious, method ended and your ability began. Maybe in your attempt to convince everyone else, you too failed to notice how much of the effect was due to your own talent.'

'I do not need kindness,' she gasped, '... not now...'

His eyes clouded with concern as quickly she moved in the opposite direction.

By now it felt as if every atom in her body was driving her from the room. She managed to make her way through to the ante-room and from there to the spiral staircase. For one perilous moment the stairs looked like a projection of her own dizziness. She took a deep breath and asserted herself. Then slowly she started to make the descent. She felt thankful that there were so many people now at the exhibition that her absence would not be noted. In just three or four minutes she would be outside and on her own.

It was when she was almost at the bottom that she heard the voice. She was at the point where she could feel that her composure would not last much longer, could feel the smile disintegrating on her face.

'Miss Provis.'

She only half recognised the voice – it had a faintly sibilant quality, but she could not recollect where she had heard it before. So at first she counselled herself that she would ignore it. Then it came again, marked and much louder.

'Miss Provis.'

Forcing a smile again, she looked up, but couldn't see anyone.

'Miss Provis,' came the voice for the third time. She climbed a little way up the stairway and looked up again. Her eyes flared with brief alarm. Now she could see the man identified to her as the critic Pasquin. He smiled at her – a carrion crow waiting to swoop. 'May I seek a word with you?' he asked. 'Now I could shout what I have to say down the staircase. But I suspect you would rather our conversation was quieter than that.'

So this is how it ends, she thought to herself. With an exhausted calm, she started to walk back up the stairs again.

'I am not sure I comprehend what you are saying,' she declared as she reached half way up. He continued to smile. But the look in his eyes was pinched by malice.

'My question is purely one about technique,' he said. 'Something I am sure you are well-equipped to answer.'

She hesitated. If his question is one of technique, then maybe this is not how it seems, she thought.

She smiled more confidently.

'You of course understand that I can only talk to you about isolated details of the secret,' she said. 'The artists in possession of it and I have signed a document promising not to disclose the full formula.'

'Yes,' he replied. 'So I hear.'

He was silent. She walked further up the steps so they were standing on a level.

Pasquin looked her in the eye. For what seemed like almost a minute he did not speak at all. As she shifted uncomfortably, finally he said, 'Now the artists have paid you much money for this method. It sounded to me like it might have been a good investment. And indeed it would have been if it had genuinely contained Titian's colouring techniques. But I believe I have proof that it didn't. Now my great question is whether or not you knew too. Whether you are the deceiver, or the deceived.'

She wanted to say, 'To whom have you been talking?' But she knew this would be as good as a confession. Instead she repeated 'Definitive proof? That is quite an assertion from someone who has only looked at the paintings for about twenty minutes.' She mustered all the polite contempt she could. 'Please, Mr Pasquin, tell me – what is definitive about your proof?'

'Where did you get the document from?' he asked. Each syllable enunciated like the beat of a drum.

She repeated the story as she had so many times of Mr Provis's grandfather. 'The method has, in addition, been thoroughly explored by the members of the Academy,' she said. 'If the country's most eminent artists believe the document is valid, who,' she concluded, 'are you to disagree?'

Pasquin's eyes narrowed. 'Who indeed am I to disagree?' he said.

A society couple emerged from the ante-room and came to the top of the stairs. They made their way past Pasquin and Ann Jemima. She watched with barely disguised longing as the clack of

their footsteps spiralled them towards the outside world. Once they had disappeared, Pasquin started to talk again. His voice was even softer now – she almost had to stoop to hear him.

'Miss Provis,' he said.

'Mr Pasquin, I really have nothing more to say on the matter,' she began.

'I was very curious about Mr West's *Cicero*. It seems to me rather less admirable than many of his other works.'

She opened her mouth to reply, but he stilled her with a raised hand.

'I asked him about some of the colours used in the method. He said a key colour in the evocation of shadow was Prussian Blue.'

'He should not have said anything at all without consulting me,' she replied with clipped rage.

'As you yourself said, there is no harm in talking about elements of the method. It is hardly a revelation of the secret,' he declared. 'But it is of interest to me. I would like to ask you, is a key colour Prussian Blue?'

She felt as if she had been cornered by a snake. She heard the word 'Yes' escape from her mouth.

'You concur – that is interesting,' he replied. 'So explain to me this.' He looked closely at her. 'Prussian Blue was only developed as a colour at the beginning of this century.' It is a synthetic colour developed in a scientist's laboratory. If that is the case, how can it have been so intrinsic to the work of painters three centuries ago?'

She took a step back, then clutched at the banister as she almost fell down the stairs.

'That is only on your assertion,' she declared, her heart beating hard.

'It proves that the manuscript is a fake, does it not?' he declared. 'The only question is at what point the rot set in. When your great-grandfather was in Venice with Signor Barri?' He paused. 'Or at a more recent date than that.'

'What you imply is outrageous calumny!' she cried.

'Well, something is outrageous,' he said. His voice wheedling, malevolent. 'I am not sure of many things here, but I am sure you have received rather more money than the method merits, Miss

Provis. I could have told you that just by looking at their paintings, but after what Mr West told me – well, there is little doubt.' Slowly, he clasped his hand on the rail of the staircase. 'My review will be published in two days' time and I think it will cause them all to survey their investment rather differently.' He paused. 'Maybe you should start calculating how you can hand the money back.'

Now he began his descent of the stairs. She listened to the progress of his shoes on the cold stone. She was trembling with anger. For a moment she wondered whether she should throw herself into the stairwell and end everything. She took a few deep breaths. No, this situation is redeemable, she told herself firmly. Her mind whirred faster and faster. Even he is not certain that I am responsible for creating the manuscript. I do not have to lose everything. I will leave London this afternoon.

She waited till she was sure Pasquin had left. Then she made her own descent of the stairs. She stayed away from the bannister, pressed her hand against the stone wall as she came down. Then she heard the whistling coming from above her.

'Miss Provis,' came the call. This time she recognised the voice, but just as before she continued without looking round. 'Miss Provis.'

Wearily she turned to see Josiah Darton coming down the staircase. The expression on his face was guarded.

'It seems to have worked…' he began to say. But then he saw her properly. 'What has happened here?' he asked swiftly.

'I have been discovered,' she declared angrily.

'It was not at my instigation,' he responded with puzzlement.

'No, I know.' Her voice dropped low. 'I apologise. Do not misread my tone. I have betrayed myself.' She shook her head. 'I have betrayed myself.'

He came close to her, frowning.

'You have confessed? After all we have done to preserve appearances for you? Do you know what this means for Thomas Provis?'

He grabbed her wrist firmly.

'No, I have not confessed,' she hissed, wrenching her wrist away. 'Then how?'

'The critic Pasquin.' She was silent for a few moments. Darton

looked around. Quickly he ushered her into the courtyard.

'What has he said?'

'I have made a terrible mistake. I cannot countenance my stupidity. One of the paints in the method… was not invented till this century.'

He regarded her with disbelief.

'You did not know this?' She shook her head violently. 'Of course not. And nor did any of the gentlemen of the Royal Academy, it would seem.'

'So the worst of our fears has been realised.' She could see him making rapid calculations. 'We must act straight away to make sure that neither you nor Thomas Provis end up in prison.'

Grimly she nodded.

'We need to get you out of London as quickly as possible. I will work out something for Provis,' Darton continued. 'I have friends who live in Dover. We can commence by getting you to their house tonight, and thence you can go to France. Have you your two hundred pounds?'

She nodded.

'Of course you have. I have admired your resourcefulness though this. We are very similar animals.' Her eyes widened for a second, as she looked at him she detected a deep sympathy that she had not previously suspected.

'I thought that by now you would have detested me,' she exclaimed.

'I have never met an individual so extraordinary as you.' Before she could respond, his gaze suddenly hardened. 'The money should be enough for you to survive on the continent for a while,' he snapped, and she looked down. 'I can also make introductions for you in Paris.'

Ann Jemima took a deep breath. 'I can pay you for this. I do not wish you to do this as a favour.'

He shook his head.

'Keep the money for yourself. I have just one payment I want from you.'

She regarded him warily.

'I want you to say goodbye to Provis.' She nodded. 'Right now I wish you to return to that exhibition room and act as if everything is normal so that nobody's suspicions are raised until the review comes out.'

'You wish me to return upstairs?' she said incredulously.

'You are a strong and resilient woman,' he said. 'You can do this one last good deed for the man who has acted as your father for the last three years. Ensure you are back at the apartment for mid-afternoon so you can sort out your affairs. I will call for you at the palace gates at five o'clock this evening.'

morning, two days after the exhibition, to be greeted by the usual display of eggs, kidneys, chops and fresh bread. To his surprise he found his son Raphael standing by the mantelpiece busily feeding a fire that leapt higher and higher the more paper that was fed into it. Chemical green flames mixed with the blue and orange. A stench of burnt ink filled the room. He rushed over and saw *The Observer* and *Bell's Weekly* disintegrating. But *The Morning Post* was still lying on the table.

He seized it, almost ripping it as he did so. The newspaper shivered in his hands.

When he finally found Pasquin's article it took him three or four attempts to read the first sentence. Once he started to make progress, he felt the blood slowing in his veins as he absorbed what the critic had said.

'Thomas Lawrence's *Satan* has suffered greatly, as I feared it would,' he declared. His son waited – West felt something deadly in his stillness. He swallowed uncomfortably. 'Now,' he continued with empty jauntiness, 'let us see his pronouncements on *Cicero*. There will be criticisms – there always are with Pasquin – but there must have been certain aspects he admired.'

His son remained motionless. As West's eyes reached the words they blurred and then clarified before him. '"Some fearful delusion…"' he began.

'"Some fearful delusion"?!' He looked up at Raphael.

'Read on, father.' The dreadful knell of that voice.

'"Some fearful delusion must have seized the President of the Academy in embarking on this dreadful project",' he continued grimly. '"This is the latest technique seized upon in London for enabling artists to paint like the ancients. Yet what kind of spell was cast on him that removed his capacity for observation?"'

His hands twitched as he looked up.

'"What kind of spell"? The impudence of it.'

Ralph had now turned his back and walked away to the other end of the room.

'Does it become worse?' West asked. If a moan could be silent,

The critics' verdict

'Hee forgetteth his owne condition, and doth not remember himselfe a man, who will not beare with other mens errours.'

Franciscus Junius,
The Paintings of the Ancients, 1638

'**I**s this what Hell is like?'

The question haunted Benjamin West in the weeks following the opening of the exhibition. Whether he was out in the City, or visiting people privately, there was a constant sense of irreverent whispers, scathing laughter, and mouths stiffening into smirks. Shame stalked him across town. It burned him up and down during his waking hours, and blasted great holes into his sleep. It was as if thieves had held rapiers to his throat and robbed him of gravitas, dragging it behind their horses like a corpse as they made off into the distance.

He had received compliments at the exhibition opening itself. But that, he had known, was the way of such things. The effusiveness of compliments given directly to an artist who has just displayed his work bears no relation at all to how gently or savagely the critical post-mortem will be conducted. The assault had commenced in *The Morning Post*. He descended to the dining-room door at ten in the

he thought, I have just heard it. He lowered his head again. "'The very technique that is meant to bestow Venetian light has in fact bestowed a Stygian gloom upon the scene, so you wonder why the Syracusans have followed Cicero, given the clear risk that he might be leading them straight to Hades.'"

He put his hand to his forehead. 'It is wordplay, just wordplay. Pasquin is always extreme in his opinions. It is of little import.' He realised he was breathing a little harder. 'Damn him.' He bit his lip. 'What have the critics in *Bell's Weekly* and *The Observer* written?'

His son put his head in his hands.

'The papers you have just burnt?'

Ralph turned and walked out of the room.

'What can be so terrible?' West shouted after him.

A door slammed across the corridor.

'What can be so terrible?' he whispered.

Questions of what he should do next scattered and regrouped in his mind. He walked towards the entrance hall. He would go out to buy more papers. But at the moment he reached for his overcoat there was a ring at the door.

'Who is here to taunt me now?' he muttered to himself as a servant ran to open it.

Fuseli was revealed. His demeanour unreadable. Under his arm was gathered a pile of that morning's newspapers.

'My dear West, I must offer my condolences. How shall we contain this scandal?' he asked.

'Scandal?' repeated West with growing terror. Fuseli stepped into the hall and deposited the papers on the table as if they had been contaminated.

'The critics have seen even more clearly than I that there is no merit to this method at all.'

You cannot even make the effort to hide your schadenfreude, thought West bitterly.

'The fact that they have seen it so clearly raises worrying questions,' continued Fuseli. He reached his hand towards *The Morning Post*.

'Desist,' cried West. Fuseli regarded him quizzically. 'I have already read Pasquin's words,' said West more quietly. 'I am not quite composed enough to hear them again.'

He indicated that Fuseli should precede him into the dining room.

'You have read all the reviews?' Fuseli asked, bringing the papers with him.

'I have not...' West could not avoid glancing at the fireplace as he said this, 'I have not had a chance to look at the others yet.'

Fuseli's eyes followed his glance but did not read its meaning. Sniffing punctiliously, he sat down and picked up *Bell's Weekly*.

'The best review is here. The critic says that the pictures painted according to the method are "remarkable for a dark and purperine hue, which seems in some degree to counteract the force of the effect".'

'That is the greatest accolade?' West asked sourly, also sitting down.

Elaborately Fuseli folded *Bell's Weekly*, and picked up *The Observer*.

'The language here is less poisonous than that used by Pasquin. But I believe it analyses the problem more unforgivingly,' he said as he unfolded it.

West was put in mind of a barber dentist who twenty years beforehand had removed two of his teeth using pliers.

'"These paintings, rather than possessing 'Titian's warmth divine"',' continued Fuseli, '"are nothing but the chalky and cold tints of fresco and that gaudy glare and flimsy nothingness of fan painting."' He put the paper down. 'In other words they reduce rather than augment their subjects. My dear West, they are the superficial tints of the amateur who aims for effect rather than depth.'

'Of the amateur?!' West replied.

'That is my word, not the critic's.'

'I am aware of that,' said West angrily. 'You – my friend – are accusing me of producing work like an amateur?'

The more outraged he became, the more complacent was Fuseli's expression.

'Yes, I am your friend,' said Fuseli. 'The word amateur is cruel,

but you must awaken yourself to what has happened. The document revealing Titian's secret is clearly a piece of quackery, as I warned you from the start. There is no merit in it whatsoever.'

West fought the desire to flatten Fuseli's head against the wall.

'It may not be the fault of the method,' he declared. 'I combined it with other techniques.' He thought back to Ann Jemima's accusation at the opening of the exhibition. 'Miss Provis even chastised me for doing so.'

'She had the effrontery to chastise you?' Fuseli exclaimed. 'This is an irrelevance. Yours is not the only picture criticised.' He tapped his fingers crisply on the table beside him. 'Benjamin, you know the degree of my respect for you. You have created many important paintings. But *Cicero* has proved a terrible mistake.'

West looked wretchedly into the flames.

'I created my best work almost thirty years ago,' he replied softly. 'Was I doomed to be a better artist then than I am now?'

'Many of us look up to your judgement,' continued Fuseli. 'But all men are fallible – and on this occasion, you have failed.'

West thumped his fist on the table.

'You yourself dismiss the critics as much as anybody. You would be the last to deem a work to have failed just because of an article in a newspaper...'

'Please, Benjamin,' interrupted Fuseli. 'This is clearly different. I may be proved wrong. But did it never seem to you that Thomas Provis and his daughter were fraudsters? How did you ever become entangled in this mess?'

The light in his eyes was now kind, concerned.

West leant back in his chair. Fuseli, concerned, was even more irritating than the Fuseli who rebuked. He linked his fingers and ground his left thumb against the palm of his right hand.

'I refute that they are fraudsters. They are both genuinely passionate about art. She, particularly...' His words trailed off. 'I began my dealings with them extremely sceptically. It was only after I had performed many experiments that I became sure that I wanted to use the method.'

'You went to the girl for demonstrations.'

West was quiet. 'I was quite moved by her dedication. I felt there was a lot I could teach her.'

He looked at Fuseli.

'She flattered you in the best way she could,' the Swiss painter said evenly, 'by making you feel you could help her even as she sold you something she claimed would help you. But you didn't play the game in the way she expected. So then she turned on you.'

Painful visions danced before West's eyes. 'She understood the way I felt about Titian,' he eventually said, shaking his head. 'She talked about him in a way that…' he hesitated, 'there was genuine understanding there. And she was most charming.'

'Charm is very different from truth. Often people who deceive others possess it in abundance.'

West inhaled deeply.

'I apologise, Mr Fuseli. I believe solitude would help me more at this moment,' he said.

Fuseli nodded.

'That is natural. There is much to consider. You are lucky that so many of the other Academicians were taken in by the Provises. The King cannot dismiss all of you, so I would predict that – for the time being – your position as President can be sustained.'

'Pasquin did not dismiss all the paintings created according to the method,' declared West with the air of a drowning man grasping at a reed. 'He acknowledged that Farington's paintings were good.'

Fuseli's contempt was so tangible it was as if there were a separate person standing in the room. 'You and I have talked about this before. Farington is tediously adequate most of the time. He offends nobody, either with his opinions or his art. I have little respect for the man.'

For the rest of the morning Fuseli's assertions itched at West's mind. Yet despite their conclusions on Farington, he decided that

it was the diarist whom he should see next. At this point in the whole painful process he needed an ally in embarrassment. Since Farington had been one of the Provises' chief champions, West felt that he was more than qualified to take up the role.

He sent a boy round with his calling card, announcing he would like to see Farington that afternoon. When the reply arrived, just over an hour later, it came as little surprise to West to hear that Smirke would also be in attendance. If a satirist should sketch a cartoon of the two, he thought to himself, he would yoke them together and label them as Disdain and Ambition. West did not trust Smirke, he could smell the lack of respect on him. Yet though he credited Farington's loyalty still less, he suspected that now the reviews had been published, the diarist would be building a defence against ridicule that could prove most useful for himself.

But if he had hoped to find some splinters of comfort, he was disappointed. 'It is all most unfortunate, most unfortunate,' declared Farington as West was shown into his study. 'Most painful to be written about in such a way.'

'Do you credit the critics' judgement?' West refused Farington's offer for him to sit down. 'You at least have emerged from this with some acclaim. Surely that suggests the method has some merit.'

'Oh, Mr West – it is not the critics to whom I refer.' Farington blinked at him. With that blink a dividing wall was clearly erected between the two of them. Farington, it was clear, had no intention of making himself an ally.

'I believe the method does have some merit when it is practised properly.'

And now he affixes broken glass to the top of the wall, thought West. 'No, it is the other more informal publication that distresses me.' Farington continued.

West and Smirke found their eyes meeting – both looked quickly away again.

'I congratulate you that you maintain some faith in the method,' declared West. 'But the informal publication – forgive me, I do not...'

'Have you not heard of…' in that hesitation he could discern Farington's clear triumph at being ahead on the news, 'Have you not heard of the song?'

'The song?'

Now West stared at both Farington and Smirke. As they stood silent a new circle of hell seemed to announce itself.

'A song has been travelling around the coffee houses ever since the evening of the exhibition opening,' continued Farington. 'Not only is it most dismissive of the method, it suggests that we were all engaged in…' he coughed, and took out a handkerchief to wipe his forehead.

'It suggests…' he hesitated again.

'It suggest we were all engaged in sexual liaisons with Miss Provis,' said Smirke, with slight impatience.

'All of us?' responded West drily.

'Yes, all of us,' said Smirke, tapping his cane on the floor. 'The author has dedicated at least a verse to every painter involved in the scheme.'

This is like dancing on knives, West thought. He gazed disbelievingly at them.

'Who is the author of this song?' he asked.

'It is an Academy member – Paul Sandby,' said Smirke. 'Normally a most civil man. But he has been highly savage in his attack. Highly savage.'

'Do you have the publication?' West asked.

Now it was Farington and Smirke who exchanged glances. Farington lifted up a folded document from his desk as if he were a forensic scientist revealing the latest piece of evidence for a crime.

As West started reading it he raised a hand to his forehead. As he went further, a groan escaped him. His lips moved from time to time as his eyes moved down the text, but he stayed silent until he reached the fourth verse.

'"Oh! What a Field for modern genius
To handle all the Charms of Venus
With flowing tools like Mars's Penis,

Doodle doodle do…'"*

He looked up. 'Well…' He felt his voice scrape against the air. 'Sandby is hardly an Alexander Pope, is he?'

There was no cheer to be found in Smirke's expression.

'It becomes infinitely worse,' he said. 'I suggest you peruse the verses dedicated to individuals.'

West looked down again.

'"Miss bought her Titbit first to West a'

A President to all the rest a'

He to the Bottom Groped it best a'

Doodle doodle do…'"

He stared ahead of him for a moment into the distance. 'You say it has been going around the coffee houses. How many of them?'

He turned his gaze back to Farington and Smirke.

'We do not know,' said Smirke. 'Enough for it to be the talk of the town.'

'You say each one of the artists has been attacked?' asked West.

Farington and Smirke nodded. He raised the piece of paper again.

'"First Farington with fire shoving

He Artful mystic modes approving

Explores in haste Dame Natures Oven,

Doodle doodle do…'"

'It is a most vulgar work,' said Farington in discomfited tones. He cleared his throat. 'As for what he says of Smirke…'

Smirke gave him a Medusa's glance.

Farington walked over and grabbed the paper from West.

'"Such tawdry doings did confound her",' he read. '"Till Smirke",' he hesitated, '"drew out a Long Nine Pounder".' Smirke dropped his head. '"Charg'ed full with Nouse enough to drownd her. Doodle doodle do." There is a second verse…'

'Mr Farington, I feel that is quite ample', interrupted Smirke. 'We all have a sense of the tone of it.'

West realised they were all regarding at each other with the

* This is from a genuine historic document. The Sandby 'doodle-do' song, along with the Gillray cartoon, is one of the main public responses to the incident.

mixture of wariness and mutual loathing of prisoners shackled together in their cell.

'What shall we do?' he asked.

Smirke took a deep breath. 'If we issue a denial, no one will credit us,' he replied.

'Sandby's doggerel is mere satirical tittle-tattle,' said Farington, who had been sitting looking pained. 'I think we must rise above it.'

'And the allegations we have been defrauded?' asked West. 'Sandby's contribution is dismaying – mortifying, but I agree we must rise above it. I am more concerned in addressing accusations that we have been deceived.'

Farington gazed at him as if he had just pronounced a philosophical impossibility.

'Deceived? My dear West, I do not believe Miss Provis to be the agent of any deception,' he said.

'But what of the method? The method for which most of the artists paid only after you, Mr Farington, led a campaign to ensure that money was handed to the Provises.' Finally he felt a mild satisfaction as he saw the diarist shift uncomfortably. 'Do you agree with the critics that it does not work?'

'The critics said that your interpretation of the method did not work,' Farington snapped. 'When you read their reviews of other paintings in the exhibition, they are less scathing. Do you really imagine the Provises to have invented this great-grandfather who went to Venice, to have drawn up the details of the document themselves. It would have taken months and months, perhaps years, of devoted study.'

They were all silent for a moment.

'Miss Provis, for all her attributes,' continued Farington, 'is a mere young girl – and her father, if you'll forgive me, could not have done it. I think if there has been any crime on the Provis's part, it has been that of over-enthusiasm for a family document that they hoped would make them money.'

His stare challenged West, who realised it was time to retreat.

'Perhaps you have put your finger on it, Mr Farington. Yes, indeed, what you say is, on reflection, most perceptive.'

'The situation may look straightforward to the critics,' replied Farington, 'but the more I think of it, the more I believe they have missed many of the subtleties.'

'Often people react badly to what is new,' interjected Smirke.

'Do you think that is what it is about. A refusal to engage with the unfamiliar?' asked West.

'I certainly intend to continue experimenting with the method,' said Farington. 'In a few days these reviews will be forgotten.'

West felt his distress start to abate. 'Wise words indeed. Wise words.' He frowned. 'Have you talked to the Provises on this matter? What is their reaction to all of this?'

Farington cleared his throat.

'I sent a message earlier today,' he replied. 'Ann Jemima has gone to the country for a few days after what she, poor girl, still believes to be the success of the exhibition.'

'And her father?'

'Provis himself has been taken ill, and cannot leave his apartment right at this moment.'

The momentary calm West had felt ceased.

'So we cannot talk to either of them?'

The full implication of his words resounded round the room.

'Some people might say that is suspicious,' replied Farington.

Again Smirke and West looked at each other.

'But they were both most diligent in their efforts as we approached the exhibition,' continued Farington. 'We were all concerned about Thomas Provis's health: it surprises me not at all that he is unwell. It makes perfect sense that Miss Provis has escaped London for a few days too. She is a young girl – she has much to cope with, and has behaved, I think, admirably throughout.'

The pattern was set. West had gone for reassurance to Farington's house, but his doubts had proved hydra-headed. His hopes that the story would fade quickly as other topics scandalised and delighted Londoners proved equally fallible. When Ann Jemima did not

reappear from the countryside after a few days, he was concerned. When, two weeks later, she had still failed to appear, he acknowledged bitterly that no matter what her charms, perhaps her motives had not been honourable. It was around this time that the whisper that Prussian Blue had been developed only a century beforehand started to circulate. This revelation in particular stunned West. He tried to reason with himself that it was clearly an acceptable substitute for another shade used by Titian. But in his heart it proved the death knell to the method's credibility.

He remembered once reading a description of Rumour in Vergil's *Aeneid*. As she ran around the city she grew in direct proportion to the speed at which she moved. Soon her head reached the sky. Her body was covered in feathers, and for each feather she had a corresponding eye, tongue and ear. That sense of endless eyes and jeering tongues seemed to him perfectly to evoke the scorn of cultured London as it picked at his reputation.

Often, during those early weeks, he would return to his studio and stare at other canvases on which he had tried the method. As if to perform an exorcism of what had happened he started to map out a second version of the *Cicero*, furiously sketching out in charcoal the details of the story. 'This time,' he whispered to himself savagely, 'I shall colour it according to my own principles.' He walked to the table where the glass containers of paint powder were contained. He was about to open the Burnt Umber when some instinct in him picked up the whole jar, and he threw it against the wall. The satisfaction was immense as it smashed – two more jars followed. After that the footsteps came running.

There are occasions when it is a relief just to be an insignificant detail in a larger picture, as slight as a blade of grass or a drop of water in the sea. One small consolation in the entire wretched affair was its occurrence at the same time as the marriage of Charlotte, Princess Royal, to Prince Frederick of Württemberg. Daily West anticipated the ire of the King. But because of the elaborate preparations for

the wedding it never came. He gave thanks that he had been spared this final humiliation.

Other artists, he knew, had been less subtle in their response. Westall, he heard at an Academy dinner, had posted a parcel containing a dead rat through Provis's door. Thomas Stothard and John Hoppner had confronted him one day after Chapel and held him up against a wall until his shouts led to the Serjeant of the Vestry ordering them to leave the Palace. Fuseli wanted Provis to be summoned to the Academy and ordered to account for his actions. His suggestion was greeted by many with cheers, and West was urged to set a date for the confrontation.

He wrote a letter and was on the point of sending it, when Farington and Smirke paid him a call. They had heard of Fuseli's pronouncement, but to West's astonishment they urged caution. Farington had continued to be praised for his work using the method. West flinched at the vanity of the man as he mentioned this. The diarist declared he had decided it would be best for all the Academicians to err on side of generosity towards the Provises.

West swallowed his cynicism.

'Why do you think this, Mr Farington?'

'If we denounce the man outright, we will concede that many of us have been fools. I believe we should send Mr Provis a straightforward letter asking for half our money back, in the light of the disappointing critical response. But to my mind it is far better to sustain an air of ambiguity over whether or not we were deceived outright. If we declare that we believe the Provises were simply a little misguided, and we showed them too much charity.' He blinked.

'Yet you have suffered far less than I,' replied West with irritation. 'I have been accused of being a criminal, when I was the chief victim of the crime.' His voice rose.

'Do you truly believe you will alleviate or perpetuate your suffering by pursuing this course?' Farington replied coldly. 'You do understand the complexity of the situation – of the huge number of reputations that are at stake here. The more of a stir you try to create, the more questions will be asked. Why do you remain as

President? What really motivated you – and us – in entertaining the Provises? What is the point of the Royal Academy if we cannot spot charlatans when they are sitting in front of us?'

West went to his desk and ripped up the letter. He then told Farington and Smirke that he required their company no longer. Many times he considered going to challenge the Groom of the Vestry on his own at his apartment. But in those early weeks he did not know what kind of violence he might carry out should he find himself face to face with the agent of his public humiliation.

It was an early summer's evening, after an audience with the King, when he found he could put off the confrontation no longer. There is no drum beat as sinister as the knock we make on a door when we do not wish to see who is on the other side, he thought to himself. He looked at the veins on his hand as he rapped grimly on Provis's apartment door. When he heard the latch slide across, he was tempted to walk away. But he forced himself to stay there.

To his shock, it was the ghost of a man who peered out and beckoned him in with the words 'I have been expecting you.' West walked into the dark front room. He could not disguise his horror as Provis sat down on one side of the chimney and beckoned him to take the other chair. Even though it was early June a fire burnt in the fireplace. Though he was not discernibly thinner, Provis seemed frailer. His eyes peered out from parchment-dry skin and his hands trembled.

'I had heard you had been ill,' said West.

'The physicians cannot concur on any diagnosis.' Provis attempted a smile, but it slumped back in exhaustion after a couple of seconds. 'I have been wanting to come and see you. I wanted to offer an explanation.'

West felt the anger rise in him like bile.

'Have you heard from Ann Jemima?' he asked after a moment.

Provis laughed bitterly. 'Ann Jemima robbed me of all the money we received for the method.'

'She robbed you?' asked West incredulously.

Provis nodded.

'She believed she had received the money for her own work. She saw no reason why she should share it.'

West pondered for a moment on what he had said.

'The document...'

'... is false.' Provis nodded. 'But I had nothing to do with creating it. I confess I supported her knowing it was false. I was very much party to the crime.' He laughed lugubriously. 'Her teacher, Richard Cosway, was blackmailing me – and there was no other route to take. I had more to lose by not helping her than by doing so. In truth, I thought you would all perceive its weaknesses straight away.'

He looked directly at West, who dropped his head.

'Then you did not. Matters became very complicated.'

West frowned.

'How was Cosway blackmailing you?' he asked.

'She was not my daughter,' Provis replied.

West nodded.

'Of that I am aware.'

'When she came to me with this scheme to make money, I told her there was no point in going ahead with it. She told me that if I did not help her, she would let it come to the attention of the King that I was living with a young woman to whom I was not related. That was the first moment I realised the mistake I had made.'

'She blackmailed you, when you had saved her from poverty?' said West incredulously.

'I could not condemn her.' Provis's voice cracked. 'She was a young girl who needed help and knew no better.'

He looked desolate. West was struck not so much by the sense of Provis's grief as by the fact it was not the only time he had observed it. Farington, Rigaud, and even Smirke had been visibly upset as much for the fact that Ann Jemima had not been who they thought she was as for the fact they had been deceived over the method. 'She seemed so in her element among the painters of the Academy,' Farington had observed, 'Smirke and I spent some delightful after-noons in her company.' Rigaud had merely been uncharacteristically silent whenever she was mentioned. This, West knew from experi-ence, spoke more about his feelings than any words could.

He looked once more at Provis, and observed yet again the decline in his physical condition. The tuber-like nose seemed to

protrude more acutely from his face, his movements seemed painful. His suffering is genuine, he thought to himself. All the angry sentiments with which he had knocked on the door, all the accusations and recriminations, shrivelled on his lips and died. He leaned forward.

'She had a talent for inspiring love, did she not?' he found himself saying.

Provis took a deep breath.

'I knew she was going to leave at some point. Just as all daughters leave their fathers, I knew she would leave me.'

West did not detect the observant gleam in Provis's eyes just at the moment before he put his head in his hands.

'Against my better judgement, I would have liked to have seen her again. To ask her why she did it. To ask if there was anything she took from our sessions...' he hesitated, 'if she saw me as more than a fool.'

Provis was silent.

'I cannot pretend that I have not felt a great deal of anger towards you,' West continued. 'My humiliation over this has been considerable, and the thought that you should be punished has played often on my mind.'

'Do what you will,' said Provis quietly. 'I personally would not hesitate to take revenge.'

West felt the rise and fall of his chest as he looked at the man once more. Observed once more the ashen exhausted face, the slumped shoulders, and trembling hands.

He took a deep breath.

'You have nothing to fear from me,' he said softly.

He stood up and moved towards the door. Briefly he watched Provis staring into the flames. Outside a blackbird sang its piercing hymn to the evening.

Venice, November 1797

'It is not without the impulse of a lofty spirit that some are moved to enter this profession, attractive to them through natural enthusiasm. Their intellect will take delight in drawing, provided their nature attracts them to it of themselves, without any master's guidance, out of loftiness of spirit. And then, through this delight, they come to want to find a master; and they bind themselves to him with respect for authority, undergoing an apprenticeship in order to achieve perfection in all this. There are those who pursue it, because of poverty and domestic need, for profit and enthusiasm for the profession too; but above all these are to be extolled the ones who enter the profession through a sense of enthusiasm and exaltation.'

Cennino Cennini,
The Craftsman's Handbook, c. 1400

The cold afternoon is steeped in sunshine. A boat carves a line up the coast of the Adriatic. There is a small party on it that has met in Rome, and then travelled up to Assisi before crossing to Ancona and taking the boat to Venice. A young woman sits near the prow of the boat, staring out at the water with a faraway look in her eyes. Around her the voices of the travelling party come in and out of focus.

'There is a part of me that fears seeing Venice,' one of the other women declares. She is in her late twenties, but her hair has turned grey early. Swept back into a stylish chignon, it is offset by a youthful, slightly over-pink complexion.

'Napoleon's victory there has brought most grievous harm,' concurs her husband, who is some ten years older. 'His soldiers have plundered and looted everything they can.'

'My friend has written to me that they took the four bronze horses from the front of St Mark's,' the woman interrupts, keen to be perceived as the expert on this matter. 'It was as if they wanted to tear out the very spirit of the Republic.'

The young woman has been trying to stay her tongue for a while now. 'But the Venetians themselves stole the horses from Constantinople in the thirteenth century,' she says, turning back to her travelling companions with an easy laugh. 'The horses' heads were severed so they could bring them more easily from Constantinople to Venice.' Her pale blue eyes flash.

The slightly older woman, Mrs Allenby, surveys her. 'My dear Emily – you never cease to surprise me with your distinctive observations. We have enjoyed your company greatly on this tour – how sad it is for all of us that your husband cannot also join us.'

A look of distress flickers across Emily's face. 'I will write to him tonight. Hopefully he will be in a position to join me soon,' she replies softly, and looks away again. Around them the water turns molten gold in the sunset.

The young woman has been a source of fascination to the other members of the party – which consists of herself and two married couples – ever since their first encounter in Rome. She talks as eloquently as any man about art, but in company reveals very little about her own personal affairs. Mrs Allenby has made assiduous efforts to befriend her. The discovery of a hidden tragedy has been a triumph. 'Her husband was taken ill in Paris,' she has told her husband. The latter nods through his habitual fog of disinterest. 'He may not live another year,' she continues. 'Yet he refused to let her stay in Paris to look after him, and begged her to go on to Rome. He had a business matter that he trusted only her to address.'

Emily, for that is now Ann Jemima's name, has proved most agreeable company for a couple whose conversational resources were fully spent within minutes of leaving Dover. The other couple on the boat are only slightly better matched. The wife, Caroline, a handsome woman with black hair and lips painted a vivid red, has an astringent wit which is often directed at her husband, Mr Dornoch. A mature clergyman and amateur scientist with extraordinary empathy for humankind's fallibility, he has so far proved the most interesting companion of the journey.

Despite the disparities in their characters, the five have agreed to embark together on a difficult expedition. It is but six months since Venice fell to Napoleon, and just one since he signed it over to Austria. Emily has met the Allenbys by chance at the Roman Forum, as they all stared at the faded grandeur of the Arch of Septimius Severus. Around them the sprawl of relics from an ancient empire seemed somehow more alive through the reports they were receiving of Bonaparte's desire to reinvent himself as a latterday Caesar. Over dinner two nights later, Mrs Allenby proposed they should take the trip to Venice to see what had happened in the wake of his invasion there.

'My friend Isabella Albrizzi has written very movingly of how difficult it has been since the French invaded,' she said. 'The soldiers have proved both drunken and brutish.' She lowered her voice. 'Many women have been violated. Napoleon denies such transgressions strongly.'

'His intentions were brutal from the start,' said Mr Dornoch. 'He wanted not just victory but revenge. He told the Venetians, "You have murdered my children – the winged lion of St Mark must lick the dust."'

'Then it sounds as if we should not go,' Mr Allenby said.

'I believe the barbarity is starting to recede since the Austrians took over,' Mrs Allenby replied. 'Now that France has attempted to invade Britain, I know many Venetians would feel a certain fellowship with us. I think we should take up her invitation.' Her eye lit on Emily. 'She has asked my husband and myself to spend a week with her there. I am sure, if I sent word, that you would be most welcome too.'

Emily has now absorbed her new identity so fully that she would not even look round in the street should someone call out Ann Jemima. The invitation has proved the culmination to a trip that has been both less terrifying than she feared and more profitable than she had dared hope. The trip across the Channel did not initially bode well. Though it was a short crossing, the waters were choppy and the summer rain relentless. Few people paid heed to the girl scratching methodically in her notebook with a quill, mapping out the boundaries of her new life.

Since the grief she had brought to London had been compounded by the grief for those she left behind there, she considered that the title of recent widow might suit her. But a little more thought led her to decide that the device of a sick husband would be far better. It would create a haze of discomfort which would mean people would not ask her too much about her past. It would also deter proposals from men who might delude themselves that they could provide her with a new future on their own terms. In short, she concluded, an imaginary husband will allow me both freedom and protection. She determined she would write letters telling two people of her changed identity. One was to Josiah Darton, who wrote back swiftly promising her introductions under this new identity to individuals he knew in Paris and Lausanne. The other was to Thomas Provis, from whom she received no reply.

From Lausanne she continued across the Alps through the St Bernard Pass. The roads felt treacherous – at one point a mule died of exhaustion. As she gazed out over the rocky landscape plunging towards the valley below Emily felt a strong sense of the perilous conditions that now circumscribed her existence. Yet gradually she was realising that she had the resources to survive on the Continent, just as she had in London. The shades of Darton's other lives were proving more useful than she entirely wanted to admit. The people whom she had met in Paris had given her introductions for Turin, and Florence – and the new friends in Florence in turn sent letters to acquaintances in Rome who declared they would be very willing to have Emily to stay. In Rome she had finally started painting again, creating a small Alpine scene in oils for her delighted hostess.

On the day that she finally takes the boat up the Adriatic with the Inghams, Emily is somewhat distracted. After six letters to Thomas Provis without a reply, she has despaired of ever hearing from him again. Yet this morning a letter has finally arrived from London. She has been filled with contradictory emotions on seeing the familiar spiky handwriting. Carefully she has broken the seal, which she recognises as one from his collection of unusual designs. The red wax bears an imprint of Laocoön wrestling with snakes, and she smiles at the irony.

'My dearest Ann Jemima,' the letter begins.

'Forgive me for what may seem an Inappropriate style of address by now. Hard-forg'd habit makes any other form of Approach seem wrong to me. I trust that you are in good health. It seems that Europe is proving every bit as Extraordinary as you anticipated, even under the constant threat of Napoleonic invasion. From your letters it seems you have turned the Vexatious circumstances of your departure into a Triumphant beginning for a journey that you have dreamt of for some while.

'I ask myself if there are moments in your life when you might Reflect on what the news is from London. It may surprise you that it barely seems to have stopped talking about you and the Venetian Secret ever since you left. I flatter myself that you may be a little Curious to know how this has affected my own life. Perhaps it will come as some relief to you that I have not suffered terribly – certainly not as terribly as Benjamin West. I did Precis'ly as you and Darton instructed. I waited for West to come and see me – and then I told him that you had Blackmail'd me into taking part in the scheme and took all the money. The old fool never learns. He ingested the story whole, and told me he felt Sorry for me. I suffer'd a while from bad health, but have now recovered. If he sees me at the Palace now, he is so Embarrass'd, he does all he can to avoid conversation with me, which suits us both perfectly.

'Each time that it seems London has wearied of the Venetian Secret, something fresh occurs to Remind people of it. If you'll forgive me, it is not Unlike watching an animal in its death throes. In June, a great enemy of Benjamin West, the Irishman James Barry, wrote an Open letter to the Society of Dilettanti, decrying the Academy because of the scandal. There were more calls for Benjamin West's resignation, but here we are in late October, and still he remains in his position. That seemed to be the Sum of it, but just this week, the alcoholic Gillray has produced a cartoon that goes into some detail about the way he thinks we deceived the Royal Academy.*

'Yes, my dear, you have even inspired a work of Art. I think in some strange sense it would please you that it is a work of art in which you yourself appear as the main Artist, though the Depiction is obviously not without its ironies. As you know, Gillray has caricatured everyone from Pitt to Napoleon – so you should take some pride that you have seized his attention.'

Provis has enclosed a copy of the cartoon. Now she is on the boat she cannot resist taking it out of her bag once more. She looks at it surreptitiously, feeling as if she is taking some great risk in doing so. The detail is both absurd and extraordinary. It both makes her laugh and seizes her with horror.

Her own image is etched on top of the rainbow. She wonders who has described her to Gillray. His drawing does not replicate her perfectly, yet somehow in the poise and silhouette of her figure he has caught something essential about who she is. Her arm is raised triumphantly as she draws Titian's head on the canvas. Her slender frame perches on precarious red heels. On the right hand side of her, the Neoclassical building that Gillray has drawn to represent the Royal Academy is in the midst of apocalypse. A large crack rends the façade, while shooting stars rain down from the sky as if about to launch their own assault on the building.

* *Titianus redivivus;–or–the seven-wise-men consulting the Venetian oracle.* A copy of this Gillray cartoon is owned by the British Museum.

The wretched artists at the centre of the scandal sit at the front of a large crowd as if on trial at the Day of Judgement. For a moment she feels the enormity of what she has left behind, and shivers a little. In a corner, West, with his palette and brushes, is sneaking away to evade detection. A little behind him, the ghost of Sir Joshua Reynolds is rising up out of the ground in a shroud, his hand raised like an ancient prophet issuing dire warnings. As ever in Gillray's work there are Rabelaisian elements – to the left a grinning monkey, crouched next to a headless statue of Apollo, urinates on a pile of Academy artists' portfolios. Above them cherubs fart their condescension.

Her hand shakes – she feels hot and cold in the same instance.

'A letter from your husband?' enquires Mrs Allenby softly.

Emily looks at her startled. Swiftly she folds the document and puts it in her bag.

'That is right,' she declares. 'There is good news – it seems there is a slight improvement in his health.'

'Your love for him is very clear my dear,' Mrs Allenby continued. 'I could see it on your face when you were reading.' She darts a glance towards her husband.

'He is in good spirits. He sounds quite like the man he was when I first met him.' To Emily's surprise, tears start to slide down her cheek.

Mr Dornoch, the clergyman, clearly considers Mrs Allenby's curiosity to be intrusive.

'What will be the first thing you go to see when we arrive in Venice?' he asks, skilfully diverting the conversation. 'The boatman has just announced we will land shortly. I have wanted all my life to go to Santa Croce to see the tomb of Galileo – I trust that Napoleon's soldiers have not ransacked that.'

A strand of red hair has fought loose of Mrs Allenby's chignon. Distractedly she pushes it back into place. 'I wish to go and see Canaletto's *View of the Grand Canal from the Campo San Vio*,' she replies. 'It was seeing a print of it that made me wish to see Venice – despite the dangers.'

'What is your choice, Emily?'

Emily wipes the tears away with a handkerchief.

'I think,' she pauses for a moment, 'I will go and see Titian's *Assumption of the Virgin in Santa Maria dei Frari*.' She smiles. 'He created it in the face of huge scepticism. I have a love of those who defy sceptics.'

She takes a deep breath, and looks out of the boat again. As she glances down she sees a sea bream dash below the boat, and briefly envies its solitary progress through the cool waters. She raises her head again, and realises they are about to arrive in St Mark's Basin.

'We are there!' she exclaims. 'We are there.'

In front of them the Campanile of St Mark soars up on one side, while on the other side the dome of the cathedral is just visible. The evening sky is seared with vermilions, angry golds, and muted pinks. Emily feels that she has never experienced such colour in one landscape before, never seen buildings that looked so much as if they have been imprinted on their surroundings by a painter's brush. The calls of men lap across the water from other boats as they come into shore. She and her companions look at the buildings imprinted against the raging sky, at the mortals walking before them in the square.

The bells from St Mark's strike four o'clock. The water throws back the shimmer of their sound. Now she realises that while she has often imagined how Venice looks, she has never thought of the sound of it, the smell of it. The slap of the water against the boats, the faintly diffracted sound of the crowd, the coldness of the air she is inhaling, the scent of chestnuts roasting next to the quay.

Mr Dornoch holds his hand out to her to help her off the boat. 'I have been told many times that even those who haven't been to Venice feel they have seen it before when they arrive,' he says.

'People always say Venice seems a little unreal,' she replies. 'But I have never seen anything so real in my life.'

She gets off the boat. As the others preoccupy themselves with their luggage, she takes a quick look around her. She frowns for a moment and briefly puts her hand on her forehead. The swoop of her gaze becomes wider, she looks beyond the people with whom

she has arrived – first out to the lagoon, and then to the far corner of the square.

Suddenly, without saying a word, she picks up her small bag and starts to walk away rapidly.

At first the group does not notice. When they do, the two older women start shouting and waving at her to come back, but she will not heed them. Mr Dornoch makes as if to walk after her, but then he stops himself, recognising the sense of purpose in what she is doing. For a brief while her silhouette remains distinct – there is a point when she turns as if to call something out to them, but then she checks herself and turns away again.

They look towards her, not knowing what to do or say. As they continue to watch, she starts to become eclipsed by the movement of other people. A flock of pigeons cuts dark shapes against the air, a lone trumpeter begins to play to the crowd. Distracted, they realise they can see her no more – she has become just a detail in the ebb and sway of the Venice evening.

I stumbled upon the eighteenth-century cartoonist, James Gillray, in an exhibition at The New York Public Library in 2004. His world instantly captivated me – not only was it full of dirt, gossip, and intrigue, it also gave a sense of a society undergoing profound change. About ten years later, when I was thinking about writing a novel, I was looking through a collection of his cartoons and discovered a satire of a real-life scandal. *Titianus redivivus;–or–the seven-wise-men consulting the new Venetian oracle* erupts from the page with ribald detail: it includes the shamed artists, a urinating monkey, the ghost of Sir Joshua Reynolds, and a young woman presiding over them all from a rainbow. It is simultaneously cryptic and outrageous. I started to research it the same day.

The true story of Benjamin West – then President of the Royal Academy of Arts – and Ann Jemima Provis is every bit as extraordinary as it first appears: it deals with obsession, jealousy, vanity, deception, lust, disappointment, and the elusive pursuit of genius. It also shows the Royal Academy at a point when it was still a radical young institution, introducing new artists and contemporary art in a time when many collectors were obsessed by historic works. The artists themselves came from a range of backgrounds, so the Academy was a microcosm of tensions in London immediately after the French Revolution – some were close to King George III, others were closer to those wanting to overthrow him. Beyond this was the cat-hissing rivalry that automatically sprang up between individuals who wanted to mark themselves out as the greatest artists of their time.

It was fertile territory. For about a year before writing anything I immersed myself in the letters, diaries and historic records of the real-life characters involved. As with other historical fiction

writers, for me – while the history was fascinating – it was in the gaps between what is known historically that this story was able to come to life. Next to nothing is known of Ann Jemima, apart from the extraordinary effect she had on everyone who met her. One satirical song published at the time suggested that the main interest the artists had in her was sexual, but it did not take much research to gain a sense both of her artistic accomplishment and of her intelligence.

The resulting book is not a faithful historical account – for that it is best to go to the diaries of Joseph Farington, one of the artists caught up in the events depicted. The outrageous deception central to the plot comes from fact, but the motivations, ambitions and intrigues of the different characters are my imaginative response to the arc of the story. Researching the era more widely was both illuminating and liberating – one particularly enjoyable discovery was that there were many more female innovators at the time (in science, art, literature and music) than most conventional histories suggest. Unorthodox and law-unto-herself though she is, Ann Jemima is also an indication of the many other voices that have been silenced, and a world of stories still waiting to be told.

ACKNOWLEDGEMENTS

I began my research in the hushed and perfectly formed surroundings of the Royal Academy's beautiful library and archive. As well as holding historical accounts of the scandal, the library contains the actual manuscript presented by the Provises to the Academicians. I would like to thank Nick Savage, the Royal Academy's former director of collections, for giving me permission to come and study the manuscript, and Mark Pomeroy, the Royal Academy Archivist, for suggesting other sources.

I am neither an art historian, nor an artist – it was the human aspect of the scandal that drew me in. In terms of helping me understand the extremely technical aspects of the manuscript I will be eternally grateful to Nicholas Walt, director of London's oldest art suppliers, L Cornelissen & Son, who sat me down one morning before Christmas to explain the different terms. Among other matters we debated whether or not Indian Yellow was really made from cows' urine. A jar full of strong-smelling pigment seemed to settle the question – though further research shows the answer, like several aspects of colour, is more complex.

David Cranswick – artist, Royal Academician, and expert in traditional methods for making paints – was also generous enough to let me into his studio on a cold April day and demonstrate to me some of the paint-making techniques with which both Titian and Benjamin West would have been familiar. On top of this he was happy to discuss matters ranging from Newton's *Opticks* to rabbit glue.

In terms of historic detail, David Baldwin – Serjeant of the Vestry at the Chapel Royal at St James's Palace – helped hugely by giving a tour of the palace and the chapel. My character Josiah Darton is entirely fictional – it was an act of imagination to make him sing in the choir and be a spy – so it was with some amazement

that I heard from David that church musicians were often spies at that time in history, both because of their connections and as a result of the travel involved in their work.

I owe a huge amount to my agent Toby Mundy, who understood my motivations for writing the book straight away, and whose belief in it and advice has made all the difference. I must also thank him for linking me up with Peter Mayer, President and Publisher of Duckworth Overlook, a publishing legend who turned out to know better than I how much further I could push the book. I am extremely grateful for my long and enjoyable conversations with Peter, and for his ability to balance valuable guidance with giving me free rein.

I feel very lucky to have a number of friends who bit the bullet and agreed to read the book in the early stages. It's a big test of friendship, and Ben Rogerson, Patrick Marmion, Gurion Taussig, and Robert Pfeiffer, you all made invaluable suggestions. Rebecca Glover, you probably helped more than you realised when we agreed I would send you a chapter a day for Advent. And Imogen Robertson, former brunch companion and successful novelist, you have been there ever since I started writing seriously, and are a constant source of wonderful advice about negotiating the publishing industry.

My husband, Bill McIntosh, deserves a huge amount of credit, not least for telling me to stop doing other work and to sit down and concentrate on finishing the novel. Authors' spouses put up with a lot, and he has dealt with the ups and downs of this process with endless patience. My son, Fergus – far from providing a 'pram in the hall' distraction from creativity, in fact gave me the motivation to organise myself properly and ensure I had something to show for my work. For that, and the constant adventure of watching him grow up, I am forever grateful.

Finally, I suspect most aspiring authors show their mothers their work first, and according to most mothers they are geniuses. And that's where the journey ends. However, when you know someone well, you can also tell if they're lying. It was when my very strong-minded mother, Jenny Halliburton, genuinely seemed to enjoy what I was writing that I realised that this story might have a life outside my head.